Unfo
the South

Nineteenth-century British women
writers and artists in Italy

edited by
Alison Chapman and Jane Stabler

Manchester University Press
Manchester and New York

distributed exclusively in the USA by Palgrave

Published by Manchester University Press
Oxford Road, Manchester M13 9NR, UK
and Room 400, 175 Fifth Avenue, New York, NY 10010, USA
www.manchesteruniversitypress.co.uk

Distributed exclusively in the USA by
Palgrave, 175 Fifth Avenue, New York, NY 10010, USA

Distributed exclusively in Canada by
UBC Press, University of British Columbia, 2029 West Mall, Vancouver, BC, Canada V6T 1Z2

British Library Cataloguing-in-Publication Data
A catalogue record for this book is available from the British Library

Library of Congress Cataloging-in-Publication Data applied for

ISBN 0 7190 6129 6 *hardback*
　　0 7190 6130 X *paperback*

First published 2003

10 09 08 07 06 05 04 03 10 9 8 7 6 5 4 3 2 1

Typeset by Graphicraft Limited, Hong Kong
Printed in Great Britain
by Bookcraft (Bath) Ltd, Midsomer Norton

Contents

Illustrations

Contributors

Isobel Armstrong is Professor of English at Birkbeck College, University of London. Her books include *Victorian Poetry: Poetry, Poetics and Politics* (1993), the *Oxford Anthology of Nineteenth-Century Women Poets* (1996), edited with Joseph Bristow and Cath Sharrock, and two collections of essays on eighteenth- and nineteenth-century women's poetry, edited with Virginia Blain, *Women's Poetry in the Enlightenment* and *Women's Poetry: Late Romantic to Late Victorian* (1999). Her *The Radical Aesthetic* (2000) is a work of theory exploring a democratic aesthetic after the hermeneutics of suspicion and its anti-aesthetic stance. She is currently working on a study of glass, technology and culture in the nineteenth century. She is co-editor of the journal *Women: A Cultural Review*.

Alison Chapman is Lecturer in English Literature at the University of Glasgow. She is the editor of *The Icon Critical Guide to Elizabeth Gaskell's* Mary Barton *and* North and South (1999), the author of *The Afterlife of Christina Rossetti* (2000) and the co-editor, with Richard Cronin and Antony H. Harrison, of the *Blackwell Companion to Victorian Poetry* (2002).

Richard Cronin teaches at the University of Glasgow. His most recent books are *The Politics of Romantic Poetry* (2000) and *Romantic Victorians* (2002).

Angela Leighton is Professor of English at the University of Hull. She is the author of *Shelley and the Sublime* (1984), *Elizabeth Barrett Browning* (1986), *Victorian Women Poets: Writing Against the Heart* (1992), and is the co-editor of the *Blackwell Critical Reader of Victorian Women Poets* (1996). She is currently writing a book on *Aestheticism* as well as a collection of essays on nineteenth- and twentieth-century poetry.

Jan Marsh is author of *Pre-Raphaelite Sisterhood, The Legend of Elizabeth Siddal* (1985) and biographies of Christina Rossetti (1994) and Dante Gabriel Rossetti (1999). With Pamela Gerrish Nunn, she curated the exhibition 'Pre-Raphaelite Women Artists' shown at Manchester City Art Gallery, Birmingham Art Gallery and Southampton Art Gallery in 1997–98.

Catherine Maxwell is Senior Lecturer in the School of English and Drama at Queen Mary, University of London. She is the editor of *Algernon Charles Swinburne* (1997) and author of *The Female Sublime from Milton to Swinburne: Bearing Blindness* (2001). She is currently working on the Swinburne volume for the series 'Writers and their Work'.

Pamela Gerrish Nunn is Associate Professor of Art History at the University of Canterbury (New Zealand). Her publications include *Canvassing* (1986), *Victorian Women Artists* (1987) and *Problem Pictures* (1996). With Jan Marsh, she has published *Women Artists and the Pre-Raphaelite Movement* (1989) and *Pre-Raphaelite Women Artists* (1997), the catalogue for a record-breaking exhibition which toured Britain in 1997–98. She is currently working on women's art in the first decade of the twentieth century.

Francis O'Gorman is Lecturer in Victorian Literature at the School of English at the University of Leeds. He has published widely on Victorian literature, including *John Ruskin* (1999), *Late Ruskin: New Contexts* (2001) and *Blackwell's Critical Guide to the Victorian Novel* (2002). He has also co-edited collections on *Ruskin and Gender* (2002, with Dinah Birch) and the writing of Margaret Oliphant (1999, with Elisabeth Jay).

Esther Schor is Associate Professor in the Department of English, Princeton University. She is the author of *Bearing the Dead: The British Culture of Mourning from the Enlightenment to Victoria* (1993) and editor of the *Cambridge Companion to Mary Shelley* (forthcoming). She is also co-editor of *The Other Mary Shelley: Beyond Frankenstein* (1992) and *Women's Voices: Visions and Perspectives* (1990).

Jane Stabler is Lecturer in English at the University of Dundee. She is the editor of the *Longman Byron Critical Reader* (1998) and is the author of *Burke to Byron, Barbauld to Baillie, 1790–1830* (2001) and *Byron, Poetics and History* (2002).

Nicola Trott is Lecturer in English Literature at the University of Glasgow. Among recent publications are *1800: The New Lyrical Ballads*, co-edited with Seamus Perry (2001), and '*Middlemarch* and "The Home Epic"', in *Master Narratives: Tellers and Telling in the English Novel*, edited by Richard Gravil (2001).

Acknowledgements

Any collection of essays owes the greatest debt to its contributors and this volume is no exception. The editors wish to thank all the contributors for their patience, fortitude, grace, and, most of all, for their wonderful chapters. We also acknowledge the generous help and guidance of Matthew Frost and Kate Fox at Manchester University Press, together with the anonymous reader who recognised at an early stage all that is good about the contributions. Any errors or infelicities are our own.

The idea for a volume of essays on women and Italy came in a moment of epiphany when, during a conversation about our research, we realised how much our interests overlap. That is the especial joy of working with colleagues who are also friends. We wish to thank members of the English Department at the University of Dundee who helped to create this collegial environment during the volume's germination, in particular Andrew M. Roberts. Conversations with family, friends and colleagues have, over many years, inspired our love for Italy and sustained our mutual work on the volume. We wish in particular to thank Vivian Bone, Heather Card, Robert and Norma Chapman, Richard Cronin, Robert Cummings, Cian Duffy, David Fairer, Anne Fleming, Gwen Hunter, Robert Miles, Nicholas Roe, and Gillian Wright.

Finally, we wish to offer grateful thanks to Peter Vassallo for organising the conference *England and Italy: Literary and Cultural Relations* in September 2000, at the Institute of Anglo-Italian Studies at the University of Malta, and for giving us the opportunity to talk about our research.

Introduction

Alison Chapman & Jane Stabler

'C'EST MOI', Felicia Hemans wrote in the margin of her copy of Madame de Staël's *Corinne, or Italy* (1807).[1] The novel exerted a powerful hold on nineteenth-century women writers whether they travelled to Italy or, like Hemans, only imagined it. De Staël asked her readers to re-think their preconceptions about women, art and the Italian peninsula. The chapters that make up this collection share the same aims. Not only did *Corinne* explicitly confront the conventional rhetorical associations of Italy with the feminine but the novel also haunted nineteenth-century women with a conflicted paradigm of the inspired female artist. De Staël attempts, according to Carla Peterson, 'nothing less than a new Romantic aesthetic',[2] forged in Corinne's improvisations, the account of Italy's political and artistic heritage, and the travel narratives that many northern visitors to Italy were to use as their guide. As Ellen Peel and Nanora Sweet suggest, 'The aesthetic is liquid, colorful, insinuating, and sensuous; it is perishable, nonutilitarian, destabilising'.[3] The nineteenth-century British and American women artists and art historians, poets, novelists, travel writers and political commentators discussed in the essays that follow were all in different ways haunted by their fictive precursor, Corinne.

1 Henry Fothergill Chorley, *Memorials of Mrs. Hemans. With Illustrations of her Literary Character from her Private Correspondence*, 2 vols (London, Saunders and Otley, 1836), 1: 304. Quoted in Nanora Sweet, ' "Lorenzo's" Liverpool and "Corinne's" Coppet: The Italianate Salon and Romantic Education', in Thomas Pfau and Robert F. Gleckner (eds), *Lessons of Romanticism: A Critical Companion* (Durham and London, Duke University Press, 1998), pp. 244–60 (p. 252).
2 Cited in Ellen Peel and Nanora Sweet, 'Corinne and the Woman as Poet in England: Hemans, Jewsbury, and Barrett Browning', in Karyna Szmurlo (ed.), *The Novel's Seductions: Staël's* Corinne *in Critical Inquiry* (Lewisburg, Bucknell University Press, 1999), pp. 204–20 (p. 207). One of the most important early feminist responses to Corinne is Ellen Moers, *Literary Women* (London, The Woman's Press, 1978), chapter 9.
3 *Ibid.*, p. 207.

One of the most enthusiastic readers of de Staël, Elizabeth Barrett Browning, declared in 1832 that 'Corinne is an immortal book, and deserves to be read three score and ten times – that is once every year in the age of man.'[4] As quickly as a decade after its publication, the Corinne myth was famous enough to be the subject of reverential homage and playful parody. The travel writer, Charlotte Eaton, narrates her entry into St Peter's, Rome, and wryly observes that Corinne must have been 'a lady of amazonian strength' if she could hold the curtain at the threshold aside for Lord Nelvil.[5] The joke is that Corinne was, in some ways, the archetypal figure of female suffering and vulnerability. Although she performs the role of confident, independent artist and guide, inducting the English Lord Oswald Nelvil into the mysteries of Italian culture, the novel ends with her death from grief when she cannot marry him. Anna Jameson recalled Corinne's capacity for loss and anguish in her cult travel journal, *Diary of an Ennuyée* (1826):

> 'Corinne' I find is a fashionable vade mecum for sentimental travellers in Italy; and that I too might be *à la mode*, I bought it from Molini's to-day, with the intention of reading it on the spot, those admirable and affecting passages which relate to Florence; but when I began to cut the leaves, a kind of terror seized me, and I threw it down, resolved not to open it again. I know myself weak – I feel myself unhappy; and to find my own feelings reflected from the pages of a book, in a language too deeply and eloquently true, is not good for me.[6]

Jameson already knows *Corinne* well enough to have an idea of its 'admirable and affecting passages', but the act of opening the book induces 'terror' because, for the isolated woman artist, it reflects more than fashionable sentimentalism. While Jameson sees in Corinne an overpowering image of her own plight as unrequited lover, other women writers in the nineteenth century drew on the novel to articulate professional and political alienation, using de Staël's paradigm of troubling correspondences and second selves.

Multiplying the doubleness of the title, Corinne is a pseudonym adopted by de Staël's heroine 'because of the story of a Greek woman,

4 Barbara P. MacCarthy (ed.), *Elizabeth Barrett Browning: Unpublished Letters of Elizabeth Barrett Browning to Hugh Stuart Boyd* (London, John Murray, 1955), p. 176.

5 Charlotte Eaton, *Rome in the Nineteenth Century... Written during a Residence at Rome in the years 1817 and 1818*, 3 vols (Edinburgh, Ballantyne, 1820), 1: 112.

6 Anna Jameson, *Diary of an Ennuyée* (new edn, London, Henry Colburn, 1826), pp. 115–16.

Pindar's friend and a poetess'.[7] Graeco-Roman myths have always been closely interlinked in European cultural history, and Greece and Italy were seen as the foundations for modern western civilisation as well as enticing gateways to the East. In this volume, Nicola Trott's discussion of George Eliot's *Romola* examines this cultural synaesthesia in the person of Tito, suggesting that Eliot's fascination with Tito's hybrid origins and mercantile slipperiness figure the novelist's own negotiations with the literary market place with a work which is itself mediating between two languages and cultures. Her chapter also points to Eliot's quiet questioning of the patriarchal inheritance of Renaissance Italy: although her heroine fails to live up to the high ideal of classical scholarship she sets herself, 'it is she who ends up passing on her classical training to the next generation' (p. 158). Romola's eventual transformation into motherly teacher holds a distant memory of Corinne's last role as tutor to Lord Nelvil's daughter.

Corinne, or Italy asks readers to project the tragedy of a gifted woman artist allegorically onto a geographically whole but, as yet, politically fragmented nation. As Madelyn Gutwirth notes, '[t]he incoherence of the peninsula's odds and ends of antiquity, its cities' rises and falls from political power, combine . . . to give Italy the nonlinear temporal quality Mme de Staël wishes to associate with Corinne's genius'.[8] Politics and aesthetics are interwoven in the novel in ways that many of the following essays explore. Notably, Corinne's Anglo-Italian parentage and her repressive British upbringing allow her to reflect critically on northern culture and society. One episode Corinne narrates from her past enables readers to sound the gulf between northern and southern perspectives. Bored by the silence of an English dinner party, Corinne tells how she tried to talk to a neighbour:

> and, in the conversation, I quoted some very pure, discreet Italian verses commenting . . . on love. My stepmother, who knew a little Italian, looked at me, blushed, and even earlier than usual, signed to the ladies to retire and prepare the tea, leaving the men alone at table during desert. I did not understand this custom at all. In Italy it is very surprising, for these people cannot conceive of any pleasure in society without women . . . At supper my stepmother told me quite gently that it was not usual for young ladies to speak, and above all

7 Madame de Staël, *Corinne, or Italy*, transl. Sylvia Raphael (Oxford and New York, Oxford University Press, 1998), p. 260. It is significant that the heroine renames herself without a patronymic, in an attempt to forgo her British paternal heritage.

8 Madelyn Gutwirth, *Madame de Staël, Novelist: The Emergence of the Artist as Woman* (Urbana, University of Illinois Press, 1978), p. 210.

that it was never permissible for them to quote poetry in which the word 'love' was mentioned. (pp. 244–5)

Soon after this, Corinne decides to leave England and return to Italy (her mother's country) where she will be more free to develop her poetic talent and her interest in literature and the arts. The contrast between warm south and cold north is re-played in the novel as Oswald, the archetypal British man abroad, struggles to choose between Corinne and her fully English half sister, Lucile, as potential marriage partners. He is captivated by Corinne's passionate nature and aesthetic accomplishment, but daunted by her independent spirit. In the interests of 'domestic happiness' and in deference to his father's wishes, he eventually chooses the 'reserve and restraint' of Lucile (pp. 310, 308). The marriage quickly chills into a relationship of mutual 'constraint' (p. 382).

De Staël's questions about the nature of marriage anticipated one of the leading social issues of nineteenth-century Britain. Oswald's outraged exclamation that 'infidelity itself is more moral in England than marriage in Italy' (p. 95) prompts Corinne's defence of Italian liberality: 'In England, domestic virtues constitute the glory and happiness of women, but if there are countries where love continues to exist outside the sacred bonds of marriage, Italy is the one, of all those countries, in which women's happiness is best fostered' (p. 101). In imaginative terms, Italy certainly offered the prospect of independent life outside the confines of the northern domestic sphere.[9]

Italy had been portrayed as a dream-like haven for male northern travellers since Milton's *Paradise Lost* presented Eden as an Italianate garden of unfallen sexuality.[10] In the nineteenth century, however, assisted by the rapid growth of affordable transport to the continent, Italy became a utopian space for women as well, who found their 'imaginative experience at cross purposes with social and sexual morality': this is how Angela Leighton defines 'the essence of the Victorian imagination, as well as being the especially burdensome anxiety of the Victorian *woman* writer'.[11] In the present collection, Esther Schor's chapter investigates

9 See Julia Markus, *Across an Untried Sea: Discovering Lives Hidden in the Shadow of Convention and Time* (New York, Alfred A. Knopf, 2000).

10 John Milton, *Paradise Lost*, ed. Alastair Fowler (Harlow, Longman, 1968), 4: 172–392. See also James Buzard, *The Beaten Track: European Tourism, Literature, and the Ways to Culture, 1800–1918* (Oxford, Clarendon Press, 1993), pp. 155–216.

11 See Angela Leighton, *Victorian Woman Poets: Writing Against the Heart* (Hemel Hempstead, Harvester Wheatsheaf, 1993), p. 3.

some of the deeper implications of the marriage metaphor as two nineteenth-century women journalists applied it to the union between the new kingdom of Italy and Vittorio Emmanuel II. Schor argues that optimism about reform of marriage laws in Britain followed by disillusionment with the actual outcome shadows Theodosia Garrow Trollope's and Frances Power Cobbe's narrative of *la bella Italia* in 1859–60. Although both writers construe marriage very differently, Schor reveals the way in which they both 'emphasise the agency of the bride *Italia* in entering into the unity of marriage' (p. 92 below), and she traces the poetic language of desire which infiltrates their observations of popular responses to the rapidly changing political situation.

For some observers, the coronation of Vittorio Emmanuel was a positive re-enactment of the ceremony which had previously made Napoleon Bonaparte king of Italy, ushering in decades of political humiliation. De Staël was a famous opponent of the Emperor's designs and she criticised Napoleon's urge for European domination in the scene where Corinne is crowned as Italy's leading poet at the Capitol in Rome: 'Her triumphal chariot had cost no one tears, and no regrets or fears restrained admiration for the finest gifts of nature, imagination, feeling, and reflection' (p. 23).[12] Throughout the novel, Corinne's capacity for tender feeling forms a deliberate contrast with masculine military aggression, and yet Corinne herself describes Italy as a land 'which nature seems to have adorned like a victim' (p. 54), indelibly marked by defeat and subjection. Drawing on Corinne's language, Anna Jameson meditates on early-nineteenth-century Italy's double legacy of monumental past and disempowered present in lyric form:

> Torn and defaced, and soiled with blood and tears,
> And her imperial eagles trampled down –
> Still with a queen-like grace, Italia wears
> Her garland of bright names, – her coronal of stars,
> (Radiant memorials of departed worth!)
> That shed a glory round her pensive brow,
> And make her still the worship of the earth! (p. 223)

12 In a gesture worthy of de Staël, Mazzini expressed his gratitude to Harriet Hamilton King by offering to crown her on the Capitol Hill. See Alison Milbank, *Dante and the Victorians* (Manchester, Manchester University Press, 1998), p. 77. King's conventional middle-class familial life is punctuated by her correspondence with Mazzini and her apologia for Felici Orsini (the Italian patriot who had tried to assassinate Napoleon III). See her *Letters and Recollections of Mazzini* (London, Longmans, 1912).

The gendered portrait of Italy as 'a woman in distress' was a disturbing legacy for many women writers and artists.[13] In the writing of Felicia Hemans, Mary Shelley, Janet Hamilton and Elizabeth Barrett Browning, however, we can see a determined effort to revise the historical view of Italy's passivity at the hands of 'her' captors. In prose and verse, these writers articulated their own bids for freedom in various accounts of a 'spirit . . . gradually working its way beneath the surface of society, which must, ere long, break forth'.[14] Different aesthetic and political risorgimenti are discussed in several of the following essays. Pamela Gerrish Nunn's chapter focuses on the little-known work of women artists Jane Benham Hay, Joanna Boyce and Eliza Fox, revealing the extent to which female artists engaged with the political actuality of Italy's struggle for self-determination. The relative critical neglect of their mid-nineteenth-century paintings, Nunn argues, should not obscure the ways in which their work expresses a bold desire for self-realisation and in some ways helped to create the shift in prevailing views 'making it less and less credible to generalise about "Woman" as a way of keeping women under control' (p. 136 below).

Many of the writers and artists discussed below, however, were battling against their own fear of failure, and to some extent internalising the critical bias of male social commentators. Corinne might be an inspiring figure in her ability to take centre stage and sway the crowd, but her wilting away at the end of the novel re-inscribes Sappho's tragedy.[15] Added to Corinne's sacrifice of her poetic gift for love is the way in which her art-form takes a deliberate transience. Corinne celebrates the musicality of the Italian language: 'There is a continual music which blends with the expression of feelings without detracting in any way from its power' (p. 121). But the power of music holds sway only for the instant of performance. As *improvisatrice*, Corinne commands the moment, but the oral form of her work means that it will be inevitably excluded from the canon.[16] One of the ways in which women artists and writers cope with Corinne's ambiguous legacy is to turn indeterminacy

13 See Maura O'Connor, *The Romance of Italy and the English Imagination* (Houndmills and London, Macmillan, 1998), p. 20.

14 Jameson, *Diary of an Ennuyée*, p. 308.

15 For the connections between Sappho and Corinne, see Leighton, *Victorian Women Poets*, pp. 3–4 and chapter 1, and Moers, *Literary Women*, pp. 173–210.

16 See Caroline Gonda, 'The Rise and Fall of the Improvisatore, 1753–1845', *Romanticism*, 6. 2 (2000), pp. 195–210.

into an aesthetic *forte*. Often this indeterminacy adopts and adapts the musicality of the Italian language. In 'Italia, io ti Saluto', Christina Rossetti figures and then subverts the contrast between the north and the south, Britain and Italy. At home once more, 'Where I was born, bred, look to die', 'the sweet South' nevertheless is remembered imaginatively, if conditionally, when the swallows migrate: 'The tears may come again into my sweet eyes / In the old wise, / And the sweet name to my mouth'.[17] Other women poets similarly describe the subversive sensuality of the Italian language. Emma Lazarus's 'Restless' yearns 'To hear the liquid Tuscan speech',[18] while Celia Thaxter, describing an encounter with a beggar girl on San Miniato in Florence, celebrates 'The voice that charmed like woven melodies!'[19] Perhaps this line owes a debt to the opening of Elizabeth Barrett Browning's *Casa Guidi Windows*, in which 'a little child' singing joyfully 'O bella libertà, O bella!' is compared to the beating heart of Florence and, analogously, Italy, seemingly poised to embrace liberty.[20] The celebration of Italian is usually, for women poets, confined to the Tuscan dialect of Dante. The young Aurora Leigh, herself exiled in her father's country, England, cannot be taught by her aunt to forget the Tuscan cadences of her mother (and dead mother's) tongue:

> I left off saying my sweet Tuscan words
> Which still at any stirring of the heart
> Came up to float across the English phrase
> As lilies (*Bene* or *Che che*).[21]

The most adventurous (and hyberbolic) admiration for the Tuscan lilt, however, is arguably to be found in Adah Isaacs Menken's celebration of the century's most famous soprano, Adelina Patti, the 'Pleiad of the lyric world', as rivalling only the city of Florence for her grace and art.[22] A. Mary F. Robinson (1857–1944), scholar, translator, biographer, poet

17 Christina Rossetti, *The Complete Poems*, ed. R. W. Crump (Harmondsworth, Penguin, 2001), pp. 282–3.
18 Emma Lazarus, *The Poems of Emma Lazarus* (Boston, Mass., Houghton, Mifflin and Co., 1889).
19 Celia Thaxter, 'In Tuscany', l. 36. From *Poems* (Boston, n. p., 1896).
20 Elizabeth Barrett Browning, *Casa Guidi Windows*, ed. Julia Markus (New York, The Browning Institute, 1977), 1: 3, p. 8.
21 Elizabeth Barrett Browning, *Aurora Leigh*, ed. Margaret Reynolds (Ohio, Athens University Press, 1992) 1: 387–90.
22 Adah Isaacs Menken, 'Adelina Patti', in *Infelicia* (Philadelphia, J. B. Lippincott, 1873), p. 108.

and close friend of Vernon Lee (Violet Paget), was the most extensive interpreter of the musicality of the Italian language. Her verse forms adopt and adapt peasant songs and ballads, such as in her 'Stornelli and Strambotti' and 'Tuscan Olives: Seven Rispetti'.[23]

For women artists and writers, Italian sensuality and fluidity becomes transformed into a new aesthetic. In Jan Marsh's chapter on Marie Spartali Stillman, which represents an important contribution to the work of recovering this unjustly neglected artist, we see how the artist's political allegiances to national liberation and women's independence were 'set aside' after her marriage. Marsh shows, however, that Spartali brought her 'vision of Italian art, landscape and literature to the centre of her practice, to create a distinctive pictorial aesthetic' (p. 167 below). Analysing Spartali's use of Dante and Petrarch, Marsh argues that while living and working in Italy, the artist also drew on an imaginary dream-vision of Italy which helped to create the unique gentleness of hand, lyricism and restfulness of atmosphere, beauty of form and finely modulated colour.

Nineteenth-century women did not always, however, find Italy creatively liberating. Often the encounter with Italy involved complex and painful anxieties about professional identity and vocation, exemplified by Francis O'Gorman's chapter on the multiple negotiations between Margaret Oliphant and John Ruskin's *The Stones of Venice* (1851–53). Both admiring and critiquing his account of the city, Oliphant's response to the 'Ruskinisation' of Venice is profoundly double. O'Gorman argues that what is at stake for Oliphant is nothing less than her own textual self-definition, forged from within the capacious shadow of Ruskin. In *The Makers of Venice* (1887), Oliphant offers a palimpsest of Ruskin's Venetian work as a way of forging her own literary identity. He criticism of Ruskin is detailed, specific and, at times, caustic. In the end, her conflictual reading of Ruskin provides her with an anxious self-determination, achieved over the metaphorically fluid site of Venice, the city of excess that notoriously eludes definition and capture.

Italy is, then, not only a real and imaginative place of sensuality and fulfilment. Interwoven with pleasure and *jouissance* are also tales of loss and abandonment, following consciously or not the paradigm of Corinne. 'Corinne's Last Love Song', by Speranza (the pseudonym of Lady Wilde), follows this tradition and seems, indeed, like a love

23 See in particular the volume 'An Italian Garden and Other Lyrics', in A. Mary F. Robinson, *The Collected Poems* (London, T. Fisher Unwin, 1902), pp. 1–128.

poem to Corinne as much as a lament in Corinne's voice.[24] For Amy Levy, Italy is woven with both love and despair. 'A Reminiscence' recalls a conversation with an unnamed addressee, in which springtime in Florence is an ironic counterpoint to the talk of the 'dark mysteries of death'.[25] Another poem, 'To Vernon Lee', similarly juxtaposes joy and pain in a reminiscence of a spring walk with her close friend on a hill above Florence known for its Anglo-American expatriate community: 'Thereby ran on of Art and Life our Speech; / And of the gifts the gods had given to each – / Hope unto you, and unto me Despair'.[26] Edith Wharton's short story 'Roman Fever' demonstrates that Rome can also provide a backdrop for narratives of loss and disappointment. Grace Ansley and Alida Slade visit Rome, and the city forces them to remember, in too much detail, a previous visit that reveals Mr Slade's infidelity. As the past unravels in painful clarity, Alida gazes on the menacing, sinister ruin of the Colosseum, a testament to the violence of the historical and personal past.

In two intricate ekphrastic poems about Sandro Botticelli's *Spring* (c. 1481–82) in the Accademia of Florence (now in the Uffizi), Katherine Bradley and Edith Cooper, writing together as Michael Field, confront a symbol of Italian cultural rebirth in pagan terms. Their poems, both published in *Sight and Song* (1892), read as a reply to Dante Gabriel Rossetti's sonnet, published in 1881, which asks of the painting 'But how command / Dead Springs to answer?'[27] Michael Field answers by seeing death at work in the season. In 'Spring', the 'troubled blessing' (l. 51) of Venus signifies an awareness of Cupid, Hermes and Zephyrus, all just out of her line of vision. The former, blindfolded and poised to shoot his long flaming dart of desire, is about 'to mar / Those without defect', the graces. Hermes is also sinister, for he 'Rather seems the guide of ghosts / To the dead, Plutonian coasts, / Than herald of Spring's immature, gay band'(ll. 61–3). With the 'sudden birth' of flowers, the poem tells us, love is cruel and the shadows descend. Zephyr, who makes to steal away Flora, is the agent of change and mortality as well as spring.

24 Angela Leighton and Margaret Reynolds (eds), *The Blackwell Anthology of Victorian Women's Poetry* (Oxford, Blackwell, 1995), p. 298.

25 See Leighton and Reynolds, *Blackwell Anthology*, p. 606. In the companion poem, 'The Sequel to "A Reminiscence"' (p. 607), the talk of death becomes a prophesy as the speaker visits the addressee's grave and is painfully and abruptly forced to accept the reality of her loss.

26 Leighton and Reynolds (eds), *Blackwell Anthology*, p. 609.

27 Jan Marsh (ed.), *Dante Gabriel Rossetti: Collected Writings* (London, J. M. Dent, 1999), p. 427.

Another poem, 'The Figure of Venus in "Spring"', laments the coming of spring and love for bringing also bitterness and blight.[28]

Italy, then, is a place of renaissance, usually signified by Florence, but also decay and the speculchre, usually figured by Rome. Angela Leighton's chapter discusses the importance of the Renaissance for women, including Michael Field, writing towards the end of the century. Her chapter rewrites the conventional account of the rebirth symbolised by Italy and the renaissance into a narrative of gothic resurrections: 'While early Victorian women writers claimed Italy as a body of their own, an instrument of song and suffering, later aesthetes find in it a body figured almost for its own sake, impersonal, inhuman, and the sign, therefore, of a materialist aesthetic which subversively challenges many of the values of high Victorianism' (p. 223 below). These resurrections, for writers such as Michael Field, Vernon Lee and Edith Wharton, are not necessarily resurrections into life. Earlier in the century, Elizabeth Barrett Browning's investment in the reunification of Italy is shown, by Alison Chapman's chapter, to be associated with her interest in spiritualism. Both, she argues, are closely inter-related risorgimenti that attempt to resurrect both nation and body, and that productively transform Barrett Browning's poetics in her 1860 volume *Poems Before Congress*. Chapman draws out the implications of Barrett Browning's spiritualist contact with two precursor poets, with striking significance for her role as a public orator in Italian and English cultural circles. By linking herself with Dante, the voice of masculine political power, and Keats, the figure of feminine martyrdom, Barrett Browning's engagement with Italy describes a ghostly double career of patriotic fervour and fragile collapse.

Tracing a different kind of uncanniness in Italy, Catherine Maxwell's essay on Vernon Lee maps her personal and literary connections with the past as ghostly. For Maxwell, Vernon Lee's obsession with the past creates in her writings an Italy as a series of vistas indelibly watermarked by history. This psychic geography haunts both the reader and writer with its ghostliness, defined by Lee as an aesthetic atmosphere, specifically Italy. Maxwell guides us through Lee's own past associations with

28 Michael L. Ross discusses rejuvenation that goes wrong in Florence, in relation to narratives that follow the city's violent medieval past: 'Conflict, within this most chronically divided of settings, has the power to generate rebirth; but it can also, at worst, crush the tremulous stirrings of new life.' His account is a valuable contribution to the criticism of British and American writers and Italy, but it is dominated by male writers. See *Storied Cities: Literary Imaginings of Florence, Venice, and Rome* (Westport, Connecticut, and London, Greenwood Press, 1994), p. 27.

Italy in her life and writing, especially her short stories that suggest the overlap between physical and mental landscapes.

Italy through northern eyes is a place of enchantment and transformation, gothic and the uncanny. Although the artists and writers discussed in this volume all re-inscribe to some extent Anglo-centric experiences, they frustrate any sense of a static and monolithic 'Italy'.[29] Like the nation itself which struggled for unity up to the proclamation of the Kingdom in 1861 and the fall of Napoleon III in 1870 and beyond, the metaphorical space of Italy – as well as its geographical actuality – refuses rigid identifications. Indeed, women writers of the nineteenth century categorise Italy as a set of paradoxes, most notably an aesthetic place and a home for the expatriate and exile, but also a place of political turmoil and homelessness. Fanny Kemble sums up just such a contradiction in her poem 'Farewell to Italy', in which the speaker looks back at the vanishing shore as the boat pulls away: 'oh! Thou are lovely still! / Despite the clouds of infamy and ill / That gather thickly round thy fading form'.[30] In addition, Italy is figured by women writers as a place that transgresses categories and boundaries, often expressed in terms of the landscape. Kemble, for example, calls Italy 'A melting boundary 'twixt earth and sky'. Alice Meynell describes travelling into Italy across the alps as a 'watershed':

> But O the unfolding South! The burst
> Of summer! O to see
> Of all the southward brooks the first!
> The travelling heart went free
> With endless streams; that strife was stopped;
> And down a thousand vales I dropped,
> I flowed to Italy.[31]

Meynell's 'unfolding' metaphor captures the dismantling effect of her immersion in an expansive summer landscape of 'endless streams'. Italy is an imaginative and liberating space of possibilities and revelations, opening up the 'travelling heart' to new experiences, pleasures and subjectivities. The idea of Italy's palimpsestic layering of nature and culture recurs in the work of many writers, allowing them to reflect

29 For an interesting description of the differences between Italian cities, see Margaret Oliphant, *The Makers of Florence: Dante, Giotto, Savonarola and Their City* (London, Macmillan, 1892), pp. 1–2.

30 Leighton and Reynolds, *Blackwell Anthology*, p. 150.

31 Alice Meynell, 'The Watershed', in Leighton and Reynolds (eds), *Blackwell Anthology*, pp. 521–2.

back on where they have travelled from as well as looking towards new horizons. Women travellers in Italy often record their explicit sense of negotiation between different nations, languages and religions. Their fascinating narratives of direct encounters with Italians, furthermore, present interesting juxtapositions with the communities of Anglo-American expatriates who often had a very limited intercourse with the locals.[32] Although deeply committed to the cause of popular Italian liberation, Elizabeth Barrett Browning and Robert Browning had only a passing acquaintance with the few Italians who happened to work as their servants. Women travellers, too, had more contact with inn-keepers, guides and drivers than other Italian inhabitants, but they were able to use the sense of strangeness between themselves and the lived lives of local people to creative advantage. Many of their accounts reflect on the experience of being scrutinised by another culture. This enabled them to articulate the sense of de-racination they endured as middle-class women who had exposed themselves to display at home on the literary market place or the artist's exhibition hall. While she is a re-spected figure in Italian society, Corinne feels like a monster in England. British women in Italy mirror this acute sense of displacement and it makes them peculiarly sensitive to the different dynamics of social and familial organisation across the Italian peninsula.

Religion was one of the issues that alienated Britain from Italy and in the popular celebration of Garibaldi's campaign many writers con-trasted his energy and love of freedom with the 'gloom of Papal night' and a people who were condemned as 'slaves of the Papacy'.[33] Focusing on the early years of the nineteenth century, Jane Stabler's chapter looks at a group of women, Dorothy Wordsworth, Hester Piozzi, Charlotte Eaton and Mary Shelley, whose disparate responses to Italy led them to question the views of public and private Oswald authority figures at home. In their position as self-conscious sight-seers, often 'the object of fascinated attention by curious Italian locals', these women, Stabler suggests, 'became the image of the venerated matriarchal spectacle at the heart of Catholicism' (p. 16 below), a transformation which raised profound questions about representation and identity. Depicting a dif-ferent experience of indeterminacy in the mobility of travel, Stabler suggests that aesthetic encounters with Catholic church music and fest-ivals enabled women writers to relinquish inherited political scepticism

32 See, for example, Giuliana Artom Treves, *The Golden Ring: The Anglo-Florentines 1847–1862*, transl. Sylvia Sprigge (London: Longmans, Green and Co., 1956).

33 Janet Hamilton, 'Freedom for Italy', in *Poems and Ballads* (Glasgow, n. p., 1868).

about the absolute power of the Papacy and to participate with zest in 'the enchanting *south*'.[34]

In a chapter that challenges traditional accounts of nineteenth-century literary history, Richard Cronin places Barrett Browning's engagement with the Italian Question at the centre of a newly civic poetry. Cronin provocatively argues that *Casa Guidi Windows* (1851) is the first properly civic poem, transforming the poet's personal rejuvenation in Italy into political capital. Barrett Browning, Cronin contests, was immune to the English recoil from the idea of citizenship. Enabled and empowered through the precursor text, *Corinne*, the poem finds a link between the disenfranchisement of the female poet because of her sex and the disenfranchisement of Italians because of their nationality. Cronin continues, furthermore, that *Casa Guidi Windows* looks finally to a citizenship without patriarchal rule of law, by forging a notion of the state in continual process and negotiation.

Isobel Armstrong's chapter similarly argues for the importance of *Casa Guidi Windows*, but as '[a] wholly experimental poem' that 'explores a new genre of urban writing' (p. 51). Bringing together revolutionary politics, historiography, new optical technologies, architecture and physics, the essay argues that Barrett Browning's radical 'window poetics' (p. 53) is a virtuoso performance which works through the disappointments of 1851 to arrive at hope and optimism. Armstrong's essay ends with the suggestion that 'modern Italy might be born from the gaze from a window' (p. 69). *Casa Guidi Windows* may be placed at the centre not only of the century but also of women's multiple and audacious engagements with Italian politics and aesthetics that are enabling, despite the loss and suffering represented by their precursor Corinne.

Several of the essays in this collection address *Casa Guidi Windows* directly, and, through the diversity of their critical approaches, they share with the rest of the volume a sense of how much is to be gained from a detailed reassessment of canonical and non-canonical nineteenth-century women writers and artists in Italy. This collection recovers what had been lost in many more general studies of British artists and writers in the peninsula: the awareness that as well as being a vision and a waking dream, nineteenth-century Italy was very much part of what Barrett Browning called in *Aurora Leigh* 'this live, throbbing age, / That brawls, cheats, maddens, calculates, aspires' (5: 203–4). By re-examining the myths that shaped Anglo-Italian relations during this revolutionary period, the essays that follow dismantle neat north/south and Romantic/Victorian

34 Jameson, *Diary of an Ennuyée*, p. 218. Italics are Jameson's own.

perspectives, replacing them with an infinitely more complex diorama. When Garibaldi visited England in 1864, he was welcomed by 'everyone except English and Irish Catholics and Queen Victoria'.[35] Similarly unexpected alliances and discrepancies are thrown up in this collection of essays, interrogating the Anglo-Italian romance of mythic heroism with narratives of abjection, dirt and disorder. De Staël's Oswald is disconcerted by the frivolity which can turn St Peter's into a 'Roman café where people met each other for pleasure' (p. 176), but as a whole, this book suggests how much territory remains to be mapped between the sublime and sentimental polarities which Oswald wrongly believes to be mutually exclusive. In her recent anthology and companion to Italy, Susan Cahill notes that writers such as Goethe, Stendhal, Byron, Shelley, Dickens, Robert Browning, Ruskin, Henry James, and D. H. Lawrence 'have been declaring their love of Italian cities, art and people for centuries'. But, she adds, 'still to be heard are the stories of women's passions for Italy'.[36] This book unfolds some of those stories.

35 O'Connor, *The Romance of Italy and the English Political Imagination*, p. 149.
36 Susan Cahill (ed.), *Desiring Italy* (New York, Fawcett Columbine, 1997), p. xi.

I

Devotion and diversion: early nineteenth-century British women travellers in Italy and the Catholic Church

Jane Stabler

'THE SUPERSTITION of the uneducated Italians, the severity of the convents, the relics of paganism in the Catholic ritual, these and a dozen other objections caused the average Englishman to turn from Catholic Italy with disgust'.[1] This was the verdict of one influential critic as he surveyed the travel writing of Victorian men in Italy. His summary elides anti-papal and anti-Catholic sentiment. In this chapter, however, I want to distinguish between the two and examine a number of different ways in which British women travellers in Italy encountered the Catholic faith between the 1780s and the 1840s. During this period, there was growing pressure in Britain for Catholic emancipation, culminating in the hard-won Acts of 1828 and 1829 which finally allowed Catholics to hold public office in England. The campaign for Catholic emancipation was linked by many to the anti-slavery movement, and it had a similar effect in that popular opinion challenged the principles of the British establishment.[2] Early nineteenth-century aesthetic responses to Catholic Italy anticipate the British middle-class enthusiasm for Italian liberation (discussed later in the collection) which also became a popular cause, embodied in the person of Garibaldi as a champion of the interests of the Italian people against those of the papacy.

Dorothy Wordsworth (1771–1855), Hester Piozzi (1741–1821), Charlotte Eaton (1788–1859) and Mary Shelley (1797–1851) all visited Italy and experienced a tension between their self-conscious 'sight-seeing' role (the

1 C. P. Brand, *Italy and the English Romantics: The Italianate Fashion in Early Nineteenth-Century England* (Cambridge, Cambridge University Press, 1957), pp. 218–19.

2 See Byron's notes to *Childe Harold's Pilgrimage*, 2: 73. For the increasing numbers of Catholics in England between 1780 and 1840 due to immigration and conversion, see Robin Gilmour, *The Victorian Period: The Intellectual and Cultural Context of English Literature, 1830–1890* (London, Longman, 1993), pp. 70–1.

word Eaton applies to herself), and their inherited scepticism as Protestants of the visual and performative aspects of Catholic custom.[3] These contradictions were augmented by the way in which, as isolated foreign female figures and the object of fascinated attention by curious Italian locals, they became the image of the venerated matriarchal spectacle at the heart of Catholicism; a transformation that was at once profoundly disturbing and empowering.[4] Italian Catholicism provided two conflicting versions of the sublime, one based on absolute political papal authority and one on the transcendent aesthetic possibilities of music, art and communal festive joy.

As Dorothy Wordsworth crossed the Alps from Switzerland into Italy in 1820, her journal entries anticipate the encounter with Catholicism.[5] In her eyes, the picturesque landscape before her was shaped by religious practices, especially evident in the contribution of churches and oratories to the composition of mountainside villages. Dorothy is quick to note, for example, 'those pretty paths that look as if they were only made for going to church, and for fêtes and festivals'.[6] Fêtes and festivals are, however, highly visible throughout the Wordsworths' stay in Italy and they rarely enter a village or city which is not observing some sort of religious holiday.

In villages on the Swiss-Lombardy border, Dorothy observes the 'numerous assemblage . . . keeping festival. It was like a *Fair* to the eye . . . cakes and fruit spread abundantly on the church-yard wall' (2: 171). This expectation is confirmed once they are inside Lombardy. Near Lake Como, Dorothy finds 'the church yard . . . crowded with people assembled for the Fête, all in holiday trim' (2: 226). Her fascination with the festive aspect of church-going concentrates on impressions of surface

3 Charlotte Eaton identifies herself as 'sight-seeing' in *Rome in the Nineteenth Century . . . Written During a Residence at Rome in the Years 1817 and 1818*, 3 vols (Edinburgh, Ballantyne, 1820), 1: 23.

4 Chloe Chard notes that women travellers 'transmute into part of the spectacle' especially in relation to 'feminised ruins . . . converting historical time into personal time' in 'Grand and Ghostly Tours: The Topography of Memory', *Eighteenth-Century Studies*, 31 (1997–98) 101–8 (pp. 102–3).

5 Dorothy's brother, Christopher, became the ultra-orthodox Master of Trinity College Cambridge in 1820. For William's contribution to debates about the Catholic Question, see Stephen Gill, *Wordsworth and the Victorians* (Oxford, Clarendon Press, 1998), pp. 40–80. I shall refer to Dorothy and William Wordsworth as Dorothy and William to avoid a potentially confusing use of the surname.

6 Ernest de Selincourt (ed.), *Journals of Dorothy Wordsworth*, 2 vols (London: Macmillan, 1941), 2: 170. References are cited in the text hereafter.

colour with a suggestion of pagan exoticism. Another mountain chapel is described as possessing 'something of a *festive* aspect, accordant with our notions of a Grecian or Italian Temple . . . the inner walls painted in bright colours, with figures, at that distance indistinctly seen' (2: 173). The inference of a sort of primitivism here is born-out by her harsh judgement of 'exploits . . . rudely depicted on the walls of the Chapel' and later her note of 'a gigantic daubing of the figure of St. Christopher on the wall of the church steeple' (2: 173, 175).

Dorothy's preconceptions about Catholics themselves come through strongly when, after detailing Fluelen as 'a gaudy place with a gaudy churchyard' (recovering the specific Catholic sense of *gaudium*), she describes a meeting with local beggars in much less sympathetic terms than her careful consideration of the mendicants of Grasmere:[7]

> [W]e were pestered by beggars. A wretched creature who ought to have been taken care of in an hospital was clamorous, and when we gave nothing, she hobbled to an oratory by the way-side to try the force of prayer; and kneeling (not towards the virgin who was to be the mollifier of our hard hearts) with her face towards *us*, vociferated her prayers. The sun had shone the whole morning but there had been a breeze on the lake; and I, at least, was never overheated. (2: 173–4)

In her record of this encounter, Dorothy composes herself after the experience of being assailed by a less fortunate woman. The 'wretched creature who ought to have been taken care of in an hospital' is a foreshadowing of Dorothy's own position in later life when, fortunately, she was tended to by William's family. As an Englishwoman abroad, however, Dorothy remains coolly detached from the 'clamour' of Catholicism and she regards the woman's praying as a sort of performance. The assumption that Catholicism is all about theatrical display is voiced explicitly when the Wordsworths visit the cathedral at Como:

> From the bright sunshine we passed through a shabby door into the building, lighted up by wax candles, and the day-light nearly excluded,

7 According to *OED* the gaudy is one of five tapers burnt to commemorate the Virgin's joy; it is, by extension, any merry-making or grand feast. A 'gaud' is one of the larger beads placed between the decades of 'aves in the rosary'. The later applications of the word turn it to mean a pretence or pastime, also a gew-gaw, a piece of finery. See Susan J. Wolfson, 'Individual in Community: Dorothy Wordsworth in Conversation with William', in Anne K. Mellor (ed.), *Romanticism and Feminism* (Bloomington, Indiana University Press, 1988), pp. 139–66; Anne K. Mellor, *Romanticism and Gender* (New York and London, Routledge, 1993), pp. 144–69.

by hangings of tapestry. It was like being admitted to a Theatre in the midst of the performance. The fête was in its glory. The Priests (many in number) on the altar-platform in gaudy garments, with their white-robed youthful attendants, incense smoking from swinging baskets – while the music of various instruments, accompanying the organ, happened to be in a strain more fitted to bring to mind the band at an opera than the solemnities of a religious Temple. (2: 229)

As for many writers, Dorothy's entrance into the Catholic church is a metaphorical as well as a literal step in the dark. Her interest in lighting, costume and stage props is eager, but she cannot surmount a feeling of displacement (being admitted late to the theatre) which is enhanced by aesthetic dissatisfaction: 'gaudy' has pejorative undertones of show and luxury which anticipate her comment that '[t]he general effect was very much injured by the tapestry, covering the marble pillars' (2: 229). As we shall see, the image of the veil, mantle or covering recurs in travel writing about Italy, often symbolising the loss of clear vision or the relinquishment of the acquisitive tourist gaze.

Despite her initial suspicion of visual show and representation, Dorothy's journal of the tour suggests that actual contact with the Italians, even for the short duration of their visit, allowed her to shed some of these ingrained prejudices, and in occasional entries her orthodoxy wavers before new aesthetic and religious principles. In the border village of Altorf, for example, the popular festive element of Catholicism is outweighed by more mysterious and invisible aspects of Christianity with its obscure and sublime aesthetic potential:

> The convent of the Capuchins is considerably elevated . . . almost *propped against* the side of the black declivity, marvellously lofty. On all sides, the town appears to be imprisoned by impassable barriers . . . Before our return to the Inn we ascended to the Convent – still between high walls. A grey stone image of our Saviour on the cross was very striking in the early twilight, beside a rushing fountain, near the Convent, – the building itself entirely shut out from view when close at hand . . . Mr. R., Wm., and I entered a church. All was in darkness except where four dim tapers were burning on the Altar. Gradually the silver cross gleamed forth, and indistinct forms were seen – pictures of saints – and three or four motionless and silent figures upon the benches at their prayers. We sate – and could not help sitting. A rustling wind came suddenly with a fluttering sound, which disturbed the taper lights and sent a creeping through my body, though not from cold. (2: 176)

The rest of the journal entry shows that Dorothy was too disturbed to sleep after this and spends a long time 'keeping watch' at her window 'while the transient touchings of the moonlight produced a most romantic effect upon the many coloured paintings on the wall of the old Tower' (2: 177). At moments such as this, the Catholic Church is inextricably bound up with Dorothy's picturesque aesthetic inheritance, and her style is correspondingly 'elevated'. While Dorothy's prose account guards the mysterious liminality of the scene, William's poem, 'Effusion in presence of the painted tower of Tell, at Altorf', gathers her sketch into the William Tell myth of masculine control in which the 'gaudy show' of the painted wall gives pleasure to 'burghers, peasants, warriors old' as well as schoolboy 'Heroes' and 'the passing Monk':

> How blest the souls who when their trials come
> Yield not to terror or despondency,
> But face like that sweet Boy their mortal doom,
> . . .
> Assured that Heaven its justice will proclaim,
> And to his Father give its own unerring aim.[8]

By contrast, Dorothy's journal account focuses on the 'fitful moon-shine', 'uncertain light' and, instead of calm vision, a loss of clear sight: '[a] fierce hot wind drove through the streets whirling aloft the dust of the ruins, which almost blinded our eyes' (2: 176–7). This moment of blindness represents a temporary clouding of the tourist gaze and, occurring as it does on the threshold of Dorothy's entry into Italy, it seems to permit the possibility of different perceptions.

Perhaps wisely, Dorothy never attempts to establish Miss Lavish-like rapport with 'the true Italy', but she has the capacity to imagine how she appears to the Italians they meet.[9] Regarding the crowded church in fête at Neisen, Dorothy registers that '[t]hey stared at me; and no wonder – a solitary female from a foreign country. The young laughed, yet not rudely' (2: 226). After her initial hostility to the 'gaudiness' of the Catholic church, she finds 'a pretty scriptural painting' at Belaggio (2: 220–1) and identifies particular pleasure in the sound of 'a congregation of Rustics

8 William Wordsworth, *Poetical Works*, ed. Thomas Hutchinson, rev. edn Ernest de Selincourt ([1904] Oxford, Oxford University Press 1985), pp. 268–9. The Italian celebration of William Tell at this time was due to his legendary rebellion against the Austrian authorities.

9 E. M. Forster, *A Room With a View* ([1908] Harmondsworth, Penguin, 1986), p. 37.

chaunting the service' (2: 194), an experience which is repeated with a number of variations. In Milan, for example, they attend a military mass in the open air: Dorothy brings scepticism about 'the tinselled altar and other fineries' which have to be packed up afterwards by people 'very much like a company of players with their paraphernalia' (2: 237). During the service, however, Dorothy is seduced by 'the sound of sacred music, which upon minds unfamiliarized to such scenes had an irresistible power to solemnize a spectacle more distinguished by parade, glitter, and flashy colours than anything else' (2: 237).

Recurrently in the presence of Italian religious acts, Dorothy is disturbed by visual spectacle but has her faith restored by sublime auditory experience. In this she follows Romantic suspicion of the tyranny of the eye, but also anticipates the later nineteenth-century expressive theory of poetry particularly associated with Anglo-Catholic aesthetics.[10] Her delight in the 'heart-stirring' music of the mass is related to her appreciation of the 'sweet sound of the Italian tongue [which] has a bewitching charm' (2: 197), but it is also to do with a gradual openness to a different form of worship and to an intermittent weakening of her northern Protestant inhibitions about pleasure or 'gaudiness'. When the fête at Como comes out of the cathedral and into the pleasure boats on the lake, Dorothy is enchanted:

> In one of those barges a congregation, that would have filled the little Chapel at Buttermere, were chaunting the Litany. The grave sounds floated to us upon the water – the steady Company (male and female) all standing (the women with white handkerchiefs cast over their heads) continued their chaunting while passing us. It was a pretty sight, at once gay, rustic and solemn. (2: 228)

By being able to respond to something which is simultaneously 'gay' *and* 'solemn', Dorothy displays an openness to the aesthetics of mixture which marked English travellers' experiences of Italy. De Staël's Oswald, by contrast, is troubled by the Italian 'instability of temperament which allowed such different feelings to follow each other so quickly'.[11] Dorothy's

10 See Isobel Armstrong, *Victorian Poetry: Poetry, Poetics and Politics* (London, Routledge, 1993), p. 337, and Catherine Maxwell's discussion of a disruptive female sublime in nineteenth-century male poets 'informed by a radically disfiguring power which distorts normative vision' in *The Female Sublime from Milton to Swinburne: Bearing Blindness* (Manchester, Manchester University Press, 2001), p. 3.

11 See Madame de Staël, *Corinne, or Italy*, transl. Sylvia Raphael (Oxford, Oxford University Press, 1998), p. 176.

conversion to the *jouissance* of Italian Catholicism is certainly not instantaneous or complete, but her journals reveal a distinct softening of attitude and occasionally, a yielding of northern Protestant self to a southern, pagan celebration of physical pleasure.

From Porlezza Dorothy admires 'a lovely valley, a mixture of cultivation and that species of rich wildness peculiar to an Italian climate' (2: 214). Her appreciation of variety is, of course, partly derived from a long immersion in picturesque aesthetics, but as Dorothy travels through Italy this appreciation of picturesque irregularity gradually expands to include a greater acceptance of Catholic expressiveness. Like many other women travellers, Dorothy begins to relax into 'the power and the pleasures of an Italian climate' (2: 218). At Gravedona she again remarks on the 'peculiar lightness in the air, which at least upon *my* frame, prevents oppression from the same degree of heat with which in England I have been completely exhausted' (2: 224). At the same place, this sensation of 'lightness' leads to a more sympathetic identification with local religious practices:

> Looking up to the church, the boatman told us that service was performed there twice in the summer on certain fête days, and that men and women, from all quarters, flocked thither, leaving a part of their garments, if they could bring nothing else, at the shrine of the virgin, an offering for the poor: and the better to illustrate the fact, and, to help out our ignorance of his language, this eloquent describer enumerated with appropriate actions and signs, the different articles of dress deposited in that holy place. Surely it is a delightful part of the Roman Catholic's duty who happens to dwell on the banks of Como – to pass a summer's day on that pastoral mountain! When the Chapel is attained, what a magnificent prospect of the lake! – and behind the chapel, is uplifted and outspread the solitude of a far higher mountain; scenes which cannot but exalt the devout imagination, while the labour of the ascent is, in the spirit of self-sacrifice, an encouraging motive, even to the weak and aged; and to the young and careless will but give zest to a day's holiday. (2: 222)

Blending her own love of sublime scenery with curiosity at the material signs of Catholic devotion and something approaching envy of the opportunities for the 'devout imagination', Dorothy thinks her way into the 'zest' of Catholicism. Her word choice conveys both the attraction of exotic spice and receptiveness to the Italian appetite for holidays. The northern Protestant work ethic is lost, temporarily, in the liberating prospect of 'delight' and carelessness.

A sensation of physical release is captured in the prospect 'out-spread', and this is also discovered by Dorothy in the interior of Milan cathedral:

> I wandered about with space spread around me; the floor on which I trod was all of polished marble, intensely hot, and as dazzling as snow; and instead of moving figures I was surrounded by groupes and stationary processions of silent statues – Saints – sages – and Angels. It is impossible for me to describe the beautiful spectacle, or to give a notion of the delight I felt. (2: 234)

It is unusual for Dorothy to express 'delight' at an interior view. Her sensual bewilderment comes from a mixture of sublime space with high artifice and it is interesting that the 'stationary processions' of religious statues rather than diminish her joy in the 'spectacle' (invested here with wholly positive meaning). A moment of similar aesthetic and religious apostasy occurs on the Sunday in Milan when Dorothy goes to watch the fireworks. On the way to the display she watches 'a glorious sunset. I thought I never before had beheld such a mixture of lightness in substance with the brilliancy of rosy or ruby colouring . . . and, after such a spectacle expected to find it [the firework display] very tame' (2: 238). She surprises herself, however:

> Then began the fire-works, and, with them, our childish delight; for all the preparations were despicable, and at best could but raise a smile that served to put away the sadness one could not help feeling at sight of so many thoughtless people having no better employment for a sabbath evening than gazing at such fooleries. But when the rockets mounted to the clear sky, twisting, eddying, shooting, spreading – I was really in ecstacy, having never before seen any fire-works better than we sometimes exhibit to children. The trains of smoke were hardly less beautiful than the mounting fire. (2: 239)

This is, I believe, an important turning point in Dorothy's Italian journey. From the strict disapproval of 'childish [. . .] fooleries' she confesses a move to 'ecstacy', and her response to the 'twisting, eddying, shooting, spreading' effect of the lights suggests a loosening and dilating of both mental and physical constraints. The moment is brief, and as if to counter this lapse, Dorothy soon afterwards records the more familiar distrust of priestly power:

> Yesterday we happened to be in the Cathedral [of Milan] during the preaching of a Sermon. The Priest, in his scarlet cap and party-coloured robes, more like a showman, addressing a crowd on the outside of his stage, than a minister of the Gospel in a Christian Temple.

He paced from side to side on the floor of the Pulpit; and when he had finished his discourse, took off his cap, bowed to the audience, and vanished. (2: 240)

With the vignette of the priest as actor-conjuror, Dorothy shakes herself free of the spell of the 'burning red' spectacle of the fireworks, but the possibility of a more hedonistic participation in the other culture has been established. She leaves Italy with 'pensive regrets, for the treasures of Italy unseen, and probably never *to be seen* by us' (2: 263). It is the lament of the tourist who has run out of time for sight-seeing, but it also suggests a craving for visual spectacle somehow sanctified by her experience of Italian Catholicism.

Hester Piozzi married a Roman Catholic (to the great chagrin of Samuel Johnson) and the consequent adjustments in her religious and political views foreshadow the slow change in British public opinion in the first decades of the nineteenth century.[12] Her inquisitive account of European travels continued the model set by *Corinne* for the possibility of an encounter with the Catholic faith which could question religious (and other) laws back in England.[13] Like Wordsworth, Hester Piozzi detects and disapproves of the theatrical properties of Italian churches, referring critically to the custom

> of deforming the beautiful edifices dedicated to God's service with damask hangings and gold lace on the capitals of all the pillars upon days of gala . . . while the church conveys no idea to the mind but of a tattered theatre; and when the frippery decorations fade, nothing can exclude the recollection of an old clothes shop.[14]

The elements of popular performance extend beyond the decoration of the place to the behaviour of those participating in church ceremonies. And where women become spectacles, Piozzi's response is mixed. She describes in admiring detail the jewels of Florentine females: 'every Sunday or holiday, when they dress and mean to look pretty, their elegantly-disposed ornaments attract attention strongly' (1: 305–6). The fascinated

12 For Piozzi's revisions to her pronouncements on Catholicism, see Katherine Turner, *British Travel Writers in Europe 1750–1800: Authorship, Gender and National Identity* (Aldershot, Ashgate, 2001), pp. 177–80.

13 In the 'Holy Week' section of *Corinne* (Book 10, ch. 5), Oswald is questioned about the differences between 'harsh and solemn' Protestantism and 'lively and affectionate' Catholicism.

14 Hester Lynch Piozzi, *Observations and Reflections made in the Course of a Journey through France, Italy, and Germany*, 2 vols (London, A. Strachan and T. Cadell, 1789), 1: 85.

attention she devotes to minute details of dress and hair provides a secular aesthetic version of Catholic idolatry. In Naples, Piozzi observes an act of contrition by a lady 'looking like Jane Shore in the last act, but not so feeble' (2: 28–9).[15] Piozzi admits that together with the rest of the congregation her own heart was 'quite penetrated' by the sight; but, in the last analysis she finds the 'burst of penitential piety . . . indecorous' (2: 29).

Piozzi's awareness of the difference between two religious outlooks is what distinguishes the *Observations* from many contemporary accounts by male writers who document only one point of view. Piozzi notes, for example, that the Italians refer to themselves as '*Noi altri Christiani*' to distinguish themselves from British visitors whom they 'class among the Pagan inhabitants' (1: 359), and she takes the anti-Catholic theatrical analogy a stage further by using it to reflect back on the vagaries of English custom. In Lucca she remarks:

> [T]he ideas of devotion and diversion are so blended, that all religious worship seems connected with, and to me now regularly implies, *a festive show*. . . . Well, as the Italians say, '*Il mondo è bello perche è variabile*'. We English dress our clergymen in black, and go ourselves to the theatre in colours. Here matters are reversed, the church at noon looked like a flower-garden . . . while the Opera-house at night had more the air of a funeral, as every body was dressed in black. (1: 335–6)

As well as her fascination with the variables between cultures, Piozzi shows great interest in the eclectic combinations of religion evident in Italy. Rather than regarding Catholicism as the same for all the different regions of Italy, Piozzi describes the regional and the temporal spectrum of belief. She is fascinated by the way in which Christianity was grafted on to pre-Christian forms of worship so that the figures of Diana and St Agnes are merged, as are the images of the Madonna and Cybele 'with a tower on her head' (2: 164). Piozzi tries to explain these compounds by emphasising the tenuousness of Christianity in its early stages: 'When Christianity was young, and weak, and tender, and unsupported by erudition, dreadful mistakes and errors easily crept in' (2: 164). And yet some of these 'dreadful errors' emerge in her account as strangely compelling.

Among the Lazaroni of Naples, Catholicism still bears the vestiges of much more ancient practices, but Piozzi exceeds the traditional linkage

15 This incident is discussed by Chloe Chard in *Pleasure and Guilt on the Grand Tour: Travel Writing and Imaginative Geography 1600–1830* (Manchester, Manchester University Press, 1999), pp. 166–7.

of Catholic custom with the Far East when she relates the 'half-Indian custom' of men tattooing religious symbols onto the skin. 'One need not', she points out, 'wander round the world with Banks and Solander, or stare so at the accounts given us in Cook's Voyages of "*tattowed Indians*", when all this is easily visible in Naples':

> The man who rows you about this lovely bay, has perhaps the angel Raphael, or the blessed Virgin Mary, delineated on one brawny sunburnt leg, the saint of the town upon the other: his arms represent the Glory, or the seven spirits of God, or some strange things, while a brass medal hangs from his neck, expressive of his favourite martyr.
> (2: 17, 15)

The sacred and the secular meet on the brawny body of the man, which Piozzi gazes at unashamedly. By adorning his flesh with objects of devotion, the boatman embodies all the gross superstition that Protestantism despised, and yet the effect as detailed by Piozzi is undeniably powerful. A similar conflict of erudition and instinct occurs when Piozzi confronts the figure of the Black Madonna at St Luce near Bologna:

> The girls, who sit in clusters at the chapel doors as one goes up, singing hymns in praise of the Virgin Mary, pleased me very much, as it was a mode of veneration inoffensive to religion, and agreeable to the fancy; but seeing them bow down to that black figure in open defiance of the Decalogue, shocked me. Why all the *very early* pictures of the Virgin, and many of our blessed Saviour himself, should be *black*, or at least tawny, is to me wholly incomprehensible, nor could I ever yet obtain an explanation of its cause from men of learning or from connoisseurs.
>
> We have in England a black Madonna, very ancient of course, and of immense value, in the cathedral of Wells in Somersetshire.
> (2: 263–4: italics in original)

She is, Piozzi notes, 'eminently handsome'. Her fascination with the culture of the black Madonna hints at the subversive potential of Mariolatry when in touch with its non Judæo-Christian origins.

The black Madonna is a goddess of fertility and the underworld. Julia Kristeva traces the exclusion of this deity from Jewish law, observing that '[a]s ultimate homage to the fertility of the mother-goddess, such rites were necessarily dismissed from a religion of the father'.[16] With reference to Sicilian culture in particular, Lucia Chiavola Birnbaum

16 Julia Kristeva, *Tales of Love*, transl. Leon S. Roudiez (New York, Columbia University Press, 1987), p. 95.

has recently pointed out that this Madonna is not the sorrowful, meek mother of God, but a much more potent chthonic divinity associated with Demeter, Isis or Cybele. In Italy her association with the earth and the cult of the dead led to her incorporation in the Catholic cult of saints which begins on 1 November and precedes the start of carnival on 6 January. The black Madonna was traditionally honoured with fireworks, animals, wheat and trumpets. Her fête involved political satire together with parodies of conventional religion, generated by the folk custom that the matriarchal reign of Cybele had been a time of justice and equality for all.[17] Since pre-Christian times, the figure of the mother earth goddess has presented a challenge to corrupt systems of government, and the festivals witnessed by eighteenth- and nineteenth-century travellers make it clear that her adoption by the Catholic Church also incorporated this questioning of the status quo.[18]

Without pursuing these explicitly subversive cultural resonances, Piozzi's inclusion of the black Madonna has a similar effect. Her discussion of her response to the veneration of the figure leads to her observations on matters of taste in worship (suggesting that no one faith has exclusive access to the truth) and then to an admission that 'men of learning' are utterly unable to account for anomalies within the history of the English church. Piozzi's comparison points out the residual pagan rituals in English culture. The Shrewsbury Show with its Rose Queen is likened to Romish superstition (2: 207), and Piozzi goes as far as to applaud the vitality of Italian customs: '*they* live nearer the original seats of paganism; many old customs are yet retained, and the names not lost among them, or laid up merely for literary purposes as in England' (1: 75; emphasis in original). In this account, English Protestant culture is subtly divested of its superiority and, despite the repressive reputation of the Catholic Church, Italy emerges as a more open and liberal society for both men and women.[19]

Piozzi does criticise aspects of the Catholic Church in Italy (for example, the custom of churches sheltering criminals), but in her selective praise for other aspects of the faith (the homage accorded to martyrs, the startling convention of carnival cross-dressing, fireworks and a

17 For dissenting use of this myth in the Romantic period, see Nicholas Roe, *John Keats and the Culture of Dissent* (Oxford, Clarendon Press, 1997), pp. 257–67.

18 See Lucia Ciavola Birnbaum, *Black Madonnas: Feminism, Religion, and Politics in Italy* (Boston, North-Eastern University Press, 1993), especially pp. 18–82.

19 See also Piozzi's comments on the relative misuse of the Lord's name in England and Italy in which England appears as the more blasphemous nation (1: 346).

soprano taking the part of St Peter in the Passion of Metastasion), she opens the way for an appreciation of Catholicism which is not limited to regressive matriarchy or sentimental charity. Instead, we see the toleration of diverse religious practices as a basis for a society in which individuals are co-operative, but independent agents. In Leghorn, Piozzi looks down from her balcony upon a crowd scene where all the actors are free from the constraints of a single creed:

> [A] Levantine Jew, dressed in long robes, a sort of odd turban, and immense beard . . . a Tuscan contadinella, with the little straw hat, nose gay and jewels . . . Here an Armenian Christian, with long hair, long gown, long beard, all black as a raven; who calls upon an old grey Franciscan friar for a walk; while a Greek woman, obliged to cross the street on some occasion, throws a vast white veil all over her person, lest she should undergo the disgrace of being seen at all. (1: 352–3)

This balcony view forms an interesting contrast with the single-minded rapture of crowds depicted by Elizabeth Barrett Browning and Theodosia Garrow Trollope (see p. 51 and pp. 97–9 below). Nevertheless, British middle-class sympathy and support for Italian unification drew strength from the non-conformist movements of the early nineteenth century which grew out of the liberal intellectual tradition fostered by writers like Piozzi. Piozzi's awareness of herself as a spectator, and the only Protestant in a party of Catholics placed her in a unique position and it took several decades for her reflective and discriminating approach to different versions of Christianity to influence mainstream politics in Britain.[20]

If we turn to Charlotte Eaton's *Rome in the Nineteenth-Century* (1820), it appears at first that she is exercising all the masculine Protestant prejudices documented by Brand. She prefaces her account with a damning generalisation about the Italians:

> Like the French, the Italians live in perpetual *representation*; like them, they sacrifice *l'être au paroitre*. The study of both nations is to *seem* gay, rich, wise, witty, learned, and pious. But, whatever be the object of an Englishman's ambition he labours to *become*. (1: xvi–xvii; italics in original)

This is, of course, the old anti-Catholic prejudice against idolatrous reliance on the image: 'with them', Eaton observes, 'it is in the image that

20 For an extreme anti-Catholic reaction by a woman to the carnival as a form of 'contamination', see Jane Robinson's discussion of Selina Martin in ' "With Foreigners Alone": Some British Women Travellers in Italy during the 15th to the 19th Centuries', *Annali D'Italianistica* 14 (1996) 483–92 (p. 491).

all the virtue and holiness resides' (1: 22). Her own reaction to seeing a statue of God is 'amazement' and 'horror':

> The image of God, fashioned by the hands of man, was to me the excess of profanation, and the sight of it was to my eyes what blasphemy would be to my ears. But the Italians seem to think representations of the Deity in painting and sculpture neither impious nor reprehensible. (1: 21)

There is a space here for reflection of cultural difference; and indeed Eaton recounts the verdict of an old priest on their sight-seeing party who declared that they were all ' "*Lutherani! si! e vann'tutti, giù, giù, giù –*" ' [Lutherans who will all go down, down, down (to hell)] (1: 349). Eaton is aware of the gap between the two perspectives, but rather than investigating it in terms of social anthropology as Piozzi had done, she sees it as a matter of true and false taste. Statues of saints and the holy family are for her 'grievously offending [to] the protestant eye of taste, however they may rejoice the catholic spirit of piety' (1: 135).

In the course of her narrative, however, these aesthetic categories are assailed by the experience of Italian religious art. Eaton begins her tour from the traditional eighteenth-century aesthetic standpoint of Sir Joshua Reynolds.[21] From this perspective multiplicity and diversity disrupt the aesthetic ideal of the completed whole. Eaton's response to the cathedral in Florence was that its 'diversity of colour and patched piecemeal effect' were 'totally destructive of that unity of appearance which is an indispensable requisite to architectural grandeur' (1: 18). But there are signs that Eaton begins to be bewitched by the Italian 'profusion of ornament' (1: 18). She is more open about the aesthetic impact of the cathedral at Siena, finding the mixture of details 'perplexing' as well as 'useless' (1: 46) and admitting to the sensation of being overwhelmed: '[t]he eye is bewildered with the varieties of splendour that attract it in every direction' (1: 47–8).

The potency of images on view in Italian churches presents a challenge to the travel writer, whose art is also that of representation. In Rome, Eaton again describes a peculiar version of the sublime, reminiscent of Dorothy Wordsworth's ravishment at the riches spread around her in Milan:

> I despair of finding words even feebly to describe the objects around me, or give back the faintest image of the various impressions, and the

21 For Reynoldsian theory underpinning travel writing, see Elizabeth A. Bohls, *Women Travellers and the Language of Aesthetics, 1716–1818* (Cambridge, Cambridge University Press, 1995).

multiplicity of feelings, that crowd upon each other, and overpower
me with their force. My mind is confused and agitated like a tumultu-
ous sea, and thought chaces [sic] thought as rapidly as its waves roll
over each other. (1: 109)

What we find in both Dorothy Wordsworth and Charlotte Eaton is the
discovery of a new architectural sublime which is not predicated on the
obscurity and austerity of Burke's masculine category, but on a more
feminine abundance and proliferation of aleatory material forms.

Sublime and baroque art forms co-exist in the classical structure of
the Pantheon. Although this is another instance where Eaton decries
Catholic clutter of 'dusty altars, frippery Madonnas, and faded old arti-
ficial flowers that lumber up the recesses' (1: 341), she is responsive to an
atmosphere which supersedes all party spirit:

Who does not experience an elevation of soul in this ancient temple
of the gods? Who does not feel, that man, who formed it, is allied to
the divinity whom he here adores, and whose presence still seems to
fill it? Be it

'Jehovah, Jove, or Lord',

It is still the same, the one, great, and only God, that inhabiteth
eternity. (1: 335)

But again, she counters her rapture with the criticism that 'it has never
been washed since it was a Christian place of worship . . . Catholics seem
to think that there is a great sanctity in dirt' (1: 340). This juxtaposi-
tion of awe with hostility towards the earthiness and darkness of faith
characterises Eaton's account of Catholicism in Italy. Every time she is
seduced by the spectacle of fabulous piety, she feels bound to reassert a
more brusque detachment. In so doing, her prose style moves between
a lyrical fluidity and clipped irony. The same thing happens in the Church
of Saint Sylvester where, while investigating the crypt, Eaton's party
hears the voices of the Carmelite monks chanting the evening service
above them: 'These solemn sounds of praise, thus raised to God by the
unseen inhabitants of the cloister . . . breathed the sublime spirit of devo-
tion; and . . . touched our hearts with emotions not born of this world'
(2: 102). As soon as they return to the upper church, however, Eaton
records that 'the spell of feeling was broken, and Reason resumed her
empire'. In this spirit, Eaton doubts that this was the secret location of
Saint Sylvester's ministry: 'nothing . . . could convince me that . . . old
St. Sylvester was such a fool as to say mass in the Baths of Titus' (2: 103–
4). Veering in this way between enraptured eulogy and irreverent satire,

Eaton makes her way round Rome, guarding her Protestant independence, but enfolding in her account moments where her senses are ravished by the flamboyant excess of Catholic visual splendour.

The most pronounced instance of this doubled vision comes, appropriately, as Eaton approaches St Peter's and the Vatican. She admits that from her English perspective 'the Vatican . . . stood in my fancy only as the gloomy and hateful residence of a bigotted and imperious Pontiff' (1: 150). Once inside, however, her prose style explodes into a pæan of aesthetic wonder, predicated wholly on visual pleasure:

> I have seen the Vatican! But how shall I express the delight, the admiration, the overpowering astonishment which filled my mind! How describe the extent and splendour of that almost interminable succession of lengthening galleries and marble halls, whose pictured roofs, mosaic pavements, majestic columns, and murmuring fountains, far surpass even the gorgeous dreams of Eastern magnificence, and are peopled with such breathing forms of beauty and of grace, as sometimes deign to visit the rapt fancy of the poet, and seem to have descended here from happier worlds! (1: 148)

Knowingly, Eaton appropriates the term 'miracles of art' to capture what she sees inside 'the temple of taste, the consecrated seat of the muses' (1: 148–9), the most memorable item being the Apollo Belvedere, which she makes into an idol:

> The god of light, and poesy, and imagination, stands confessed to our dazzled senses; and well does he stand here, where every thing seems to breathe and burn with his essence . . . and every tributary form bows to him! . . . Vain, indeed, is the cold language of critics and connoisseurs. The heart and mind feel its power, and are penetrated with its transcendent beauty. (1: 166–8)

In her homage to the Apollo Belvedere, Eaton adopts the language of Catholic devotion. This prose description was written, Eaton insists, 'during Lord Byron's short visit to Rome, and before the Fourth Canto of Childe Harolde was composed' (2: 196). Like Byron, she documents the dangerous 'madden[ing]' possibility of falling in love with 'a dream of Love'.[22] This reversal of the Pygmalion myth violates restrained Protestant taste, yielding to the Catholic spirit of piety in style and subject matter as the sceptical tourist lapses into a wholly transgressive lover's discourse.

Mary Shelley praised Eaton's work as 'an inestimable guide . . . a faithful account', and Jeanne Moskal notes Shelley's 'engagement with

22 See Byron, *Childe Harold's Pilgrimage*, 4: 162.

Charlotte Eaton's view that dirt, indolence and beggary were endemic to Catholic communities'.[23] Moskal does not, however, detail the extent of Shelley's variance from the negative views of Catholicism evident in *History of a Six Weeks' Tour* (1817). This variance emerges in a pattern of reflection or afterthought in *Rambles in Germany and Italy* (1844) which persistently qualifies pejorative views of Catholicism. Shelley follows the usual English preference for simple harmony in church architecture over 'a multiplicity of ornaments' (8: 279), but in St. Mark's in Venice she is intrigued by 'barbaric elegance':

> Every portion glistens with precious stones. Its walls are covered with pictures in Mosaic: its pavement, and the five hundred columns that adorn it, are composed of verde antique, jasper, porphyry, agate, and the most precious marbles. Usually, one cares little for such things; but here the barbaric magnificence – the Eastern aspect – the tombs of heroes it contains, and its association with the glories of the republic – combine to render the tribute of Mammon to Heaven interesting. (8: 293)

The 'usually . . . but' structure signals the exceptional aesthetic quality of Venice which might stand metonymically for Italian Catholicism as a whole.

As with the female contemporaries we have considered above, Shelley's accounts of religious painting and music in Italy entail an acceptance of the Catholic art of devotion and a new sort of sublimity. In the sacristy in Ravello she finds 'virgins, whose gentleness is full of majesty, whose humility is that of one who, placing herself last, shall be first' (8: 384). The feminine decorum Shelley herself struggled to keep up here becomes a source of power and she adds two comments which suggest the aesthetic and moral inferiority of more recent masculine achievements:

> Since those days men have lost the power of portraying the passion of adoration in the countenance . . . They told us that an Englishman had wished to buy these pictures, but the Bishop had very properly refused to commit the sacrilege of selling them. (8: 385)

This moment recalls Dorothy Wordsworth's quiet disapproval of her brother's desire to carry away a stone cherub from the ruined chapel at Fuentes (2: 244–5). By applying the term 'sacrilege' to English

23 Nora Crook *et al.* (eds), *The Novels and Selected Works of Mary Shelley*, 8 vols. (London, William Pickering, 1996), 2: 159, 8: 27. References are cited in the text hereafter.

connoisseurship and commercial venturing, Shelley challenges her readers to abandon the tourist perspective and to follow her respect for 'the seraphic school' (8: 384).

Throughout her artistic explorations in Italy, Shelley remains fascinated by the depiction of 'rapt expression' and religious transport (8: 298). During Holy Week she attended the performance of the Miserere in the Sistine Chapel and shares with her readers the experience of Catholic ecstasy:

> [T]he soul is rapt – carried away into another state of being. Strange that grief, and laments, and the humble petition of repentance, should fill us with delight – a delight that awakens these very emotions in the heart – and calls tears into the eyes, and yet which is dearer than any pleasure. (8: 352)

The 'ardent aspiration' which Shelley locates in the idealised forms of Catholic adoration recalls her worship of her dead husband, but it is also a moment of imaginative empowerment; the 'and yet' qualification shows her desire to explore 'the sentient link between our heavenly and terrestrial nature' (8: 352).[24]

Shelley's revisionary view of Catholicism extends to social practice as well as 'the triumph of Christian art' (8: 346). Having quoted Eaton's harsh line on Catholic dirtiness Shelley continues, '[i]t must be added, that wherever the Catholic religion prevails, great works of charity subsist' (8: 353–4). She contrasts this culture with the Poor-Laws which the Reformation brought to England:

> During the time of Catholicism, charitable institutions . . . abounded all over England – in some few obscure corners such still survive, where the old may find a peaceful refuge – not in crowded receptacles, where they are looked on as useless burthens on a heavily-taxed parish – but in decent almshouses. (8: 354)

Shelley condemns the 'superstition' and 'absurd buffoonery' which made people believe that the cholera outbreak of 1837 would not invade Rome, and the illuminations and processions which were undertaken to keep plague at bay. 'Yet', she notes that there are 'many redeeming touches in the dark picture'. In particular, Shelley praises the conduct of the Jesuits: '[t]hey were seen taking, with gentle care, babes from the sides of

24 For the political significance of Shelley's different representation of the Italians, see Esther H. Schor, 'Mary Shelley in Transit', in Audrey A. Fisch, Anne K. Mellor and Esther H. Schor (eds), *The Other Mary Shelley: Beyond 'Frankenstein'* (New York, Oxford University Press 1993), pp. 235–57.

their mothers, who lay dead in the streets, wrapping them tenderly in their black gowns, and carrying them to . . . refuge' (8: 355–6). The image of maternal monks accords with Shelley's view of a country where 'nature is the indulgent mother instead of the stern overseer of our species' (8: 357), and a travelogue which often focuses on actual households, the situation of mothers and older women. In one such encounter, Shelley describes the faith of a 'Juno-looking' woman from Capri with a sick child to care for:

> '*Sono sempre allegra,*' she said. 'I am gay – we ought to be gay.' '*Siamo come Dio vuole.*' We live as God pleases, and must not complain' . . . '*Ma, allegra, Signora*' – 'the Virgin will help us;' and she began, in a sweet voice, to sing a plaintive hymn to the Virgin. Poor people! their religion is hung round with falsehood; but it is a great, a real, comfort, to them. (8: 373)

With this reflection, in which the duplicitous drapery 'hung' round religion suddenly becomes 'a real comfort', Shelley locates moral value in the facet of Catholicism which had always appalled Protestant observers. She accomplishes something similar in her anecdote of the hospitable Italian town which sheltered an English family who had fled the cholera epidemic in Rome:

> They not only provided them with provisions, but exerted themselves to please and amuse them. Each day some little fête was given by the mere country people for their diversion; so that they seemed, like the personages of the Decameron, to have escaped from a city of the pest, to enjoy the innocent pleasures of life with the greater zest. (8: 357)

In this case it is the tradition of the fête which is redeemed, enabling Protestants to participate in communal Italian life with 'zest'.

Shelley attempts to define the unique quality of Roman people as a 'dreamy contentment' that 'militates against our notions of manly energy' (8: 358), and we find a similarly sensuous responsiveness in her description of art in the Sistine Chapel ('the eye is so fed by sights of beauty, "that the sense aches at them"' (8: 343)), and her view of the Gulf of Salerno ('the senses ache with the effulgent beauty' (8: 370)). Alluding to Othello's tortured admiration of Desdemona before he kills her, marvelling that what is believed to be false might be true, Shelley captures the mingling of seduction and resistance in women travellers' accounts of Italian sight-seeing. This aesthetic tension, evident in a variety of approaches and styles, heralds the revaluation of Italian Catholics as a

worthy British cause and predicts the 'worship' of Garibaldi (see p. 134 below). Responding and contributing to enhanced religious toleration in the early nineteenth century, these women writers helped the British public to imagine Italy as an emergent nation and humane concern instead of what Macaulay referred to as 'the headquarters of ... the strange Brahminical government established in the Ecclesiastical States'.[25]

25 Quoted in Brand, *Italy and the English Romantics*, p. 218. I would argue that this aesthetic and political tension extends to writers such as Lady Morgan, who used a critique of abuses of power by the Catholic Church to advocate political change in England. See her comments on the 'unholy alliance between the throne and the altar' and her support for the Reformation because it 'violated the social order of that day' (Lady Morgan, *Italy*, 2 vols [London, Henry Colburn, 1821]), 1: 236, 175.

2

Casa Guidi Windows:
Elizabeth Barrett Browning,
Italy and the poetry of citizenship

Richard Cronin

IN A POEM written just after the passing of the Great Reform Bill, Tennyson announced that the modern poet should dedicate himself to the 'civic Muse' ('Hail Britons!', l. 169). This essay is dedicated to the proposition that this ambition was not fulfilled until the publication of *Casa Guidi Windows* in 1851, and seeks to explain why the possibility of a properly civic poetry should have been first realised in the period by a woman poet, and by a poet addressing herself to the politics of Italy rather than of Britain.

The project requires me to adjust the most influential modern reading of the poem. Sandra Gilbert has argued that Barrett Browning found in the Italian Risorgimento an allegory both of her own personal life and of her literary endeavour.[1] For Gilbert, Barrett Browning tells through her poem on Italian politics the story of her own risorgimento both as a woman and a poet. This account of the poems seems to me in its own terms entirely persuasive, but not fully adequate, because it does not register strongly enough the demand that Barrett Browning consistently made of herself, and that Romney Leigh recognised had been fulfilled in Aurora's new poem in which she 'showed [him] something separate from [herself]' (8: 606).[2] I prefer to follow Esther Schor in reinstating *Casa Guidi Windows* as a political poem, or, more precisely, as a poem that seeks to define the nature and duties of citizenship.[3]

A version of this chapter first appeared in Richard Cronin, *Romantic Victorians* (Basingstoke, Palgrave, 2001) and is republished with permission.

1 Sandra Gilbert, 'From Patria to Matria: Elizabeth Barrett Browning's Risorgimento', in Angela Leighton (ed.), *Victorian Women Poets: A Critical Reader* (Oxford, Blackwell, 1996), pp. 24–52.

2 All citations from *Aurora Leigh* are taken from Margaret Reynolds' edition (Athens, Ohio University Press, 1992).

3 Esther Schor, 'The Poetics of Politics: Barrett Browning's *Casa Guidi Windows*', *Tulsa Studies in Women's Literature*, 17 (1998) 305–24.

Since the 1790s the word 'citizen' had been for many English people a tainted word. For Wordsworth, for example, throughout the years in which he wrote his greatest poetry, it was a translation of a French term, *citoyen(ne)*, the dead hollowness of which struck him with an intensity precisely proportionate to the thrilling resonance that it had once possessed. In the sonnet, 'Jones! as from Calais southward you and I', he recalls, as he walks the same road, the tour of France that he had undertaken with his college friend, Robert Jones, in the summer of 1790. But, in 1802, during the brief interruption of the war between Britain and France, he is conscious only of the difference:

> And now, sole register that these things were,
> Two solitary greetings have I heard,
> 'Good morrow, Citizen!' a hollow word,
> As if a dead man spake it!

From 1798 both Wordsworth and Coleridge were concerned to rescue the ideal of freedom by releasing it from any connection with the idea of citizenship.

In the war years the idea of citizenship was usurped, as one would expect, by the idea of patriotism. Scott's minstrel asserts his devotion to his 'own his native land' quite independently of the political settlement that obtains there, and the Spanish in Wordsworth's *The Convention of Cintra* fight heroically not for a constitution but for Spain. Indeed, it seemed to both men in these years that interest in the constitution was itself unpatriotic, an expression of the diseased mania for constitution-making that characterised the French. The second generation of Romantics disowned the politics of their predecessors, but were unable to recover the ideal of citizenship that Blake, Wordsworth, Southey and Coleridge had shared in their youth. In *Childe Harold* Byron instituted the manner that was to dominate the immediate post-war years, a manner that offered as the one guarantee of an individual's authenticity his withdrawal from civil society.

Dickens' *A Tale of Two Cities* (1859) offers the most striking evidence of how long that English recoil from the idea of citizenship lasted, and it was a necessary condition of Barrett Browning's achievement that she seems oddly immune from its effects. Far from seeking to redeem the word citizen from the 'hollow' resonance that it had been given by the Terror and the Napoleonic wars, she was ready to insist that it was precisely in France that the civic ideal had its origin, and in France too

under its new emperor, Louis Napoleon, the citizen king, rather than in the constitutional monarchy of Britain, that it found its strongest contemporary realisation. In their election of him the people of France committed themselves once again to an ideal of citizenship that had been defeated in 1815. They chose that

> This man should renew the line
> Broken in a strain of fate
> And leagued kings at Waterloo,
> When the people's hands let go.[4]

This poem, 'Napoleon III in Italy', was written only shortly before it was published in 1860, but from the very first Barrett Browning placed herself firmly within the tradition of liberal politics which had found, for her as for most of her contemporaries, its most glamorous spokesman in Byron, 'the Mont Blanc of intellect' (*An Essay on Mind* [1826], l. 70). In her very first published poem, *The Battle of Marathon* (1820), the fourteen-year-old girl was already commemorating a battle that, as all readers of Byron knew, sustained the dream 'that Greece might still be free' (*Don Juan*, 3: 704) . It was the political stance to be expected in someone raised as she was in a non-conformist family,[5] and it informs several of her early poems. 'Lines on the Portrait of the Widow of Riego', for example, published with *An Essay on Mind*, celebrates the staunchness of a woman widowed when her patriot husband was executed after the failure of the Spanish Revolution of 1820. But, in poems such as 'The Switzer's Wife' and 'Gertrude', Felicia Hemans had already made exhibitions of patriotic fortitude by women a popular poetic topic. It is more revealing to consider a poem that Barrett Browning did not write. In 1845 she was invited to write a poem for the Anti-Corn Law League, but was persuaded by her father, her closest male advisers, Kenyon and Chorley, and her brothers, that it would be unbecoming in a woman

4 'Napoleon III in Italy', stanza 1. *The Poetical Works of Elizabeth Barrett Browning* (London, Oxford University Press, 1932), p. 541.

5 The complicating factor was that her father's wealth came from his ownership of large West Indian slave plantations. When the slaves were emancipated in 1833, her father was forced to give up his Hertfordshire country house, and the family moved to rented accommodation, first in Sidmouth, and then in London in Wimpole Street. It is worth noting, as one of the few actions that speak to his credit, that her father supported the emancipation despite the financial consequences to himself.

poet to write on a controversial political issue.[6] It was not until 1846, when she escaped from Wimpole Street to Italy and from her father into marriage with Robert Browning, that she became free to cultivate the civic muse.

It is also true that Barrett Browning most often, like Byron, engages with the politics of nations other than her own. Her first important civic poem, 'The Cry of the Children' (1843), protested against the employment of children in British factories and mines, but *Casa Guidi Windows* (1851) and *Poems Before Congress* (1860) address themselves to Italian politics.[7] Byron had found in Italy and Greece the only arenas in which he could comfortably address himself to political realities because abroad, in pre-industrial, neo-feudal societies, he could assume his preferred political role as champion of the people without compromising his aristocratic status. Italy freed Barrett Browning to write political poetry for quite other reasons. For her, as for Hemans and Landon, *Corinne* was 'an immortal book' that 'deserves to be read three score and ten times – that is, once every year in the age of man'.[8] For her, as for her predecessors, the painful relationship between Corinne's identities as a woman and as an artist, and the conflict that disturbs Corinne between the desire for love and the desire for fame, provided the model through which she came to understand her own place as a woman poet in the nineteenth century. It is a theme that she explores most fully in

6 See Elizabeth Barrett Browning's letters to John Kenyon, 8 February 1845, to Mary Russell Mitford of the same day, to Miss Stansfield, the representative of the Leeds Anti-Corn Law committee of women who had first extended the invitation, of 10 February, and to Mary Russell Mitford the following day. It is in this last letter that she most fully reveals her shame and humiliation: 'What was the folly called my "poetical reputation," in comparison to the duty to which I was invited?' Philip Kelly and Ronald Hudson (eds), *The Brownings' Correspondence* (Winfield, KS, Wedgestone Press, 1984), 10: 60–8.

7 She was also exercised by slavery in the Unites States, an evil to which her own family history no doubt made her especially sensitive, in poems such as 'The Runaway Slave at Pilgrim's Point' (1848) and 'A Curse for a Nation' (1860). It is perhaps the first of these and 'The Cry of the Children' that she has in mind, when she allows Romney Leigh to mock both the social utility and the authenticity of such verse:

> You gather up
> A few such cases, and, when strong, sometimes
> Will write of factories and of slaves, as if
> Your father were a negro, and your son
> A spinner in the mills. (*Aurora Leigh*, 2: 192–6)

8 Kelly and Hudson (eds), *The Brownings' Correspondence*, 3: 25.

Aurora Leigh. But *Corinne* is both a novel about a woman artist and about a country, both a romance and a travel book (even in long sections a travel guide), and, as its full title suggests, for de Staël the two aspects of the novel are indissoluble: it is *Corinne, ou l'Italie*, a title to which Romney Leigh pays his own unconscious tribute when he addresses Aurora as 'My Italy of women' (8: 358). Corinne's Italy is occupied and ruled by the French as Barrett Browning's was by Austria, and hence its people are deprived of citizenship in their own country. This is a sad truth that Corinne insistently presses on the Scottish aristocrat, Lord Nelvil. His pride, she tells him, is the product of the free institutions of his country, and he should look indulgently on Italians who 'have been denied the lot of being a nation'. In Italy, men are unlikely to 'acquire the dignity and pride characteristic of free, military nations', with the consequence that Italian 'men's characters have the gentleness and flexibility of women's'.[9] This is why it is a country that may appropriately be represented by Corinne, a woman, and it is also why her countrymen are so generously appreciative of her genius, so free from the prejudice, shared alike by Aurora Leigh's cousin Romney, and by many of Barrett Browning's reviewers, that women are by their gender barred from producing art of major importance. For Barrett Browning, then, residence in Italy was, as it had been for Mary Shelley, curiously empowering, curiously because it was a consequence of living among a people disenfranchised by their nationality as definitively as Shelley and Barrett Browning were by their sex.

The absence of a civil society in Italy is, de Staël shows, in itself liberating in so far as it frees Italians from the constrictive power of a commanding public opinion. Corinne attends Lord Nelvil on his sick bed, and visits her country house alone with him, both actions that would have compromised the reputation of an unmarried Englishwoman. It was the desire to enjoy such freedoms that attracted many foreigners to Italy in the nineteenth century; people such as the friends of the Shelleys, Lady Mountcashell and George Tighe, who, because Lady Mountcashell was still legally married, found that they could live together more comfortably in Italy. One reason that Aurora takes Marian Erle and her infant son to Italy is her desire to return to the country where she was born, but another is that Italy offers a less rigid, more yielding social space in which to establish a family consisting of a mother, a surrogate mother, and their child, who has no father, and yet as Marian

9 *Corinne, or Italy*, transl. Sylvia Raphael (Oxford, Oxford University Press, 1998), pp. 38, 103, 97.

insists to Romney Leigh is in spite of that not 'fatherless' (9: 414). Italy offers a place in which you can 'be, as if you had not been till then, / And were then, simply that you chose to be' (7: 1194–5). So, in the house overlooking Florence, Aurora can establish a new domestic economy in which she, a woman, assumes the male role of provider, and yet is still woken each morning by the kisses of Marian's child, his 'mouth and cheeks, the whole child's face at once / Dissolved on mine' (7: 949–50). In the house at Bellosguardo Aurora and Marian establish a small, enclosed matriarchy, the domestic equivalent of the alternative civil society that Mary Shelley placed in fourteenth-century Italy in *Valperga* (1823), the hill-top fortress from which Euthanasia exercises a nurturing, uncoercive maternal rule over her dependants.

For de Staël 'free' nations, civil societies, are also 'military' nations, because, presumably, a nation devoid of military virtues would be incapable of securing its freedoms. Britain is free because its citizens live under a rule of law that secures their rights, but the rule of law can itself only be secured by men such as Nelson and Wellington. It is a lesson that Mary Shelley's Euthanasia learns when Valperga is attacked and taken by the hero-villain of the novel, the warlord Castruccio Castracani. In defending the tiny state over which she rules, Euthanasia is obliged to appeal to the masculine heroic code that in her governance of the state she repudiates. Unsurprisingly, when the warrior Castruccio forces her to meet him on his own terms, she is defeated, and left with the bitter reflection that she has betrayed the values by which she sought to govern by the very manner in which she was obliged to defend them:

> Euthanasia wept when she heard of the blood that had been spilt for her; and self-reproach, who is ever ready to thrust in his sharp sting, if he find that mailed conscience has one weak part, now tormented her that she had not yielded, before one human life had been lost in so unhappy a cause. 'Do not evil that good may come,' thought she. 'Are not those the words of the Teacher? I have done infinite evil, in spilling that blood whose each precious drop was of more worth than the jewels of a kingly crown; but my evil has borne its fitting fruit; its root in death, its produce poison.'[10]

The problem for Barrett Browning was less intractable, for she did not share Mary Shelley's absolute aversion to violence. But it remained severe.

10 *Valperga: or, The Life and Adventures of Castruccio, Prince of Lucca*, in Nora Crook *et al.* (eds), *The Novels and Selected Works of Mary Shelley*, 8 vols (London, William Pickering, 1996), 3: 221.

How could Italy achieve nationhood, and its people the dignity of citizen-ship, without submitting to a patriarchal rule of law that, as it was embodied in her father, Barrett Browning had fled to Italy to escape? Her solution is articulated in her poems, best of all in *Casa Guidi Windows*, and it is founded on a re-definition of citizenship not as a state but as a process. It is not an idea peculiar to Barrett Browning, and might, in fact, be claimed as the dominant Victorian idea of citizenship. It supposes that the individual is neither subsumed within the state nor distinct from it, but rather that the idea of citizenship is realised in an unending process of negotiation by means of which the individual defines and re-defines her place within the body politic. It is in this sense that all civil societies should be like Tennyson's Camelot, which is a city 'They are building still, seeing the city is built / To music, therefore never built at all, / And therefore built for ever' (*Gareth and Lynette* [1871], ll. 272–4). Barrett Browning never condenses her civic ideal into so memorable a lyric cadence, but in *Casa Guidi Windows* she gives it more substance.[11]

Barrett Browning's poem takes as its subject the defeated Italian revolution of 1848. It is in two parts. The first, which records the Florentine celebration on 12 September 1847 of the restoration of their civil liberties, is heady with enthusiasm: the second, which records the entry into Florence of an Austrian army of occupation on 2 May 1849, is heavy with disillusion. It is a poem in which Barrett Browning is much concerned with her own place in literary history, and hence it is appro-priate that she should have borrowed this structure from the first major political poem in English written by a woman, Charlotte Smith's *The Emigrants* (1793), but it is still more important that the structure enables Barrett Browning to present her meditation on Italian nationalism dramatically. It is a structure that compels the reader at once to look with the speaker, to see events through her eyes, and to look at the speaker, to trace through her responses the universal truth that those who enter-tain excessive hopes leave themselves vulnerable to a correspondingly painful disillusionment. It is, then, an example of the 'double poem' that, as Isobel Armstrong has shown us, is the defining mode of Victorian poetry.[12] But male Victorian poets tend characteristically to establish an ironic relation between the two aspects of their poems, and one result of

11 *Casa Guidi Windows* has been well edited by Julia Markus (New York, The Browning Institute, 1977). Her introduction and notes provide the best account of the poem's political background. All quotations are taken from this edition.

12 Isobel Armstrong, *Victorian Poetry: Poetry, Poetics and Politics* (London, Routledge, 1993). For Armstrong's definition of the double poem, see pp. 11–21.

this is that an interest in politics is almost always subordinated to an interest in character. Clough's *Amours de Voyage* (1849), for example, describes the thwarted Roman revolution that immediately preceded the Florentine revolution of *Casa Guidi Windows*, but for Clough the Roman Republic functions most importantly as a means through which Claude, the English tourist, reveals and discovers his authentic or inauthentic selfhood. *Casa Guidi Windows*, too, is flecked with irony, but Barrett Browning never fixes the poem within an ironic mode, and in consequence the personality of the speaker never displaces the stumbling advance of Italy towards nationhood from the centre of the poem's concerns. The male poets use irony to dramatise their alienation from the social group, but Barrett Browning is interested in working out her relationship with the group. Hence the oddity that she, a disenfranchised woman, unlike her male contemporaries, finds an idiom that makes possible the writing of directly political poetry.

The poem's long opening movement defines the responsibilities of the civic poet by exploring two closely related questions: what language should civic poetry be written in, and what relationship should the civic poet assume with her literary tradition? Barrett Browning's insistence that the poet's responsibilities as an artist and her responsibilities as a citizen are inseparable informs the whole discussion. To select a metaphor is to make a political decision. For example, to describe Italy as the 'Niobe' of nations (1: 32) is to manufacture 'cadenced tears which burn not where they touch' (1: 35); it is to employ figurative language to disguise the pain that such language dishonestly claims to express. The poet has a responsibility not to 'sigh for Italy with some safe sigh / Cooped up in music 'twixt an oh and ah' (1: 163–4). *Casa Guidi Windows* is the first important poem that Barrett Browning wrote after her marriage, and the first poem in which she matches Browning in his ability to inform the metre of the poem with the fractured, agitated rhythms of thought, but in her poem the refusal of easy plangency signals a recognition that metrical choices, like choices of metaphor, are inevitably political choices too. Her attack is explicitly targeted against the Italian poet, Vincenzo da Filicaja, and his sonnet 'All'Italia'. Her poem is prompted when she hears a young child singing '*O bella libertà, O bella!*', and resolves that she would rather join her song to that child's

> Than, with those poets, croon the dead or cry
> 'Se tu men bella fossi, Italia!'
> 'Less wretched if less fair'. (1: 167–9)

But the implicit target is Byron, who had offered his own translation of Filicaja's sonnet in Canto 4 of *Childe Harold*.[13] Byron, the suggestion is, despite his evident commitment to the cause of both Italian and Greek nationhood, had failed to address either in a responsibly civic poetry. In *Childe Harold* 3 and 4, Byron meditates on the pathos of Italy's lost greatness, content to awaken in his readers a passive melancholy when what is needed is a poetry that prompts to action.

Byron meditates on Italy's past, and the proper use in the present of the past is the second theme of the poem's opening section. Here Barrett Browning takes apparently inconsistent positions. One must re-member one's predecessors in order to remind oneself that the duty of a modern poet is to act differently:

> For me who stand in Italy today,
> Where worthier poets stood and sang before,
> I kiss their footsteps, yet their words gainsay. (1: 49–51)

From this point of view the artists of the past are the undead, who 'cling to us' with their 'stiff hands' and 'drag us backward' into the past (1: 230–2). From another, they are the inspirational figures who fire their successors with the ambition to match their greatness. So, the Florentines gathered on 12 September 1847 (the first anniversary of the Brownings' marriage), begin their celebratory march to the Pitti Palace 'On the stone / Called Dante's', the 'plain, flat stone' opposite the cathedral where Dante would bring his chair to sit in the evenings (1: 801–2). Alternatively, the poets of the past are the eagles from whose back modern wrens mount higher: 'Could I sing this song, / If my dead masters had not taken heed / To help the heavens and earth to make me strong' (1: 432–4). Or, more originally, a poet's predecessors challenge her to re-make them in her own image, in order that history fulfil its proper function by serving the needs of the present. Barrett Brown-ing re-creates Michelangelo and Dante as Mazzini's true predecessors,

13 Oh, God! that thou wert in thy nakedness
 Less lovely, or more powerful, and couldst claim
 Thy right, and awe the robbers back, who press
 To shed thy blood, and drink the tears of thy distress. (4: xlii)

See also Schor's chapter in this volume, and also Susan Wolfson, 'Hemans and the Romance of Byron', in Nanora Sweet and Julie Melnyk (eds), *Felicia Hemans: Reimagining Poetry in the Nineteenth Century* (Basingstoke, Palgrave, 2001), pp. 155–80.

republicans who recognised only one authority, 'il popolo'.[14] In this, she was at least following Mazzini himself, but Savonarola is re-created in her own image, as a Protestant non-conformist, who 'tried the tank / Of old church-waters' and 'said they stank!' (1: 267–9).

The inconsistency is the point. The ambition entertained by some radical visionaries, the Jacobins and Shelley for example, to abolish the past, to consume it in a single apocalyptic conflagration to make way for an utterly new future, and the Burkean notion that the past must be allowed to hold the present forever in a dead man's grip, are for Barrett Browning both and equally refusals of the duty of citizenship, which requires that the relationship between past and present be unendingly re-negotiated. As with citizenship so with poetry. To write is to make delicate and always provisional accommodations with the poetry of the past. *Casa Guidi Windows* begins as a celebration of the Florentines' recovery of their citizenship, but it begins too by remembering a failure that saddened Barrett Browning throughout the rest of her life, the failure of her husband's poetry. The child's song, heard through the windows of Casa Guidi, recalls, as Barrett Browning's editors have noted, the song in *Pippa Passes* that transforms the lives of all who hear it when it sounds through their windows. But even more clearly it recalls the boy's song at the end of *Sordello*, which, like the song that Barrett Browning hears, mounts higher and higher until it leaves the 'lark, God's poet, swooning at his feet' (6: 866). *Sordello* was the climactic failure of Robert Browning's career, and a failure that Barrett Browning in her two most important poems repairs. *Sordello* traces the failure of its central character to become 'the complete Sordello, man and bard', and Aurora Leigh is allowed to pursue the same enterprise to a rapturously happy conclusion. Sordello cannot find any means of bringing his poetic ideals to bear on the political world, so that his life amounts only to a 'solemn farce'. In *Casa Guidi Windows*, Barrett Browning seems to have no more success, and yet her poem ends smilingly confident that no human effort, neither the Italian revolutions of 1848 nor even *Sordello*, is ever wasted, for the 'world has no perdition, if some loss' (2: 780). She begins her poem with the song that ends *Sordello*, and yet hers is a quite different song, celebrating the beauty of liberty rather than the beauty of Elys' hair, and her poem founds its quite unironic confidence that 'God's in his heaven' and that all will be, even if patently it is not at present, 'right with the world', not in the joy of hopes realised but in the bitter experience of their failure. So her poem at once recognises her husband's failure, denies it, and

14 Mazzini's motto, as Barrett Browning records in 1: 499.

redeems it, and in this it offers a model for the manner in which both poets and citizens should conduct their dealings with the past.

Dorothy Mermin points out that in *Casa Guidi Windows* Barrett Browning 'defines herself explicitly . . . as a woman',[15] but in fact the first part of the poem is as concerned to conceal her gender as the second part is to display it. Even when she describes visiting Vallombrosa with her husband, he is neutrally invoked as 'beloved companion' (1: 1130). In the preface to the poem she offers the 'discrepancy' between the two parts as a guarantee of her 'truthfulness'. She does not try to hide the fact that 'she believed, like a woman, some royal oaths, and lost sight of the consequence of some popular defects' (p. xli). Here, her womanhood is presented as the sign of her credulousness, which makes it entirely appropriate that she should, throughout the first part of the poem, conceal it. It serves also to alert us to the fact that the rhetoric of the first part of the poem is carefully deployed in a not quite successful act of repression.[16] She has to blur her clear-sighted recognition of the folly of the widespread confidence that the Pope, Pius IX, would act the part of a benevolent liberal. Any such confidence, she insists, runs counter to the entire history of the papacy, is inconsistent with the character that a man must develop if he is ever to rise to the papal throne, and supposes that the Catholic Church might willingly embrace a contradiction that threatened its own existence, for free institutions are, she believes, a threatening affront to the claim to absolute authority on which the power of the papacy is founded. And yet, despite the overwhelming evidence to the contrary, she 'fain would grant the possibility / For *thy* sake, Pio Nono' (1: 867–8; emphasis in original). All the objections to the likelihood of the Pope emerging as a hero of the liberal cause seem to apply equally to Florence's Grand Duke Leopold II, and yet, as she watches him acknowledge the people from the windows of the Pitti Palace, and present his children to them 'to suggest / *They*, too, should govern as the people willed' (1: 559–600; emphasis in original), and especially when he is reported to have shed 'good warm human tears' (1: 563) on the occasion, she is eager to believe in his good intentions. 'I like his face', she writes, which is 'mild and sad', but the phrase itself conceals a warning in its

15 Dorothy Mermin, *Elizabeth Barrett Browning: The Origins of a New Poetry* (Chicago, University of Chicago Press, 1989), p. 163.

16 The first part of the poem was written in 1847 and offered immediately to *Blackwood's*, but was rejected. It cannot be demonstrated that, before she published the two parts of the poem in 1851, she revised the first, but I think it likely that she did, not at all as a means of denying the 'discrepancy' between the two parts of the poem, but in order to establish that discrepancy as the poem's point.

echo of her husband's description of Charles I, who fixed himself in Strafford's heart as the 'man with the mild voice and mournful eyes' (2: 2: 193), and later signed the warrant for his execution.

Finally, in the poem's first part, as she watches the Florentine people walking in procession to the Pitti Palace, she successfully represses her knowledge of them as they are. She sees them walk along, all neatly divided into their orders, the magistrates, the lawyers, the priests, monks and friars, the artists, the trades, and last of all the 'populace, with flags and rights as good' (1: 497). And then there are the representatives of the other Italian states, marching behind their banners, Siena's she-wolf, Pisa's hare, and Arezzo's horse, and finally the delegation of foreigners

> Greeks, English, French – as to some parliament
> Of lovers of her Italy in ranks,
> Each bearing its land's symbol reverent. (1: 513–15)

For Barrett Browning, and for all like her who knew their Carlyle, such processions are a warning in themselves.[17] Descriptions of them punctuate Carlyle's *The French Revolution*. They constitute the great set pieces of his history, and always prompt his deep, fierce laughter, for what they offer is an idea of citizenship reduced to a mummery, an empty masquerade, and they command the belief only of those who cannot see the people marching in the procession for what they are, of those who can successfully repress any recognition of people in their gross, physical individuality. But in Part One of the poem, looking from Casa Guidi windows, Barrett Browning successfully sustains the illusion that the people who pass beneath the window, 'These oil-eaters, with large, live, mobile mouths / Agape for macaroni', as she so vigorously describes them earlier in the poem (1: 200–1), are transformed into an ideal citizenry rather than acting out a pantomime of citizenship.

After she had written the first part of the poem, and before she began to write the second, Barrett Browning became a mother, so that when the young boy singing who begins the poem is reflected at its end it can be in the form of Barrett Browning's 'own young Florentine' (2: 743), her son, Pen. Her motherhood informs the poem's second part

17 As Steve Dillon and Katharine Frank point out, *Casa Guidi Windows* is Barrett Browning's most emphatically Carlylean poem, especially in its desire that a leader appear, whether he be 'last peasant or first Pope' (1: 835) who will in his own person embody Italian unity. See 'Defenestrations of the Eye: Flow, Fire, and Sacrifice in *Casa Guidi Windows*', *Victorian Poetry*, 35 (1997) 471–92.

throughout. When the Austrian troops enter Venice, her first thought is that the 'regular tramp' of their feet should not disturb her sleeping child (2: 288–98). It is her motherhood, too, that gives poignancy to her account of the death of Garibaldi's pregnant wife, who died as she was retreating with her husband and his army from Rome, and was hastily buried on the beach. She,

> at her husband's side, in scorn,
> Outfaced the whistling shot and hissing waves,
> Until she felt her little babe unborn
> Recoil, within her, from the violent staves
> And bloodhounds of the world: – at which, her life
> Dropt inwards from her eyes, and followed it
> Beyond the hunters. Garibaldi's wife
> And child died so. And now, the sea-weeds fit
> Her body like a proper shroud and coif,
> And murmurously the ebbing waters grit
> The little pebbles, while she lies interred
> In the sea-sand. (2: 678–89)

Hers is the death of the woman hero, and it seems, as Barrett Browning admits, to reinstate the image of Italy that in the first part of the poem she had so vigorously rejected, Italy as the woman beautiful in her grief, mourning her dead children, 'Still Niobe' (2: 726). The buoyant optimism of the poem's first part seems now only a symptom of womanly weakness, an inability to believe that even a Duke could lie when his children's kisses were warm on his face:

> And I, because I am a woman, I
> Who felt my own child's coming life before
> The prescience of my soul, and held faith high,
> I could not bear to think, whoever bore,
> That lips, so warmed, could shape so cold a lie. (2: 95–9)

She watches Duke Leopold return to Florence under the protection of the Austrian army, and knows that the Pope has already co-operated in the overthrow of Garibaldi's Roman Republic by entering into a league with Austria. The faith in Italy that she had so triumphantly expressed in the poem's first part stands revealed as not at all the prophetic utterance of the true poet, but just a woman's wishful thinking.

All the uncomfortable truths that had been repressed return. Leopold is revealed as a weak worthless man, and Pius IX as, after all, just a Pope, 'only the ninth Pius after eight' (1: 1033), who acted, quite predictably,

as all the other Piuses had done. And the people had shown themselves quite unable to live up to the image of themselves as a noble, united citizenry that they had so flamboyantly presented as they marched in procession to the Pitti Palace on 12 September 1847. When Leopold fled from the city, its citizens 'set new café signs, to show / Where patriots might sip ices in pure air / (Yet the fresh paint smelt somewhat)' (2: 125–7). If they 'did not fight / Exactly', they at least fired their muskets into the air (2: 154–5), and would have fought in earnest, had they been willing to leave their 'piazzas, shops and farms / For the bare sake of fighting' (1: 169–70). And at the last they had been quite happy to invite Leopold back, and watch passively as he re-entered the city under Austrian protection. This whole section of the poem is weighted with a fierce, satirical Carlylean scorn for a people who had proclaimed a 'true republic in the form of hats' (2: 131), and there is even a trace of savage Carlylean satisfaction at the arrival of the Austrian army as a brute fact to shatter play-acted republican flummery. It is as a sign that she will no longer repress her grasp of unheroic actualities that Barrett Browning does not write the second part of the poem in the person of an abstract, ungendered poet, but rather from 'the faint heart of [her] womanhood' (2: 406). She confesses her womanhood, then, as a signal of her disillusionment, but the work of the poem's second part is to locate in that same confession the ground of a renewed and strengthened optimism.

Most obviously her optimism is grounded on the fact of her child. She presents herself in this part of the poem as an 'Italy of women', and, if that is granted, then the fact of the child, Pen, grants Italy a future, and frees the land from the sweet, sad nostalgia that benumbs it when it is characterised as Niobe. More importantly, the manner in which the mother looks at her child offers a model of the way we should all look at our fellows, a maternal model. Women, the suggestion is, can at once see children as they are and see them lovingly. So, Aurora Leigh can look smilingly at Marian's child in a temper. Marian peels him a fig, but does not place it in his mouth, so that he

> sucked at it
> With vehement lips across a gap of air
> As he stood opposite, face and curls a-flame
> With that last sun ray, crying, 'give me, give,'
> And stamping with imperious baby-feet. (8: 10–14)

This is a real child, a human child, but the hair that becomes an aureole in the light of the setting sun reminds us that he is also divine. It is the same image that ends *Casa Guidi Windows*. Pen shakes 'the glittering

nimbus' of his hair, and in so doing he becomes the 'witness' that 'New springs of life are gushing everywhere' (2: 760–2).

In the poem's second part Barrett Browning looks at the Italian people and finds them cowardly in their failure to defend the revolution, vicious in the assassination of the Pope's minister, Count Rossi (2: 540–65), and fickle in their invitation to Duke Leopold who had fled from them to return as their ruler. But she can see all this without losing her faith in them, because she looks at them with the eyes of a woman and a mother, and in this poem the maternal gaze can look lovingly not despite, but because of, the individual's flawed humanity. It is repelled only by the sight of people who have surrendered their individuality to the group, and in so doing have become inhuman, a nightmare vision that is realised when the Austrian troops march into Florence, staring straight ahead, 'not an eye deflect / To left or right' (2: 312–13), and every 'single man, dust-white from head to heel' (2: 305). *Casa Guidi Windows* acts out the recognition that Aurora Leigh expresses abstractly, that 'all society', all civil society

> Howe'er unequal, monstrous, crazed, and cursed,
> Is but the expression of men's single lives,
> The loud sum of the silent units. (8: 876–8)

But, unlike *Aurora Leigh*, it remains a civic poem, because it acknowledges the importance of the sum as well as of the units, and of political as well as moral reformation. Neither does the poem try to fix the relationship between the two. It suggests instead that civil society comes into being, like the poem itself, in an unending process of negotiation between the claims of the individual and the claims of the state, which is why civil society is at once always building and never built.

As with the national, so with the international community. Other nations, but especially Britain and France, have a duty to support the Italians, because nations, like the individuals that make up those nations, have duties to each other, and in both cases that duty is confirmed rather than threatened by a recognition of difference. The Great Exhibition that was taking place in Crystal Palace as Barrett Browning wrote is wittily offered as at once an expression and a parody of proper international relations. It has become a 'Fair-going world' (2: 578), and those who visit the Crystal Palace see arranged the products of every nation, all of them boasting their distinctive national character: 'These corals, will you please / To match against your oaks?' (2: 592–3). The Exhibition offers a model of an international community, except that it confines itself to objects rather than values, to goods rather than goodness.

All the events of the poem are seen through Casa Guidi windows. In her preface Barrett Browning presents the poem's title as a defensive stratagem:

> The poem contains the impressions of the writer upon events in Tuscany of which she was a witness. 'From a window,' the critic may demur. She bows to the objection in the very title of her work.

The windows acknowledge that she is separated from the events she describes both by her nationality and her gender. She looks at Italy through English eyes, and the business of men through the eyes of a woman. But, in the end, the poem suggests, her vision is the truer for it, because the poem repudiates equally an exclusive cultivation of our own 'single lives' and the kind of surrender of the single self to the state so powerfully figured in the Austrian soldiers, all of them rendered indistinguishable, 'dust-white from head to heel'. The windows secure the distinction between the room and the street, between private and public spaces, which civil society must admit if its citizens are to enjoy their right to a private life, but because the windows open onto the street it is a private life that is not freed from public responsibility. In looking through the windows Barrett Browning proclaims herself as, like her son, a 'Florentine'. The windows do not work to reveal that she is peripheral to the events that she sees, but rather to establish her as the poem's type of the true citizen, at once separate from the state and joined to it. The windows, as Helen Groth has recently suggested, establish the 'spatial division' between 'an abstract public self' and the self understood as a centre of 'inchoate private desires' on which Barrett Browning's liberalism is founded.[18] It is the civic ideal that many Victorian poems moved towards in their attempt to evade either of the uncomfortably intransigent ideals that their Romantic predecessors had left to them: either the uncompromising assertion of irreducible individuality that Byron celebrates in a poems such as *Manfred*, or the contrasting ideal that informs the fourth act of *Prometheus Unbound*: 'Man, oh, not men, a chain of linked thought' (394). But it is a civic ideal that is, I think, first adequately expressed in *Casa Guidi Windows*.

18 Helen Groth, 'A Different Look – Visual Technologies and the Making of History in Elizabeth Barrett Browning's *Casa Guidi Windows*', *Textual Practice*, 14: 1 (2000) 31–52 (p. 36).

3

Casa Guidi Windows: spectacle and politics in 1851

Isobel Armstrong

An experiment

'FROM CASA GUIDI Windows I looked forth'.[1] A wholly experimental poem, *Casa Guidi Windows* explores a new genre of urban writing. It is about a quintessentially urban experience, the breathtaking sensory overload of a civic procession in a city street, compounded by the excited energies of the onlookers that include the poet. To see a political event through a window is an experience peculiar to nineteenth-century modernity: intrinsic to this modernity is that the very act of looking through the window becomes part of the political experience itself. Spectacles to one another, the street procession held to mark liberal concessions made by Grand Duke Leopold in 1847 – here, in the first part of the poem, on its way to the Pitti Palace in Florence to celebrate Italy's emergent nation state – and those frantically applauding it from above, are bound up in an act whose social meaning requires the onlooker in order to be complete. The procession lasted for three hours, and forty thousand people converged on Florence. The event took place on the Brownings' wedding anniversary and for them presaged a nascent republicanism that challenged England's backward monarchical state. Elizabeth Barrett Browning wrote to her sister about the 'phrenzy' and 'rapture' of the crowd, conducting itself with a self-belief so different from brutal English city crowds.[2]

1 All references to *Casa Guidi Windows* are from Julia Markus's edition (New York, The Browning Institute, 1977).
2 In her appendix to the poem Markus quotes from Elizabeth's letter to her sister, Henrietta: 'Robert and I waved our handkerchiefs till my wrist ached'; 'The windows dropping down their glittering draperies seemed to grow larger with the multitude of pretty heads, & of hands which threw out flowers & waved white handkerchiefs – there was not an inch of wall, not alive, if the eye might judge' (Markus (ed.), *Casa Guidi Windows*, p. 66).

A small sketch crowded with windows occupied a corner of the letter. The mediating frame of the window was self-consciously recognised by Elizabeth Barrett Browning in her 'Advertisement' to the poem. Claiming that she was a 'witness' to the events in Tuscany, she immediately provides a counter-statement that questions the authority of her legal (and religious) noun: 'From a window, the critic may demur. She bows to the objection in the very title of her work' (p. xli). Yet the concession actually discloses the opportunity provided by her liminal site and the impassioned onlooker's response. This never claims objective status but is important for that very reason. The frame of a window, as Ruskin recognised, organises and limits the perspective of the observer. It is both partial and unique, with a uniqueness always renewed by the changing events outside. Thus the two-part poem is split into a double perspective, like the two parts of a stereoscopic image that will not fuse into a unified field, as bitter betrayal superseded Risorgimento optimism. In 1849 armed Austrian troops marched through Florence in dead silence. Leopold, who had now adopted Austrian uniform, and Pio Nono, a seemingly liberal Pope, proved untrustworthy. The poem's uneven paragraphs, revising one another, provide the formal equivalent of revisionary visual perspectives.

These new perspectives go with aural effects not evident before. A new voice and tone emerges, strong rhetorical, decibel-intensive, often hectoring, aggressively authoritarian and independent even when it is arguing for democracy. As if spoken in the open air, it is an attempt to develop a public female rhetorical voice, idiosyncratic but assertive. This raised voice repudiates private lyrical tonality culturally associated with femininity.

Casa Guidi Windows is a genealogical poem in the Nietzschean sense that it accounts for English misrecognitions of Italian history. Reciprocally, English misrecognitions of British history, as well as the possibility of the poem's own blind spots, become possible. Leigh Coral Harris has written an important account of Elizabeth Barrett Browning's attempt to demystify unscrupulously romantic, colonial appropriations of Italian history and politics by the British. She claims that the poem 'presents an aesthetics of liminality that avoids reducing Italy to either cultural or political cliché'.[3] Her discussion forms an indispensable context for my

3 Leigh Coral Harris, 'From Mythos to Logos: Political Aesthetics and Liminal Poetics in Elizabeth Barrett Browning's *Casa Guidi Windows*', *Victorian Literature and Culture*, 28 (2000) 109–31. See in particular 'The Window-Framed Space of the "Advertisement" ' (pp. 116–18). The window enables the link between

rather different theme. The poem also explores the deeply mediated con-
dition of Italy's present. The inescapably modern condition of media-
tion through all forms of representation – art, history, the photographic
image, revolutionary politics, commerce, popular songs, and things, from
guns to telescopes – the many-times-mediated present, dominates both
sections. Despite her critique of Leopold's ultimate betrayal, Elizabeth
Barrett Browning attempts to evolve an account of sociality from this
modern condition, an account that turns on the mediations of the
window. In doing so she radically shifted a poetics of the window from
privatised experience to intersubjective relations where it is the condi-
tion of modern polity. Indeed, the window is a political space, albeit an
uneasy and contradictory one: the narrator describes Leopold and his
children, putting the family on show as both democratic bourgeois icon
and symbol of power, appearing at their palace window to celebrate the
procession celebrating him. His appearance also doubles that of the
crowd he acknowledges as legitimating polity, for they, too are at their
windows. As Elizabeth Barrett Browning recognises, the 'democratic'
moment is a media creation, because it does not have substance in law
but only in gesture. The text is thoroughly aware that nation-building
depends on the insecurity of mediated images. I will turn to Barrett
Browning's window poetics before approaching the poem.

Poetics of the window

A sound outside a window. A child sings, '*O bella libertà, O bella!*' (1: 3).
Another sound: a knock, and a longed-for letter arriving at the house.[4]
In her correspondence with Robert Browning, Elizabeth Barrett Brown-
ing shows herself hypersensitive to the sounds of the world outside the
window with an almost psychic alertness. Her life was organised round
that outside life's absence or denial, but perhaps for that very reason she
was acutely responsive to the insideness of her room, and to the
outsideness of what was beyond it. The window, that frail film between
herself and the world, letting in sound and bitter wind, seems to have

spectacle and spectator, rewrites 'the category of objectivity', and ensures that the
poem can move from 'metaphorical to modern ways of writing Italy' (p. 117).
For another recent reading of the poem in Carlylean terms see Steve Dillon
and Katherine Frank, 'Defenestrations of the Eye: Flow, Fire and Sacrifice in
Casa Guidi Windows', *Victorian Poetry*, 35 (1997) 171–92.

4 Elvan Kintner (ed.), *The Letters of Robert Browning and Elizabeth Barrett Brown-
ing, 1845–1846*, 2 vols (Cambridge, Mass., The Belknap Press of Harvard Uni-
versity Press, 1969). All references to this edition.

been felt on her nerves as a marker of that insurmountable antithesis between her own enclosure and what was beyond it. In her 'close room', where flowers 'die of despair', 'clocks all round strike out of hearing, or at best, when the wind brings the sound, one upon another in confusion'. 'I had been shut up here too long face to face with my own spirit', she writes.[5] The window, as Daniel Karlin notes, early becomes a trope between the lovers, its ambiguity suggesting both enclosure, risk and *libertà*, to use the later poem's phrase.[6] She chooses the window as threatening image – being 'thrown out of the window' – to figure her father's rejection of her were he to know of her marriage. To signify hope and openness she writes that 'the brightest place in the house is the leaning out of the window!' Do not 'lean out of the window', Browning quickly replies, 'when my own foot is only on the stair'.[7]

'"As the doves fly to the windows", so I think of you!', she wrote.[8] But to fly to the window was often the last thing she wanted. Browning's constant attempts to persuade her to go downstairs, to go out, are extraordinary testimony to his persistence in forcing independence upon her. 'Now, walk, move'.[9] Did she go out? Was the wind too strong? One time she does not go out, but opens the window instead. When she gets as far as finding a piece of laburnum for him in Regent's Park, people moved about 'like phantoms of life', unearthly amid 'that green light through the trees', carrying 'the very essence of the leaves, to the ground'.[10] The outside world is spectral. Windows shut one in protectively. In 1843 she wrote, surely mythologising herself through the sleeping beauty motif:

> In the window is fixed a deep box full of soil, where are springing up my scarlet runners, nasturtiums, and convolvuleses . . . among them . . . a great ivy root with trailing branches so long and wide that the top tendrils are fastened to Henrietta's window in the higher storey, while the lower ones cover all my panes.[11]

Her letters about the window epitomise the way that the window figured the lyrical privacy of the subject in the nineteenth century, its withdrawn

5 Kintner (ed.), *Letters*, 1: 348, 1: 299, 1: 33.
6 Daniel Karlin, *The Courtship of Robert Browning and Elizabeth Barrett* (Oxford, Clarendon Press, 1985), pp. 6–7, 65.
7 Kintner (ed.), *Letters*, 1: 394, 1: 31, 1: 33.
8 *Ibid.*, 1: 362.
9 *Ibid.*, 1: 357.
10 *Ibid.*, 1: 695–6.
11 Frederic G. Kenyon (ed.), *The Letters of Elizabeth Barrett Browning*, 2 vols (London, Smith, Elder and Co., 1897), 1: 144.

interiority. The lens or retina of the bourgeois room, the window is the scopic space that turns both outward and inward, creating an enclosure for the self and providing a scene of reverie. Barrett Browning recognised this in her earlier sonnet about a misted up window. 'Methinks we do as fretful children do / Leaning their faces on the window pane / To sigh the glass dim with their own breath's stain'.[12] Whether the outlet of the camera obscura or the shutter of the camera, both metaphorical possibilities for the window here, the aperture can be blocked by the self's own distortions. Scarcely more than a hundred and fifty years old, the vertical window was the predominant type across Europe. Its height was necessitated by load-bearing problems: building technology had not developed ways of producing light without high ceilings to accommodate high windows. The lengthened window, sometimes reaching to the floor, sometimes projected outwards onto a balcony, was an architectural solution to the supply of light. It was not until the twentieth century that Corbusier engineered the horizontal window that could bring an eleven foot landscape into the house like a mural.[13] There is a remarkable generic similarity between the vertical windows of the Barrett house in Wimpole Street and the long shuttered windows of Casa Guidi. So was enabled the dialogue between self and world, as the visual law of the window allowed the lyric subject to look down upon the street and up to the sky. The self's autonomy could, it seemed, be preserved and contained by the physical structure and containment of the frame. A protected, one-way movement between the enclosed self and the outside was instigated. The window mediated the subject-object divide. But this was also the space of consuming desire, often desire without a content, for the viewing subject is cut off and alienated by the very poetics of solitude that creates its being. Those people, phantoms of life, that unearthly green light, belonged to an estranged, unreal world.

The oblong window, taking stress at its centre and crossed with horizontal supports, Ruskin said, can only evolve as a peace-time structure. The requirements of war for range of shot and vision, attack and defence, determine other forms of inlet. Peace-time windows require 'the annihilation of the thickness of the wall' and maximise the act of seeing, commanding as much of the view as is compatible with slenderness: their prime need is of 'approachability', a function Ruskin reiterates, for

12 'The Prospect', Ruth M. Adams (ed.), *The Poetical Works of Elizabeth Barrett Browning* (Boston, Houghton and Mifflin, 1974), p. 199.

13 Bruno Reichlin, 'The Pros and Cons of the Horizontal Window: The Perret-Le Corbusier Controversy', *Daidalos, Berlin Architectural Journal*, 13 (1984) 65–78.

the nearer the viewer approaches the aperture the greater the visual possibility is added to the eye through the window's prosthesis.[14] Matched to visual potential but also extending it, the vertical window silently confirmed the privileged human gaze. The window at which one can stand or lean organises the field of vision towards 'the earth and the doings upon it'. The peace-time window ministers not only to those who transcendentalise the experience of seeing, 'at rest' in light, but those 'idle and curious' about 'what is going on upon the earth'. It is the prerogative of the peace-time subject to have 'it in their power to look out of a window'.[15]

To have 'it in their power to look': enabling, yes, but this could also be a question of power. If Benjamin is right that the bourgeois room cherishes the interiority of the subject, then the window as ideological form both endorses and questions it.[16] At the intersection of private citizen and public spectacle, the window's boundary creates a spatial ambiguity that hovers between privately owned property and public territory – the space that is not yours. Ruskin found himself unable to look at the street and its different inhabitants – 'carriages, dust-carts, drays, muffinmen, postmen, footmen, little boys, nursery maids and milkmaids, noisy living things of a city rumbling, rattling, roaring and crying'.[17] Compulsively attempting to control the street's chaotic taxonomies through alliteration and internal rhyme, he subsumes transport, services, sellers, employees, men and women under the rubric of noise. But none of the inhabitants own the street either. A technological control that produces and often owns, through capital investment, what Henri Lefebvre terms 'dominated space', the space of the street, marks off individual and corporate possession.[18]

But the window is not quite an innocent space, contrasting with the public scene and technologically dominated space below. Lefebvre would think of the window less as a private than an 'appropriated' space, that which is owned by the private citizen rather than the huge machinery of capital, and whose commercial identity is often mitigated by the aesthetic as the private owner has the prerogative of decoration and ornament,

14 E. T. Cook and Alexander Wedderburn (eds), *The Library Edition of the Works of John Ruskin*, 39 vols (London, Allen, 1903–12), 9: 217.

15 *Ibid.*, 9: 232. Ruskin refers here specifically to London houses.

16 Walter Benjamin, *Charles Baudelaire: A Lyrical Poet in an Era of High Capitalism*, transl. Harry Zohn (London, Verso, 1985), p. 46.

17 Cook and Wedderburn (eds), *Works of John Ruskin*, 1: 264.

18 Henri Lefebvre, *The Production of Space*, transl. Donald Nicholson-Smith (Oxford, Blackwell, 1991), pp. 164–8.

stamping aesthetic being – and his or her own being – on the object. Hence those complex drapes and frills, great ruches, swags and cordage seen at the nineteenth-century window and celebrated by John Claudius Loudon. The aesthetic window genuinely liberates from commerce, enabling a moment of expressive and creative life, but reintroduces through its liminality all the anxieties of ownership that the window conjures up. Its indeterminate generic status as peepshow, theatre, diorama, lens, picture, frame, ensures that the window never belongs to a stable category for long.

Hence the window not only questions the commanding gaze it enables to come into being but produces anxieties of relationship and possession. Barrett Browning was well aware of the nervous condition of power and privilege associated with the gaze from the window. To be deprived of that gaze, and with it, light and air, as the oppressive machine of capital deprived her factory children in 'The Cry of the Children' (1844), is to sicken and die. Perpetually turning machinery 'Turns the sky in the high window blank and reeling'.[19] Sight deprivation leads to the dizzying, dysfunctional optical experience confirmed by the twisting 'turns', or lines, of the verse. She herself had added to the nineteenth-century genre of figure-at-the-window poems that trope the isolated gaze. Her 'The Poet's Vow' (1838) followed Tennyson in exploring a solitary figure who sets art against communality. The poet is immured behind his lattice – the semantics of this archaic word emphasise the imprisoning bars rather than the spaces of the window. He is unresponsive to voices outside, even to those passing people who represent religion, marriage, and family and children, those three psychologically powerful institutional pulls of the nineteenth century. Casa Guidi, however, knowingly changes the terms of the window relationship.

I turn to the politics and poetics of the window as Barrett Browning saw them in Florence, a window environment that still allowed interaction with the street. Florentine streets were unlike the newly Haussmannised and impersonal boulevards of Paris. These were deliberately developed to prevent political action. Manet was to paint their balconies a decade or so after *Casa Guidi Windows*, with their groups of gazing figures standing in curiously estranged isolation from one another and their oddly dissociated gaze.[20] The windowscape of Casa Guidi, however, makes for collective relationships of another order.

19 'The Cry of the Children', Adams (ed.), *Poetical Works*, pp. 156–8, 157.
20 See Jonathan Crary, *Suspensions of Perception: Attention, Spectacle, and Modern Culture* (Cambridge, Mass., The M.I.T. Press, 1999), pp. 82–8.

Light waves and the communal field of vision

Moving from the popular song of the poem's first lines, the crucial form in which ideas of liberty circulate, the narrator quickly turns to other forms of cultural mediation through aesthetic images. Though these belong to the traditions of high art, they constitute an abuse of it, and by it, to repress political understanding. Shakespeare's Juliet has become a 'personating image' of Italy for the English, an erotic corpse that is a representation of weakness and feminine debility acting as a screen against understanding power relationships in modern Italy. 'Masks' and 'effigies' 'Men set between themselves and actual wrong' (1: 47, 44) refuse the dynamic of weak and strong at work in contemporary politics. How far history can be invoked in the cause of modern Italy is a constant concern throughout the poem. The 'dry bones' of the past, and 'sketchers lauding ruined towers' (1: 149–50), the mystified, obsolete representations of Italy, are obstructive. On the other hand, a civic and religious procession bearing a Cimabue madonna to the church, is a genuine manifestation of popular feeling – 'the shout / Wherewith along the streets the people bore' the celebrated painting (1: 358–9) – a meaningful symbol of organic belief that requires a memorial. Living tradition, for Cimabue discovered Giotto, is an ideal but now an impossibility. Implicitly the popular procession is to be compared with the manipulated publicity of the contemporary ceremonial. Congealed, dead tradition is to be deprecated. On the other hand, the poem asserts, in one of the passages that cuts suddenly to a new perspective, to be disinherited from the past is to be orphaned (1: 441). The technique of cutting adopted by the narrative, one view often ruthlessly displacing another, is a way of refusing easy continuity. At the same time a provisional position can be adopted with vehemence and inwardness, until it is pushed aside by another. It is a sophisticated form of alienation, one ideological position exposed by another but without abandoning the commitment and complexity that makes each position worth arguing with. It is a peculiarly modern form, a consciousness split and distributed across multiple and sometimes contradictory positions. National identity, correspondingly, has no organic principle of cohesion.

Throughout the poem Barrett Browning recurs to Renaissance art to figure the aesthetic that does not betray. Michelangelo's republican contempt for his patrons, the Medici dynasty, is inscribed on the supreme Medici tomb sculpture. The tombs are successful because they are about the horrors and glories of transformation. The gazing eye, here generating

its own light rather than reflecting it through the mediating 'marble film' of artwork, epitomises the rage and power that overcomes tyranny: 'Day's eyes are breaking bold and passionate / Over his shoulder, and will flash abhorrence / On darkness' (1: 82–4). Day breaks, hearts break, marble breaks. Michelangelo is his own mighty iconoclast, prefiguring a light that must break out of the matter in which it has been embodied by his labour, even breaking the mould of his art to do it. This both is and is not a triumphalist idealist reading: breaks with history and the destruction of material culture and art itself occur in the transformation of a society. If transforming ideas do not destroy for the good, unchecked power will certainly destroy for the bad. We are reminded of the transient ice sculptures the sculptor was humiliatingly forced to create under the gaze of Pietro, Lorenzo de Medici's successor: 'Laughed at the palace-window the new prince' (1: 106). Tyranny can literally dissolve aesthetic work.

Light everywhere, as in the eyes' daybreak over the landscape of Day's body, signifies transformation. But does this mean that Elizabeth Barrett Browning is returning to an idealist celebration of pure, unmediated light as model of transforming experience, such as she had played with in earlier poetry?[21] No, the laughter from the window can be collective because she has derived another account of light from contemporary physics to support a brief, very brief, emancipatory moment. The indicators of this account occur early in the poem. The two discussions of art, as dead effigy and as light released from matter, flank an audacious intervening passage charting the flow of the river Arno and its reflections through the city:

21 In her extraordinarily precocious poem, *An Essay on Mind* (1826), Elizabeth Barrett Browning sustains a curiously platonised account of Locke, accepting the associative capacity of mind to generate thought through the relation of thought and thought, which always begins with existing perception. However, she also subscribes to a romantic account of mind or genius as torch, lamp, or source of light. At the end of the poem, in a curious reversal of Locke, it is mind's 'dear impress' that throws 'a magic o'er the wilderness' (Adams (ed.), *Poetical Works*, 2: 510), just as a reflection enhances what it pictures, whereas at the start of the argument, thought catches light reflected from the object of contemplation. The poem accepts a compromise between idealist and dualistic readings of mind: 'Mind is imprisoned in a lonesome tower: / Sensation is its window' (2: 507). Compare the unlonesome windows of Casa Guidi. Nevertheless, perhaps because of her understanding of the very power of mind, this early poem presages the scepticism about history and ideology that appears in *Casa Guidi Windows*, and the metaphor of light is turned against itself. See below, note 24.

Through Florence' heart beneath her bridges four!
 Bent bridges, seeming to strain off like bows,
And tremble while the arrowy undertide
 Shoots on and cleaves the marble as it goes,
And srikes up palace-walls on either side,
 And froths the cornice out in glittering rows,
With doors and windows quaintly multiplied,
 And terrace-sweeps, and gazers upon all,
By whom if flower or kerchief were thrown out
 From any lattice there, the same would fall
Into the river underneath no doubt,
 It runs so close and fast 'twixt wall and wall,
How beautiful! (1: 54–66)

Helen Groth has seen the reflections of the river as an image of modern technology, the photograph, and points astutely to many places in the poem where the photograph is figured as the new medium for representing experience.[22] Light painting, as photography was termed, is a convincing analogy here. As Robert Browning was to write a year or so later in 'Mesmerism', the 'imprint' can be made 'fast / On the void

22 Helen Groth, 'A different look – visual technologies and the making of history in Elizabeth Barrett Browning's *Casa Guidi Windows*', *Textual Practice*, 14 (2000) 31–52. Groth beautifully describes the first Arno passage in terms of the 'fracturing of visual planes and loosening [of] the eye's hold' and 'multiple distortions of a momentary glance into a unified legible image' (p. 40). She reads the poem's changing positions in terms of the superimposition of daguerreotype impressions that also call into question the trustworthiness of the eye among multiple and distorted images. Thus she sees a conflicted response to modern technology and nation-building on the part of the poet: on the one hand republican ideals are valorised while on the other Barrett Browning uses the unique seizing of an image as yet another analogy for the unique idealist and elitist vision of the privileged liberal woman who lives 'vicariously through the lens of the windows that frame and delimit her perspective' (p. 49). Similarly she offers an idealist account of the poem as a photographic arrest of time in the face of the Crystal Palace's (and modernity's) homogenisation of it. I believe, however, that the relativism of the photographic image as she describes it works against some of her conclusions. She overlooks the central ideological critique of the Crystal Palace, which is that it is a form of what Deirdre David calls mercantile colonialism that is predicated on continuing violence and oppression in other parts of the world. (See Deirdre David, *Rule Britannia: Women, Empire, and Victorian Writing*, (Ithaca, Cornell University Press, 1995)). Similarly she fails to see that the references to Milton's republicanism must implicate England as well as standing in for Italian politics, that is, the poem is anti-monarchical in its stance to both countries, not a position associated with liberalism.

at last / As the sun does [imprint] whom he will / By the calotypist's skill'.[23] The image developing as if in fluid in the Arno passage is a fine analogy for a provisional, work of art of the future in process. The image takes fixed but ephemeral, at most provisional, form. At the end of the first part of the poem Barrett Browning writes of the impossibility of utilising the 'electric cells' of life 'in sunbeams' to 'Fix your shapes' of Italy, because the infinity of possibility in the past opened out in modern Italy defies representation. Indeed, she cannot 'dare' to do this (1: 1153). The photograph cannot deal with history. The photograph, indeed, recording the present, assists the narrator in committing historicide, eliminating the oppressive life of the past that can suck the life out of the present. From the *Essay on Mind*, her earliest work, the poet has been sceptical of the authority of history.[24] But here Galileo's telescope, another prosthetic device, might be, on the other hand, a preferable optical instrument to the photograph. Seeing as it does into earth and heaven: it is a conceptual tool, mediating the visible and penetrating the unseen by assisting 'dreams' (1: 1170).

The allusions to optical technology are frequent, but these come into being through the operation of light, and light is the prime mover in the text. The Arno passage plays with the move from a Newtonian conception of light as substance to the incorporation of light into wave theory. In one light is the most ethereal substance in existence. In the other it is a form of energy that belongs to, and indeed creates, a field.

To return to the Arno. The waves of the river that 'cleave' the marble and reflect the inverted arches of the bridges into bow-shapes that pair with the curved structures above, also double the outlets and apertures of the buildings above the water by reflecting them in multiple form, 'With doors and windows quaintly multiplied'. The audacity of the description lies in the fact that it is simultaneously of the buildings above and below, the upper and the inverted landscape reflected by the river, as water waves and light waves collaborate to produce a secondary image. The glittering cornices, the 'terrace-sweeps, and gazers upon all', are likewise doubled. 'By whom', the poet speculates, 'if flower or kerchief were thrown out, / From any lattice there, the same would fall / Into the river underneath no doubt, –'. In other words, an object

23 Robert Browning, *The Poems*, ed. J. Pettigrew and T. J. Collins, 2 vols (Harmondsworth, Penguin, 1981), 2: 574 (ll. 42–5).

24 In the *Essay on Mind* history cannot help but be the tomb of dead experience, and historians (Gibbon is her object here) make the dead serve living feuds: 'Moreover, in the historian's bosom look, / And weigh his feelings ere you trust his book' (Adams (ed.), *Poetical Works*, 1: 502–3).

thrown from a window would not only fall into the river underneath but meet its own reflection – the 'same', its replication in water. This is a brilliant account of mediating reflection, but it also incorporates within the structure of the visual imagery itself a question about the significance of an intervention into the physics of light and water. The effect of the act of throwing a flower or kerchief into a moving river, the act of disturbing a reflection, is to alter the visual field, to participate in it. As the flower falls a material object merges with its image, changing the environment and the unstable flow of images as virtuality is transformed by material intervention.

The Arno passage appears well before the narrator's account of the hectic animation of windows as handkerchiefs wave in acclamation of the procession, but it already prefigures the questions of the later account: what kind of intervention is it to wave from a window as the river-like procession flows through the streets? The flow of a river, a street, a diorama. Modern spectacle, with its many flags, signs and codes, dissociated from its onlookers, has replaced the simple hierarchies of the Cimabue procession: the magistrates, priests, artists, trades, populace, city states, foreign representatives, bear banners, insignia and symbols that represent representation – in default of the 'charta' (1: 543) that has not yet appeared to consolidate democracy. But given the poem's willingness to reject the past's dead cultural memories, we would not expect modernity to be deprecated: 'We do not serve the dead' (1: 217). Indeed, the text re-imagines communality through the wave from the window. With characteristic daring, the wave from the window becomes a metaphor derived from physics.

> And all the people shouted in the sun,
> And all the thousand windows which had cast
> A ripple of silks, in blue and scarlet, down,
> (As if the houses overflowed at last,) . . .
>
> . . . Whereat the popular exultation drunk
> With indrawn *vivas*, the whole sunny air,
> While, through the murmuring windows, rose and sunk
> A cloud of kerchiefed hands! (1: 477–80, 487–92)

Gillian Beer has shown us the importance of wave theory at this time.[25] Rather than a luminous ether composed of physical particles, light was coming to be seen as a wave vibration. James Clerk Maxwell's

25 Gillian Beer, 'Wave Theory and the Rise of Literary Modernism', in *Open Fields: Science in Cultural Encounter* (Oxford, Clarendon Press, 1996), pp. 295–318.

electromagnetic theory of light was a model developed in detail later in the century, though wave theory was gradually becoming generally known over the period of *Casa Guidi Windows*.[26] In the process of electromagnetic radiation electric and magnetic fields transfer energy, not matter. 'But already light too seems to be nothing other than one more kind of motion of these two agencies [magnetism and electricity], and the aether filling space is acquiring wholly new characteristic properties as a magnetisable and electrifiable medium', wrote Hermann Von Helmholtz, the major theorist of vision.[27] An account of light as motion had repercussions in accounts of vision. The new optics was empiricist and antiidealist. As Jonathan Crary, in an account of Helmholtz, describes it, 'a decisive shift occurs between 1810 and 1830 from the geometrical optics, based on the properties of light and its refraction and reflection, of the seventeen and eighteenth centuries to a physiological optics'.[28] The primacy of the eye's interpretative power gave over to a situational account of correspondence in which perception was organised externally through the signs of systematic interrelations among objects, rather than through the 'matching' of individual object and internal sight. The eye's inherent propensity for aberration, undermining accounts of visual objectivity and even suggesting that perception might be the inner phantoms of unreliable vision, was one aspect of the new thinking. 'Trust to the inadequate and act on it; then it will become a fact', Helmholtz wrote.[29]

But loss in one direction was gain in another. If sense impressions are simply signs that consciousness interprets as it can, such signs belong to objectified relational systems. As recent commentators on Helmholtz's epistemology observe, 'what is retained (in the sign) is not

26 James Clerk Maxwell's precursors are discussed in Daniel M. Siegel, *Innovation in Maxwell's Electro Magnetic Theory: Molecular Vortices, Displacement Current, and Light* (Cambridge, Cambridge University Press, 1991), pp. 5–28. Maxwell's Treatise on Electricity and Magnetism was not published until 1873. Hermann Ludwig Ferdinand Helmholtz's *Handbook of Physiological Optics* (1856) was not translated into English until 1867. See James P. C. Southall (ed.), *Treatise on Physiological Optics* (New York, Dover, 1962). But a shift in understanding was taking place. Recently Stephen Clucas has defended Michel Serres's belief that poetry anticipates scientific invention. Stephen Clucas, 'Poem Theorem', *Parallax*, 7 (2001) 48–65. Certainly a paradigm shift in light theory is to be found in *Casa Guidi Windows*.

27 Hermann Von Helmholtz, 'The Facts in Perception', in *Epistemological Writings*, ed. Robert S. Cohen, transl. Malcolm F. Lowe (Dordrecht, D. Reidal Publishing Company), p. 145.

28 Crary, *Suspensions of Perception*, p. 214.

29 Helmholtz, *Epistemological Writings*, p. xx.

the special character of the thing signified, but the objective relations, in which it stands to others like it'.[30] The dissolution of classical dualistic subject-object relations is a result. Now 'reality includes both the external object and the sense organs with their sense-impression states'.[31] That is to say, the relational system of external objects includes the perceiver's own visual experience, which is incorporated into the sign system. Consequently, the relational field can be altered by the observer's presence. She can accomplish 'change in the external world by bodily and instrumental movements'.[32]

To return to the virtuosity of Barrett Browning's modern procession seen from above, her wager is not only that individual vision must 'trust to the inadequate and act on it', but that the individual vision also belongs to a communality organised as an interactive field. The field of interacting relations created though light as wave vibration constitutes an intervention in the world because bodily movement and perception itself is included in that field. The very objective relation in which the waving figures stand to each other is the source of their sociality. In her risk-taking metaphor, bodies intervene in the body politic. She dares to assign iconography to abstract laws of physics in the face of a scientific culture that was already forcing them away from poetry. Wave theory, though, is itself a metaphor. Blue and red ribbons 'ripple'; houses 'overflowed'; 'hands broke from the windows' like water; the windows themselves become animate, 'murmuring' as the kerchiefed hands 'rose and sunk' like breakers. The energy of wave vibration is physically embodied in the waving materials. Moreover, the watchers watch each other – windows watching windows – provoking further waves of reactive feeling. The modern crowd can affirm, and in affirming, confirm themselves and their collective aims. Affirmation brings their aims nearer to becoming a 'fact'.

This optimistic reading remains as a moment of social passion even when betrayal has seemingly negated it. The dead silence that greets the invading troops who don olive leaves is itself a form of resistance, a refusal to intervene. The formal olive leaves recall the cascading bay leaves of the first procession, a reciprocal act denied here. We might think, perhaps, of the former crowd as merely a hystericised manifestation of the non-collective and dissociated bourgeois world that Crary elicits from Manet's balcony painting.[33] The surges of feeling might look

30 *Ibid.*, p. xx.
31 *Ibid.*, p. xx.
32 *Ibid.*, p. xxiv.
33 Crary, *Suspensions of Perception*, pp. 82–9.

forward to the power relations of fascist demonstrations where the crowd was bonded into an undifferentiated mass. But Barrett Browning makes it clear that crowds can make choices. Individual action may be impossible for a poet, an intellectual, an ex-patriot – 'What now remains for such as we, to do?' (2: 25) the narrator exclaims in the second part of the poem – but this despair does not eradicate the possibility of collective life that glimmered in the first part of the poem.

Resources of hope

Swords, bayonet, artillery and cannon: the Austrian presence is brutally cognisant of 'acts, not imageries' (2: 318). The narrator is painfully aware that the earlier rejoicing was built not upon legal democracy but on 'imageries' of national unity reinforced by spectacle and symbol. The start of the procession at the Loggia where Cellini's Perseus stands is a reminder that Perseus fought the Medusa by looking at reflections in his shield. There is self-castigation for wishful sentimentality and optimism, and bitter threnody. But, as Leigh Coral Harris has exhaustively demonstrated, the poem moves from a masculine republicanism personified by Brutus to a feminised political vision of liberation personified by Anita Garibaldi, whose death while pregnant becomes not only a symbol of 'the aggressive woman fighter' but also embodies 'the tragic realism ... we recognise [as] the maternal price of Italy's freedom'.[34] I will end by considering Barrett Browning's complex reading of the place of symbol in modernity.

A dialectic between symbol and action arises in Part 2. They become, finally, interdependent, even though this means, in keeping with the text's realism, accepting that the commercially mediated world of the nineteenth century also manipulates symbol. The dereliction of Florence after the betrayal boils over in the street in a mixture of symbolic action and material vandalism that elicits a serio-comic despair. The Duke's arms are pulled down, new café signs advertise patriot ices, boys 'broke windows in a civic glow' (2: 129), ignored by the civic guard that had once been invested with power by Leopold's gesture to democracy, rebel songs are sung to 'loyal tunes' (2: 130). This is a hybrid mixture of gestural and immediate rebellion, just as the adoption of sumptuary icons, the black velvet worn by democrats, the graffiti, the bearing of muskets as a sign of dissent among republicans and democrats (but only fired into the air), are a mixture of action and token. In

34 Harris, 'From Mythos to Logos', p. 122.

the same way the mounting of 'trilling' opera as a symbol of national culture is no substitute for a civil society whose roots are deep (2: 226). The Duke's betrayal politicises the people, who now cry 'Live the People' instead of 'Live the Duke' (2: 115–16). Yet such symbolic language of gesture does not prevent the steady movement of oppression, the restriction on the free press, taxes, unemployment and the worsening state of the poor, the reinstatement of reactionary clerics. Despair leads the narrator to abandon the aggressive pacifism of Part 1, where the peaceful emergence of a popular political leader had been envisaged (albeit on the model of a Carlylean hero), and assert that the only effective action is in war (2: 400–5). The interests of international capital in peace now ironically make peace suspect and create an exploitative imperialist project that masks oppression in countries all over the world – of prostituted women in England, the forced labour of Poles in Russia, of slaves in America. The line, 'Because men made the laws' (2: 639) covers all these abuses.

But it is, paradoxically, through the analysis of the voracious commodity culture of the Crystal Palace, that the place of symbol becomes clear. The imperialist economic project of the Crystal Palace in Part 2 is set against the ideal church of Part 1, symbolising the universal diffusion of light. It is an imagined church, in opposition to the moribund Catholic Church based on awe and power:[35]

> I believe
> In one Priest, and one temple, with its floors
> Of shining jasper, gloom'd at morn and eve
> By countless knees of earnest auditors,
> And crystal walls, too lucid to perceive,
> . . .
> While still the permeable crystals hint
> At some white starry distance, bathed in space. (1: 945–9, 953–4)

35 Though the narrator eschews 'the bigot's sense' (1: 942), anti-Catholic and anti-papal feeling continues through the different perspectives of Parts 1 and 2. The Church's resort to literal physical torture (Part 1), and its use of the cross as 'yoke' (Part 2), is attacked because of Catholicism's collusion in political oppression and violence. The Church is the prime enslaver of common people through the imagination and the body. The people are 'cheaply priced', buying 'death-fields with their sacrificed'. Perhaps it is here that the vexed question of the degree to which the poem genuinely respects rather than patronises the Italian populace is located.

This transcendental church is also in opposition to the commercial palace of glass, whose walls were literally 'permeable crystals', where a competition for the extravagant artifice of luxury goods is staged.

> 'I wove these stuffs so subtly, that the gold
> Swims to the surface of the silk like cream,
> And curdles to fair patterns. Ye behold!' –
> 'These delicatest muslins rather seem
> Than be, you think? Nay, touch them and be bold,
> Though such veiled Chakhi's face in Hafiz' dream.' –
> These carpets – you walk slow on them like kings,
> Inaudible like spirits, while your foot
> Dips deep in velvet roses and such things.' –
> 'Even Apollonius might commend this flute.
> The music, winding through the stops, upsprings
> To make the player very rich! Compute.' –
> Here's goblet-glass, to take in with your wine
> The very sun its grapes were ripened under!
> Drink light and juice together, and each fine.' –
> 'This model of a steamship moves your wonder?
> You should behold it crushing down the brine,
> Like a blind Jove who feels his way with thunder.' (2: 598–615)

And so the competition continues, through sculpture, porcelain and wood carving, 'where birds in bowers / With twisting snakes and climbing cupids play' (2: 626–7). There is a great deal to be said about the orgiastic consumerism of this passage, with its excess, glut and grotesquerie – and its ventriloquised celebration of brute power, as in the evocation of the 'real' steamship 'crushing down' the waves. But I want to remain with the fact that these are both mediated buildings, gaining their meaning through symbol. One, the church of light, has no material existence but wants to persuade the listener that it has a reality, the other has an existence in matter but wants to persuade the listener that it is not wholly so, indeed, that it 'produces' the transcendent. Jasper, icon of spiritual being, grounds crystal walls 'too lucid to perceive' that reanimate the idea of the crucifixion. In the other, highly worked artefacts labour to make their materiality disappear, so that the idea of luxury displaces the object – they could not claim their status as luxury goods without this oxymoronic process of transcendental 'sensuous' experience. Muslins dematerialise, appearance – seeming – displacing the real – being – and invoking the legendary image of the Arabian Nights, favourite image for the Crystal Palace. Carpets silence footsteps, as thick pile muffles and

impedes, converting them into those of inaudible 'spirits'. (Though they are 'spirits' whose feet violate the representation of natural life, the 'velvet roses and such things'.) Glass goblets are so transparent, 'too lucid to perceive', that the consumer drinks light as well as wine from them. Allusion – to the thousand and one nights, to Apollonius, to Jove – is rife, appropriating myth and legend in the service of commodity. What is occluded is the labour of production, the suffering on which luxury is founded. However, there is no structural difference between the myth of the transcendental church and the myths of commodity, although Christ's suffering is remembered in the first and the human suffering of labour is forgotten in the second. Both work towards the idea that will precipitate action and the action that precipitates ideas.

Yet this deconstructive understanding of the convergence of idealist and materialist strategies of symbol does not disarm the poem, but rather gives it strength. If the technological magi of modernity bring symbolic gifts of incense, gold and myrrh, then a renewed effort of understanding and analysis is required in order to distinguish false imaging from meaningful symbol. Prior to the Crystal Palace episode a renewed assault on the misuse of symbol by reactionary Catholicism occurs, the rock of Peter, the crucifix (2: 443–56, 485–525). After the Crystal Palace sections the poem recurs to the graves of the dead – 'Still, graves, when Italy is talked upon' (2: 724) – but with a renewed sense of their symbolic power. The terrible insight that the death of Charles Albert, who abdicated after the disastrous battle of Novara against the Austrians in 1849, offers a myth of renewal but that the myth of renewal is only earned by death, continues the dialectic of symbol and action, image and material reality. Though each depends on the other the dialectic is never resolved, but simply gives way to the living child, the poet's child, who is necessarily mythologised in his turn as the symbol of rebirth. Christ, Apollo, harbinger of sunlight, the child carries the burden of symbolic interpretation that is inseparable from human attempts to make meaning. The symbolic closing of the windows, a reversion to the camera obscura of the mind, is perhaps what makes the creation of myth possible.

Ending with light – 'The sun strikes, through the windows, up the floor' (2: 742) – *Casa Guidi Windows* reverts to an earlier text, 'The Seraphim' (1838), in which seeing is the initiating moment of fallen experience and where representation rather than unmediated experience is the necessary condition of the fallen world. Here Barrett Browning presents the Passion of Christ, with extraordinary boldness, through the spectacle of the crucifixion, vision in the literal sense, as the Passion

becomes an optical occurrence. Ador and Zerah, the two seraphs, speak a shadowless language of light in which pure seeing is the logos. Nonverbal and immaterial, the impossible language of light and silence guarantees the separation of Seraphs and the earth, who 'cannot see' and cannot speak this transcendental language.

> And the golden harps the angels bore
> To help the songs of their desire,
> Still burning from their hands of fire
> Lie without touch or tone
> Upon the glass-sea shore.[36]

The words here perform this immaterial language by enabling 'desire', a psychological condition, to combust and incandesce into fire as the rhyme words – 'desire', 'fire' – bring pure feeling and the purification of fire together. Negatives – 'without' – defy the sensory, and, as 'glass' modifies both 'sea' and 'shore', both take on transparency that is like the immaterial 'permeable crystals' of the later poem. Pure representationless language is in an ideal state of absolute identity with itself.

But language cannot deny its mediating function. While Ador tries to block the vision of Christ, the gaze upon suffering is the moment of the Fall for Zerah. He is haunted by the reciprocal look of Christ. To look is to suffer, and to suffer is to recognise lack, which displaces the language of pure seeing, for lack splits the sign from its object. Only with representation, then, is reciprocity possible. Zerah realises that the fusion of matter and spirit in human experience means that man is capable of loving more than the spirits because lack makes love and desire possible. 'Heaven is dull', he says, in a moment of blasphemy. Its light is 'self-bound', burning in interminable 'fluent, / Refluent motion', turning upon itself.' [37]

In *Casa Guidi Windows* Barrett Browning transposes the Seraphim's 'fallen' language, now shadowed by representation, into the optical culture of contemporary nineteenth-century modernity. Here a mediated world is inevitable. Though bewildering in its proliferation of optical signs and image-ridden technologies, the multiplicity of symbol forces choice upon the subject, who is obliged both to discard outworn symbol and commit to new images. Which is why modern Italy might be born from the gaze from a window.

36 Adams (ed.), *Poetical Works*, p. 1.
37 Adams (ed.), *Poetical Works*, p. 8.

4

Risorgimenti: spiritualism, politics and Elizabeth Barrett Browning

Alison Chapman

TWO SEEMINGLY unrelated enthusiasms gripped Elizabeth Barrett Browning from the early 1850s until her death in 1861: spiritualism and Italian politics. The importance of her investment in the Risorgimento was suggested by Sandra Gilbert's study of Barrett Browning's personal and professional revival after her flight to Italy with Robert Browning in 1846.[1] In this volume, Isobel Armstrong and Richard Cronin continue the critical conversation about her poetry and her politics, augmenting important earlier interventions by, for example, Alison Milbank and Esther Schor.[2] Aside from Kathleen Porter's study *Through a Glass Darkly*, and the interest of biographers, Barrett Browning's association with spiritualism continues to suffer from critical neglect.[3]

Material from the Berg Collection of English and American Literature is quoted with permission of The New York Public Library, Astor, Lennox and Tilden Foundations. Letters from the Frederic Kenyon typescript, held by the British Library, are with the permission of John Murray. The Syndics of the Fitzwilliam Museum have granted permission to quote from their material. Thanks are extended to all these archives for their generous assistance.

1 Sandra M. Gilbert, 'From *Patria* to *Matria*: Elizabeth Barrett Browning's Risorgimento', in Angela Leighton (ed.), *Victorian Women Poets: A Critical Reader* (Oxford, Blackwell, 1996), pp. 24–52.

2 See Alison Milbank, *Dante and the Victorians* (Manchester, Manchester University Press, 1998) and Esther Schor, 'The Poetics of Politics: Elizabeth Barrett Browning's *Casa Guidi Windows*', *Tulsa Studies in Women's Literature*, 17.2 (1998) 305–24.

3 Kathleen H. Porter, *Through a Glass Darkly: Spiritualism in the Browning Circle* (Lawrence, University of Kansas Press, 1958). Porter makes a useful distinction between Barrett Browning's early and late interest in spiritualism. In the early 1850s she had an intellectual curiosity about the spirits, partly inspired by her reading of Swedenborg. After her famous séance with Daniel Dunglas Hume in 1855, she became more personally involved. Always, however, she writes about spiritualism with a degree of scepticism and humour, often directed against the mediums. See chapter 3.

More importantly, the inter-relationship between spiritualism and the Risorgimento in Barrett Browning's letters and poetry has passed unnoticed. Frederic Kenyon's side sweep of these two subjects, however, inadvertently points to their connections in the letters that he edits for publication in 1897: 'what she believed, she believed strongly and with a perfect conviction that no other view could be right. Just as her faith in Louis Napoleon survived the *coup d'état*, and even Villafranca, so her belief in communications with the spirit world was proof against any exposure of fraud on the part of the mediums'.[4]

Kenyon's reference to Villafranca is significant. The unexpected peace of 11 July 1859 between France and Austria put a temporary halt to hopes for Italian reunification. As Barrett Browning's 'A Tale of Villafranca' puts it, the 'joy which flushed our Italy', the growing optimism about independence, 'Has faded since but yesternight' and left Florence in mourning.[5] 'First News from Villafranca' is more strident and bitter: 'There *is* no peace, and shall be none, / Our very Dead would cry "Absurd!" ' The news of the peace brought about a serious collapse in Barrett Browning's health and, after three weeks prostrate in bed, she was removed to Siena on doctor's orders to recuperate. Barrett Browning herself ruefully acknowledges the interconnections between her health and the political process. In a letter to Fanny Haworth she comments: 'My answer to politics and personal subjects may be one – I have been very ill.'[6]

The Peace of Villafranca coincided with the dramatic cessation of her spiritualist experiments with Sophia Eckley, renamed Sophie 'my "sister" of the spiritual world' by Barrett Browning, and 'speckly Eckley' 'that dunghill of a soul' by Robert Browning.[7] Since about September 1857, Barrett Browning had been conducting an intense friendship with Eckley, an American heiress. Eckley claimed to be a skilled medium who

4 Frederic G. Kenyon (ed.), *The Letters of Elizabeth Barrett Browning*, 2 vols (London, Smith, Elder and Co., 1897), 2: 92.

5 *The Poetical Works of Elizabeth Barrett Browning* (London, Oxford University Press, 1932), p. 547. All quotations from the poetry, except *Casa Guidi Windows*, are taken from this edition.

6 Letter from Elizabeth Barrett Browning to Fanny Haworth, July 1859, Kenyon typescript vol. 4.

7 Letter from Elizabeth Barrett Browning to Sophia Eckley, 30 June ?1858, Berg letter 11. Robert Browning's comments are found in Edward C. McAleer (ed.), *Dearest Isa: Robert Browning's Letters to Isabella Blagden* (Austin, University of Texas Press, 1951), p. 295, and Henry James, *William Wetmore Story and His Friends*, 2 vols (London, Thames and Hudson, n. d.), 2: 136.

could access the spirits, in particular the spirit of Barrett Browning's dead brother 'Bro'. In correspondence with Eckley before Villafranca, she repeatedly asserts that their relationship restores her and makes her whole. Eckley's love, her spiritual talents, and the warmth of her many letters and notes have a medicinal property, as evinced by the following letter sent from Le Havre:

> But the life somehow is different, and that sequestration in the south so long enjoyed by me, spoils me, I fear, for the common 'give and take' of English life. I feel like an earthen cup in the midst of the gold and silver and peradventure pewter cups – a touch cracks me and chips me, – sets me longing for the quiet corner of the shelf, out of sight and in the dust – that's the place for me – Then Sophie will take me down and blow softly the said dust aside, and will say (who knows?) that she'll drink her cold pure water out of me, till I shall be glad and proud.[8]

This letter is significant, for it suggests that Eckley not only has an erotic power to heal Barrett Browning, but, like the Italian climate, she restores her health. With her apparent purity, poetic nature and the power of reviving the dead, Sophia Eckley functions analogically for Italy and the aspiration for Risorgimento, connoting, in Italian, resurgence, renaissance and the resurrection of the body.

In the same summer months in which Italian unification seemed to have collapsed, so too does the experiment to unify body and spirit.[9] From Siena, as she recovers from the shock to her health caused by the peace of Villafranca, Barrett Browning writes to Eckley breaking off their automatic writing experiments because she believes no spirits belonging to her have been present. Furthermore, certain 'slight Americanisms' in the writing prove 'that my particular spirits were not present or speaking'. Although stating that 'there's not a shadow of a suspicion on the medium's "integrity" (need I say it?)', an accusation of fraud is implicit. Barrett Browning still insists, however, that '*I believe in the spirits* – nor do I mean to express a doubt that *spirits* have written

8 Elizabeth Barrett Browning to Sophia Eckley, 28 August ?1858, Berg letter 16.

9 For more on the Eckley controversy, see Alison Chapman, 'Spirit Sisters: Elizabeth Barrett Browning and Sophia Eckley', *Studies in Browning and His Circle*, forthcoming, and 'Elizabeth Barrett Browning and Sophia Eckley: A Note on the End of the Affair', *Notes & Queries* (June 2001) 144–5. It is impossible to date the exact break with Eckley, although it is certain that it occurred after Villafranca. Afterwards, the Brownings were careful to remain on polite if cool terms with the Eckleys, for fear of unpleasantness and exposure (Sophia had, of course, retained the intimate correspondence).

through you and me'.[10] Her earlier letters to Eckley about the political scene expressed a continued belief in the possibility of the Risorgimento despite the peace; similarly, her reaction to the unveiling of Eckley's fraud does not diminish the truth of spiritualism and the possibility of spirit communications. In both cases, it is the triumph of hope over experience. She comments to Eckley on the peace in terms that also might express her attitude to spiritualism: 'everything, in this state of the world, tends to making us earnest and sincere towards high aims. Grief and doubt shook and overwhelmed me, but the receding wave leaves stronger ground.'[11]

Indeed, in the letters to her close female friends that announce the break with Eckley, there are associations both implicit and explicit between the medium's betrayal and her intense disappointment in the political situation. To Isa Blagden, Barrett Browning laments her 'sweet sleep of credulity' which left her vulnerable to disappointment with Eckley.[12] In a letter to Fanny Haworth of 24 August 1859, Barrett Browning tells how 'painful experience has undone all my good conclusions concerning her', and that 'I have paid a heavy price (not for the first time) for my want of discernment'. Although not 'malignant', Eckley is nevertheless 'utterly false – her life is one "manière de poses" '. Barrett Browning stresses throughout the letter that the fault is mainly her own lack of judgement and, significantly, she makes an explicit reference to the Emperor as she attempts to distinguish between her lack of judgement in spiritualism and her political beliefs: 'Well – never mind – I suppose I deserve such things – I suppose, I am taken somehow by flattery (not Napoleon's though!).'[13] After Napoleon has signed away Italy's hopes for unification, Barrett Browning struggles to forgive his betrayal. She comments to Fanny Haworth, in another letter written on or around the same date:

> Observe – I believe entirely in the emperor. He did at Villafranca what he could not help but do. Since then, he has simply changed the area of struggle – He is walking under the earth instead of on the earth,

10 Letter from Elizabeth Barrett Browning to Sophia Eckley, Summer ?1859, Berg letter 52. The italics are Barrett Browning's own.
11 Letter from Elizabeth Barrett Browning to Sophia Eckley, 30 August 1859, Berg letter 51.
12 Letter from Elizabeth Barrett Browning to Isa Blagden, 1859, Fitzwilliam Museum letter 108.
13 Letter from Elizabeth Barrett Browning to Fanny Haworth, ?24 August 1859, Fitzwilliam Museum letter 74.

but *straight* and to unchanged ends. This country, meanwhile, is conducting itself nobly. It is worthy of becoming a great nation.[14]

Just as Barrett Browning attempts to rehabilitate mediumship despite the fraudulence of Eckley (who, in her poem on the affair, 'Where's Agnes?', is precisely *not* 'straight'), so she insists that the Emperor, although perhaps guilty of subterfuge (walking under the earth), nevertheless still has the Risorgimento as his end game.

Barrett Browning's letters from this period thus weave between the disappointments of spiritualism and Italian politics while they also attempt to explain how she left herself vulnerable to disappointment in both. While Barrett Browning tries to separate these betrayals from each other in her letters, in a rhetoric that nevertheless demonstrates their connections, other observers note in public the relationship between her lack of personal and political judgement. In the *Spiritualist Magazine* in 1860, she remarks to correspondent Mrs Martin, William Howitt 'suggests gravely in an article that I have lately been "biologised by infernal spirits," in order to the production of certain bad works in the service of "Moloch," meaning, of course, L.N. [Louis Napoleon]'.[15] In this same letter, and in more detail in an unpublished letter to her sister Arabel, Barrett Browning also comments with irritation on Harriet Martineau's letter to an American newspaper which juxtaposes the politics of the newly published *Poems Before Congress* with an allusion to her betrayal by a false medium. To Arabel, she angrily cites Martineau's reference to: ' "*prior evidence of such misconception of the character of persons whom she supposed she thoroughly knew as may enable us to understand how she may fancy even* [illeg.] *Napoleon a great man.*" ' Barrett Browning defends herself thus to Arabel:

> Certainly I have thought too well of certain persons in private life, who have been treacherous to me in the long run – but that Miss Martineau can surely have heard of these painful experiences [obliterated]. Nor do I consider that *a freedom from suspicion in personal associations* [obliterated] leaves one incompetent to judge of a course of political action of the character of men far removed from any personal sphere of the observer.[16]

14 Letter from Elizabeth Barrett Browning to Fanny Haworth, 24 August 1859, Fitzwilliam Museum letter 89.
15 Kenyon (ed.), *Letters*, 2: 403. See also William Howitt, 'The Earth-Plane and the Spirit-Plane of Literature', *The Spiritual Magazine*, 1: 7 (July 1860) 289–302.
16 Letter from Elizabeth Barrett Browning to Arabel Barrett, ?March ?1860, Berg letter 107. The italics are Barrett Browning's own.

Barrett Browning also comments, in an implicit contrast to the Eckley affair, that she suspected the Grand Duke of 'weakness and cowardice' before she knew for certain that he was a traitor. This letter, whose deletions are presumably Arabel's, suggests the painful personal associations within Martineau's publication, but also Barrett Browning's determination to separate the private disappointment with her medium from the disappointment with politicians.

Although her attempts at spirit manifestation cease, she nevertheless continues to invest her energy, in a more abstract fashion, on spiritualism. As she comments frequently to her correspondents, one can distrust the medium but still accept the fact of there being communications with the dead. Perhaps, then, it should not be surprising that the language and symbolic resonance of spiritualism continue to haunt Barrett Browning; what is significant about her continued adoption of spiritualist discourse, however, is the renewed vigour it gives to her political aspirations for resurrection of Italy as a nation.

After the peace of Villafranca, Barrett Browning writes to Eckley: 'Wouldn't it have been well to have died with my Italy? But I hold on to hope, to hope – and this is a growing feeling among the Florentines.'[17] She often admits her special capacity for resurrection.[18] In Siena, during her convalescence, Barrett Browning has a strange and disturbing series of dreams that represents her unconscious as it works through the political crisis. Italy is often figured by Anglo-American travellers and expatriates as a land of dreams and visions. In *Pictures from Italy* (1846), for example, Dickens explicitly signals that his account will be 'a series of faint reflections – mere shadows in the water' and will have no 'grave examination into the government or misgovernment of any portion of the country'.[19] Nathaniel Hawthorne's Italian notebooks similarly dwell on Italy as a vision; Florence, for example, is described as 'a city of dream and shadow so close to the actual one.'[20] Lilian Whiting, whose

17 Letter from Elizabeth Barrett Browning to Sophia Eckley, [Summer 1859], Berg letter 49.

18 See for example Kenyon (ed.), *Letters*, 2: 192, where she associates her swift recovery from an illness in 1855 with Florence: 'There's something vital about this Florentine air, for, though much given to resurrection, I never made such a leap in my life after an illness.' Compare also her comment to Mrs Kinney: 'You know I have a natural aptitude to resurrection.' Cited in Adrienne Munich, 'The Yale Browning Collection: The Beinecke Library', *The Browning Newsletter* (Spring 1972) 20–5 (p. 25).

19 Charles Dickens, *Pictures from Italy* (Harmondsworth, Penguin, 1998), p. 5.

20 Nathaniel Hawthorne, *Passages from the French and Italian Notebooks*, 2 vols (Boston, James R. Osgood & Co., 1872), 1: 303.

biography of Elizabeth Barrett Browning is entirely predicated on an assumed spiritualist kinship with her subject, writes extensively of the innate dreaminess of Italy, termed, in her words, 'the Magic Land' of 'romance and song'. The country is for her an atmosphere and her narrative 'fragmented impressions of various sojourns in Italy, refracted through the prism of memory'.[21] Italian supporters of the Risorgimento feared that such overly metaphorical associations distract attention from and indeed displace political realities.[22] Barrett Browning also frequently compares Italy, and especially Florence, to a dream; homesick for Italy in Le Havre, for example, she looks back on Italy as 'some strange sweet dream of a scarcely possible Heaven.'[23] In Barrett Browning's dream related to Isa Blagden, Italy is figured in a vision and as visionary *per se*, but it is a dream that allegorises the uneasy political situation following Villafranca:

> I dreamed lately that I followed a mystic woman down a long suite of palatial rooms. She was in white, with a white mask, on her head the likeness of a crown. I knew she was Italy, but I couldn't see through the mask. All through my illness political dreams have repeated themselves, in inscrutable articles of peace and eternal provisional governments. Walking on the mountains of the moon, hand in hand with a Dream more beautiful than them all, then falling suddenly on the hard earth-ground on one's head, no wonder that one should suffer. Oh Isa, the tears are even now in my eyes to think of it![24]

The identification of Italy with a mysterious and tragic woman was a rhetorical figure that had been condemned several years earlier at the start of *Casa Guidi Windows*, when she boldly castigates Filicaja and others as 'Bewailers for their Italy enchained' (1: 21) who overly feminise the country.[25] The result is an Italy figured like Juliet's tomb at Verona: 'void', as 'are all images / Men set between themselves and actual wrong'

21 Lilian Whiting, *Italy, The Magic Land* (London, Cassell and Co., 1911), pp. 6, vii. See also Lilian Whiting, *A Study of Elizabeth Barrett Browning* (Boston, Little, Brown and Company, 1899). Compare Samuel Rogers, *Italy* (London, n. p., 1822), which describes Florence as the quintessential place of magic and enchantment.

22 Gilbert, 'From *Patria* to *Matria*', p. 26.

23 Letter from Elizabeth Barrett Browning to Sophia Eckley, 28 August ?1858, Berg letter 16.

24 Letter from Elizabeth Barrett Browning to Isa Blagden [July–August 1859], Kenyon (ed.), *Letters*, 2: 321.

25 All references to *Casa Guidi Windows* are from Julia Markus's edition (New York, The Browning Institute, 1977).

(1: 43–4). In *Casa Guidi Windows*, the feminisation of Italy is condemned as a passive political move, 'since 'tis easier to gaze long / On mournful masks, and sad effigies, / Than on real, live, weak creatures crushed by strong' (1: 46–8). In her dream, however, Italy is figured as a dispossessed woman, wandering passively, doomed to inaction because of the peace. But the dream also tells us something else. Italy is figured not just as a woman, but as a spirit who proves elusive, a 'mystic woman' in white who masks her face in occult fashion.

The major political players in the struggle for the Risorgimento, as well as many other European statesmen, were reported to be actively interested in spiritualism. Barrett Browning's letters frequently contain gossipy and often uncomplimentary references to the consultations conducted by Louis Napoleon and others with the spirits, usually mediated through the notorious Daniel Dunglas Hume.[26] For example, she comments sharply on 24 August 1853 to Isa Blagden: 'Louis Napoleon gets oracles from the spirits – and so does the Czar (pity he is not better advised!).'[27] Spiritualism and its paraphernalia – table-rapping, automatic writing, crystal-ball gazing, clairvoyancy – was part of the social intercourse of the Anglo-American expatriate community throughout Europe. In 1853 she comments 'The *circoli* [circles] at Florence are as revolutionary as ever, only tilting over tables instead of States, alas!'[28] The spiritualist enthusiasm was particularly vibrant and controversial in Florence thanks to the enthusiasm of expatriates such as Seymour Kirkup, Frederick Tennyson and William Wetmore Story. Even a Florentine shop was not averse to advertising tables, in a display window and with a nod to Galileo, with the advertisement '*e pur si muove*' (and it also moves).[29] Interest was regularly heightened by American travellers who brought with them accounts of the latest séances and manifestations, together with recent books and journals on the subject. In addition, the especial symbolic associations of Italy as a 'magic land', in which the past lives in palimpsestic fashion with the present, makes the country a particularly fitting site for the spiritualist concern to reanimate the dead. The ideological work of spiritualism at this period in Barrett Browning's letters and poetry, as exemplified by her dream of the mystic white

26 The Brownings spelled the surname thus, and it was pronounced the same way, but the medium later changed it to Home as part of his continued process of self-fashioning.

27 Letter from Elizabeth Barrett Browning to Isa Blagden, 24 August 1853, Kenyon typescript vol. 3.

28 Kenyon (ed.), *Letters*, 2: 117.

29 *Ibid.*, 2: 120.

woman, is to return to the traditional image of Italy as a woman aban-
doned, raped, bereaved, and overly aestheticised, in order to resurrect
her as a living, breathing and active trope. In the Risorgimento of north
and south, in other words, there is shadowed another resurrection, the
rise of the dead body.

Barrett Browning's first documented encounter with the spirits asso-
ciates mediumship with Italy. At dusk, on 25 July 1855, the Brownings
seated themselves around a table at the Ealing home of the Rhymers
and participated in a séance with the celebrated medium Daniel Dunglas
Hume. At the start, Robert reported to fellow sceptic Elizabeth Kinney
on 25 July, they experienced 'some noises, a vibration of the table, then
an up-tilting of it in various ways'. More raps and noises then followed,
'which were distinguished as the utterance of the family's usual visitor,
the spirit of their child "Wat" who died three years ago, aged twelve'.[30]
The spirits ceased their raps, reported that the circle was too large, then
eliminated all but Hume, the Rhymers and their two living children,
two family friends and the Brownings. The spirit of Wat then grew in
confidence, tugging Elizabeth's skirt and manifesting a hand. Taking
charge of proceedings, Hume instructed Elizabeth to take the seat next
to him. A larger hand appeared and placed a wreath on her head. Julia
Markus comments: 'In the hushed circle of nine, in the dark room, the
spirits crowned Elizabeth Barrett Browning in laurels.'[31]

Hume, in his autobiography, *Incidents of My Life*, attributes the
hand to Dante and notes that the wreath was fashioned out of clematis
from the Rhymers' garden.[32] This identification was circulated in liter-
ary circles in London, but even Barrett Browning was hesitant to be-
lieve, commenting to Anna Jameson: 'It really is a pity to contradict the
story about Dante's hand. I should have been enchanted to have had
such a coronation.'[33] Responding to Robert Browning's outrage at what
he took to be the trickery of the séance, Hume suggests he was driven by

30 Ironically, Mrs Kinney was to convert to spiritualism after witnessing Hume's
 mediumship firsthand in Florence. See the letter from Elizabeth Barrett
 Browning to Henrietta, 6 December 1855, in Leonard Huxley, *Elizabeth
 Barrett Browning: Letters to Her Sisters* (London, John Murray, 1929), p. 237.

31 Julia Markus, *Dared and Done: The Marriage of Elizabeth Barrett and Robert
 Browning* (London, Bloomsbury, 1995), p. 231.

32 The first account by Hume of the séance appeared in the *Spiritualist Magazine*
 in 1864. For an account of the controversy, see Porter, *Through a Glass Darkly*,
 pp. 47–57; Markus, *Dared and Done*, pp. 229–40; and especially Daniel Karlin,
 Browning's Hatreds (Oxford, Clarendon, 1993), chapter 3.

33 Cited in Markus, *Dared and Done*, p. 235.

jealousy that his wife was crowned as poet by the spirits. Browning's indignant expulsion of Hume from his house a few days later, when he threatened to fling him down the stairs despite the protests of Elizabeth, confirms Hume's suspicions. Whether the garland was made of clematis flowers or not, its recipient treasured it in her bedroom in Casa Guidi until, two years later, Robert Browning threw it out of the window in a heated discussion, presumably about spiritualism.[34]

Hume's Ealing séance is perhaps the most famous encounter of the Brownings with spiritualism. Indeed, critics have frequently cited the Hume séance and its aftermath as paradigmatic of Robert Browning's hatred of spiritualism, famously evinced in 'Mr Sludge the Medium'. Karlin's insightful analysis of the Hume incident suggests that:

> [W]hat Browning witnessed in Home was the poet's degradation, a kind of alchemy in reverse: the magical transformation of gold to dust and ashes. Home's social and sexual ambivalence, his tone of emotional aggression and strident, self-proclaimed weakness, his aping of filial and erotic bonds, gave his performance its peculiar resonance for Browning. He was a nightmare of what a poet might become, imprisoned by his patrons and forced by his dependence into feeding them the lies they craved. (pp. 65–6)

In an earlier article, Karlin argues that Browning's antipathy towards the masterful male mesmerist in his dramatic monologue 'Mesmerism', and his willingness to have Barrett, in the courtship correspondence, portray him as her erotic magnetiser, derives from Browning's uncomfortable sense that the poet was also a mesmerist.[35]

In his account of the Ealing séance, Karlin notes that Browning displays, within the supposedly factual section of his letter, a particular revulsion in his description of the spirit-hand as '(a kind of soft & fleshy pat)' (p. 54). At the thought of the materiality of the spirit-hand, 'the rhetorical mask slips'. Sophia Hawthorne, in a letter to Elizabeth Peabody on 25 August 1858, reports Browning's conviction that 'the two hands were made by Mr Hume and fastened to Mr Hume's toes, and that he made them move by moving his feet'.[36] For Barrett Browning, in her account of the séance to Henrietta, however, the hands fascinate her, as Sophia Hawthorne comments: 'she *knew* they were spirit hands'. Indeed, her account reiterates mention of the 'hands'. In the half-light of

34 Markus, *Dared and Done*, p. 235.
35 See Daniel Karlin, 'Browning, Elizabeth Barrett, and "Mesmerism"', *Victorian Poetry*, 27. 3–4 (1989) 65–77.
36 Cited in Garrett, *Browning Chronology*, p. 92.

the séance, the hands are sighted as an authentic sign of mediumship. Unfortunately, they did not touch her, but their presence is nevertheless compelling:

> We did not see quite as much as Mr Lytton did – but we were touched by the invisible, heard the music and raps, saw the table moved, and had sight of the hands. Also, at the request of the medium, the spiritual hands took from the table a garland which lay there, and placed it on my head. The particular hand which did this was of the largest human size, as white as snow, and very beautiful. It was as near to me as this hand I write with, and I saw it as distinctly. I was perfectly calm! not troubled in any way, and felt convinced in my own mind that *no spirit belonging to me* was present on the occasion. The hands which appeared at a distance from me I put up my glass to look at – proving that it was not a mere mental impression, and that they were subject to the usual laws of vision. These hands seemed to Robert and me to come from under the table, but Mr Lytton saw them rise out of the *wood of the table* – also he tells me . . . that he saw a spiritual (so-called) arm, elongate itself as much as two arms across the table and float away to the windows, where it disappeared. Robert and I did not touch the hands. Mr Lytton and Sir Edward *both did*. The feel was warm and human – rather warmer in fact than is common with a man's hand.[37]

Lytton's extravagant claims aside, her sight of the spirit-hands vouches the truth of the séance and also associates, as Browning does, the séance with poetry. For Barrett Browning, however, the association is of writerly agency and not poetic weakness and dependence. The key moment in the letter asserts that the hands are as near and as visible 'as this hand I write with'. In Browning's letter to Mrs Kinney, he professed an inability to lay hold and 'catch' the spirit hands, in order to prove their human fleshliness, because of his concern for his hosts' feelings. Nevertheless, he imagines the feel of the hands as grossly material, soft and fleshy, disproving the spirits. For Barrett Browning, however, the fleshliness of the hands signifies their veracity: they look like her own writing hand and they are reported, she notes, to feel even warmer than a man's hand.

The retrospective identification of the fleshly materialised spirit hand with Dante is significant. As Alison Milbank argues, the figure of the medieval poet embodies loss and recuperation, dislocation and political centrality: 'Where they [the Victorians] experience geographical centrality yet metaphysical homelessness, Dante experienced actual exile yet a

37 Letter from Elizabeth Barrett Browning to Henrietta, 17 August 1855 (Huxley, *Elizabeth Barrett Browning*, p. 220). Italics in original.

unified metaphysical system.'[38] Furthermore, Dante offered to the Victorians an opportunity to forge an analogy between the physical and transcendent realms, so that the material is pregnant with eternal meaning (p. 26). Such a conflation of the earthly and the spiritual embodied in Dante's metaphorical presence constructs him, I argue, as the figure for spiritualism's attempt to unite flesh with spirit. Indeed, when Hume identifies the spirit hand that crowns Barrett Browning as that of Dante Alighieri, he also attempts to guarantee the authenticity of the proceedings.

As a poet of exile and banishment, however, Dante also represents to British poets the desire for Italian reunification and political liberation from foreign and papal tyranny. In *Casa Guidi Windows* (1851), Barrett Browning turns to Dante in order to inspire the Florentines to action, but it is a doubly removed and even ghostly spectre of Dante that is invoked. The speaker addresses Dante, 'a banished Florentine' (1: 608), through a meditation on the *sasso di Dante*, his stone opposite Brunelleschi's Duomo, which has become a 'tryst-place for thy Tuscans to foresee / Their earliest chartas from' (1: 618–19).[39] Even Dante's tomb in Santa Croce, we are reminded, is 'forlorn / Of any corpse' and filled with 'empty marbles' (1: 623–4, 625). The speaker, however, announces that the civic memory of Dante deems him 'no longer exiled, now / Best honoured!' (1: 626–7). Indeed, Dante has now returned, softer in the brow, less stern of demeanour, 'To meditate what greatness may be done' (1: 648). The greatness, however, needs action: while Florentines now bring Dante metaphorically out of exile, so his spirit returns to his stone and his empty tomb, 'While Florence, now, to love him is content'. To do Dante's returning spirit justice, in other words, the Florentines must do more than merely love. For Hume to invoke the spirit of Dante four years after the publication of *Casa Guidi Windows*, with its lament for a lost opportunity for political freedom in Part 2, is also to suggest that Elizabeth Barrett Browning is his natural poetic and political heir. The return of his fleshly hand, to crown her in laurels (or clematis), signals this legacy.

Dante often manifests himself in the séance. Barrett Browning relates to Mrs Martin in 1855 how 'Dante has pulled down his own picture

38 Milbank, *Dante and the Victorians*, p. 1.
39 Compare Margaret Oliphant's discussion on Dante's banishment from Florence, after which her chapter, without commentary, is illustrated with a line drawing of Dante's stone that is implicitly emblematic of his absence. See Mrs Oliphant, *The Makers of Florence: Dante Giotto Savonarola and their City* ([1876] London, Macmillan, 1892), p. 54.

from the wall of a friend of ours in Florence five times, signifying his pleasure that it should be destroyed at once as unauthentic'.[40] As in the Ealing séance, Dante appears to guarantee not only the authenticity of the experiment, but also to prove the inauthenticity of his portrait. In these later experiments with the spirits in Italy, Barrett Browning came to be sceptical of the appearances of historical figures. In a letter to Fanny Haworth of 2 November 1859, she declares of automatic writing produced by such spirits: 'I don't like those wonderful signatures of public persons: I doubt much the identity. . . . The spirit of somebody who died yesterday, would come more easily and probably.'[41] Nevertheless, she remained attracted to the possibility of communion with dead poets, as well as with spirits belonging to her.

In an unpublished manuscript poem in her early notebook from 1840–44, Italy is inherently an intense visionary experience. In the reverie of 'Italy! World's Italy! / Beautiful, though no more free', the speaker embarks on a pilgrimage 'not indeed with pilgrim shoes / Nor with staff to lean upon', 'But along earth's giddy verge / With my Soul's foot white and bare'. Once in this dream space of Italy, the speaker 'sing[s] aloud in English tongue / Of poets who true poems sung / In shadows which these branches flung!' This remarkably fluid poem turns into a homage addressed to Italy on behalf of the 'poets' tongues' 'Which ceased upon thy shore'. Furthermore, the speaker sings by their very graves of those exiled poets who 'died in youth': 'With a love beyond my fear / [I] kiss the slab of either tomb'.[42] The graves are presumably those of Keats and Shelley in the Cimitero Anticattolico in Rome. Barrett Browning's eulogy, self-consciously in English to exiled and idealised dead precursors, implicitly figures Keats and Shelley as representatives of England's cultural and political interest in Italy.

Barrett Browning returns to the association of Italy with the graves of young English poets in the late 1850s. As Alison Milbank notes, 'The presence of the remains of Shelley and Keats in Italian graves gave this symbolic alliance [between England and Italy] a certain sacrificial resonance' (p. 58). From the Regency period, Milbank argues, Britain was constructed as the guardian of Italian nationalism and, in turn, Italy guaranteed English poetic validity. Such a symbiosis, however, becomes more problematic when the British government sides implicitly and explicitly with Austria against France. Barrett Browning repeatedly

40 Kenyon (ed.), *Letters*, 2: 193.
41 Kenyon typescript vol. 4.
42 Berg manuscript notebook.

fulminates in her letters and political poetry against the British government's agenda. At this period of British betrayal of the Italian cause, Barrett Browning once more finds herself at the grave of Keats, figured for her now as an aesthetic screen against England's political machinations rather than an idealised Dantesque exile. Among the material originally pasted in Eckley's album of letters and memorabilia is a page pasted with a pressed leaf, inscribed at the top 'I feel the flowers growing over me' and, at the bottom below the leaf, 'Picked by Ba for Sophie, at the grave of Keats – Rome – April'.[43]

The year of the visit to the Cimitero Anticattolico in Rome would have been 1859, at the height of Barrett Browning's spirit experiments with Eckley. Whereas Barrett Browning fashions Florence into a space of rejuvenation and dream, as well as a civic place on the cusp of freedom, Rome is associated with death, disease and mourning. The day after the Brownings arrived in Rome on a previous visit, in 1853, their close friend William Wetmore Story lost his six-year-old son to gastric fever. Barrett Browning writes to Anna Jameson, 'you have heard how our first step into Rome was a fall, not into a catacomb but a fresh grave, and how everything here has been slurred and blurred to us, and distorted from the grand antique associations'.[44] To Mary Russell Mitford, she gives an account of the drive to the Cimitero Anticattolico to bury Joe Story 'close to Shelley's heart': 'I can't think about the Cæsars in the old strain of thought; the antique words get muddled and blurred with warm dashes of modern, every-day tears and fresh grave-clay.'[45] The traditional representation of Rome as a sarcophagus, as a place of ancient memories and graves, becomes more immediate for Barrett Browning. In addition, its reputation as a fashionable resort among the Anglo-American expatriates prompts her to comment: 'It's a palimpsest Rome – a watering-place written over the antique – and I haven't taken to it as a poet should, I suppose.'[46] In 1859, she writes to Isa Blagden from Rome in the same terms: the city is a place of 'reckless dissipation' and 'a great roaring watering place . . Cheltenham or Baden Baden . . . How the Caesars can sleep through it is hard to fancy – but I can't work through it.'[47]

On 23 April, Austria attacked Sardinia and Piedmont. France retaliated by declaring war on Austria on 3 May. The visit to Keats' grave

43 Berg 119397B.
44 Kenyon (ed.), *Letters*, 2: 147.
45 *Ibid.*, 2: 153.
46 *Ibid.*, 2: 165.
47 Letter from Elizabeth Barrett Browning to Isa Blagden, 15 February 1859, Berg letter 211175B.

1 Spirit drawing from the Eckley album, 1859

with Eckley is in this milieu of heightened political tension. Eckley wrote a sonnet on the visit to the Cemetery, 'Keat's [sic] Grave / Rome / "I feel the daisies growing over me" ', which tropes the grave and its famous wild flowers as a sanctified space which must be reverenced as pure absence and sacred memory, and yet also must be left undisturbed: 'Speak gently, Poet, o'er the hallowed dead.'[48] Nevertheless, it does seem that both Eckley and Barrett Browning attempted to disturb the grave. The album Eckley composed to commemorate their friendship includes tiny scraps of spirit drawings, presumably executed through mediumship of either Eckley or Barrett Browning or both [1], one of which is remarkably similar to Haydon's profile of Keats [2] which he sent to her in late December 1842, and which she copied in a subsequent letter [3]. The spirit drawing's long, sloping forehead, protruding top lip, eyebrow shape, and curl against the cheek,[49] all characteristics of the representations of Keats' profile, suggests that Eckley and Barrett Browning were attempting to have the spirit of Keats draw, and perhaps write, through them. Her spirit experiments resurrect the memory and the body of Keats as an aesthetic screen against her fears for the future of Italy's cause for, as a young sacrificial victim, as English blood transplanted into foreign soil, he represents England's interest in Italy. In the political poems that date from this period, collected in *Poems Before Congress* (1860) and *Last Poems* (1862), spiritualism is figured to call for the opening of the graves of patriots as Italy, the cause for which they fell, is resurrected.

48 Sophia May Eckley, *Poems* (London, Longman, Green, 1863), p. 165.
49 In *A Vision of Poets*, Keats is described with 'Fresh vernal buds half sunk between / His youthful curls'. See Barrett Browning, *Poetical Works*, p. 168.

2 B. R. Haydon, Profile of Keats, 1842

3 Elizabeth Barrett Barrett, Profile of Keats, 1842

The preface to *Poems Before Congress* pre-empts criticism in the British press by redefining patriotism in a brave condemnation of British foreign policy.[50] For her, patriotism does not mean 'exclusive devotion to one's country's interests'. She continues: 'I dream of the day when an English statesman shall arise with a heart too large for England'. The sense of resurrection in the use of the verb 'arise' is augmented by her

50 Barrett Browning's fears about her volume's reception were to prove well founded. *Blackwood's*, for example, dismissed her thus: 'women should not interfere with politics'. See the unsigned review, 'Poetic Aberrations', *Blackwood's Edinburgh Magazine*, April 1860, pp. 490–4.

definition of nationhood that implies, through analogy, the afterlife: 'If the man who does not look beyond this natural life is of a somewhat narrow order, what must be the man who does not look beyond his own frontier or his own sea?'[51]

One of the most strident poems in the collection, 'Napoleon III in Italy', was written, or in progress, by the Peace of Villafranca, and, unlike her husband's poem on the Italian question, she decided to publish it despite Napoleon's betrayal of the Risorgimento.[52] The poem repeatedly interrogates whether or not Italy is resurrected. The language is apocalyptic and revolutionary, offering the image of a risen Italy as disturbingly gothic and grotesque. Barrett Browning articulates her poetics with a sinewy political voice that has the power of enacting what it transcribes, recalling her conviction in the Ealing séance that the spirits are associated with writerly agency. The poem pays homage to the crowning of Napoleon as Emperor, which Barrett Browning believed would guarantee democracy in Europe and reunification in Italy. The poetic voice is a God-given power, the poem argues, to crown Napoleon in song: 'O voice and verse, / Which God set in me to acclaim and sing / Conviction, exaltation, aspiration' (stanza 4). Furthermore, she counts herself among the 'poets of the people, who take part / With elemental justice, natural right', and who anoints Napoleon with 'the poet's chrism' (stanza 5). After the initial five stanzas, in which homage and reverence is paid to the Emperor, the poem turns to wonder if Italy, figured as a woman, really has risen from her grave. Intriguingly, the diction and intensity of these stanzas recall the early Italy dream-poem in the notebook ('Italy, world's Italy'), but this time Barrett Browning trusts that Italy has truly arisen:

> But Italy, my Italy,
> Can it last, this gleam?
> Can she live and be strong,
> Or is it another dream
> Like the rest we have dreamed so long
> And shall it, must it be,

51 Barrett Browning, *Poetical Works*, p. 540.
52 See Martin Garrett, *A Browning Chronology: Elizabeth Barrett and Robert Browning* (Basingstoke, Macmillan, 2000), pp. 114–15. Charles Hobday comments that a reference to 'friend Home's stilts and tongs and medium-ware' in this particular poem by Robert Browning, 'Prince Hohenstiel-Schwangau', suggests his association of the charlatan spiritualist with Napoleon. See *A Golden Ring: English Poets in Florence from 1373 to the Present Day* (London, Peter Owen, 1997), p. 183.

That after the battle-cloud has broken
She will die off again
Like the rain,
Or like a poet's song
Sung of her, sad at the end
Because her name is Italy, –
Die and count no friend?
Is it true, – may it be spoken, –
That she who has lain so still,
With a wound in her breast,
And a flower in her hand,
And a gravestone under her head,
While every nation at will
Beside her has dared to stand
And flout her with pity and scorn,
Saying, 'She is at rest,
She is fair, she is dead,
And, leaving room in her stead
To Us who are later born,
This is certainly best!'
Saying, 'Alas, she is fair,
Very fair, but dead,
And so we have room for the race.'
– Can it be true, be true,
That she lives anew?

(stanza 6)

Barrett Browning recalls the disappointment after the celebrations of 1848, recounted in *Casa Guidi Windows*, in which hopes for Tuscan independence were dashed: 'is it true / That she has not moved in a trance, / As in Forty-eight?' (stanza 6). Also remembered here is the condemnation in *Casa Guidi* for the excessive feminisation of Italy that inspires passivity rather than action on the part of the Italians. Instead, 'Napoleon III in Italy' imagines a curious kind of action as a response to the revivified process of Risorgimento: the opening up of patriots' graves as Italy's political star rises. As the poem asks, 'Now, shall we say / Our Italy lives indeed?' (stanza 7), it wonders whether, but for the sound of the military beat, 'Should we feel the underground heave and strain, / Where heroes left their dust as a seed / Sure to emerge one day?' (stanza 7). This curious image of the earth giving birth to patriots is followed by the speaker pondering whether ghosts 'thrill' and 'throb' along 'ruined aisle and arch' and 'frescoed wall' (stanza 7). The poem suggests that expressing such a thought makes it happen: 'Aye, it is so, even so. / Aye,

and it shall be' (stanza 8). The text is both prophetic and performative, invoking the spirits out of the patriots' graves. From the memory of Italy's many disappointments, 'Through the cairns of Time', 'Up springs a living man' so that the soldiers will be augmented by the spirits of the dead 'To quicken a living hand / In case it should ever be slow' (stanza 8). Italy, through the newly crowned Emperor, is delivered from tyranny and 'heroically self-reconciled' (stanza 11).

The other poems in the volume similarly suggest that their language is performative. Like the expected congress of nations on the Italian question, due to meet in January 1860 but never held, the political poems bring together disparate parts and aim to legislate and enact Italy's new future as a united nation. 'The Dance' forges a political allegory and a prophecy out of an incident in the Cascine, in which French soldiers danced with Italian women. 'An August Voice' requests and invokes the recall of the Grand Duke Leopold from Florence. Alison Milbank criticises the volume for failing to inspire action, as in *Casa Guidi Windows*, and, instead, for stridently attempting to enact the political outcome it desires (p. 73). The distinction is not that fast and hard, however, and Milbank seems more anxious to account for the absence of reference to Dante than to map the changing symbolic geography of Italy in Barrett Browning's poetry. As the trope of Dante and his spirit hand suggests, the writing hand of the poet can forge risorgimenti of its own – revivals of nations and bodies.

Such associations are, if anything, clearer in 'Italy and the World', which describes the very process of enactment in the resurrection. The first four stanzas voice the passive politics of England that postpones Italy's destiny. In stanza 5, the tables are turned: 'Here you paused, and growing / Scornful, . . suddenly, let us add, / The trumpet sounded, the graves were open.' In a strange mixture of description and invocation, the poem relates Italy's resurrection: 'Rise heroic and renovated, / Rise to the final restitution':

> Life and life and life! agrope in
> The dusk of death, warm hands, stretched out
> For swords, proved more life still to hope in,
> Beyond and behind. Arise with a shout,
> Nation of Italy, slain and buried!
>
> (stanza 6)

The resurrection from the dead is a dissolution of differences of language, nationhood, self: 'Hush your separate voices before us / Sink your separate lives for the sake / Of one sole Italy's living forever!'

(stanza 14). This is a 'sublime indiscretion' (stanza 27): 'Each sublimely dispossessed, / That all may inherit what each surrenders!' (stanza 15). The poem desires and invokes a 'release . . . / Into the larger coming time' (stanza 9), which brings about not just an Italian Risorgimento, but the afterlife, Heaven on earth: 'For civilization perfected / Is fully developed Christianity' (stanza 11).

In a letter to her sister Arabel on 27 June 1859, Barrett Browning announces: 'Other wars have to do with commerce and political theories – this has to do with life, love, natural salvation.'[53] To Chorley, a couple of months later, she writes: 'I have been living and dying for Italy lately. You don't know how vivid these things are to us, which serve for conversation at London dinner parties.'[54] Her own sense of her health's contingency on Italian hopes was to prove prophetic. Cavour, the Italian diplomat in whom Barrett Browning invested her hope for a united Italy, died suddenly on 6 June 1861, the Brownings' first day back in Florence after wintering in Rome. The shock to Barrett Browning precipitated her collapse and, on 29 June, she died in her husband's arms. With terrible irony, she became in her death a sacrificial victim of the Risorgimento (not finally achieved until 1871) and her grave that of a patriot's. As with the patriots' graves in *Poems Before Congress*, however, the life and death of this nationalist has an agency of its own, recognised as poetry's power of prophecy and enactment by the municipality of Florence. The Italian inscription placed on the walls of Casa Guidi, composed by the poet Niccolò Tommaseo, inscribes her poetry and her very body as unifying not just Italy, but Italy and England and translates thus:

> Here wrote and died Elizabeth Barrett Browning, who in her woman's heart united the learning of a scholar with the spirit of a poet, and made of her verse a golden ring between England and Italy. Grateful Florence erected this memorial in 1861.

53 Letter from Elizabeth Barrett Browning to Arabel Barrett, 27 June 1859, Berg letter 104.
54 Kenyon (ed.), *Letters*, 2: 334.

5

Acts of union: Theodosia Garrow Trollope and Frances Power Cobbe on the Kingdom of Italy

Esther Schor

Italia! thou, by lavish Nature graced
With ill-starr'd beauty, which to thee hath been
A fatal dowry, whose effects are traced
In the deep sorrows graven on thy mien;

Oh! That more strength, or fewer charms were thine,
That those might fear thee more, or love thee less,
Who seem to worship at thy beauty's shrine,
Then leave thee to the death-pang's bitterness!

Not then the herds of Gaul would drain the tide
Of that Eridanus thy blood hath dyed:
Nor from the Alps would legions, still renowned,
Pour down; nor wouldst thou wield a foreign brand,
Nor fight thy battles with the stranger's hand,
Still doomed to serve, subduing or subdued!

– Filicaia, 'Italia, Italia,' transl. Felicia Hemans

WHEN FELICIA HEMANS supposed in 1821 that this sonnet must be 'familiar to every reader who has any acquaintance with Italian literature',[1] the figure of *la bella Italia*, doomed by her own attractions, was already a commonplace. Not only had Byron translated this sonnet in *Childe Harold's Pilgrimage*; Hemans had used the Italian original as the epigraph to her 1816 *Restoration of the Works of Art to Italy*, published her own translation in 1818, and reprinted it in 1821 in 'Patriotic Effusions of the Italian Poets'. Sandra M. Gilbert, in her classic essay,

1 Susan J. Wolfson (ed.), *Felicia Hemans: Selected Poems, Letters, Reception Materials* (Princeton, Princeton University Press, 2000), p. 31, n. 1. On her revisions of Byron's English rendering of the Filicaia sonnet, see Susan J. Wolfson, 'Hemans and the Romance of Byron', in Nanora Sweet and Julie Melnyk (eds), *Felicia Hemans: Reimagining Poetry in the Nineteenth Century* (New York, Palgrave, 2001), pp. 158–9.

'From *Patria* to *Matria*: Elizabeth Barrett Browning's Risorgimento' (1984), argues that nineteenth-century British women poets imagined a personal risorgimento of 'insurrection and . . . resurrection'.[2] Through the allegory of a gifted, suffering *Italia*, writers such as Barrett Browning and Christina Rossetti redeemed themselves as female artists. But even as these poets used *la bella Italia* to figure a personal redemption, British women journalists used it to figure the political transformations that resulted, in 1859–60, in an Italian state. This essay examines how Theodosia Garrow Trollope and Frances Power Cobbe each brought the image of *Italia* to bear on what was known in Britain as 'the Italian Question' – the question of whether, how, and by what means Italian nationalism should be realised in an Italian state.[3]

Born in 1822 and 1825 respectively, Cobbe and Trollope both wrote in keen sympathy with the Risorgimento for a middlebrow, middle-class British audience. That both writers lived in an oblique relation to 'Englishness' – Cobbe was Anglo-Irish; Trollope, of mixed Jewish, Indian and English heritage – gives their nuanced accounts of Italian national identity particular point. That both allegorise the new Kingdom of Italy as a marriage between *la bella Italia* and the King of Savoy, Vittorio Emanuel II, should not surprise us, for by the 1860s, decades of agitation by such early feminists as Caroline Norton and Barbara Leigh Smith to reform the laws governing marriage and divorce had begun to show results. Prior to 1857, marriages could only be dissolved by ecclesiastical annulment or by an Act of Parliament. The 1857 Matrimonial Causes Act was a watershed in allowing a writ of divorce to be obtained through the courts, though the bar was set far higher for women seeking divorce than for men seeking the same: whereas a woman had to prove not only her husband's adultery but also incest, bigamy, cruelty or desertion, a man needed only to prove his wife's adultery.[4] The ideal of 'companionate

2 Sandra M. Gilbert, 'From *Patria* to *Matria*: Elizabeth Barrett Browning's Risorgimento', in Angela Leighton (ed.), *Victorian Women Poets: A Critical Reader* (Oxford, Blackwell, 1996), p. 26.

3 For a discussion of Britain and the 'Italian Question', see Miriam B. Urban, *British Opinion and Policy on the Unification of Italy 1856–1861* (Scottdale, Pa., Mennonite Press, 1938); Denis Mack Smith, *Italy: A Modern History* (Ann Arbor, University of Michigan Press, 1969), pp. 117–24; Stuart Woolf, *A History of Italy 1700–1860* (London, Routledge, 1986), pp. 407–16; Noel Blakiston, *Inglesi e Italiani nel Risorgimento* (Catania, Bonanno, 1972); and Eric J. Evans, *The Forging of the Modern State: Early Industrial Britain 1783–1870* (London, Longman, 1996), pp. 351–4.

4 See Mary Lyndon Shanley, *Feminism, Marriage, and the Law in Victorian England, 1850–1895* (Princeton, Princeton University Press, 1989), p. 44.

marriage', a marriage entered into at the pleasure of the couple and not their parents, a marriage whose goal was lifelong companionship rather than the soldering of family fortunes, had been gaining momentum among the aristocracy and the upper middle classes since the mid-eighteenth century.[5] It was the work of Victorian feminists to steer a clear course between this egalitarian ideal and the sentimentalisation of the family which tended to obscure the protocols of patriarchal power.

Given this background, it is not surprising that both writers emphasise the agency of the bride *Italia* in entering into the unity of marriage. And yet, as we shall see, Trollope and Cobbe construe this marriage very differently. For Trollope, writing in the heat of the Florentine Revolution of 1859–60, the Italian Kingdom is a rapturous consummation of popular desire. For Cobbe, writing in 1864 during an arduous period of modernisation and political compromise, the marriage is an unromantic arrangement of convenience and prudence whose chief benefit is to allow Italy to mature into a nation of stable, enlightened institutions. Their different stances bespeak more than different moments of composition; where Trollope focuses on the working class as the 'heart' of Italy, Cobbe's interest in a strengthened, newly active Italy leads her to look carefully at the condition of Italian women – and their English counterparts. But if both writers offer optimistic, partisan surveys of the Italian scene, their nationalistic allegories have darker undertones, uncovering desires that would threaten the stability of Italy's royal marriage.

Theodosia Garrow Trollope: 'a rose-water revolution'

Eclipsed in her lifetime by her prolific husband, Thomas Adolphus Trollope (himself eclipsed by his more famous brother, Anthony), Theodosia Garrow Trollope is today all but unknown. Her Jewish mother, said to have been 'more than fifty'[6] when Theodosia was born, married a man twenty-three years younger than herself. Joseph Garrow was himself of mixed background, born to a British officer and an Indian woman.

5 For a discussion of variations among social classes in marriage patterns, see Lawrence Stone, *The Family, Sex, and Marriage in England 1500–1800* (New York, Harper and Row, 1977), pp. 392–4. For an account of companionate marriage in the English novel, see Katherine Sobba Green, *The Courtship Novel, 1740–1820: A Feminised Genre* (Lexington, Ky., University Press of Kentucky, 1991).

6 Thomas Adolphus Trollope, *What I Remember*, 2 vols (London, Bentley, 1887), 2: 358.

In Thomas Trollope's memoir, Theodosia is said to resemble neither parent so much as her 'Brahmin Sultana' grandmother; her delicate constitution and small hands and feet are traced to her Indian blood. Raised in Torquay, she wrote ambitious poems as a girl and was proclaimed a new Sappho by Landor, who predicted that her fame would someday exceed that of Barrett. 'The preposterousness of this', wrote Thomas, 'no human being would have felt more strongly than Theodosia Garrow';[7] no human being, perhaps, except Barrett Browning herself, who admired Theodosia's 'fluent graceful melodious verses'[8] but thought Landor's outsized appraisal ridiculous.

Theodosia Garrow arrived in Italy in the mid-1840s with her family, and soon undertook to translate Niccolini's play *Arnaldo da Brescia*, a Risorgimento *cause célèbre*; Niccolini returned the compliment by translating one of her poems into Italian. She met Thomas Trollope during the heady days of 1847, when liberal hopes in Florence were buoyed by a relaxation in censorship, the formation of a civil guard, and other ducal concessions. Both wrote for the short-lived *Tuscan Athenaeum* (30 Oct 1847–22 Jan 1848), a liberal, English-language journal that ran for thirteen issues, Thomas contributing essays proclaiming a new dawn in Florence, and Theodosia rhapsodising in verses signed, simply, 'θ.' Fifteen years his junior, she and Thomas were married in 1848.

With a small inheritance from her mother, Theodosia and Thomas (along with her father) settled in the house that would become known as 'Villino Trollope'; from its windows, they would witness the unfolding events of the 1859–60 revolution, when the nearby Piazza Maria Antonia was renamed 'Piazza dell'Indipendenzia'. To many, their dwelling was a counter-Casa Guidi: a spirited salon for writers and artists, a noisy mecca for foreign visitors, and the place where they raised their only daughter, Beatrice (Bice), who would sing for visitors at the drop of a hat. After Theodosia died of tuberculosis in 1865 in her fortieth year, Italian friends placed a plaque on Villino Trollope for a writer '*che scrisse in inglese con amo italiano delle lotte e del trionfo della Libertà*' (who wrote in English with an Italian soul of the struggles and triumph of Liberty). It remains there to this day.

While Thomas Trollope wrote a small book on the revolutions in Tuscany (*Tuscany in 1849 and 1859*), Theodosia was asked by the *British Athenaeum* to cover the tumultuous events of 1859–61. As a political

7 T. A. Trollope, *What I Remember*, 2: 362–3.
8 Guiliana Artom Treves, *The Golden Ring: The Anglo-Florentines 1847–1862*, transl. Sylvia Sprigge (London, Longman, 1956), p. 138, n. 1.

journalist, she made her liberalism plain; George Eliot, who along with George Henry Lewes became close friends of the Trollopes, had high praise for her stinging analysis of Cavour's diplomacy.[9] More typical was the response of *The Examiner*, which compared the collection of her *Athenaeum* pieces to 'the report of a very watching nurse, who, without the physician's scientific knowledge, uses her own womanly instinct in observing every change of countenance and every movement indicating the return of health and strength to the patient'.[10] The reviewer ascribes Trollope's 'nurse-like' observations to 'womanly instinct' rather than informed political judgement. By comparison to Cobbe, it is true, Trollope is relatively uninterested in Italy as a new organism; unlike Cobbe, she makes no systematic examination of the 'patient'. In Trollope's *Social Aspects of the Italian Revolution*, however, liberal politics and womanly sentiment converge in a political romance, a narrative of Italy's betrothal to the King of Savoy, followed exactly a year later by the celebration of nuptials. Beginning 'on this beautiful starlight night of the 27th of April [1859], when, for the first time, we shall lie down under the shadow of the Silver Cross of Savoy',[11] the letters cadence on Florence's 'wedding day' (p. 258), when 'her long-desired Soldier King' (p. 257), arrives in the city. A lengthy postscript dated November 1860, instead of inaugurating the workaday novel of wedded Italy, raises the possibility that the romance with King Vittorio Emmanuel may be superseded by another romance, more exciting and potentially much more dangerous.

Trollope opens her eyewitness account of the Tuscan revolution of 1859–60 by declaring, 'We have made at Florence a revolution with rose-water' (p. 1). The alternative to a rose-water revolution, of course, is a revolution in blood, and Trollope's abiding purpose in her first letter is to move a middle-class English audience beyond its innate horror of a violent *coup d'état*. Trollope inscribes her hypothetical English readers into her account, only to prod them gently toward a more authentic, informed view of things: 'We appear no doubt at this moment to English eyes to be boiling and bubbling, pour souls! In the fiery cauldron of revolution' (p. 1). At the same time, she wants her English audience not to trust to diplomats, who have earned her deep mistrust:

9 George Eliot to Mrs Thomas Adolphus [Theodosia Garrow] Trollope, 5 July 1861, in George Haight (ed.), *The George Eliot Letters*, 9 vols (New Haven, Yale University Press, 1954), 3: 436.

10 Quoted in T. A. Trollope, *What I Remember*, 2: 362.

11 Theodosia Garrow Trollope, *Social Aspects of the Italian Revolution, in a Series of Letters from Florence* ([1861] New York, AMS Press, 1975), p. 2.

'A slight stroke of the pen in a ministerial closet, how easily it can sign away a nation's birthright!' (p. 74). Announcing that 'a fifteen years' residence in Tuscany seems to invest one with a right to the possessive [first-person] pronoun' (p. 12), Trollope heralds 'our revolution', an 'immense revolution in the popular heart of Italy' (p. 60).

Forestalling her English reader's view of Italians as a 'totally worn-out, effete, degraded race' (p. 3), she argues that Italians are creatures of their perennially hard circumstances, which include foreign occupation, harsh misrule, a repressive church, and poverty. Hence, what appears to be racial character proves mutable; in fact, 'the last ten years of suffering and humiliation [since the failed 1848 Revolutions] have strangely matured and tempered the fitful impulses and aspirations of the then half-asleep, half-childish, wholly misruled population of Tuscany' (p. 2). Asserting that 'not a little of the old far-away civilisation yet remains at the people's heart' (pp. 4–5), she trains her journalist's eye on the heart of the people, the Tuscan working classes. From the start, she represents the Tuscans as peaceable, restrained and sober, for 'the madness of strong drink . . . is happily unknown to these excitable Southern brains' (pp. 3–4). Perhaps the strongest evidence of the 'popular moderation' (p. 6) lies in the crowd's silence as the carriage of the fleeing Duke and his family passes by. Meanwhile, she reports on sealed documents in which the Duke had ordered his guard, in case of a popular revolt, to fire directly into houses from the sidewalks. Bloodlust is laid squarely at the feet of the aristocracy, not the commoners.

Trollope also praises the working class for resisting the overtures of the papacy, even on pain of death and torture. Throughout, her animus against the Pope, 'the aged iniquity [propped] on St. Peter's Chair' (p. 48), is directed chiefly at his temporal power which she calls, quoting the Genovese *Corriere Mercantile*, ' "an impossibility, an absurdity, a permanent injustice" ' (p. 48). In late June, after the massacre of nationalists at Perugia, she calls the papal troops 'wild beasts . . . gorged with prey' (p. 45), detailing atrocities of biblical proportions: children murdered before their parents' eyes, fingers and other body parts hacked off; madmen burned alive in their cells. 'We can only . . . cry in the bitterness of our human hearts, "How long, O Lord? How long?" ' (p. 47). To bring home the case to her English readers, she compares the Pope to 'a potent medicine-man of old time, the celebrated Dr Guy Fawkes' (p. 159); unlike Guy Fawkes, however, the Pope puts his gunpowder in guns. With 'fiendish malice' (p. 155), the Pope had sent a delegation of released prisoners to the Romagna 'to kindle disorder by deeds of blood and violence' (p. 155). In her Christmas letter from Florence, Trollope

blasts the legitimist friars of Santa Maria Novella for harbouring two small cannon, recently discovered by the police: 'So much for Santa Maria Novella and its unison with Christmas thoughts and aspirations' (p. 192). That same winter, she reports, intercepted papers detailed the Pope's plan to march on Florence with 8,000 troops, in the hope of luring 12,000 *contadini* (peasants) to his cause. But Trollope vindicates the 'honest vinedressers and olive-growers' (p. 162) who will not be bought. Indeed, the Florentine artisans had shown a similar distaste for papal bribes, asking, ' "What are we to do with this money, which is not ours?" ' (p. 163).

To prove that 'the national feeling among the peasantry is steadily on the increase' (p. 175), Trollope peppers her letters with quotations in Italian from various *contadini*, servants and local artisans. In July 1859, for example, she reports news of the agonising Peace of Villafranca, in which Napoleon III made a separate peace with the Austrian Empire, leaving them in control of Venice.[12] The scandal is viewed through the eyes of 'a poor uneducated servant-girl who, on hearing the report that day, rushed breathless into her mistress's room, with clasped hands and scared eyes, exclaiming, "Mio Dio! *Egli* ci ha traditi!" (My God! *He* has betrayed us!)' (pp. 54–5). Like a 'Florentine Cruikshank' (p. 31), she gives us the telling sketch, the revelatory detail: the 'shrewd and jovial master-carpenter' (p. 58) who reassures her that, according to his buddy, the army will avenge this betrayal; a 'fair-haired girl of about eighteen' whose 'white silk kerchief was pinned at the back of her smooth hair, as the lower ranks wear it here' (p. 80), singing the Garibaldi hymn, her eyes full of tears; a greengrocer who skewers every watermelon with the words 'Vittorio Emanuele', partly to announce his partisanship, partly to drum up sales; the *facchini* (porters) of Leghorn, famously anarchical and belligerent, who now go about on peace patrols; Florentine *gamins*, who chant derisive stanzas about 'Babbo', the deposed Duke. Above all, the poor are shown to be charitable to the cause. A 'patriotic garden-pot maker', first introduced eulogising a fallen patriot, declares, 'though I'm a poor man, I've found a *francescone* [Tuscan coin, also called scudo, worth about 5 French francs] for [Garibaldi], and welcome! And then we're all of one mind, you see' (p. 187). Almost an entire letter is devoted to a fund-raiser among the 'peasant patriots' (p. 208) at Pistoia; in the end only a pittance is raised, but Trollope uses it to reproach the 'retrograde' party for assuming the support of the peasants. During the parliamentary elections of August 1859, she reports that half the votes cast at

12 On the Peace of Villafranca, see Woolf, *A History of Italy 1700–1860*, pp. 446–9.

Empoli were from peasants, with the nationalists gaining about 99 per cent of the vote. Repeatedly, she follows the swift progress of rumours from battlefield to bulletin to boulevard, mouth to mouth; rumours that unite the body politic in heartache.

'The people's strong desire'

Trollope also delights in showing the hearts of the people pulsing in unison as they gather for a variety of lavish nationalist spectacles. In a 'rose-water revolution', she reminds her reader, crowds assemble 'not [for] the erection of a span-new guillotine' (p. 166), but rather for a public ball to honour the new National Guard. Such gatherings appear to happen often, some rather spontaneously: the farewell to the Piedmontese attaché, the opening of a Livornese academy, a sombre memorial for victims of 1848, a festival for the Prince of Savoy. But all these events pale before the joyous Florentine reception of her 'soldier-King'. 'Italy', Trollope writes, 'is beginning to be united by a stronger tie of union than ever was framed by red tape and sealing-wax, and which bayonets and protocols cannot put asunder' (p. 59). As these final two words suggest, the specific 'tie of union' she has in mind is that of marriage – a union not effected by conquest, politics, or diplomatic arrangement, but one of mutual affection. Notably, the legal joining of Tuscany to the Kingdom of Piedmont and Sardinia has already occurred. Of the September 1859 plebiscite, Trollope comments, 'Tuscany laid her hand trustfully in the manly palm of Victor Emmanuel, and bade him take her for better for worse' (p. 106). That this romance is legally sanctioned without a religious ceremony is crucial, for among the 'firstfruits' of ecclesiastical reform, Trollope is most impressed with the institution of civil marriage. Specifically, she argues that the recent civil marriage of two Protestant converts 'strikes a severer blow at the insolent domineering sway of Rome than all the coquetting of practised diplomats' (p. 141). Like many Britons, Trollope voiced high hopes that the new 'liberty of creed' would amplify the numbers of Protestant converts; in fact, she felt that the lesser role of clerics in the Protestant churches would appeal to a populace weary of priestly impostures. Her expectations, along with those of most Britons, vastly exceeded the number of converts.

In one sense, then, the celebration of the new King's arrival in Florence is merely a coda to the plebiscite, a reception after the civil ceremony. Narrated in Trollope's final letter of 19 April 1860, however, 'the Bridegroom's coming' (p. 257) to Florence 'on this her wedding-day' is

more climax than coda (p. 258). Let us look closely at her account of the King's arrival:

> [A]s we waited and gazed, a parti-coloured flickering of distant plumes passed out into the sunshine from under the deep shadow of the gateway; and before it, rolling and gathering like a great wave before the wind, came the shout, the heart utterance of a loving people . . . In the tumult of that great cry, and the rain of flowers, and white flashing of handkerchiefs on all sides, from roof to pavement, we saw the King on the beautiful grey charger which bore him at San Martino. . . . I say we *saw* the King, although I believe that among the thirty or forty persons who stood on the same balcony with me, of both sexes, and native of many different lands, there was hardly one whose eyes were clear enough at the moment to know much of what they looked on. It was no great wonder if my woman's heart was fluttering up into my throat amid the rush of the great popular enthusiasm; but after the group had passed out of our sight, the ashy-white cheeks of many of the sturdy menfolk around and below me told plainly enough of the passion of joy with which they had welcomed the moment towards which all had striven for so long. (p. 261)

The King's arrival is a public consummation, or as the running heads of the first edition announce, a 'A DESIRE FULFILLED'. As a 'rolling and gathering . . . wave' climaxes in an orgasmic shout of joy, we hear the 'heart utterance' of the body politic. This horizontal, wave-like energy, at the moment of climax, bursts into a frenzy of vertical motions: raining flowers and flashing handkerchiefs 'from roof to pavement'.[13] The account teeters between sentimentality and sexuality; even the sobs that make her own 'woman's heart flutter' into her throat seem frankly sexual, a part of the general hysteria. When the King rises from his throne, 'crowds of women of the working classes, townsfolk and *contadine*, thronged to kiss the throne on which he had sat' (p. 267). To avoid representing this event as a women's affair, Trollope insists that men shared in the hysteria; she traces the men's 'passion of joy' – 'sturdy,' not effeminate, 'menfolk' – in their faces and reports that a stonemason waited an hour simply to touch the king. At the King's warm response – ' "By all means", said the King . . . "Touch me, and welcome" ' – the mason 'laid his hand once and again on "Vittorio's" thigh, kissing his fingers each time as though it were a holy relic, and then retired supremely

13 For an account of Barrett Browning's representation of contrasting processions in 1847 and 1849, see Esther Schor, 'The Poetics of Politics: Barrett Browning's *Casa Guidi Windows*', *Tulsa Studies in Women's Literature*, 17: 2 (Autumn 1998) 309–13.

content' (p. 268). And in the evening, in one of its gorgeous 'illumina-tions', Florence bathes in the afterglow of thousands of candles.

Trollope defines such popular acclaim as 'the mighty shout which can come only from the "great deeps" of a people's strong desire' (p. 78). But her epilogue, which summarises developments between April and November 1860, entertains the liabilities of a union based on 'strong desire'. Such desires, particularly when fulfilled, are an ongoing insult to the temporal power of the Church, which has excommunicated several nationalist leaders (including the King) and thwarted their plans for a national service of thanksgiving. But the more serious risk, it seems, is that the people's desire may stray to another attractive figure on horse-back: Garibaldi, whose heroic exploits in the south have made him 'the leader of Italy's forlorn hope' (p. 275). Describing the 'sublime madness of that landing at Marsala', Trollope is awed by Garibaldi's Sicilian juggernaut, his 'thousand' 'gathering and advancing, and sucking the populations into its whirling mass as it advanced; now hurriedly organ-ising its forces in the fastnesses of the tortuous mountain ravines, now pouring them down in the open plain with furious onslaught' (p. 276). With 'every eye . . . straining southwards from the shores of Italy' (p. 277), Vittorio Emmanuel has become frustrated, jealous of 'the poorest red-shirted Garibaldino in the ranks' (p. 277), not to mention jealous of Garibaldi himself. As a counterpoint to the King's entry into Florence, she gives us Garibaldi's entry into Naples:

> A transfiguring brightness, . . . shone out like a glory from the noble face of the Liberator . . . when he entered the city without a single file of his own men to back him . . . And the hostile soldiery, amazed, almost terrified into admiring sympathy with the man they were there to crush . . . flung down their matches [for igniting weapons] and waved their caps in the air with an irrepressible shout of 'Viva Garibaldi! Viva L'Italia libera!' (pp. 304–5)

Moreover, she anticipates that 'that same wondrous halo-smile – who can doubt it? – shall lighten over the hero's face again' (p. 305) when he liberates Venice. Impugning the King's 'false position' vis à vis Garibaldi's expedition, she observes, with some regret, '[N]ever had the Government of Turin so little hold on the public opinion of Italy' (p. 277). Consider-ing her earlier adulation of Vittorio Emmanuel, Trollope's assessment of the situation is surprisingly even-handed. While praising the King's military campaign in Umbria and the Marches, she implies that he was motivated as much by a desire to emulate 'the Liberator of the Two Sicilies' (p. 290) as to liberate those in the clenched fist of the papacy.

Similarly, while holding Garibaldi above reproach, she details the 'accusations of disloyalty and double dealing' (p. 289) traded between the annexationist and Mazzinian factions of *Garibaldini*. Throughout, she is at pains to defend Piedmont against the charge that the King is merely a figurehead in a government run by Cavour and other diplomats, a government compromised by its connections to Imperial France; her allegory of 'Diplomacy mournfully wagging her high well-born head' (p. 272) merely hints at her contempt for Cavour. Moreover, the prospect of nine million residents of Naples and Sicily joining the Kingdom raises new questions about the body politic. Hence, while Trollope refutes the republican suggestion that Piedmont, in Napoleon's shadow, is not *Italian* enough to earn its domination of Italy, she impugns the ethnicity of 'the semi-oriental populations of the South' (p. 302). Moreover, the recent successful campaigns in Papal territory raise the perennial question of whether the 'heart' of Italy is not, after all, in Rome rather than Turin.

Trollope maintains that the uneasy *détente* between 'warrior and statesman' (p. 290) will benefit Italy by holding both imperialist and republican tendencies in check. Yet in turning to England 'alone, of all the crowned sisterhood' (p. 301) to guide the new Kingdom of Italy, she concedes that the 'people's strong desire' remains in dire need of discipline. It is for England to offer good counsel on 'the priceless privilege of full-grown constitutional liberties' and to educate the new Kingdom on 'the pursuit of material prosperity' (p. 301). But perhaps the surest sign of her anxiety about the 'tempestuous, all-compelling influence' (p. 303) of Garibaldi,[14] is her revision of her spousal allegory into a fairy tale: '[O]nce more after her magic sleep of ages, the peerless Ausonia, the disenchanted Queen, utters her voice among the nations . . . encircled by the strong arm of the fated Prince who broke the spell' (p. 301). Is this Trollope's bridal *Italia*, this inert Queen who needs a fated Prince to break her spell? In November of 1860, whether his 'strong arm' would avail against her 'strong desire' – whether this 'disenchanted Queen' would become disenchanted with her Prince – remained to be seen.

Frances Power Cobbe: many more acts

Born in 1822 near Dublin of affluent, Anglo-Irish parents, Frances Power Cobbe read voraciously but, unlike her brother, was educated mainly at

14 On Garibaldi's 1864 visit to England, which was brought to an abrupt end when the Queen became alarmed by his popularity, see Christopher Hibbert, *Garibaldi and his Enemies* (Boston, Little, Brown, 1966), pp. 339–51.

home. In 1857, she used an inheritance from her father to travel widely in Switzerland, the southern Mediterranean and the middle east. *Italics*, the book that emerged from her five visits to Italy, introduces most of the topics around which Cobbe shaped her career as an activist and social commentator: the rights of women to vote, hold property, and divorce; universal education, particularly for the poor; abuses in religion; and the prevention of cruelty to animals, in particular, vivisection.[15] In later years she became known for her pamphlets, articles and religious tracts, the last of which achieved great popularity, perhaps because they narrated her shifting, evolving convictions. She never married, settling in Wales with her companion, Mary Lloyd, in 1884; ten years later, she would publish her autobiography. She died in 1904.

Writing in 1864, Cobbe offers this rather unromantic assessment of Italian unification:

> Men rose three years ago to the call of an United Italy, and Tuscany, Lombardy, the Romagna, and the Two Sicilies, gave in their adhesion with acclamation. But that 'united Italy' was an Italy . . . with Rome for its capital. How far any of the new provinces would have consented to join Piedmont had they foreseen that for years to come it was, in fact, only an extended Piedmont, with Turin for capital, which was to be created, is very doubtful. By good fortune, however, the future was veiled, the union took place, and like other married parties, if they find themselves somewhat *desillusioné*, they still have no desire for any such strong measure as a divorce. (p. 199)

Three years since the passionate consummation reported by Trollope, the candlelight has been blown out, and a new day has dawned, leaving the groom in a harsh light. Cobbe's Vittorio Emmanuel is no longer an elegant figure on a charger;[16] instead, 'his ugly coarse face and burly figure speak him the dragoon rather than either the gentleman or the sovereign' (p. 178). In her mind's eye, she sees 'some old Scotch or Irish cateran . . . [riding] before his clan brandishing his pike and screaming

15 For an overview of Cobbe's career, see Barbara Caine, *Victorian Feminists* (Oxford, Oxford University Press, 1992), pp. 120–47; 'Frances Power Cobbe', in Paul Schlueter and June Schleuter (eds), *An Encyclopedia of British Women Writers*, rev. and expanded (New Brunswick, Rutgers University Press, 1998), pp. 157–8; and Lori Williamson, *Power and Protest: Frances Power Cobbe and Victorian Society* (London, Rivers Oram, 2000).

16 On Vittorio Emmanuel's 1860 entry into Florence, Cobbe corroborates Trollope's account: 'The people were quite made with joy. They did not cheer as we do, but uttered a sort of deep roar of ecstasy'; see *Life of Frances Power Cobbe: By Herself* (Boston, Houghton, Mifflin, 1894), p. 355.

"Crom aboo!" (p. 179). But instead of dwelling on Italy's act of union, she dwells on Italy's subsequent acting-out of her destiny: 'Italy has triumphantly passed through the first act of her drama of Restoration; but there are many more yet to be performed ere the most sanguine can conceive the play to be acted out' (p. 252).

In her opening survey of the new nation, Cobbe spotlights action, development, movement. Wollstonecraft, in her second *Vindication*, writes that those who 'seldom exert the locomotive faculty of body or mind' become 'nerveless', and 'listless';[17] even as keen a theorist of degradation as Wollstonecraft figured the sort of leisured, self-indulgent men many Britons encountered in Italy as a 'gangrene' in the body politic.[18] Cobbe, vindicating the rights of Italy, proclaims a new mobility of the body politic: 'Locomotive humanity is always troublesome, full of new ideas, wanting to have rights like other humanities encountered in its travels, and generally fuming and spluttering and wanting safety-valves in the most inconvenient manner' (p. 17). Her chapter titles – 'Italy Mends her Ways'; 'Italy Sent to School'; 'Italy goes to Drill'; 'Italy Reads her Newspaper' – present modernisation as the nation's increasing independence, her coming into what Wollstonecraft called 'a civil existence'.[19] Dense with statistics, these chapters frequently quote official reports (without vouching for their accuracy) and include tables of data. Her chapter on 'the Steam God' (p. 28), for example, details the number of miles of railway in different regions, the increase in the miles of railway between 1859 and 1864, the location of the most intense development, a list of new lines opened in 1863, and the cost of 1,693 kilometres of railway – between five hundred and six hundred million francs. In her discussion of education, from the curricula of the *asili infantili* up to the consolidation plans for the nineteen universities, she revels in the fact that all teachers trained in Normal Schools will now be independent of the papal authority.

Cobbe's treatment of judicial reform is noticeably less factual, probably because the expected reforms (modelled on the *Code Napoléon*) had not yet been published in Turin. Instead, she focuses on the lawlessness, chaos and hypocrisy of Rome in a series of tongue-in-cheek anecdotes pitting English residents against the Roman courts. In one story, an Englishman is sued by a neighbouring Marchese claiming that

17 Mary Wollstonecraft, *A Vindication of the Rights of Woman* (Penguin, Harmondsworth, 1986), p. 253.
18 Wollstonecraft, *Vindication*, p. 99.
19 *Ibid.*, p. 262.

the Englishman's dogs – two white dogs with short tails – killed the Marchese's calf. When the Marchese's lawyer hires seven witnesses to testify that two white dogs with short tails killed the calf, the defence lawyer trumps him by hiring nine witnesses who testify that two *black* dogs with *long* tails did the deed. The befuddled Englishman, who prevails in court, is arguably a figure for Cobbe's English reader, for whom the perpetual Italian problem of corrupt testimony – in the north, because of prudence; in the south, because of *omertà* (a feudal code of silence) – remains foreign and opaque.

The heart of darkness

Cobbe's critique of 'Catholic Italy' has the hallmarks of so many English anti-Catholic screeds: the lambasting of priestly hypocrisy; the mockery of rituals and relics; the reviling of 'monkish absurdities' (p. 282). Like Percy Shelley in the Preface to *The Cenci*, Cobbe focuses on 'how utterly in Italy Religion and Morality have been dissevered for ages' (p. 213).[20] At moments her tone lightens with Dickensian humour. Cobbe relishes the tale of a Franciscan who, losing his audience to a roaming Punch and Judy show, points to the crucifix, crying '*Ecco il vero Policinello!*' (Here is the real Punchinello!) (p. 282). In another anecdote, a preaching Capuchin arrests his audience by sniffing the air and asking if they, too, smell roasting meat: '*Si! E arrostito! O, Lorenzo, che brugia il fuco*' (p. 282).

But among English critics of the Church, Cobbe is unusual for shaping her enquiry around the question of how women are used by, and in turn make use of, the Catholic religion. Cobbe launches a five-chapter assault on Catholicism by returning to the first principles of patriarchy, what she calls 'the great masculine idea of the Mumbo Jumbo' (p. 224). This term refers to a 'barbaric scarecrow' depicted in children's books about Africa, used to frighten women and children into submission, so that 'order reigns in Female Negroland' (p. 227). Ruefully, Cobbe admits that as a child she, too, laughed in amusement at the image of fleeing women, but now her purpose is to draw a chain of identities across racial lines: if the condition of women in Catholic Italy resembles

20 '[Catholicism] has no necessary connexion with any one virtue . . . It pervades intensely the whole frame of society, and is according to the temper of the mind which it inhabits, a passion, a persuasion, an excuse, a refuge; never a check.' See Donald H. Reiman and Sharon B. Powers (eds), *Shelley's Poetry and Prose* (New York, Norton, 1977), p. 241.

'Female Negroland', the condition of women in Protestant England can be seen to resemble, however faintly, that of Italy. 'To this day', she remarks, 'there is not a country in the world wherein whatever religious darkness may exist is not gathered thickest in women's minds' (p. 237).

Cobbe assiduously resists the conclusion that 'mumbo jumbo' – whether scarecrow or scary doctrine – is an instrument of terrorism designed to keep woman subordinate to men. Treating the question in terms of England, she attacks men's appeal to women's fears rather than their reason as 'the true and fatal scepticism of our time' (p. 232), a craven doubt in the absolute goodness of Truth. By this logic, the practitioners of 'mumbo jumbo' are culpable of scepticism rather than tyranny. Second, she invokes an essential difference between women and men: 'men have more Justice and women more Piety – men more Understanding and women keener Intuitions' (p. 238). And upon this bedrock essentialism, Cobbe stakes her demand for a more rigorous education for women, English as well as Italian, one equipped to protect them from the liabilities of piety and sympathy. The heroine of de Staël's *Corinne, or Italy* (1807), makes a mordant comparison between English drawing-rooms and Italian convents: 'Since the Italian convents I had been to seemed full of life next to this circle of women, I could not imagine what was to become of me.'[21] In a footnote to de Staël, Cobbe notes that the 'young English lady' receives 'no encouragement to read or think, no useful guidance to the mode of supplying, by self-culture, the terrible blanks left in her mental education, but always the same soothing voice, "Remain orthodox, and you are safe, and women will love, and men approve, you"' (pp. 243–4). To stress how deeply in-grained is this infantilising treatment of English women, she quotes Queen Victoria's favourite poem by the poet laureate, Tennyson: 'Leave thou thy sister, when she prays / Her early Heaven, her happy views' (p. 245). Third, Cobbe avers that men need to gratify their vanity, using women as a foil to set off male strength and courage, but she elaborates this by implying that men (like Tennyson) project onto women their own most tender – most 'feminine' – feelings. Finally, she surmises a deep distrust of women's honour, virtue and affections, as if the factory of false creeds were designed to synthesise female virtue.

In an English context, then, Cobbe analyses gender relations psy-chologically, rather than politically. Yet when she narrows her view of gender relations to Italy, the political ramifications are writ large – and

21 Germaine de Staël, *Corinne, or Italy*, transl. Avriel H. Goldberger (New Brunswick, Rutgers University Press, 1987), p. 256.

in surprising characters. Where we might expect to find women's passivity under the tyranny of fathers and husbands, we instead find women's active complicity with the Church: '[T]hese priests have got, in almost every household in the land, a spy and an accomplice; Jesuits, Capuchins, secular priests, and nuns – they have between them the women of the upper ranks and of the lower, the matrons who seek them in confession, and the young girls who are placed in their convents for education' (pp. 253–4). That women are more than 'mere tools in the hands of the *neri* [the "blacks" or reactionary party]' (p. 254) is even more strongly suggested by a recent development: a blossoming cult of the virgin. Cobbe devotes an entire chapter to '*Madonna Immacolata*', the result of the recent papal definition of the dogma of the immaculate conception. She interprets this phenomenon with uncharacteristic sympathy, refuting the conventional (Protestant) wisdom that Catholics channel their meanest, most vulgar desires through the Virgin. What Cobbe perceives in the cult of mariolatry is the redress of a crucial deficiency within Catholic theology; for mariolatry proclaims 'that Love, motherly tenderness and pity, is a divine and holy thing, worthy of adoration' (p. 330). Indeed, Cobbe urges Protestant sects to be instructed by this 'wonderful act of Catholic Christendom' (p. 329), taking a swipe at ten thousand English ministers who had recently upheld the controversial doctrine of infernal punishments. Cobbe, like Trollope, boasts of the recent growth of the Protestant congregations in Italy, for which mariolatry, she believes, bodes well.

Mariolatry, however, is not without its errors and dangers for the 'poor besotted women, who crowd round the altars of winking madonnas and offer tapers for lucky tickets in the lottery' (p. 268). And Cobbe intuits that mariolatry is distinctively regressive: 'The relation of the devotee to the Madonna is simply a repetition of the sweet and tender drama of infancy, acted in after life with a mother crowned with stars and able to grant all entreaties' (p. 326). But neither the paganism nor the regressivness of mariolatry brings out Cobbe's ire; that remains for its 'vile ethics of asceticism', which she finds 'degrading' and 'perverted', an 'insult' to motherhood and a 'desecration of marriage' (pp. 332–4). However progressive the cult of the immaculate conception, Cobbe knows it is born in the sin of misogyny.

Through the looking-glass

This dispiriting survey of the condition of Italian women and women in England gives on to a more optimistic glimpse of a third group: English

and American women living in Italy. In an adroit chapter called 'People One Meets in Italy', Cobbe ignores the glittering social circles of Belgravia-in-Italy in favour of the lively company of artists and writers. Here we find sketches of Elizabeth Barrett Browning ('a great woman, [with] an eye calm and deep, looking through and through the person she addressed' [p. 391]) and Robert Browning; of Massimo d'Azeglio; of the sculptors Gibson, Story and Powers; of the intrepid American journalist Kate Field. Among these residents, she includes Thomas Trollope and 'his wife (hardly less well known in the literary world)' and their 'little fairy daughter'; sadly for us, with a comment about Bice's 'wondrous' singing, she moves on.

Cobbe's greatest enthusiasm, however, is reserved for two independent women, one a young American, the other an elderly Englishwoman. In the sculptor Harriet Hosmer, Cobbe finds 'the first woman who has combined genius, with opportunity and resolution to study thoroughly . . . the noble art of sculpture' (p. 413). Marvelling at how Hosmer captures the vivacity of her fauns and satyrs, Cobbe captures her as 'a girl who has spent the bloom of her youth in voluntary devotion to a high pursuit, adding to unusual gifts scarcely less unusual resolution and perseverance' (pp. 413–14). Taken with Hosmer's personal attractiveness – her charms, her equestrian skills, her 'drollery' – Cobbe seems especially intrigued by Hosmer's all-female household, living 'in the happy way women club together in Italy' (p. 414). Julia Markus, in her group biography of the Charlotte Cushman circle, quotes a letter in which Cushman reports that 'Miss Cobbe is here & making great love to Hattie . . . [who] is so fickle she makes me heartsick'.[22] Whatever the truth of their sexual relations, Cobbe's infatuation with Hosmer and her household of independent women can hardly be contained. The chapter ends with an extended pæan to the twice-widowed Mary Somerville, who at age eighty-three is not only a working scientist writing 'a treatise which will probably be considered her greatest work' (p. 438), but also a heroine of Christian faith and the domestic affections. In her autobiography, Cobbe portrays their intimacy: '[she] took me to her heart as I had been a newly-found daughter, and for whom I soon felt such a tender affection that sitting beside her on her sofa . . . I could hardly keep myself from caressing her.'[23] Her greatest pleasures in all her travels, Cobbe notes in *Italics*, 'is that I have been allowed to

22 Quoted in Julia Markus, *Across an Untried Sea: Discovering Lives Hidden in the Shadow of Convention and Time* (New York, Knopf, 2000), p. 174 (caption).

23 Cobbe, *Life of Frances Power Cobbe*, p. 349.

see and know and love Mary Somerville' (p. 445). Ultimately, Cobbe redeems the disillusionment of Italy's wedded life not only in her developing independence, but also in precisely these images of female bonding, whether in cults of the Virgin, in all-female households, or in the intimate maternal affection of Mary Somerville. Though Cobbe sets these female bonds in Italy, they remind us that one current of protest to the English marriage laws ran through the English novel's depiction of same-sex unions; by the mid-nineteenth century, devotion between women had become a recurring theme in lyric poetry as well.[24] That such unions were often said to jeopardise not only the patriarchal family, but also the nation sharpens the subversive flavour of Cobbe's stress on female bonding. Indeed, looking to the future of Italy, Cobbe subverts her own heterosexual allegory of the nation's marriage to the King of Savoy by noting that when Italy incorporates Venice, 'Venice is to be the bride, whose happy union is to settle the young and unsteady nation for ever' (p. 177).

The closing chapters of Cobbe's *Italics* take us away from the pulsating, busy world of steam engines and statistics toward a far quieter, meditative one. Comparing Pisa to Florence, Cobbe writes:

> [T]he same river Arno rolls through them both, and on each side are rows of houses of the same character . . . the same Tuscan people inhabit both cities, and the same blue sky of Italy bends over all. But Pisa is the dream town and Florence the waking one . . . [Living] in Pisa people grow into a calm and placid state somewhat like that which is induced by sitting on the sea shore and listening to the waves beating up monotonously hour after hour. We persuade ourselves we are thinking deeply, but in reality we are thinking of nothing at all. Our brains have performed the process which some of the Eastern sacred books say was the beginning of all things . . . We are supremely blessed – in the next stage of existence to annihilation. (p. 452)

It is hard to imagine values more alien to those espoused in the nationalist polemic of the early chapters. In this reverie, we could not be further from Cobbe's opening survey of reanimated, enlightened, reasoning Italy. On the contrary, Pisa offers a strange empty-headedness, a soporific Eastern luxury. But Cobbe's notion of 'the next stage of existence to

24 See Lisa L. Moore, *Dangerous Intimacies: Toward a Sapphic History of the British Novel* (Durham, Duke University Press, 1997), pp. 1–21. For discussions of images of female bonding in women's lyric poetry see Isobel Armstrong, *Victorian Poetry: Poetry, Poetics and Politics* (New York, Routledge, 1993), pp. 318–80 and Yopie Prins, *Victorian Sappho* (Princeton, Princeton University Press, 1999).

annihilation' is less an approach to death, than an access to 'the begin-
ning of all things', an original state prior to consciousness, marked only
by the beating of the waves. We find a similar configuration in her
chapter, 'Nervi with no Sights', a gentle tweaking of the guidebook-
worshipping 'Murrayolator' in all of us.[25] Here, she invites her reader to
celebrate the beauty of the natural world in a town where art offers no
competing claims on our attention. 'Nothing', she writes, 'can exceed
the beauty of these seaviews at Nervi':

> Sitting there in the utter stillness, the ineffable beauty, with the soft
> waves of the tideless Mediterranean gently playing among the low
> rocks a few yards away, and the white lateen sails sweeping like swift
> and silent birds across the waters, one's heart grew soft and weak, and
> it seemed as if all the burden and the struggle of our English life were
> a troubled, senseless dream . . . The beating breast of ocean would lull
> us as when we were children in our mother's arms, and her soft voice
> murmured some low sweet song whose words we comprehended not,
> but whose tone meant peace and love. Care and sickness and all our
> pitiful troubles would be soothed even as they used to be when . . . half
> smiling at our baby woes, half weeping with motherly tenderness and
> compassion, she hushed us to rest. (p. 499)

While sibilants lap at every phrase and alliterations gently bob, Cobbe's
oceanic language soothes, comforts, sings. Again, in this deeply regress-
ive reverie, the waves are beating, as the motive for mariolatry meets
the pleasure of a watery, womb-like refuge. Here, perhaps, is Cobbe's
profound counter-image to an awakened Italy disillusioned by marriage:
a woman drifting beyond consciousness, beyond autonomy, secure bey-
ond harm in a union of female tenderness.

Discussing household objects in her chapter, 'Italian Manufacture',
Cobbe singles out for attention an Italian mirror:

> Looking-glasses . . . are matters of constant exercise, as a Quaker would
> say, to any unfortunate lady who may chance to be possessed by a
> curiosity to look at the results of her toilette. As to seeing her '*natural
> face in a glass*,' it is what she need indulge in no hopes of doing.
> Probably she will find her countenance extended laterally in an ellipse,
> one eye and cheek being much larger than another, so as to give her
> somewhat the shape of a map of Africa, while her colour will probably
> vary between drab and a delicate green. (p. 367)

25 For a dialectical treatment of tourism and anti-tourism, see James Buzard, *The
 Beaten Track: European Tourism, Literature, and the Ways to Culture, 1800–1918*
 (Oxford, Oxford University Press, 1993), pp. 80–154.

Bearing in mind both Cobbe's designation of the Italians as an 'antipodeal' race (p. 5), and her analogy between England, Italy, and 'Female Negroland', we may recognise in this distorted, discoloured mirror image, her reluctant, startled identification with the 'race' of Italians. Crucially, this image lies beyond one's control; the mirror of Italy simply cannot be mastered:

> [Y]our Italian looking-glass always swings back, with a slow motion, presenting you for a moment with a vanishing view of your chin, and then remaining delicately balanced horizontally, so as to afford all the advantages of its services to the flies on the ceiling . . . [T]his time the glass flaps forward, your forehead appears for an instant in the foreground, and the mirror remains stationary, face downward. (pp. 368–9)

For this Italian mirror is nothing if not unstable; it shatters the viewer, showing but a chin, a forehead. It is as likely to refract one's search for an image as to reflect a self changed almost beyond recognition.

Both Frances Power Cobbe and Theodosia Garrow Trollope look into the Italian mirror in their books on the new Kingdom of Italy. What they discover there may not be what we expected: that Trollope's high romance of nationhood might be shadowed with disenchantment[26] is no less surprising than that Cobbe's study of a disillusioned marriage should end in a rapturous union among women, however regressive. No less surprising; but no more, either. For upon their claims for the vitality and independence of *Italia*, both writers inscribe the vicissitudes of female experience, from maternity, to childhood, to sexual desire, to marriage, to disillusionment. Beyond their valuable, astute observations on the new questions of the 1860s, these writers leave us invaluable testimony that for striving women, as for striving nations, regeneration is no easy matter.

26 In Italy, at least, study of the Risorgimento continues to revolve around precisely this question of nationalist mythology and disenchantment; see Albert Russell Ascoli and Krystyna Von Henneberg (eds), *Making and Remaking Italy: The Cultivation of National Identity Around the Risorgimento* (Oxford, Berg, 2001), pp. 1–23.

6

Liberty, equality and sorority: women's representations of the Unification of Italy

Pamela Gerrish Nunn

THE UNIFICATION of Italy provoked a war in which Britain was a reluctant combatant but which excited great fervour in Britain, and in this enthusiasm women were conspicuous. This involvement in current affairs can be argued to be telling of the crucial decade of the 1850s in which modern womanhood emerged as a provocative element of the new middle-class society. The presence of a female monarch, as well as disconcerting individual examples of articulate upper- and middle-class women such as Florence Nightingale and Harriet Martineau, were jostling the assumption in mid-Victorian Britain that the political was a masculine discourse naturalised as such by male authority. Many women in the 1850s, refusing the intellectual limits of the domestic, were denying the image of current affairs or the making of society as lying beyond the reach of women, and busily seeking ways to interject in the public domain. It is no surprise that only a few years into the 1860s, the demand for female suffrage emerged. The specificities of the discourse of unification are worth a close examination, showcasing as it does the various aspects of women's changing role, activities and image in Victorian society at the end of the 1850s.

Women's interest in this important development in the construction of a modern Europe was manifested most famously in Elizabeth Barrett Browning's poetical discourse on the emergence of Italy as a nation-state.[1] She may have been made out by some contemporaries to be exceptional, but in some ways she might be considered symptomatic, like the artists who will be considered here. For, in addition to her outspokenness on the Italian question, her *Aurora Leigh* (1856) gave explicit voice to the seismic trend sketched above, its authority in this

1 This is discussed by Sandra Gilbert, 'From *Patria* to *Matria*: Elizabeth Barrett Browning's Risorgimento', in Angela Leighton (ed.), *Victorian Women Poets: A Critical Reader* (Oxford, Blackwell, 1996), pp. 24–52.

respect immense when it is recalled that its author had been suggested as Poet Laureate on Wordsworth's death in 1850. Though hers is a stellar contribution of the female voice to the British conversation about Italy, it is examined elsewhere in this volume: I shall concentrate here rather on the visual art which was generated by certain women's responses to the Italian cause, which have received little attention since their first appearance and which have not necessarily survived to bear their own witness.

'Although historians disagree as to how early this process began, there can be no doubt that it reached its culmination between 1859 and 1861', writes Charles Delzell of the 'Italian question', and 'with January 1859 began the two most dramatic and eventful years in the Risorgimento'.[2] A heightened consciousness of all things Italian showed itself in various British fora, as proponents of all sides of the question promulgated their views of the matters in hand: thus in Charles Dickens' new weekly magazine, *All the Year Round* – which began publication in April 1859, the very month in which the Austrians fell into armed conflict with Piedmont – no more than two weeks went by without some piece relating to the topic of Italian unification, all generally taking an anti-Austrian and pro-unification line. *All the Year Round* contained no visual material, however. When it came to pictorialising current affairs, the annual art exhibitions – especially the foremost, the Royal Academy – displayed the reach and tendencies of the mid-Victorian public's imagination and opinion. The dominance of Realism provoked a varied response from painters (and sculptors to a lesser degree) alert to any topic which the public might have on its mind as it passed through the galleries. In this climate, a remarkable recently rediscovered painting, Jane Benham Hay's *England and Italy* [4], shown in the Academy exhibition in the key year of 1859, provokes the question of the symbolic potential of the struggle for Italian unity for British women, themselves striving for self-realisation.[3]

This striking horizontal canvas, measuring 46.4 × 80 cms, depicted a strongly coloured Tuscan landscape, with two boys standing on an earthy bank against a cloudless, azure sky, facing the viewer with ambiguous demeanour. In the distance, up on the hills behind them, a small cluster

2 Denis Mack Smith, *The Making of Italy 1796–1866* (Basingstoke, Macmillan, 1988), p. 256.

3 See, amongst many, Patricia Hollis, *Women in Public: The Women's Movement 1850–1900* (London, George Allen and Unwin, 1979) and Mary Poovey, *Uneven Developments: The Ideological Work of Gender in Mid-Victorian England* (London, Virago Press, 1989).

4 Jane Benham Hay, *England and Italy*, 1859

of housing can be seen, suggesting where these playmates have come from. No bird or animal life can be discerned breaking the stillness of this quiet, hot day, as the viewer imagines he or she has just come across these boys while tramping through the richly-toned countryside beneath the unblinking Italian sun. The Florentine lily accompanied the artist's signature in red paint at bottom right, with the date and place of the painting's production – and on the reverse, like a secret message for the other supporters of the cause, she had written 'Liberty, Equality, Fraternity'.

The audience Benham Hay was addressing had been courted assiduously by Camillo Cavour since the mid-1850s. The sympathy of England for the cause was such that he could assume that 'some of the leading Sicilian emigrés will be going to London' (May 1856) and it was indeed in London that the exiled Mazzini made his declaration concerning the war, on 28 February 1859.[4] Certainly, Lord Clarendon later recalled, 'our

4 Quoted in Smith, *The Making of Italy*, pp. 210, 263–5. Further, writing to Emanuele d'Azeglio, Piedmontese minister in London, in January 1856, Cavour said: 'If you could get these subjects discussed in the London newspapers you would advance our interests . . . Put before [Lord Shaftesbury's] eyes the spectre of Popery extending its domination over half the European continent where Austria commands. In this way you might raise a cry of alarm which would trouble the ministers' repose and echo through the vaults of Exeter Hall'; and to Rattazzi, his minister of the interior, in April 1856: 'England, grieved at peace, would with pleasure see an opportunity for a new war, which would be popular because it would be a war for the liberation of Italy'; quoted *Ibid.*, pp. 201–2. This paid off in terms of general British opinion: see, characteristically, the eulogistic notification of the death of 'the architect of Italian freedom, unity, and independence, and . . . the greatest statesman of modern times' in the editorial of the *Illustrated London News*, 22 June 1861.

object at that time was to free Italy from foreign occupation, and to reform the Papal and Neapolitan governments, and that toward that end the moral support of England would always be forthcoming'.[5]

The feeling in England that the nobility of the end in view – self-determination for the Italians – made it a suitable English cause flattered a liberal notion of the English as a democracy-loving, tolerant and Christian people who had only recently distinguished themselves in the struggle to end slavery and the slave trade – a struggle in which women were also conspicuously active. But even the English people living in Italy, who supported the Italian cause as part of their love affair with the country and its peoples, ranged in their own values from republican to monarchist.[6] Certainly British government sympathies for unification – never mind popular or middle-class sympathies – were subject to personal and party bias, and typical of the qualified liberalism of the English Italophile was the *Athenaeum*'s compliment in 1861 to Theodosia Trollope, reviewing her collected reports of recent events under the title *Social Aspects of the Italian Revolution*: 'Mrs Trollope is moderate and English in her views . . . neither Cavourian nor Garibaldian'.[7] Benham Hay's theme of Anglo-Italian relations could interest many Academy-goers in 1859, then, whichever way events unfolded.

Mid-Victorian Britain's principal art periodical, the *Art Journal*, regretted that the 1859 Academy show – opening as usual on 1 May – was a mediocre one because the artists who might have presented 'noble' works were all busy on commissions for the Houses of Parliament.[8] This set the scene for a rather mixed acknowledgement of Benham Hay's exhibit:

> A very quaint conceit – that of placing two boys side by side, an English and an Italian boy, in illustration of happy England and suffering Italy. The two figures are extremely well painted, as is the entire landscape; but perhaps, in the entertainment of subject matter of this kind, there is a waste of power, that would tell effectively in more legitimate material. This accomplished lady is now resident in Italy; as

5 Quoted in Smith, *The Making of Italy*, pp. 206–7.
6 See in general Giuliana Artom Treves, *The Golden Ring: The Anglo-Florentines 1847–1862* (London, Longman, 1956) and in particular Thomas Adolphus Trollope, *What I Remember*, 2 vols (London, Bentley and Son, 1887).
7 'Social Aspects of the Italian Revolution', *Athenaeum*, 26 January 1861, p. 113.
8 'The Royal Academy', *Art Journal*, 1 June 1859, pp. 161 ff. The rebuilding of the Palace of Westminster was in the process of being completed: the foundation stone was laid in 1840 but the interior and the exterior accessories were still being put in place in the mid-1860s.

'Miss Benham' she obtained no inconsiderable repute by her pencil illustrations of Longfellow. We rejoice to find her aiming at a higher purpose, and very largely succeeding.

The female allegory of nationhood had a long tradition and the idea of Italy as an identifiable concept had been used in art well before. The Nazarene Overbeck's female pairing of *Italia and Germania* of 1828 is the best known example, and Benham Hay would have known this painting from her time in Munich in 1850,[9] and this group was still remembered in Italy where they worked from 1810. Moreover its style recommended it to any artist working, like her, in the light of Pre-Raphaelitism. Elizabeth Barrett Browning personified Italy in *Casa Guidi Windows* (1848 and 1851, written in support of the struggle for self-determination) as a weeping woman, chained by her enemies and by history.[10] The poet's feeling for this symbolic convention was, indeed, so great that she recognised it in her dreams: 'I dreamed lately that I fol-lowed a mystic woman down a long suite of palatial rooms. She was in white, with a white mask on her head the likeness of a crown. I knew she was Italy.'[11] The poet, as a woman, identifies Italy in sisterly sym-pathy as female, though also answering her own question, 'what is Italy?' with a roll-call of male names from history, literature and art.[12]

Benham Hay suggested rather a pictorial realisation of Mazzini's Young Italy, that 'free and equal community of brothers' which was to have unified Italy in the creation of a new republic back in the 1830s. Benham Hay's young heroes were described by her as 'two boys, one of English type, the other an Italian boy of the people. In one I have endeavoured to express the pure happiness of our children; in the other the obstination of the oppressed and suffering poor of Italy', she wrote for the benefit of the gallery-goer.[13] These are not the mischievous, playing boys of earlier and contemporary Victorian paintings: William Collins',

9 Benham studied in Munich with Anna Mary Howitt; they were taught by Wilhelm Kaulbach, who had himself been a pupil of the Nazarene Peter Cornelius.

10 See Gilbert, 'From *Patria* to *Matria*', and Flavia Alaya, 'The Ring, the Rescue and the Risorgimento: Reunifying the Brownings' Italy', in Sandra Donaldson (ed.), *Critical Essays on Elizabeth Barrett Browning* (New York, G.K. Hall, 1999), for a positive reading of Barrett Browning's use of this conventional symbolic strategy.

11 Letter to Isa Blagden, summer 1859, Frederick G. Kenyon (ed.), *Letters of Eliza-beth Barrett Browning*, 2 vols (London, Smith, Elder and Co., 1897), 2: 321.

12 Elizabeth Barrett Browning, *The Poetical Works of Elizabeth Barrett Browning* (London, Smith, Elder and Co., 1897), p. 325.

13 This gloss appeared in the Royal Academy catalogue.

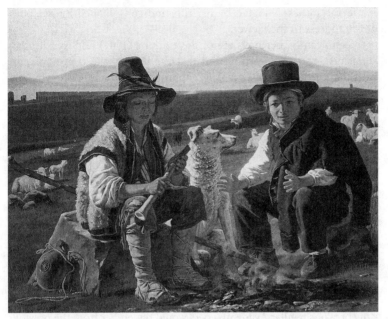

5 Martinus Rørbye, *Two Shepherd Boys in the Roman Campagna*, 1835

say, William Mulready's or F. D. Hardy's, paired so often in rough and thoughtless play.[14] Equally, the comic competitiveness defining John Faed's idea of *Boyhood* (1849)[15] is foreign to Benham Hay's young companions. They break even more determinedly with the tradition of picturesque ragamuffins produced by many European artists for decades for their home markets as souvenirs of an Italy often imagined but actually unknown. Such a composition as the Dane Martinus Rørbye's *Two Shepherd Boys in the Roman Campagna* (1835) [5], for instance, though possessing a directness comparable to Benham Hay's and boasting authenticity in its inscription, costume and discreet use of classical ruins, nevertheless offers an animated boyishness which Benham Hay refuses her viewer. Rørbye's hinting at political meaning in the Mazzinian red, green and white of the boys' clothing and their prominently placed charcoal-burning fire is pressed by Benham Hay towards

14 See Marcia Pointon, *William Mulready* (London, Victoria and Albert Museum, 1986).

15 See Mint Museum of Art, *The Defining Moment: Victorian Narrative Paintings from the Forbes Magazine Collection*, 2000 and, more generally, Manchester City Art Galleries, *Innocence and Experience: Images of Children in British Art*, 1992.

the forthrightness initiated by her title and consolidated by her boys' direct address to the viewer.

Significantly, her boys are of the working (Italy) and middle class (England), paired to recommend that the latter make common cause with the former, as *noblesse oblige*: appropriately for English sympathisers, the English boy's arm lies protectively around the shoulder of his Italian fellow. He and his companion appear at home in, and against, the land, the traditional symbol of working peoples' struggle for self-determination, matrix of power, influence, wealth and independence, and for the peasant a means not only of self-respect but of survival. The habit of identifying unindustrialised, poor nations and peoples such as Italy and Ireland through peasant figures was well established in English painting,[16] but Benham Hay's juxtaposition of classes and the class difference thereby insisted upon – and her equal insistence on the desirability of its being bridged – disconcerted some gallery-goers.[17] For liberal British viewers, the foreground of stones tumbled on the rich brown soil by the roadside pressed the question of class further in its evocation of the hard manual labour to which so many of Britain's own unpropertied poor were consigned. In this it would have directly echoed the two stonebreakers regular Academy-goers would remember from the previous year's exhibition by John Brett and Henry Wallis.[18] But where Brett's and Wallis's protagonists could be seen as victims, body and head bowed by their tedious task, Benham Hay's boys confront the viewer alertly. It is undoubtedly her son Ernest who posed as the representation of his native country, exhibiting his classic English colouring in distinction from his swarthy companion. In this particular strategy, evoking and yet not endorsing the Disraelian notions of Young England and the Two Nations, it can be wondered whether Benham Hay inspired another politically progressive figure on the fringes of Pre-Raphaelite painting, Ford Madox

16 An equivalence could be argued in British art's treatment of Italy and Ireland in this respect; on the latter see Fintan Cullen, *Visual Politics: The Representation of Ireland 1750–1930* (Cork, Cork University Press, 1997), chapter 4, pp. 116–59.

17 The *Examiner*'s reviewer, for instance, was provoked to call the English boy 'a sentimentally fair little gentleman': 'Will Mrs Hay contrast next year, in a companion work, the child of an Italian lady with a little Wiltshire scarecrow, or some child of the gutter picked up in an English town?' ('Royal Academy', 4 June 1859, p. 358).

18 Viz. John Brett, *The Stonebreaker*, no. 1089 and Henry Wallis, *Thou wert our conscript*, no. 562. See Michael Hickox and Christiana Payne, 'Sermons in Stones: John Brett's *The Stonebreaker* Reconsidered', in Ellen Harding (ed.), *Reframing the Pre-Raphaelites* (Aldershot, Scolar Press, 1995), pp. 99–114.

Brown, in his interesting characterisation the following year of his own son Oliver as *The English Boy*.[19]

Benham Hay's scene is laid in Tuscany, whose position within the Italian question was one of the chief issues in the balance as the Academy opened. Even as the painting hung on the gallery walls, the decisive battles of Magenta and Solferino (4 and 24 June) saw Florence finally freed from Austrian occupation (if, as it transpired, still vulnerable to French paternalism). For many British, Florence and its surroundings particularly represented their idea of Italy, and was the most resonant part of that area they already lumped together in the term 'Italy'.[20] As a review in the 15 October issue of *All the Year Round* of Thomas Trollope's *Tuscany in 1849 and 1859* characteristically had it, not only was Italy 'the country to which all Europe is looking with deep interest and active curiosity', but 'the affairs of Tuscany' were 'the affairs of Italy' which were 'the affair of every man who would see thought and honest action set free everywhere to help in the advancement of society'.[21] Thus, though this was the part of Italy which the artist had adopted when she left England definitively in 1856, her choice of Tuscany to represent Italy as a whole was by no means of only personal significance. Both *England and Italy* and its companion at the 1859 Academy, *A Boy in Florentine Costume of the 15th Century* [6], indicate the artist's close relationship with the Tuscan countryside, though by 1861 she had moved from the Val d'Arno into Florence itself.

Benham Hay's interest in and her position on the Italian Question must be linked to two important contemporary relationships. The first was with Jesse White Mario, one of the foremost English agitators for the cause of Italian unification.[22] It was she, an early admirer of Garibaldi

19 Manchester City Art Galleries. Brown's diary, which might have answered this question, does not cover the years 1859 and 1860. Two years younger than Ernest in 1859, Oliver Madox Brown does resemble the boy 'England' strikingly, with similar hair, hat and gaze.

20 See Artom Treves and Olive Hamilton, *Paradise of Exiles: Tuscany and the British* (London, Andre Deutsch, 1974).

21 Anonymous, 'Fruit Ripening in Tuscany', *All The Year Round*, 25: 1 (15 October 1859), p. 582.

22 Described by Carducci as 'a great woman to whom we Italians owe a lot' (G. Carducci, *Confessioni e Battagli* (Bologna, D. N. Zanichelli, 1902), p. 192). Her biographies of Garibaldi (*Vita da Giuseppe Garibaldi* (Milano, Treves, 1882), *Garibaldi e suoi Tempi* (Milano, Treves, 1884)) were much respected in Italy. Descriptions of her by compatriots are to be found in Henriette Corkran, *Celebrities and I* (London, Hutchinson, 1902), p. 63 and Trollope, *What I Remember*, chapter 15, pp. 187–93.

6 Jane Benham Hay, *A Boy In Florentine Costume of the 15th Century*, 1859

and ardent supporter of Mazzini, who took it upon herself from 1854 to recruit the people who would have made up *England and Italy*'s admirers, lobbying English opinion for greater explicit support throughout the struggle. The second was with the Italian painter Francesco Altamura, with whom John Purkis has suggested Benham Hay became romantically involved in or about 1856.[23] Altamura, a political radical, had sought the comparative safety of Florence from Naples. Not only was he (and, presumably, therefore Benham Hay) actively involved in agitating for the unification cause, but he produced in 1859 a painting as expressive of his political hopes as *England and Italy* can be assumed to have been of his lover's, using closely comparable ingredients though employing far less striking means. *The first Italian Flag carried into Florence* (Museo del Risorgimento, Turin), which Albert Boime has recently brought to notice,[24] shows a boy walking into the great Tuscan city against a bank, behind which rises one of Florence's distinctive historic buildings, San Miniato al Monte; though his colouring is quite conventional compared to hers, Altamura's outdoor scene is also illuminated by the Italian

23 Robinson, Purkis and Massing, *A Florentine Procession* (Cambridge, Homestead Press, 1997), p. 6. Benham's biography is still fragmentary, but this gives the fullest account available. It is possible that it was meeting Altamura in Paris in 1855 that prompted Benham Hay's move to Italy, especially since her marriage to William Hay, dating from 1851, ceases to feature in the biographical data after this. This leads to the speculation that her second son Gerard was fathered by Altamura.

24 Albert Boime, *The Art of the Macchia and the Risorgimento* (Chicago, University of Chicago Press, 1993), pp. 62–3.

sunshine, and the stillness surrounding his young hero is almost as pregnant as that suffusing *England and Italy*.

Benham Hay, then, was painting a message for her compatriots as her Italian associates were for theirs at this pivotal moment, and those who received it gladly were the people who felt fervently that 'only the complicity of friendly powers on behalf of unification could possibly rescue Italy from the devastation wrought by centuries of their un-friendly complicity',[25] the people who were referred to by more resistant or mistrustful observers of events as 'the apostrophes of rebuke and regret that England has not sympathised with hopes so glorious'.[26] Such people were readers of Elizabeth Barrett Browning, 'almost an English patron saint of the Italian cause, and prophet of English supportive intervention in its favour',[27] who believed that 'the melancholy point in all this is the dirt eaten and digested with a calm face by England and the English . . . Not only the prestige, but the very respectability of Eng-land is utterly lost here'.[28] They were readers too of John Ruskin, whose views on the Italian question were not broadcast until late July[29] but whose reactions to the Academy were made known in May through his intermittent annual review, 'Academy Notes'.

While it is not known what Benham thought about Ruskin and his work, what he thought of her and her 1859 paintings can be glimpsed in that year's Notes: he called both paintings 'masterly and complete in effect' while finding fault, as other reviewers had, with *England and Italy*'s 'intention'. 'There is more misery of an outward and physical kind in a couple of London backstreets than in a whole Italian town', he wrote; 'Mental degradation, not physical suffering, constitutes the slavery of

25 Alaya, 'The Ring, the Rescue and the Risorgimento', p. 48.

26 'The Emperor Napoleon III and Italy', *Athenaeum*, 12 February 1859, p. 220.

27 Alaya, 'The Ring, the Rescue and the Risorgimento', p. 58; though she has been described by twentieth-century commentators rather as a 'neurotic Italian patriot' (William Irvine and Park Honan, *The Book, The Ring and the Poet* (New York, McGraw-Hill, 1974), p. 367); see also Leo A. Hetzler, 'The Case of Prince Hohenstiel-Schwangau: Browning and Napoleon III', *Victorian Poetry*, 15 (Winter 1977) 335–50.

28 Letter to Miss Browning, May 1859, Kenyon (ed.), *Letters*, 2: 313–14; in early 1860 she wrote 'Napoleon III in Italy' as an argument for the English to intervene on Italy's behalf, it being the ambitions of the French ruler which it was gener-ally agreed were the dangerous element hindering the progress of negotiations.

29 Two letters from Ruskin on 'the Italian Question' appeared in the *Scotsman*, on 20 and 23 July 1859: E. T. Cook and Alexander Wedderburn (eds), *The Works of John Ruskin*, 39 vols (London and New York, George Allen and Longman's, 1903–12), 18: 537–45.

Italy; both constitute that of England'.[30] While this comment in fact addresses itself more to the treatment than the aim, it reveals that this painting must have made a great impression on Ruskin: for in these observations are seen the anticipation of his vivid comparison in *Modern Painters* Part 5 between the childhoods of Giorgione and Turner, lived out respectively in Italy and England.[31] Published in June 1860, the book is the fruit of writing achieved in the first five months of that year,[32] and suggests Ruskin reciprocating the reflection of his own recent activities that can be construed in Benham Hay's painting. That is to say, her emphatically hewn and coloured Tuscan bricks and boulders may not be 'stones of Venice' but do speak to Ruskin's contention in the fourth volume of *Modern Painters*, published in spring 1856, that only ancient art offered 'any careful realisation of Stones'.[33] They certainly rival his protégé John Brett's scene in another Italian valley hanging elsewhere in the 1859 Academy exhibition.

Brett's *Val d'Aosta* [7], laid in the equally politically resonant area of Piedmont, deploys remarkably similar ingredients for a very different effect from Benham Hay. Brett's child sleeps in the heat of the day, her little goat carelessly at large amongst the Alpine boulders. Her presumed home, like that of Benham Hay's peasant boy, is tucked into the middle ground, cultivated fields beyond it. Brett's rocky foreground, infinitely observed and minutely replicated, bears no signs of human effort as does Benham Hay's, and the pastoral character of his representation of the Italian countryside, even though it wears its Pre-Raphaelitism so self-consciously, fits easily into the summery dream that the average English Italophile nurtured, unlike Benham Hay's enigmatically portentous scene. The panoramic majesty of Brett's view of Piedmont, with its breathtaking sweep from foreground to horizon, looks more and more touristic the longer one interrogates the stubborn frontality of Benham

30 No. 13, 'Academy Notes 1859', Cook and Wedderburn (eds), *Works*, 14: 211–12. Both the *Times* and the *Examiner* critics were sceptical of the painting's sociopolitical intent (30 April 1859, p. 12 and 4 June 1859, p. 358).

31 Part 9, chapter 9, 'The Two Boyhoods', Cook and Wedderburn (eds), *Works*, 7: 374–88.

32 See Tim Hilton, *John Ruskin: The Later Years* (New Haven, Yale University Press, 2000), chapters 1 and 2.

33 Cook and Wedderburn (eds), *Works*, 6: 36; see Robert Hewison, *Ruskin, Turner and the Pre-Raphaelites*, Tate Gallery, 2000, cat. nos. 202 and 207. That Benham Hay paid particular attention to the stones is suggested not only by the painting itself but by the existence of a canvas (now unknown) exhibited at the RA in 1862 as *Study of Stones in the Val d'Arno*.

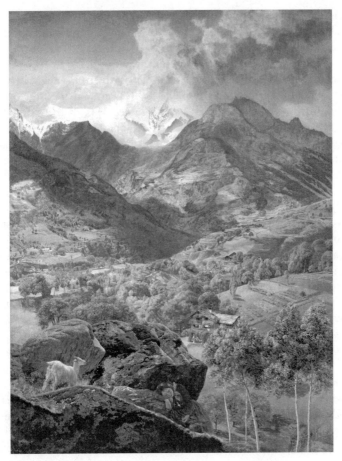

7 John Brett, *The Val d'Aosta* , 1859

Hay's picture. Her presentation of the Italian landscape stands as near to the French Realist Courbet as to Ruskin, in fact. She has come up with a 'historical landscape' not quite as Ruskin meant it[34] – being partisan, engagé, social – but rather as the French painter had offered it in his radical canvas *The Stonebreakers* at the 1850–51 Salon and his 1855 solo exhibition; and unspeakably more contemporary, more worldly

34 'Yes, here we have it at last', he wrote of no. 908, Brett's *Val d'Aosta*, 'some close-coming to it at least – historical landscape, properly so called – landscape painting with a meaning and a use'. See Cook and Wedderburn (eds), *Works*, 14: 234–5.

than Ruskin imagined women's art ever being. Only in September 1858, Ruskin had written to a female friend that 'I don't think women were in general meant to reason'.[35]

Though many artists were personally sympathetic to the cause of Italian independence, they were as a professional group caught between the contemporaneity made desirable by Realism and the timelessness called for by commercial interests: if a subject was 'of the moment' it might have a better chance of immediate sale, but that very same topicality might hamper its marketability if it initially failed to find a purchaser, and would moreover make its enduring value vulnerable to changes in public opinion. Though the successive international conflicts of the 1850s in which Britain had an interest – the Crimean War, the Indian Mutiny (sic) – had provoked conspicuous painterly and sculptural response, few painters or sculptors seem to have introduced the Italian question into the London galleries as directly as Benham Hay did. Certainly such a painting as William Gale's *Naples, 1859* (RA 1861) did not achieve the immediacy of Benham Hay's canvas, presenting its subject-matter as history – albeit recent – and attracting little critical attention.[36]

At the Academy of 1859 exhibits such as Carl Vacher's *Attila's Invasion: the first view of Italy*, Eyre Crowe's *Milton visiting Galileo in the Prisons of the Inquisition* or Thomas Marshall's *John Howard visiting the Prisons of Italy in 1786*,[37] could possess merely by their timeliness a meaning which they would not have had in other years, as had William Holman Hunt's literary *Rienzi* (1849), exhibited in the wake of the 1848 revolutions. But Italy was, as usual, most conspicuously the subject of landscape exhibits. It was the imagined timelessness of Italy and its picturesqueness, rather than its contemporary reality, which British gallery-goers were used to seeing in this genre of art.[38] Arthur Ashpitel's

35 Letter to Mrs Hewitt, 1 September 1858, Cook and Wedderburn (eds), *Works*, 36: 290. On Ruskin's attitudes to women, see Pamela Gerrish Nunn, 'The "Woman Question": Ruskin and the Female Artist', in Robert Hewison (ed.), *Ruskin's Artists* (Aldershot, Ashgate, 2000), pp. 167–83.

36 It went uncommented on in the profile of Gale and his work written by James Dafforne for the *Art Journal*'s British Artists series ('British Artists, Their Style and Character', no. 89, 1 December 1869, pp. 373–5). The painting is presently untraced.

37 No. 1171, no. 569 and no. 936. This is the Howard of penal reform, who published an account of the lazar-houses of Italy in 1789: see Leicester Museums and Art Gallery, *The Victorian Vision of Italy*, 1968, p. 17.

38 See Yale Centre for British Art, *Classic Ground: British Artists and the Landscape of Italy*, 1981. This catalogue gives a good idea of the stock range of sites which British artists, even in the mid-century, still regurgitated.

Rome as it is, from the Palatine Hill (Victoria and Albert Museum) utilised a familiar pre-Victorian idea of the before and after, treated most commandingly by Turner, in a sequel to his 1858 drawing, *Rome as it was* (Victoria and Albert Museum). Such images conveyed no sense of the momentous events being acted out in the country that year, even though they exemplified 'transience and the decay that overcame the greatness of Rome'.[39]

So it is by comparison with her own other exhibit at the Academy that year that the political directness of Benham Hay's canvas is made most stark. *A Boy in Florentine Costume of the 15th Century* [6] is so numbered to suggest her paintings were not hung together, but a pointed contrast was surely meant by the artist. This canvas has an unmistakable family likeness: of the same format, it shows the Tuscan landscape similarly occupying roughly two-thirds of the picture space, exhibiting several identical features such as the locally characteristic cypresses and white-walled cottages in the background, and a boy of similar age – appearing indeed to be the self-same child in reality as that representing England. This inscrutable child whose introversion magnetises the viewer is dressed in support of the title's directive, that this Italy is far distant in time from the mid-Victorian viewer. This is the paradise in which the boy geniuses grew into the stars of the Renaissance. They may have been championed effectively for Victorian art-lovers by Vasari some three hundred years earlier but were still vivid in this public's pantheon, the Vasarian vision of Italy having been markedly revived in the 1840s and 1850s.[40] Benham Hay's (significantly anonymous, generic) Renaissance youth can be seen as their brother and particularly as a comment on the exquisite young Giotto who fed this hero-worship in the canvas which had shot Frederic Leighton to instant fame in the Academy four years earlier, *Cimabue's Madonna being carried through the Streets of Florence* (Royal Collection). Those Victorians who preferred to gaze upon Renaissance Italy rather than confronting modern Italy[41] were challenged by Benham Hay's contrasting sets of boys to connect their habitually romantic image of Italy with their immediate knowledge of it as a site of current events.

39 Bristol City Museum and Art Gallery, *Imagining Rome: British Artists and Rome in the Nineteenth Century*, 1996, p. 116.

40 See Hilary Fraser, *The Victorians and Renaissance Italy* (Oxford, Blackwell, 1992), pp. 2, 44–5, 50. Vasari was first translated into English, by Mrs Jonathan Foster, in 1850–52.

41 *Ibid.*, p. 39.

England and Italy's boldness becomes even clearer if comparisons are made with other exhibits with Italian subject-matter contributed by women to that year's shows. Female artists, only yet emerging as a class, were not collectively encouraged to produce history painting, whether ancient or modern. Earlier in the year, Margaret Tekusch had shown *The Comrades* (untraced) at the Society of Female Artists: despite its title allowing a political reading, it depicted two Italian organ-boys resting, 'relieved by an elaborately painted landscape background', and was much admired by the *Art Journal* as a picturesque genre scene.[42] Similarly, Elizabeth Murray, a very familiar name in the annual London exhibitions by 1859, exhibited at the SFA that year her usual fare of Italian anecdotal pictures featuring street performers, beggars, pilgrims, peasants and ruffians. Again, they were generally greeted as anecdotes of touristic charm.[43] In addition, many women exhibited Italian landscapes at all the exhibitions that year, as was habitual (both among them and in the shows).

Whether despite or because of Ruskin's appraisal of the painting, *England and Italy* was not bought from the Academy. It appeared, still for sale, later that year at Liverpool's annual Autumn Exhibition, and was noticed in the artist's London home in March 1861 by George Eliot, who wrote to her friend Barbara Bodichon that she had seen there among Benham Hay's works 'a view near Florence with a foreground of stones (exhibited the year before last) [which] pleased me highly'.[44] The dependence of art's meaning on context is illustrated pointedly here: neither artist nor viewer, it seems, though both steeped in the Italian question, chose to identify this painting as a political statement only two years after its interpolation in the urgent discourse provoking its production.

Between the Academy exhibitions of 1859 and 1860 the Italian situation of course continued to develop. Palmerston's restoration to power in June made itself felt, and Britain took part in the negotiations that

42 'The Society of Female Artists', *Art Journal*, 1 March 1859, p. 84.

43 See *ibid.*, p. 83 and 'The Society of Female Artists', *Athenaeum*, 19 February 1859, pp. 257–8. Two of these Italian subjects were reproduced in the *Illustrated London News: Pfifferari playing to the Virgin: Scene in Rome*, 26 March 1859, p. 305 and *Beggars at a Church Door in Rome*, 2 April 1859, p. 353.

44 Gordon S. Haight (ed.), *The George Eliot Letters*, 9 vols (New Haven, Yale University Press, 1954–78), 3: 388. Haight mistakenly identifies this painting as its companion exhibit, *A Boy in Florentine Costume*, which does not fit Eliot's description nearly so well as *England and Italy*.

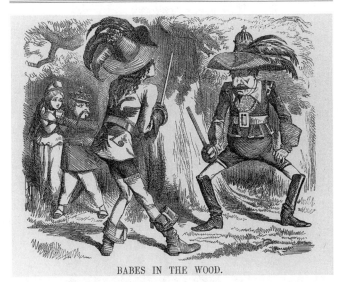

BABES IN THE WOOD.

8 John Tenniel, 'Babes in the Wood', *Punch*, 28 May 1859

followed the armistice of Villafranca in late August 1859.[45] The middle class was kept up to date after the close of the exhibition season by more ephemeral images and ever more text: 'When was England ever tired of reading, hearing, dreaming about Italy? If she ever was so, assuredly that is not her present case', declared a reviewer of Mrs Gretton's *The Englishwoman in Italy* in April 1860.[46] The allegedly documentary pictures in the *Illustrated London News* and the confessedly partial cartoons in *Punch* extended the imagery of the Italian Question which Benham Hay proffered in the Academy. *The Illustrated London News* offered maps, views and portraits of the leading actors in the events: these actors, drawn from the realm of the real rather than the symbolic, were almost exclusively male. *Punch* deployed the traditional conception of nation as an allegorical woman – with much less dignity than Barrett Browning had achieved – in its concurrent treatment of the subject, in cartoons appearing in May and July [8 and 9]. *Punch*'s Italy, either because she is

45 Barrett Browning's comment was, 'Would that England, that pattern of moral nations, would forget herself for the sake of something or someone beyond. That would be grand.' See her letter to H. F. Chorley, autumn 1859, in Kenyon (ed.), *Letters*, 2: 336. Her 'A Tale of Villafranca' was published in the *Athenaeum* in September (included subsequently in *Poems Before Congress*).

46 'The Englishwoman in Italy', *Athenaeum*, 14 April 1860, p. 503.

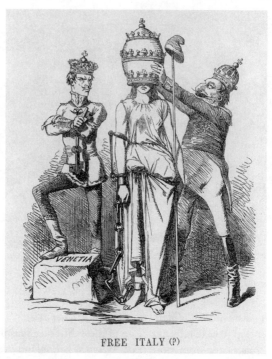

FREE ITALY (?)

9 John Tenniel, 'Free Italy(?)', *Punch*, 23 July 1859

a helpless child or because she is made vulnerable by her idealism, needs
or suffers the help or protection of male champions continuing to wrangle
for influence or power over her/it. Tellingly, a series in the *Art Journal*
entitled 'Rome and her Works of Art' by James Dafforne, which began
in May 1859, burst suddenly in October 1859 into political discourse:

> We stand in need of no 'special correspondent' to report to us, for the
> information of our readers, the march of contending armies, to tell
> of victories and defeats, to describe the horrors of war, the field of
> slaughter, the desolation of countries, the ruin of city and hamlet, the
> destruction of home and habitation, the letting loose 'the dogs of war'
> over the fairest portions of God's earth, when 'Sacked towns, and
> midnight howlings through the realm/Proclaim their presence': such
> tasks we are not called upon to perform, – and we are perfectly willing
> to leave them to other hands. But yet events have taken place recently,
> which, viewed in connection with the remarks made in the opening
> chapter of this series of papers, we can scarcely pass over . . . The eyes
> of the civilised world have, during this brief period, been turned to
> some of the Italian States struggling to emancipate themselves from

the bondage of the foreigner or the vassalage of native rulers. The contest has terminated as suddenly as it was commenced. The surface of the land has been deluged with the blood of no craven hearts among the hostile ranks, yet whether the cause for which it was so freely poured forth has been attained, can scarcely be doubted.[47]

Though it was initially thought in Britain that the agreements reached in January 1860 signified a resolution of the conflict that had raged the year before, with the declaration in March generally seen as the long-awaited sign of victory for the Kingdom of Italy, 1860 has been described as 'the year of Italy's greatest tension'.[48] Despite this, already in April – just before the opening of the year's Academy – the Italian question was being treated by some as a piece of history: Day and Son published an album of forty lithographs from drawings by one Carlo Rossoli entitled *The War in Italy*, described in the *Art Journal* as illustrating 'the sad theme yet fresh in memory . . . a contest the briefest, yet the most eventful, that has ever influenced the future of the eastern world'.[49] However, J. Beavington Atkinson, writing in the May issue, more pessimistically described 'the impending state of Italy' as 'the victim probably in coming years of military rapine, political uproar, and social anarchy'.[50]

Opening as usual in the spring, the principal exhibitions of 1860 saw the inadequacy of the familiar touristic dream of Italy to speak to the moment hinted at both by reviewers[51] and by the better landscapists. David Roberts' leading Academy exhibit, *Venice – the Piazza of Saint Mark's*, showed this well-known site filled with Austrian troops rather than merely pigeons and souvenir-sellers, although the work was not the fruit of an eye-witness experience of recent events but derived from a

47 Part 4 (1 October 1859), p. 301 'Rome and her Works of Art'. The series appeared in the following instalments: 1 May, pp. 137–40; 1 June, pp. 189–92; 1 August, pp. 237–40; 1 October, pp. 301–4; 1 December, pp. 361–4; 1 January 1860, pp. 13–16; 1 March, pp. 73–6; 1 July, pp. 201–4; 1 September, pp. 261–4; 1 November, pp. 325–9.

48 Alaya, 'The Ring, the Rescue and the Risorgimento', p. 57; see the *Illustrated London News*'s special correspondent's portentous reports on 25 February 1860, p. 190 and 3 March 1860, p. 203.

49 'Reviews', *Art Journal*, 1 April 1860, p. 128.

50 'The Arundel Society', *Art Journal*, 1 May 1860, pp. 133–4.

51 'Bella Italia! So richly endowed with every gift of nature, with bright skies and bounteous soil, 'tis man alone that prevents your beauteous land from becoming a perfect paradise', lamented the commentary to Harry Johnson's British Institution exhibit *Under the Vines* (*Illustrated London News*, 17 March 1860, p. 268).

trip made four years previously.[52] But Benham Hay's bold contribution to the political discourse of the year before was echoed more directly in the Academy of 1860 by another figurative composition, exhibited by the Danish painter Elisabeth Jerichau in only her second appearance at the Academy.

Jerichau's now unknown *Italy* embodied the country in a young male figure, 'sitting in the gloom of a dungeon', 'on whose brow the sufferings of his prostrate country have settled the darkest cloud of despair'.[53] It is difficult but not impossible to discuss an invisible painting: this one can be related *in absentia* to the artist's earlier figure of nationhood, *Denmark* (1851), her subsequent *Britannia rules the Waves* (1863) and – most of all, because of its sex – her later *Dying Pole* (RA 1869). It was seen as a portentous rather than an optimistic image, the face of the 'vigorous half-length' read as 'strongly mingling the agony and shame of the past with purpose and hope for the future'.[54] Jerichau's taking up of the Italian question can be connected not only to her already demonstrated capacity for the iconography of the nation-state but also to the fact that she had established a studio in Rome in 1845 and lived thenceforward half the time in Italy and half the time in Copenhagen. A recent appraisal has claimed that '[a]part from her portraits, her most popular work was genre paintings with Italian subjects',[55] confirming Jerichau's identification with Italy although ignoring her 1860 canvas.

The artist's ambition as well as the ability which she displayed in this high artistic genre were noted but suggested as somewhat aberrant in *The Times*' allowance that the life-size canvas showed 'such power of drawing and colouring as have rarely been manifested by a female painter'.[56] That such strength of purpose was at one and the same time unfeminine and characteristic of a contemporary trend had been indicated the year before at Jerichau's Academy debut: the *Art Journal* had

52 Roberts, resident in Rome 1853–54, 'comes out in unusual force this year', observed the *Illustrated London News* ('The Royal Academy Exhibition: third notice', 2 June 1860, p. 544); and see the 'The Royal Academy', *Athenaeum*, 26 May 1860, p. 725. By contrast, his two views of Rome shown at the Academy of 1859, though up-to-date, included no reference to contemporary politics. On Roberts, see Barbican Art Gallery, *David Roberts*, 1986.

53 'The Royal Academy', *Illustrated London News*, 9 June 1860, p. 563 and 'The Royal Academy', *Art Journal*, 1 June 1860, p. 168.

54 'The Royal Academy', *The Times*, 7 May 1860, p. 11 and 'The Royal Academy', *Illustrated London News*, 9 June 1860, p. 563.

55 Charlotte Christensen, in Delia Gaze (eds), *The Dictionary of Women Artists*, 2 vols (London, Fitzroy Dearborn, 1997), 2: 738.

56 *The Times*, 7 May 1860, p. 11.

greeted her now unknown *Danish Shepherd Dog and Sheep* as a 'very spirited work – we were about to say, for a lady; but ladies now paint with as much power as the other sex'.[57] As time went on, those aspects of Jerichau's work which disconcerted critics in 1859 and 1860 came to be overtly termed masculine, one reviewer reporting in 1863 the alleged comment of the German painter Cornelius that '[t]his woman is the only man you have amongst you'.[58]

Jerichau's other two exhibits in 1860 included *Mother's Delight* (untraced), an Italian genre scene also life-size, which showed a peasant mother dandling a child on her knee, in time-worn fashion: no exception was taken to this more familiar and feminine picture of Italy offered by the artist. Though it may not have survived, *Italy* was listed amongst Jerichau's most celebrated works by Ellen Clayton when she wrote up the artist's achievements for her compendium *English* (sic) *Female Artists* in 1876,[59] and demonstrates her readiness to make painting articulate issues of the moment: 'Madame Jerichau is perilously political; this is a picture which can only hang with impunity in a free atmosphere', commented the *Art Journal* with rebuking asperity.[60]

More acceptable to the generality of viewers was an exhibit like Joseph Jopling's *L'Italia* (no. 143, untraced), a small watercolour at the New Society's show which showed a more familiar trope in its collapsing of Jerichau's two paintings' themes into one digestible package: a female peasant as the embodiment of the new nation. The use of women – or Woman – by male artists as symbolic or allegorical vehicles, especially of nation or race, was so established as to be unexceptional; countries were commonly referred to as feminine, and some lent themselves semantically to being gendered female. The female artist's employment of male figures for the same purpose did not, though, enjoy the licence of tradition. It was novel and independent-minded at the mid-century. Though the use of children could be understood as a nod to the prescriptions of femininity, in these attention-seeking canvases both Benham Hay and Jerichau, in refusing the symbolic elision of woman and nation – which Barrett Browning accepted as powerful precisely because of its unification of the author and her subject – positioned the author as independent of

57 'The Royal Academy', *Art Journal*, 1 June 1859, p. 170.

58 'The Works of M. and Mme. Jerichau', *Art Journal*, 1 August 1863, p. 152.

59 Ellen C. Clayton, *English Female Artists*, 2 vols (London, Tinsley Brothers, 1876), 2: 106.

60 *Art Journal*, 1 June 1860, p. 168. It appears to have influenced William Gale's already mentioned exhibit at the following year's Academy, *Naples 1859*, which also showed male patriots imprisoned for their ideals.

her subject, a seeing and commenting agent fashioning a vision outside the self.[61] While male artists had shown an inclination throughout the decade equally to symbolise the contemporary nation-state in a female allegory and personify it in a realistic male (such as the soldier), these compositions signified differently – and progressively – viewed as they were not only for their literal appearance but also as the creations of their authors.[62] These canvases, greeted essentialistically as women's work, gave the lie to the tradition of narcissism determining and confining women's art; they said, women's subjectivity can be intellectual not emotional; women's vision can project beyond themselves; women's voices can speak humanity, rather than femininity. It tells much of female artists' gathering confidence that in taking up the vocabulary of nationhood and mid-nineteenth-century idealism these two artists could not only see but work beyond the habit of thought which identified the female artist with female subject-matter and locked her in thereby to the naturalised limitations of the 'woman's sphere'. Whether these paintings elicited praise, disapproval or feigned indifference, they rattled the bars of the cage which had defined women's creative space and confined the female artist to pictures (and the word seems appropriate here in its implied littleness) that functioned only to perpetuate the status quo.

Another woman concerned about the politics of women's creativity who explicitly appreciated Jerichau's exhibit was Joanna Boyce, who had known Benham Hay before her emigration to Italy through their mutual friend Anna Mary Howitt, and who was herself represented that year at the Academy with a composition of historical Italy, *The Child's Crusade* [10].[63] Her subject was an alleged incident from the thirteenth century in which bands of boys left France and Germany in pilgrimage to the Holy Land to claim it for Christendom.[64] The artist had thought of it before ever going to Italy but it came to life during a trip to that country which she made in 1857, a trip which became her honeymoon when she married her travelling companion, portraitist Henry Wells, in Rome. She clearly meant this to be a major work: 'I began a subject with

61 See Gilbert, 'From *Patria* to *Matria*'.

62 Discussed by Pamela Gerrish Nunn in 'Derring-do and the Damsel Nation in Distress' at the conference on Art and the British Empire, Tate Britain, July 2001.

63 This information and similar below comes from the artist's unpublished private papers: see Pamela Gerrish Nunn, 'A Centre on the Margins', in Harding (ed.), *Re-framing the Pre-Raphaelites*, pp. 43–60.

64 For the history of this incident and critique of its legend, see Peter Raedts, 'The Children's Crusade of 1212', *Journal of Medieval History*, 3: 4 (December 1977) 279–323.

10 Joanna Mary Boyce, *The Child's Crusade*, 1857–60

four figures which I told you I had in contemplation when I was at Brighton, an episode from the boys' Crusade', she wrote in November 1857 to her best friend; 'If you are by any chance asked what I am doing, do not mention this.' During the course of its production, she enlarged it so that, at its final dimensions of 81 × 59cms, it became the largest work in her entire oeuvre.

Once again, it is a scene which uses a boy as its emotional centre, as the artist's way of defining its subject in her correspondence indicates. Though he is joined in dramatic urgency with his kneeling mother, whose vermilion robe and anguished fortitude draw the eye; with his presumed sister, a second, smaller child clutched by their mother; and with an elderly monk, whose watchful protection the young hero reaches out for, it is in the boy that the future lies and the moral dilemma is his. His mother may emanate the drama of the moment, but he is the locus

of the drama of the future – and Rome, resonant with history's richness, is the theatre of European fulfilment: according to some reports, some of the 'crusaders' reached Rome, where the Pope urged them to return home, rather than exhorting them on.

Though Boyce was acquainted with Benham and other progressives, she clearly chose not to respond to the contemporary reality of Italy even though the country had impressed her. Authenticity was an assumed aspect of her practice – 'I painted one of the principal heads and the feet appertaining from a Todi boy and managed to get in nearly all the background from a street and cellar in the place. I hope to finish it in Italy, but am very doubtful if I can', she wrote home – but, like many English visitors then, she experienced Italy as a living museum as much as she recognised it as part of a modern Europe in the making. It is also relevant to note that, though the visual material she gathered while in Italy could have furnished contemporary compositions, Boyce's ambitions lay high up the hierarchy of genres, and modern history painting (in Madox Brown's sense)[65] was not as highly regarded by the majority of cultural arbiters as subjects from the past. This painting followed in a steady line of episodes from Roman, Florentine or Venetian history which greeted the English gallery-goer year after year. More forthright than most of these, however, Boyce's vigorous treatment here shows the continuing influence on her of the French artists Thomas Couture and Ary Scheffer, painters of the 'juste milieu', which she had encountered during her training in Paris in 1855.[66]

The Child's Crusade was badly hung by the Academy, and thus little noticed in the press, though described by one newspaper at the artist's unexpected death the following year as 'her most important work known to the public',[67] and praised by many of her acquaintances ('I think I may safely say I feel more real satisfaction in the hearty sympathy I have had about the hanging of my picture than if it had been on the line at the RA, because amongst other reasons it is a far more reliable proof that my work is good for something', wrote Boyce in an unpublished letter). Though the artist planned to exhibit it again, it never found a purchaser.

The Italian question could have been expected to attract the attention also of Eliza Fox, who did not in fact appear in exhibition in 1859,

65 See Lucy Rabin, *Ford Madox Brown and the Pre-Raphaelite History Picture* (New York, Garland, 1978).

66 See Pamela Gerrish Nunn, *Victorian Women Artists* (London, Women's Press, 1987). Another painting generated by Boyce's Italian experience was the also historical *La Veneziana*, which appeared at the RA in 1861 (destroyed; ill. *ibid.*, [10]).

67 'Fine Arts', *Athenaeum*, 27 July 1861, p. 121.

ironically because of her travels in Italy, which were prolonged by romance: 'In 1858 Miss Fox went to Rome, in order to improve herself in her art, and there she married Mr Frederick Lee Bridell, the landscape painter.'[68] While her husband's speciality of Italian landscapes is given by some historians as a reason for her sojourns in the country,[69] Fox's own politics, inherited from her father and endorsed by her Unitarian circle and friends such as the Brownings,[70] provided her with a radical attachment to this site of such intense topical interest. Indeed, Fox's perception of Italy as a subject of political rather than picturesque interest was already apparent at the 1857 Academy, where she showed a Shelley subject called *The Patriot* (untraced), which she re-exhibited the following year at the Society of British Artists. In the 1860 Academy could be seen her more ambiguous *Amongst the Ruins, Rome*.

Fox's output reflects the complexity of the female artist's position at this point: she knew herself to be the object of cliché, curiosity and controversy, but on the whole wanted to become an unexceptional member of the profession – merely part of the furniture, so to speak, able to earn her living and compete equally with men for the rewards that art offered the talented worker in modern society. Thus in 1861, Fox appeared at the Academy exhibition with a popular form of Italianism which continued the vein of women's art manifested in the works already discussed: her *Departing to join Garibaldi* was a composition with boys as its protagonists, located in a recognisably Italian setting.[71]

All these women's boys and youths conjure the figure of the man who became during 1860, with his dashing Sicilian campaign, the popularly favoured symbol and personification in Britain of a unified Italy, and who has arguably remained the most visible embodiment of Italian

68 Clayton, *English Female Artists*, 2: 85–6.

69 'With this kind, congenial friend and instructor, Mrs Bridell stayed for long periods in Italy, Italian landscapes being Mr Bridell's favourite themes' (*ibid.*); Fox married Bridell in Rome in February 1859. See Brenda Collins, 'Tottie Fox, her Life and Background', *Gaskell Society Journal*, 5 (1991) 23–4.

70 Elizabeth Gaskell was a mentor, while Elizabeth Barrett Browning recommended her to Ruskin in June 1859. Fox's portrait of the late Barrett Browning was shown at the SBA in 1866. A portrait of Barrett Browning done in Rome dated 1858 sold at Sotheby's in 1951. See Richard Garnett, *Life of W. J. Fox* (London, John Lane, 1910).

71 Noted by *The Times* thus: 'Volunteers embarking on one of the North Italian lakes; very true, apparently, and unaffectedly painted, but hung too high for proper examination' (13 May 1861, p. 6). If this is *Garibaldi's Volunteer*, which was exhibited at the Whitechapel Gallery in 1894 as the property of the artist, it would seem that Fox was as unlucky in finding purchasers as Benham Hay and Boyce.

unification. Giuseppe Garibaldi's legend began in 1849 but developed steadily until his adoption in the 1860s by Britons of many sorts as a veritable folk hero: 'Garibaldi was formerly known to Italy and to the world as a wild, daring and enthusiastic republican, barely distinguished by personal bravery and military aptitudes from the more corrupt elements of the Italian movement in 1848. To a comparatively few only perhaps at that time was he known for that which is now on the lips of everyone, a sincere and unselfish patriot and an honest man', wrote one British admirer in late 1859.[72] Thus in 1864, when the man himself visited London, *The Times* declared: 'In a few days one of the most remarkable men in Europe will set foot on these shores.'[73]

This heroisation of Garibaldi as a living symbol can be seen fostered vividly in the burst of drawings appearing in the *Illustrated London News* in June 1860 after the paper sent its own artist to the latest scene of struggle in the battle for unification, Sicily:[74] Frank Vizetelly's drawings [11] of virile conflict, echoing the imagery of the Napoleonic wars as well as recalling the 1848 revolutions, offered readers a conventionally heroic image. His pictures of Garibaldi himself, and his colleagues and lieutenants, come over as the visual product of a man-to-man conversation between the intrepid reporter and his subjects. This image is domesticated in John Bagnold Burgess's *Garibaldi's Plea* [12], painted in 1860 but apparently unexhibited at the time: the daughter of the house – a representative British bourgeois establishment of the mid-century – pleads on her knees with her presumed father for the Garibaldian, romantically bearded and cloaked, waiting in the background. Here, if Garibaldi is the romantic hero of the struggle for a united Italy, British womankind is his chief worshipper.

What does it mean, then, that no female artist seems to have represented Garibaldi to the English gallery-goer in his shining hour, though they could evidently envisage the new nation as male and represent its future lying in its menfolk? Perhaps it indicates the limits of women's own confidence in their abilities and authority, perhaps the deeply ingrained jealousy with which patriarchy guards its own symbols from the eye and hand of women; but one of the difficulties of writing women's

72 Colonel George Cadogan to Lord John Russell, 31 October 1859, quoted in Denis Mack Smith (ed.), *Great Lives Observed: Garibaldi* (New Jersey, Prentice-Hall, 1969), p. 101.

73 *The Times*, 24 March 1864, p. 8.

74 *Illustrated London News*, 26 May 1860, p. 495. Representative illustrations appear 16 June 1860, cover page; 16 June, p. 585; 23 June, p. 609; 29 December 1860, pp. 622–3, 26 January 1861, pp. 72–5, 79.

11 Frank Vizetelly, 'The Revolution in Sicily: Giuseppe d'Angelo',
 Illustrated London News, 23 June 1860

history is still the absence of evidence on which to build certainties. At any rate, an answer must consider that it is highly probable that some works produced by female artists on this topical subject were not given a public showing at the time and that not all have survived to testify for themselves. Equally, it must take into account that all the works discussed here seem to have failed to sell, and understand the newly professional female artist as a commercial operator who could not necessarily afford to be only a social commentator.

The Italian Question was not, of course, finished or solved in 1860: it rumbled on, leading one recent commentator to say of the 1860s, 'It would be difficult indeed to overestimate the quantity of dinner-conversation London's cultural elite must have expended, during that Italy-fevered decade, upon the creative resolution of the Italian question.'[75] It cannot indeed be said to have become complete until 1870, but 1859 was its pivotal

75 Alaya, 'The Ring, the Rescue and the Risorgimento', p. 59; for example not only George Eliot's *Romola* (1863) but George Meredith's less obliquely related *Vittoria* (1866).

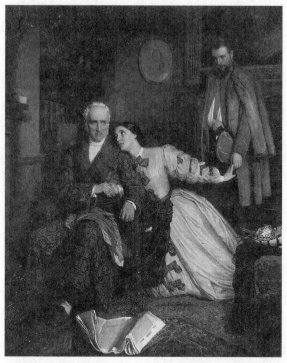

12 John Bagnold Burgess, *The Return of the Garibaldian/Garibaldi's Plea*, 1860

moment, and this significant episode in British culture's love affair with the Italianate can be seen as an important and resonant moment made vividly modern by the assertive participation of female artists.

Their reaching out extended the territory on which women in mid-century Britain stood, making it less and less credible to generalise about 'Woman' as a way of keeping women under control. The paintings presented here constitute a vivid manifestation of the agency that progressive women claimed in the mid-nineteenth century, and of the potential that female artists had to contribute to their sex's entrance into the civic realm, into the general discourse which made up 'public opinion', and thus into the making of modern Europe, of which the unification of Italy was such a significant part.

7

The difficulty of Italy: translation and transmission in George Eliot's *Romola*

Nicola Trott

THE FIRST CHAPTER of George Eliot's Italian novel opens with a pedlar, Bratti Ferravecchi, coming upon a foreigner sleeping in the street, whom he leads in search of food, and in the hope of turning a profit from his unexpected find, to 'the Mercato Vecchio, or the Old Market'.[1] There, Bratti is met by crowds of people, gossiping about the death of Lorenzo de' Medici and associated portents. This 'confusion of tongues' (p. 16) is an apt and dramatic way in which to introduce the shipwrecked stranger, Tito, to the hubbub of Florence in spring 1492; but it also seems to be half-humorously emblematic, both of the position into which George Eliot has cast her equally unfamiliar reader, and of her own experience in coming to grips with a vast range of alien material; entering 'as a new-comer' to the discussion, Bratti is depicted as 'busy in mentally piecing together the flying fragments of information' from phrases 'shot across each other like storm-driven hailstones' amid a 'pelting . . . of gutturals' (pp. 16, 17).

Romola, notoriously, is a research-led novel. Since its sources are for the most part in languages other than English, it is also a work of translation. Sometimes, for reasons I shall come to presently, it reads like a work *in* translation. On taking up George Henry Lewes's suggestion of Savonarola as a subject for 'historical romance',[2] George Eliot set herself to master not only fifteenth-century Italian, but fifteenth-century Tuscan, and not only that, but the peculiar variety of the Tuscan dialect spoken in Florence. Not surprisingly, then, questions of language were a pressing concern. When actual composition got properly under-way in January 1862, Eliot was reading 'Müller's book on Language',

1 George Eliot, *Romola*, ed. Andrew Brown (Oxford, Clarendon Press, 1993), p. 13; references are to this edition unless stated otherwise.
2 Gordon S. Haight (ed.), *The George Eliot Letters*, 9 vols (New Haven, Yale University Press, 1954–78), 3: 295.

and re-reading Machiavelli's *Mandragola* 'for the sake of Florentine expressions'.[3] Thomas Adolphus Trollope, who lived in Florence, was asked to give advice on points of local usage, but Eliot accepted his emendations to the proofs of part one of *Romola* only when they were confirmed by her own research: Varchi's *Storia fiorentina*, whose ninth chapter is referred to as 'contain[ing] many passages highly interesting to me',[4] also allowed her to confirm Trollope's 'impression' of the correct meaning of '*netto di specchio*'[5] (signifying the rights a citizen gained by virtue of being 'clean' of debt, or not being entered in the 'public book' of debtors), the topical sense of which she then incorporated into her text – ' "That is what is meant by qualification now" ' – and registered, for her reader's additional benefit, in a note at the foot of the page.[6]

The Leweses first visited Florence between 17 May and 1 June 1860. When they returned, in May 1861, T. A. Trollope was joining his brother Anthony as a writer of novels, and his first work of the kind, *La Beata*, was almost the first thing George Eliot recorded reading back home in London.[7] Though it was not historical, this 'story of Florentine Life' seems to have provided a starting-point for overcoming the fictional difficulty of Italy.[8] On 5 July, Eliot wrote to Mrs Trollope with a compliment meant for her husband: 'While reading *La Beata* I constantly feel as if Mr. Trollope were present telling it all to me *vivâ voce*'.[9]

It was the live voice Eliot herself hoped to catch yet despaired of producing. Only a month earlier, Blackwood, who thought he would be publishing *Romola*, had been fretting privately to his wife that, in place of the 'real language' of her English novels, Eliot had 'a weight upon her mind as if Savonarola and his friends ought to be speaking Italian instead of English'.[10] Odd as it may sound, however, *Romola* is by some lights very much a continuation by other means of a Wordsworthian 'real

3 Margaret Harris and Judith Johnston (eds), *The Journals of George Eliot* (Cambridge, Cambridge University Press, 1998), pp. 107, 108.
4 Harris and Johnston (eds), *Journals*, p. 106.
5 Haight (ed.), *Letters*, 3: 431 (dated by Haight to June 1861, but revised by Brown, *Romola*, p. 600, to June the following year).
6 Eliot, *Romola*, pp. 17, 599.
7 Harris and Johnston (eds), *Journals*, p. 96.
8 *La Beata* supplied the name Tito (or reminded Eliot of the artist of that name), an example of sexual betrayal and of monkish fanaticism, something of the childish character of Tessa, and a sense of what could be done with carnivals and festivities.
9 Haight (ed.), *Letters*, 3: 435.
10 *Ibid.*, 3: 427. This complaint was echoed by Joan Bennett, among others in *George Eliot: Her Mind and Art* (Cambridge, Cambridge University Press, 1948).

language' experiment.[11] When George Eliot annotated '*Boto*' as 'popular Tuscan for *Voto*', Trollope acknowledged it as a genuine 'Florentinism', commenting that she 'no doubt met with it in some of those old chroniclers who wrote exactly as not only the lower orders, but the generality of their fellow citizens, were speaking around them' (pp. 599, 16, ch. 1). As this comment goes to show, Eliot's 'real language' is incorrigibly literary, its vernacularisms dug up out of history books, or corroborated by reading in Boccaccio or the *Novelle* of Sacchetti, whose 'colloquial usage' came to the defence of certain 'phrases' queried by Trollope, and whose 'intensely idiomatic' dialogue became the model for various exchanges in the novel.[12]

Romola's language is 'real' enough, but not as we know it. The daring of the experiment is as much linguistic as it is historical; and, though critics have settled on the latter as grounds for complaint,[13] it is perhaps to the language, as much as anything, that the novel owes its awkward reputation. Yet the problem of language is also turned, if not to advantage, then at least to a vantage of a kind. That problem revolves around the necessity of translation, which arises from the assumption that educated Victorians, while they might be assumed to have Latin, would probably lack Tuscan. In *Romola* necessity becomes the mother of fictional invention. For one thing, there is a resident alien, Tito, who straight away receives instruction on how to handle the local lingo (p. 37, ch. 3). For another, a constant effort is made, by means of repetition and other mnemonic devices, to turn foreign words into 'real language': time and again, Eliot introduces an Italian locution, with its English translation, or a contextually derived meaning; and then re-introduces it, over succeeding pages, with a progressive expectation of naturalisation. On its first appearance, in chapter twelve, the word 'Piagnoni' is accompanied by both a footnote definition, and the speaker's

11 Andrew Thompson and Felix Gilbert draw attention to the politics of the Italian vernacular language question in *George Eliot and Italy: Literary, Cultural and Political Influences from Dante to the 'Risorgimento'* (Basingstoke, Macmillan, 1998), p. 83; 'Bernardo Rucellai and the Orti Oricellari: A Study on the Origin of Modern Political Thought', *Journal of the Warburg and Courtauld Institutes*, 12 (1949), p. 118. For 'the patriarchal politics of language events' in the novel, see Susan M. Bernardo, 'From Romola to *Romola*: The Complex Act of Naming', in Caroline Levine and Mark W. Turner (eds), *From Author to Text: Re-reading George Eliot's 'Romola'* (Aldershot, Ashgate, 1998), p. 89.

12 Haight (ed.), *Letters*, 3: 432, corr. 9: 347; Eliot, *Romola*, pp. 127, 631, ch. 12; pp. 173, 637, ch. 16.

13 See Eliot, *Romola*, p. xlvi; and David Carroll (ed.), *George Eliot: The Critical Heritage* (London, Routledge & Kegan Paul, 1971), p. 196.

explanation that this is the name for the ' "new saints of Fra Girolamo's making" '. A few paragraphs later, and the term is re-inserted into the conversation, with identifying behaviours, but otherwise unremarked (pp. 125, 127). Similarly, just pages after it has offered a stall of 'hot *berlingozzi*, a favourite farinaceous delicacy', chapter fourteen recycles the word as a metaphor, for the sale of quack marriages, ' "hot, eaten, and done with as easily as *berlingozzi!*" ' (pp. 140, 144).

Where single expressions are in question, the Italian is in effect anglicised. Curiously, it is the English definition that feels the strain: 'a favourite farinaceous delicacy' is sufficiently ludicrous as a description of local grub. Elsewhere, especially where a sense of dialect is aimed at, Eliot's method is to English the Italian. Her 'real language' centres, as we have seen, on 'popular Tuscan'; and popular Tuscan appears almost at once, together with the character of Bratti, and identified with him in physical type – 'the type which, in Tuscan phrase, is moulded with the fist and polished with the pickaxe' (p. 10). This 'phrase' speaks for itself, acting out its own proverbialism with amusing vigour. But something very remarkable has happened in the process. Transliteration, or a literal translation, has been preferred to a free idiomatic rendering in modern English – or, indeed, to either antiquarianism (of the 'olde English' sort) or linguistic blending ('Engliano', as it might be). When, early on in their acquaintance, Bratti tells Tito, ' "you were not born of a Sunday – the salt shops were open when you came into the world" ' (p. 13), his wording manages to ask readers to infer the English proverbial usage ('You weren't born yesterday') while allowing them to glimpse its Italian equivalents (for which Brown notes the source in *Decameron*, 8: 9).[14] *Bolla di sapone*, the Italian phrase for something insubstantial, transliterates as ' "his talk was a mere blowing of soap bubbles" ' (pp. 345, 654, ch. 39); while a sample from chapter four, ' "you come like cheese ready grated" ', was Englished only after it had appeared in Italian for the *Cornhill* serialisation (pp. 41, 608). The method can also present wholly unidiomatic expressions, only to repeat them as they would naturally fall out in Italy: the Proem, for instance, talks of 'not believing anything from the roof upward (*dal tetto in su*)'[15] (pp. 7, 594; one source here is Lastri's *Osservatore fiorentino*). In this example, an estrangement from the native tongue is released in the ready volubility of the Italian – the hope presumably being that, by arranging it to be experienced as a kind of relief,

14 Eliot, *Romola*, p. 597.
15 The order is sometimes reversed, as in ' "*solco torto, sacco dritto* – many a full sack comes from a crooked furrow" ' (p. 391, ch. 45).

fifteenth-century Florentine will be made contemporary and present in a way that, for the moment, nineteenth-century English startlingly is not.

Such acts of 'translation' can be read in either direction: Italian is being rendered into English, but, equally, the English itself is made to feel foreign, as though it were somehow the second language of the text. At the same time, the effect is to make the Italian less alien than it might otherwise be, and this familiarisation is crucial to the novel as an *English*-language historical fiction. Yet it remains a counter-intuitive process: striking peculiarity is found just where proverbial usage is anticipated. Being true to the Italian involves putting the English out of true. To Blackwood's worry about Eliot's characters sounding as though they 'ought to be speaking Italian instead of English', it might be said that, quite often, they *do* speak Italian, even when ostensibly speaking English. It should also be said that – as the Proem establishes – the narrator is from the nineteenth century; and that there is a sociological spread among the characters from the fifteenth: at the upper, Latinate end of the language-spectrum, Savonarola and friends don't deal in street-slang – though their tendency to 'talk proper' has itself brought charges of historical inconsistency. Ever ready to make a fetish of accuracy, Eliot thought it necessary, in preparing the Cabinet edition for the press, to inform readers that the sermon delivered by Savonarola, in chapter twenty-four, 'is not a translation, but a free representation of Fra Girolamo's preaching in its more impassioned moments' (pp. 232, 645). The sermon is the exception that proves the rule; and its freedom from translation is due not just to passion but to there being a viable alternative language, in the prophetic books of the English Bible.[16]

The ramifications of Eliot's method do not stop there. *Romola*'s translations have figurative as well as literal applications: indeed, the literal sense of translation, a transferral from one place to another, also describes the *figurative* action of historical fiction. By an odd symmetry, the period in which Eliot was occupied with her Italian novel opened and closed with communications from the translators of her own writings;[17] and, in the novel itself, 'translation' becomes at once an object of historical inquiry and a mode of historical understanding. It seems no accident, then, that the various translations in *Romola* produce an awareness of sameness and difference which corresponds very precisely to the

16 In 'Power and Persuasion: Voices of Influence in *Romola*', in Levine and Turner (eds), *From Author to Text*, p. 125, Beryl Gray contrasts Savonarola, whose 'need ... to speak his native Italian is obviated', with the 'unspeakable pains' George Eliot took to find the 'Idiom' of Florence. See Haight (ed.), *Letters*, 4: 301.

17 See Haight (ed.), *Letters*, 3: 416, and Harris and Johnston (eds), *Journals*, p. 117.

sort of comprehension of the past which governs the novel. That comprehension insists both that 'the changes are great' over the centuries, and that 'things have not changed'. It consists in taking a stand 'on a certain historical spot', while recognising 'the broad sameness of the human lot, which never alters in the main headings of its history' (Proem, pp. 9, 3). *Romola*'s subject requires it to make twin, and divided, commitments to historical specificity and transhistorical continuity. And the medium in which it is written, translation, is the exact rhetorical equivalent of these theoretical commitments. For translating brings about the identity of languages even as it recognises their disparity.

On historical and linguistic grounds alone, *Romola* is a novel of intensely self-conscious translatability. One of the promoters of its novelistic awareness is the fifteenth-century Tuscan poet Luigi Pulci. Pulci's role is important for both internal and external reasons. Internally, his association with Nello makes him a representative figure for all the gossipy elements circulating in and around the barber's shop, ' "the focus of Florentine intellect, and in that sense the navel of the earth" ' – and also, it follows, of the novel (p. 32).[18] Externally, his representativeness extends to the tradition of English comic verse which had sprung up in the earlier nineteenth century around Byron's translation of the first Canto of *Il Morgante Maggiore*, Pulci's burlesque epic about the adventures Orlando has (post-Ariosto) with his giant friend. Burlesque epic is a generic hybrid which makes a transition – an exhibitionist leap, rather – from classical to vulgar.

In a novel of such '*epische Breite*' as *Romola*,[19] Eliot's repeated citation of burlesque epic is striking. As with so much else in the work, there is an unease about linguistic register, but, beyond or within that, there is also an attempt to gain a novelistic purchase on the material of the period such that the vernacular can be placed on an equal, or at least a conversational, footing with the scholarly, and vice versa. Nello's little Latin might, after all, correspond to the reader's lack of Tuscan. Fifteenth-century Pulci represents a learned, and to that extent 'high', culture for Eliot's own contemporaries while at the same time operating, for contemporaries in the novel itself, as a source of local idiom and familiar reference. He can serve both these apparently opposed ends because the quotations from his poem arise in a novel whose setting is

18 Lawrence Poston, 'Setting and Theme in *Romola*', *Nineteenth-Century Fiction*,
 20 (1966) 355–66 (p. 358) and Felicia Bonaparte, *The Triptych and the Cross:*
 The Central Myths of George Eliot's Poetic Imagination (Brighton, Harvester
 Press, 1979), p. 132.
19 Haight (ed.), *Letters*, 3: 317.

separated from its time of writing by nearly four hundred years; *Il Morgante Maggiore* is one of the many routes by which *Romola* conducts its inquiry into sameness and difference, or – putting it another way – cultural change and equivalence.

Eliot's latitudinarian inclusion of *Morgante* is offset against the work's inclusion for burning amongst 'other books of a vain and impure sort' in the Dominican Bonfire of the Vanities in chapter forty-nine (p. 423). Her 'fifteenth century' presents a 'strange web of belief and unbelief' (a mesh in which, we gather, the origins of nineteenth-century thinking lie entangled). Pulci is first named, in the Proem to *Romola*, as a thread in the unbelieving weave of this fabric, a scepticism which puts him in the company, not just of fellow-diners at the table of Lorenzo de' Medici, but also of fellow-doubters among the classical world: 'Lucretius might be right – he was an ancient, and a great poet; Luigi Pulci, too, who was suspected of not believing anything from the roof upward (*dal tetto in su*), had very much the air of being right over the supper-table, when the wine and jests were circulating fast, though he was only a poet in the vulgar tongue. There were even learned personages who maintained that Aristotle . . . was a thoroughly irreligious philosopher' (p. 7). Though he is distinguished from the ancients by language and learning, Pulci sits alongside them in outlook and mentality. And, all of thirty-nine chapters later, diners at the 'Supper in the Rucellai Gardens' resurrect the memory of his meal-time irreverences (p. 345).

As Pulci's place in the novel indicates, the 'web' of *Romola* works to throw into relief the perhaps surprising links between very different eras and levels of cultural life. These links suggest an aesthetic interest which operates in ways that are more than one-dimensional – the equation of Pulci, say, with materialism or immorality[20] – and which might qualify the strictly symbolic structure that has often been attributed to the novel. Chapter one begins with Dante, the divine poet, rubbing shoulders with 'unhistorical . . . wool-carders' across two centuries (p. 10). Contacts of this kind are kept up throughout. Dante, who is epic but also vernacular, is often casually met with, as when Nello sees in unshaven men a ' "brutalizing chastisement befitting our Dante's *Inferno*" ' (p. 35). Nello's talk is full of such crossings: his comparison of the benefits of giving Tito a shave to crossing the Rubicon might be seen as emblematic of the species (p. 29). The difficulty is that the actual phrasing is often the reverse of casual – is, on the contrary, a sort of impossibly highbrow

20 Bonaparte, *The Triptych and the Cross*, pp. 140–1; Thompson, *George Eliot and Italy*, pp. 4, 76, 82.

shop talk. This difficulty is partly of the novel's own making: the attempt to colloquialise elite culture often acts only to make it more conspicuous. Still, that seems to be rather the point. As the instances of cultural exchange multiply, it becomes clear that they amount to a claim about the novel itself, as a genre of inveterately mixed resources. In two significant areas, this claim is taken up on the part of the narrative itself. One arises where the narrator's scholarly quotation of a source suddenly alerts readers to the possibility that the action of the novel is simultaneously immediate and indirect, fictional and historical (e.g. pp. 88, 336–7, chs 8, 38). The second occurs in portraying Savonarola, where the method of portrayal is fixed by appeal to the narrator's take on classical culture. Savonarola is of a type that fascinated George Eliot, the type of the flawed or frustrated hero, of greatness that is marred by egotism; and it is here that the mixed material of the novel comes into its own, with a modernising, warts-and-all revision of epic pretense which seeks to reclaim the heroic for common humanity:

> It was the fashion of old, when an ox was led out for sacrifice to Jupiter, to chalk its dark spots, and give the offering a false show of unblemished whiteness. Let us fling away the chalk, and boldly say, – the victim is spotted, but it is not therefore in vain that his mighty heart is laid on the altar of men's highest hopes. (p. 238, ch. 25)

Narrative directions of this kind serve to remind the reader that *Romola* is made up of innumerable temporal and cultural fluctuations – or, in literal and non-literal senses, translations.

Much criticism of *Romola*, in its day and ours, has dwelt on the lack of continuity in the novel's historical setting, observing, for instance, that the Victorian heroine in the foreground is out of keeping with the quattrocento history in the background.[21] Yet, even had it remained

21 See R. H. Hutton, in Carroll (ed.), *George Eliot*, p. 204, 'she is a shade more modernized than the others'; *Westminster Review*, in Carroll (ed.), p. 217, 'wish[es] that Romola had been a modern Englishwoman, she having so much more the character of one than that of an Italian lady of four centuries since'; Leonée Ormond (ed.), George Eliot, *Romola* (London, J. M. Dent, 1999), p. xxviii: '*Romola feels* like a nineteenth-century heroine'. For the argument that 'This was not simple anachronism', see Gillian Beer, *George Eliot* (Brighton, Harvester Press, 1986), p. 117; for a recasting of the inconsistency as a problem of genre, see George Levine, ' "Romola" as Fable', in Barbara Hardy (ed.), *Critical Essays on George Eliot* (London, Routledge & Kegan Paul, 1970), pp. 78–98; and for the extreme position, that the 'historical apparatus . . . may probably be ignored for all but its Victorian connotations', see Carole Robinson, '*Romola*: A Reading of the Novel', *Victorian Studies*, 6 (1962) 32.

strictly in period, the work would still have had present-day interests. For the grand subject of *Romola* is the foundation, in reformed religion and Renaissance knowledge, of modern European culture. Although the history is more distant in time and space than in her Warwickshire fiction, this too is a novel which tills the land out of which the novelist herself has been formed. The horizon of these conditions, however, can be seen to reach as far back as the dawn of civilisation:

> The progress of organic nature, say the naturalists, is from East to West. Almost everything necessary, useful & pleasant in the vegetable world has gradually proceeded from Asia towards the West. So with human development & culture. Was it that in the first revolution of our globe on its axis the East was first towards the Sun . . . & so this priority, like the first move in chess, gave the East precedence in all things?[22]

This entry in Eliot's notebook is drawn from Adolf Stahr's *Torso*, a treatise on ancient Greek art which held to the theory that it had grown out of still earlier, oriental civilisations. The westerly drift of culture was a favourite positivist-gradualist argument with Eliot: her own translation of the corresponding passage in the German original recurred in two successive reviews of Stahr's work, before its ideas ended up, in 1866, in a poem called 'Ex Oriente Lux'.[23] Eliot habitually thought of 'human development & culture' as moving from east to west. And Stahr's *Torso*, or Eliot's appropriation of it, seems peculiarly relevant to a consideration of *Romola*. For what clearer evidence of such an inevitable movement could there be than the Renaissance? – the name coined by the Victorians themselves for the period when the written records of that ancient world with which Stahr was concerned literally came west.[24]

But *Torso* presents an opportunity for reading *Romola* allegorically as well as historically. The passage Eliot translated for inclusion in her reviews of the work made the point that the 'propagation' of Asian accomplishments did not cease until temporarily 'arrested at the western coast of Europe'.[25] To read her Italian novel as an allegory of cultural 'propagation' is to be aware that its historical specificities are but one instance of that general law, a law which operates in relation to modernity as much as it does to the fifteenth century. A letter to Blackwood reveals,

22 Joesph Wiesenfarth (ed.), *George Eliot: A Writer's Notebook 1854–1879 And Uncollected Writings* (Charlottesville, University Press of Virginia, 1981), p. 11, entry 26.

23 Wiesenfarth (ed.), *Writer's Notebook*, pp. xviii, 245, 281, 285.

24 See Ormond (ed.), *Romola*, p. xx.

25 Wiesenfarth (ed.), *Writer's Notebook*, p. 245.

tellingly, that Eliot valued Florence 'from its relation to the history of modern art'; and that this relation was now directly associated with her own new and 'ambitious project' in fiction.[26] While Renaissance Italy had been the ground on which ancient texts were propagated, their modern medium of cultivation (after the feats of German textual criticism) was English.[27] And if, as Stahr proposes, the temporary resting-place of culture has been 'at the western coast of Europe', then its furthest development, and Europe's most westerly point, was to be found in Britain.

From this perspective, *Romola* emphatically means to be a nineteenth-century novel, and to act out, in its own writing and publication, the very process of transmission from east to west to whose earlier historical phase it bears witness: as Greek culture once migrated to Italian shores, so now Britain inherits and refines upon the advances of Italy. Eliot's 'romance' is itself material evidence for just such a movement. The evidence even extends to its composition, since the research done in Florence during 1861 was brought back to London, and continued there until writing began in earnest in the new year. More than this, though, the novel takes its place among many other Anglo-Italian works of the mid-1800s – the Risorgimento era – yet is perhaps the only one to historicise and to reflect upon the process of transmission itself; and since Eliot's first efforts in fiction were simultaneous with her reading of Greek tragedy,[28] the first printing of which was owing to Renaissance scholarship,[29] *Romola* may also be said to reflect upon its author's own creative origins and cultural making.

The basis for reflection is an Italy which, imaginatively at least, falls mid-way between ancient Greece and Victorian England. The reason the history of Renaissance Florence is also that of 'modern art' is, presumably, because it identifies the origins of the latter in the moment at which east and west meet, and are inextricably mingled. As has already been suggested, this principle of integration seems to be recognised at a generic level also. If the novel as a genre is the beneficiary of transmission – if, indeed, it is one of the forms produced by that historical process – it is so on

26 Haight (ed.), *Letters*, 3: 300; 27 May 1860.
27 See Richard Jenkyns, *The Victorians and Ancient Greece* (Oxford, Blackwell, 1980); *Dignity and Decadence: Victorian Art and the Classical Inheritance* (London, HarperCollins, 1991).
28 Harris and Johnston (eds), *Journals*, pp. 63, 66, 70; 22, 23 August 1856, 14, 28 February 1857, 1, 12 August 1857.
29 L. D. Reynolds and N. G. Wilson, *Scribes and Scholars: A Guide to the Transmission of Greek and Latin Literature*, 2nd edn (Oxford, Clarendon Press, 1974), pp. 138–40; for the earlier history of transmission, see pp. 46, 59, 61, 177–8, 193.

inevitably mixed terms. And in many respects, those terms can be seen in the characteristic features, be they formal, linguistic, or rhetorical, of *Romola* itself – albeit with what can only be described as mixed results.

Eliot's Florence is a ground crowded with cultural traffic, and filled with the traces of that vast endeavour by which ancient learning was transported to the west: *Romola* is greatly occupied with the business of that transmission in all its historical complexity. For while the novel may have begun life, in 1860, as a Savonarola 'romance', it soon developed a rival centre of interest in the recovery of classical knowledge. Tito addresses the subject, characteristically lightly, in chapter three: ' "I have heard that your Tuscan sculptors and painters have been studying the antique a little" ' (p. 32). Eliot for her part, needless to say, had been studying it a lot: early on in her English researches comes the diary entry, 'Read Gibbon on the revival of Greek learning'.[30] Gibbon in turn led her to Tiraboschi, where she read about 'the Discovery of Ancient MSS.', and to Humphrey Hody, in whose *de Graecis Illustribus* she found 'the life of Marullus'.[31] As novel-writing recommenced, she was looking into 'Finlay's History of Medieval Greece', and chapter four got underway in the company of the 'geography' of Christopher Wordsworth's *Greece*.[32]

Romola's attempt to 'vivify' this revival of learning begins in its opening pages,[33] where the Spirit of the Proem recalls having sight before he died of 'the first sheets of that fine Homer which was among the early glories of the Florentine press' (pp. 7, 593). What he saw was not only the first sheets, but the first printed edition, of 1488; and it is this same edition that is later incorporated as a key text of the novel itself, when it is put before Baldassarre, at the dinner in the Rucellai Gardens, in chapter thirty-nine. Its editor, Demetrius Chalcondylas, is familiar-ised, meanwhile, by taking on an Italian sobriquet as 'our excellent Demetrio', after which he is held up to Tito as a model Greek by the barber who shaves him; recalled by Romola's father to have praised her intelligence when he tutored her in the classics; and, having left for Milan, is presented as an excuse for promoting Tito to a university chair (pp. 38, 26, 29, 54, 65, 95–6, chs 2–6, 9). The poet and translator, Poliziano, conversely, sometimes goes by the Latin version of his Italian name, but enters the novel as 'Messer Angelo', the defender of Tuscan

30 Harris and Johnston (eds), *Journals*, p. 98; 24 July 1861.
31 Harris and Johnston (eds), *Journals*, p. 101; 28–31 August; p. 106; 9 December 1861.
32 Harris and Johnston (eds), *Journals*, p. 108; 22 January 1862; p. 110; 24, 27, 28 March.
33 Haight (ed.), *Letters*, 4: 457.

(pp. 30, 603, 32, 37–8, ch. 3), and returns, in various guises, as the young man who gave 'lectures on the Latin language', in chapter three (p. 35); as the author of *Miscellanea*, the Latin commentary on ancient texts from which Romola is reading aloud – as translated into English by Eliot herself – in chapter five (pp. 48–9, 611, 79); as the victor in the scholars' quarrel which occupies chapter seven, and as Professor of Greek and Latin, under the patronage of Lorenzo de' Medici, in chapter nine (p. 95). He is a topic of conversation in life (pp. 39, 41, 52, 122, 133, 169–70) and death (pp. 265, 343–4); and emerges as the composer of *Orfeo*, whose Bacchic chorus is to be played by Tito at the end of the Rucellai banquet (pp. 353–4, 656) – an occasion which, for those in the know, alludes to the work's historical performance, in 1480, and to an art form that was brought to the west from Greece and perfected in Florence.

These movements across the novel are a mere fraction of the total effort, not simply to record, but to *act out*, the transmission of knowledge. In quest of this fictional objective, *Romola* finds room for historical representatives from every type of cultural activity – travellers and translators, printers and professors, scribes and scholars, collectors and editors, philosophers and patrons – and seeks to establish them all as household names. Given that they are mostly 'mere names', this is a high-risk strategy.[34] It works, if at all, by mnemonic devices similar to those used to naturalise the Italian language. The familiar plotting of Victorian fiction, in which significant details recur in the larger design of the whole (the 'figure in the carpet'), is here pursued to fantastic lengths, as it needs to be if the novel is to retain the reader's hold on its immensely complex array of people, terms, places, parties, and events. Novelistic patterning is paramount, and operates in ways that are already implicit in the individual instances of Demetrio Calcondila and Angelo Poliziano – that is to say, through personal relationship (Eliot's Florence is a global village in which everyone knows, and refers to, everyone else); professional occupation (her Renaissance men work in a variety of media and languages, and often have several roles to play); and fictional parallelism (her historical figures have their counterparts among the invented characters, so establishing a more or less continuous sense of parallel lives).[35]

34 See the *Saturday Review*, in Carroll (ed.), *George Eliot*, pp. 208–9: 'Most of the Italians introduced are mere names to us . . . the names of men about whom we know nothing and care nothing, even when the most indefatigable and ingenious antiquarian has tried to teach us and to interest us'.

35 See Lesley Gordon, 'Greek Scholarship and Renaissance Florence in *Romola*', in John Rignall (ed.), *George Eliot and Europe* (Aldershot, Scolar Press, 1997), pp. 181–2.

Another kind of patterning allows for the possibility of collective labour, in places or institutions whose dedication to the gathering, memorialising, or furthering of knowledge enables them to serve the novel's purposes as well, by bringing together its diverse sources of information. In the first assemblage of this sort, Bardo's library, a Renaissance collection becomes also a collection of the Renaissance (chs 5–6). Since Romola is the 'only spot of bright colour' among its 'lifeless', 'mutilated', and 'obsolete' artefacts (pp. 48, 52), the scene casts self-mocking glances upon the novel's hopes of 'vivify[ing]' the past. Yet, even so, it seeks to dramatise a life lived among ' "the great dead" ' (p. 51). However distorted by Bardo's own blindness, physical and mental, the inventory of texts, manuscripts, and objects summons the memory of all those with whom they, and he, have been associated. His books prompt comparisons with those of rival collectors, his scholarship with rival scholars, his learning with those who have taught him; and the introduction of Tito marshals the whole narrative of travel and trans-mission, starting from the time when the Greek's ' "countryman" ', and uncle of one of Bardo's tutors, ' "Manuelo Crisolora, diffused the light of his teaching in the chief cities of Italy, now nearly a century ago" ' (p. 60).[36] The effect of that teaching culminates in *Romola*'s second symbol of a collective enterprise, the 'Platonic Academy' of Florence. This site of transmission is not so backward-looking as Bardo's library, and in theory at least sums up the entire phenomenon of cultural 'pro-pagation': the Academy, whose members convene in chapter thirty-nine, is a monument to Medicean patronage and, under Cosimo, has been responsible for the single greatest act of transmission of the age, Marsilio Ficino's Latin translation of Plato. Nevertheless, Ficino is viewed sceptically by both the Aristotelean Bardo ' "as the very high priest of Platonism" ', and by the narrator, as having a mind made 'a little pulpy from that too exclusive diet' (pp. 183, 53, 343). And the Academy itself is now in a decadent state: following Lorenzo's death, meetings have been transferred to the less 'transcendental' setting of the Rucellai Gardens, and chapter thirty-nine is dominated by jaded palates and murky politics.

Those two arenas have one thing in common: Tito Melema. In many ways, the character of Tito embodies the novel's cultural relation-ships. His fictional existence apparently unfolds as the means by which *Romola* gives formal recognition, both to its own movements, and to its attempts to construct an aesthetic order from the history of transmission.

36 See Reynolds and Wilson, *Scribes and Scholars*, pp. 130–2.

Born into beggary at Bari, in the Greek colonies of southern Italy
(p. 61, ch. 6), Tito has been adopted by a Neopolitan classical scholar,
Baldassarre, travelled with him to Greece on '"a pilgrimage full of
danger"' (p. 65), before turning up as a stranger in Florence, where both
his learning, and his detachment, are much in demand. He is what has
survived the wreck of Greece – he lands, in the first chapter of the novel,
having literally suffered a shipwreck. So, Tito comes from afar, and
carries with him the foreign knowledge which has been the foundation
of Renaissance Italy. Yet the crucial point here is that Tito is not fully
Greek: as he tells Nello, in chapter three, '"I come of a Greek stock
planted in Italian soil . . . and, in fact, I am a Greek very much as your
peaches are Persian. The Greek dye was subdued in me, I suppose, till I
had been dipped over again by long abode and much travel in the land
of gods and heroes"' (pp. 29, 603). In other words, he is a naturalised
Italian. If he is a 'propagator of degeneracy'(p. 35), as Nello playfully
suggests, it is a degeneracy bred from within by transplantation, yet one
that is taken for a product of 'native', exclusively Greek, growth.

From its nineteenth-century perspective, *Romola*'s hybridisation also
works in two directions; its Florence looks east as well as west, is Greco-
as well as Anglo-Italian, and presumably intends these twin relations to
mirror or reflect upon one another. Eliot dubbed the city 'this Italian
Athens',[37] and her novel makes the best of its variously awkward generic
and historical joins, by passing them off as inherent to the Renaissance
itself. On first meeting, Nello boasts to Tito of '"Lorenzo de' Medici, the
Pericles of our Athens"', before adding, more tentatively, '"– if I may
make such a comparison in the ear of a Greek"' (p. 28, ch. 3). Cultural
traffic produces cultural exchange and, to an extent, as has been said,
equivalence: Tito returns the compliment, in chapter eight, by comparing
a procession of banners dedicated to Florence's San Giovannito '"Minerva
with her peplos"' – Athena in her Roman form (p. 88, ch. 8).

Greco-Roman mythology also serves to uphold the Stahrist allegory
of the novel. Tito is repeatedly (self-)identified with Bacchus, the god of
wine whose cult spread through Greece and Asia, before coming west
with the Romans. In the positivist interpretation of the myth – to which
George Eliot would have been drawn – the god's migration describes
the spread of civilisation: culture and viniculture go hand in hand. In
Romola, Tito's Bacchic affinity performs a similar allegorical function,
suggesting as it does a close association between his voyages to and
from Greece and a myth of vegetable and cultural 'propagation'. It is

37 Haight (ed.), *Letters*, 3: 300.

symptomatic and, given his adoption by an Italian, natural, that Tito should appear alongside the wine-god's Roman designation, Bacchus, and not that of his Greek original, Dionysus. At the same time, those disguised origins are brought out by the ' "Greek dye" ' into which he has been ' "dipped over again" ' on his travels. But, as it happens, even this Levantine staining has eminently Florentine credentials: the noble name of 'Rucellai' turns out to have its roots in a Greek word for a dye-producing plant which 'Tuscan tongues speedily' naturalised as one of their own (p. 335, ch. 38). (The analogy with the novel's anglicising of Italian is there for the making.) Bardo, a Grecian snob of the old school, holds ' "no man . . . worthy of the name of scholar who has acquired merely the transplanted and derivative literature of the Latins" '; but even he has to admit the virtue of mixed varieties when observing that ' "the barbarous Sultans" ' have begun to ' "engraft on their wild stock the precious vine" ' of Greek culture (pp. 60–1, ch. 6). *Romola*, meanwhile, has been doing some grafting of its own. Into the stock debate between Greeks and Latins, ancients and moderns, the novel has implanted some very difficult questions about the relative merits of racial and linguistic purity on the one hand, and miscegenation and adaptation on the other. That these horticultural expressions of sameness and difference occur in the context of language-use is especially interesting, because it implies a convergence between the novel's representations of transmission and its acts of translation. Their point of convergence seems to be Tito himself.

Partly assimilated and partly alien, Tito lives out the novel's preoccupations with sameness and difference. And, like the novel also, he necessarily uses the 'stranger's' medium, of translation – his first words in chapter two are 'in a language which was not Tuscan or even Italian', but which are rapidly converted into the latter (pp. 23–4). Tito's translations operate on several fronts: biologically and culturally, as we have seen; economically – he gains employment, first ' "as a corrector with the Cennini" ' of ' "Greek sheets" ' then going to press (pp. 69, 62, 41, 43), later as 'a professor likely to render the Greek classics amiable to the sons of great houses' (p. 96) – and politically: he acts as a go-between for various factions, in a 'triple game' involving the Mediceans, the Savonarola interests of the 'Frateschi'[38] and 'Piagnoni of the popular party', and 'the aristocratic party, or Arrabbiati', with its younger splinter-group, the '*Compagnacci*, or Evil Companions', who are enemies of all concerned (pp. 477–80, 349, 392–3, 659, chs 57, 45). Added to which he

38 Ormond (ed.), *Romola*, p. 606.

does some on-the-spot interpreting, on three occasions in particular – when greeting the French King, on his arrival in Florence, in his own tongue (pp. 239–40, ch. 26), when announcing to the people the terms of their treaty with France (pp. 266–7, ch. 29), and when appeasing the populace by putting into Tuscan the Signoria's Latin proclamation on Savonarola's trial by fire (pp. 521–2, ch. 63).[39] If 'translation' means changing places, Tito does so all the time, playing each group off against the others.

Tito the carrier of culture is also a bearer of the novel's deepest ambivalences – as he himself declares, he becomes ' "as soiled and battered with riding as a *tabellario* (letter-carrier) from Bologna" ' (p. 394, ch. 45). In her notebook rendition of Stahr's theory of development, Eliot had compared the 'priority' of the East to 'the first move in chess'. The metaphor of chess recurrs in *Romola*, but much more darkly. There, the moves relate to a 'game' in which, for all his evasion and manipulation of events, Tito finds himself check-mated by his own wife (chs 47–8).[40] In his journey through the novel, the Stahrist pattern of cultural 'progress' takes a decidedly ironic turn; and that turn has implications for modernity quite as much as for Renaissance history. *Romola* includes a host of figures through whose efforts ancient learning reached the west; but the fact that George Eliot chooses Tito as the fictional embodiment of that transmission casts a long shadow over the brilliant spectacle of the Renaissance and, by extension, over the new centres of cultural hegemony in Victorian Britain. Temperamentally, Tito is committed to a sunny evasiveness. Philosophically, he is aligned with the pleasure-seeking strand in ancient Greek thought. And mythically, as we have seen, he is related to Bacchus. But this Bacchic triumphalism, too, has a dark side. In his pursuit of 'pleasure', Tito uses the attendant cults of 'youth' and 'Nature' to justify his abandonment of his adoptive father, Baldassarre (pp. 117–18, ch. 11). The terms of Tito's neo-epicureanism inevitably prompt comparisons with the still more 'radically natural view' being advanced by nineteenth-century evolutionary theory. Its social applications have yet to emerge, but will soon be latent in the shape of a callously Spencerian survival of the fittest; and have already been prepared for by a loftily 'philosophic view of the past' as a 'smiling

39 The translation is of course into English, which the reader is to understand as standing in for Tuscan.
40 The game of chess goes back to the Proem, pp. 6, 593, where it is already associated with marriage (pp. 6, 593); the 'game' of life is a key concept for Tito (for example p. 317, ch. 35).

survey of human folly' in sight of which only 'the age to come' is of sympathetic interest.[41]

It is partly against such aggressively progressive views that Eliot's own historical fiction is written. For, although Stahr's 'vegetable' model for the westerly 'propagation' of culture is deliberately inculcated in *Romola*'s metaphors of transmission, it is not without reservation. History teaches myth a lesson or two – in particular, that progress is as much a matter of loss as it is of change. In yet a third notice of *Torso*, for the *Westminster Review*, Eliot confronted head-on the political truth that we owe our knowledge of Greek art to Roman 'felony on a large scale, which, like so many other misdemeanours, we at once denounce and practise'.[42] In *Romola*, that felony is transferred to the successive assaults of Crusaders and Moslems, culminating in the fall to the Turks of Constantinople, in 1453, and Athens, in 1458. As narrated by Bardo and Tito, however (pp. 63, 65–7), this history of ' "conquest after conquest" ' is compelling for the traffic that ensued, ' "when erudite Greeks flocked to our shores for a refuge" ', and ' "when men . . . went out to Greece as to a storehouse, and came back laden with manuscripts" '. Greece's loss has been Italy's gain, and thereby ' "the gain of the whole civilized world" ' (p. 289, ch. 32). The painful reality, though, is that the felony on which such wealth depends is not merely historical; it is practised on a smaller but significant scale in the time-frame of *Romola* itself, and, by implication, is going on outside it, in modern Europe also. In the novel, the ousting of the Medici is followed by the spoliation of the Medicean Library and the selling of its fictional counterpart, the collection of Bardo himself, which he had trusted his heirs to preserve (pp. 534, 288, 650, 193–4, chs 64, 32, 19). Readers are left to register a double irony: that it is Tito, the bringer of classical culture, who is the cause of this second act of plunder, thereby confirming his father-in-law's bitter maxim, ' "scholarship is a system of licensed robbery" ' (p. 55, ch. 5); and that the beneficiaries of all these felonious acts are to be found in the culture of the nineteenth century – not excluding the 'history of modern art' to which *Romola* is dedicated, and of which its readers are the inheritors.

Transmission (like translation) cannot occur without loss. 'Translating' one culture into the terms of another is the way in which *Romola* poses its central question, of means and ends, of how knowledge is transferred from one age or idiom to another, and the costs and obligations

41 Haight (ed.), *Letters*, 3: 437.
42 Wiesenfarth (ed.), *Writer's Notebook*, pp. 276, 278.

this involves. When Baldassarre gatecrashes the meeting of the Platonic Academy of Florence in order publicly to confront Tito, he is presented with the first printed edition of Homer and asked to confirm his identity as Tito's scholar-father. At this critical moment, Baldassarre's mind fails him, and the potential Senior Common Room comedy of the test is extinguished in his anguished cry, ' "Lost, lost!" ' (p. 357, ch. 39). Eliot has placed a figure of catastrophic loss at the very centre of her fictional revival of learning. Why? In her darker understanding, apparently, the Renaissance is a period of deprivation as well as recovery. It is associated with transhistorical enlightenment – with ' "that far-stretching, lasting light which spreads over centuries of thought" ' (p. 51, ch. 5) – but also with the threat of (textual) darkness or blankness, as symbolised by Bardo's blindness and by Baldassarre's recurrent amnesia: 'once or twice, when he had been strongly excited . . . he seemed again to see Greek pages and understand them, again to feel his mind moving unbenumbed among familiar ideas. It had been but a flash, and the darkness closing in again seemed the more horrible' (p. 272, ch. 30; see also pp. 50, 278, 339, chs 5, 30, 38). These images of light and darkness represent two extremes of historical possibility, a drama of cultural memory and forgetting that is played out in Baldassarre himself. At the Academy dinner, he brings his darkness into the heart of light, and in doing so menaces, not only Tito, but the very idea of the western transmission of learning. His absence of mind stands also for the threat, which the Renaissance has supposedly averted, of the loss of the whole classical world (and, perhaps, for the fear of failure which was never far from Eliot's own mind in the writing of *Romola*).

The threat of cultural amnesia is enormously complicated by being gathered around abandoned father-figures, and their sons's unfilial forgetfulness. If the problem is one of bringing under moral law the recognition of the past by the present, of one culture by another, that problem is only exacerbated by being stated in terms of the claims the parent makes upon the child. Gillian Beer has remarked how hard it is to get fathers to die in *Romola*.[43] One notices, too, how many they are, and how culturally potent: not only Tito's father, the reification of ancient vengeance,[44] and Romola's, the stickler for Grecian values, but, beyond them, Homer and Plato, fathers of poetry and philosophy, and Savonarola, the religious 'father' who turns Romola back from her attempted flight out of marriage and into female scholarship (ch. 40).

43 Beer, *George Eliot*, p. 121.
44 See Rudolf Dircks, Introduction to *Romola* (London, Dent, 1907), p. viii.

Romola's division between the moral imperative of filial obedience and the libidinal desire of parricide may also be read as allegorising its own split between the cultural inertia of its historical learning and its novel-istic capacity for 'vivify[ing]' that inheritance.

Tito, I have suggested, is a representative of the many refugee-scholars named in the novel, as well as an ambassador, as it were, of the novel itself, standing in symbolic relation to its historical evidence, and personifying its acts of cultural transmission. He is notably the one character who moves at all levels and places within the fiction – from Nello's shop to Bardo's library, from Niccolò's smithy to the city's Signoria, from Savonarola's cell to the French court, from Tessa the contadina to Romola the noblewoman, and from Florence to Rome, Pisa and Siena. And all the while, in introducing him to the full range of its materials, *Romola* is also introducing the reader, and this introduc-tion in some sense takes in its own aesthetic methods along the way. Tito's activities correspond to the sorts of exchange in which the novel, too, is engaged. In *his* case, they are also thoroughly identified with the commodification of culture. Indeed, the very first person Tito meets is a *personification* of commercial dealing: 'Bratti', as George Eliot noted, is a colloquial contraction of *barattare*, 'to exchange';[45] and it is Bratti who leads Tito to the Mercato Vecchio and thence to Nello, who in turn introduces him to Bardo as a way of gaining access to Bartolommeo Scala and, through him, to further preferment and patronage (pp. 38–9, 394, 398, chs 3, 45). So cultural exchange is immersed in commodity culture: Tito has come to Florence as to a scholar's bazaar, ' "the best market in Italy for such commodities as yours" ' (p. 29); yet these com-modities include the jewels given to him by his adoptive father and for which he now seeks an ' "honest trafficker" ' (p. 38).

The implication of Tito's double-dealings over Baldassarre's ran-som is that cultural exchange is immoral insofar as it simulates unregu-lated economic exchange – in this instance, an exchange built on slavery. There are unspoken resonances here, with Britain and empire, and also with George Eliot herself. It is tempting, certainly, but also relevant to see in Tito's salesmanship George Eliot's guilty awareness of the negotiations for the publication of *Romola* which started in January 1861 and finally led her to desert Blackwood for Smith, Elder & Co and the *Cornhill Magazine* under its new consulting editor, who was none other than her own partner, George Henry Lewes.[46] One can even imagine

45 British Library Add. MSS 40768, cited, Eliot, *Romola*, p. 596.
46 See Eliot, *Romola*, pp. xxv–xxxiii.

that this awareness may have contributed to her 'great excitement' in killing Tito off at the end.[47] *Romola* in the planning was ringed round with protective anxiety: in May 1861, Eliot told Blackwood, 'I will never write anything to which my whole heart, mind, and conscience don't consent'.[48] *Romola* in the writing was a different story, however. It was the first novel Eliot composed to the rigid timetable of serial publication, and in continuous recognition of the literary market-place. All of this is felt in the work itself, where a commodity culture that is run by Renaissance systems of commissioning and patronage may be seen as loosely analogous to, if not allegorical of, the nineteenth-century London art-market. The choice of Piero di Cosimo as the novel's principal artist-in-residence, which has puzzled some critics, also seems explicable in these terms: he is valued for a prickly eccentricity and independence that go well beyond his patrons' wishes (as, one might add, does *Romola* itself – almost as though, in its crazy specialism, it were produced in defiance of market expectations).

And yet, the novel implies, modern art is founded on the exchanging of cultural capital. The subjects for which Piero gains commissions in chapter eighteen are Bacchus and Ariadne, and Oedipus and Antigone (pp. 188–90), and both come of the cultural traffic in which Tito specialises. Indeed, it is he who orders the first of these paintings. However indirectly, the mixed methods of the fiction become entangled with the machinations of its least scrupulous character. The novel seems to be a genre whose moral economy is at odds with its mode of transmission, and whose ethical purpose is challenged, or at least complicated, by its cultural impetus. *Romola* discovers a way out of these dilemmas, if at all, by turning to another means of organisation altogether, one that rests on the symbolic function of Romola herself, but is also, appropriately enough, drawn out of Piero's works of art. His paintings turn out to be ekphrastic sketches for the outcome of the novel as a whole.

Romola's likeness to Antigone emerges in relation to her father, Piero's model for the blinded Oedipus. Her role as Ariadne is assigned to her by Tito, who wishes to rescue her from such tragic awareness by an alliance with her Bacchus or '"Care-dispeller"' (p. 205, ch. 20). Her later appearance as '"Madonna Antigone"', a manner of address invented by Piero (p. 261, ch. 28), introduces yet a third term, and hints at her final, synthesising power. The fruit of Tito's grafting is his union with Romola, envisaged as the triumph of Bacchus and Ariadne; but the

47 Harris and Johnston (eds), *Journals*, p. 117.
48 Haight (ed.), *Letters*, 3: 417.

larger intention of the novel is to see this cultural equation as a corrupt and sterile miscegenation: as Piero privately observes, ' "my *Bacco trionfante* . . . has married the fair Antigone in contradiction to all history and fitness" ' (p. 235, ch. 25).

Romola is an Ariadne in whom the Antigone becomes more and more apparent. That sympathy with suffering leads her to reflect upon another of the novel's conflicts, one which in Romola's case echoes that of Antigone herself,[49] and which R. H. Hutton saw as the 'fundamental conflict between Greek scholarship and the mystical Christian faith which runs through the book'.[50] It is Romola who asks whether these 'clashing deities' can ever be 'reconcile[d]'; and it is she who provides an 'answer' or at least assuages the 'need' for one (pp. 182–3, ch. 17). If bacchanalian Tito is the first proposition in a series of antithetical statements – joy and nemesis, pleasure and vengeance, epicurean and eumenidean, as well as Greek and Christian, scholar and monk, pagan nature-worship and ascetic theosophy – then it is the novel's dialectical purpose to resolve these conflicts through Romola's own hard-won progression, via the false synthesis of her marriage to Tito, and the dread of being 'torn by irreconcilable claims' (p. 450, ch. 52).

Having been subject to both Bardo (blind scholarship) and Savonarola (politicised religion), Romola passes beyond them by her own sympathies to a reverent humanism – to that 'piety – which is venerating love'.[51] Many have seen this path as a positivist road to salvation; and have produced Comtist readings accordingly.[52] This is indeed one aspect of the dialectical arrangement into which Romola's ultimate transfiguration casts the novel.[53] Another has to do with transmission –

49 Like Sophocles' heroine, she is torn between a ruler and a brother; in defiance of her pagan father, she attends Dino's Christian death-bed.

50 Carroll (ed.), *George Eliot*, p. 202.

51 Haight (ed.), *Letters*, 3: 376.

52 See Bonaparte, *The Triptych and the Cross*, p. 241; J. B. Bullen, *The Myth of the Renaissance in Nineteenth-Century Writing* (Oxford, Clarendon Press, 1994), pp. 235–6. For more general accounts, see T. R. Wright, 'George Eliot and Positivism: A Reassessment', *Modern Language Review*, 76 (1981) 257–72, and *The Religion of Humanity: The Impact of Comtean Positivism on Victorian Britain* (Cambridge, Cambridge University Press, 1986), pp. 173–201. For *Romola* as 'moral postulation' rather than 'dialectical argument', see Andrew Sanders, *The Victorian Historical Novel 1840–1880* (London, Macmillan, 1978), p. 174.

53 Alternative versions are Mary Wilson Carpenter's, of *Romola*'s 'post-Christian and post-patriarchal vision of humanity' in *George Eliot and the Lands of Time: Narrative Form and Protestant Apocalyptic History* (Chapel Hill, University of North Carolina Press, 1986), p. 61; Jennifer Uglow's, of the dawn of the 'single,

one of the finer ironies of *Romola* being that, though its heroine fails in her bid to become a scholar after the historical pattern of Cassandra Fedele (pp. 54, 327, chs 5, 36), it is she who ends up passing on her classical training to the next generation. The dead-end which runs from Bardo to Dino and Baldassarre to Tito is not permitted to be final: our first glimpse of Romola is as her father's scribe, but she is last seen, in the Epilogue, talking of scholarship, among other things, to Tessa's *boy*-child (pp. 586–7). However patriarchal in origin (pp. 51–4, ch. 5), classical learning is handed down through the female line; not for nothing did Eliot subscribe £50 towards the foundation of Girton College, Cambridge, 'from the Author of *Romola*'.

A third aspect of the novel's synthetic purpose may, however, be the mere possibility of 'order' itself (p. 482, ch. 57). Tito comes to stand for power 'without traditional ties, and without beliefs' (p. 353, ch. 39). The terror of lawless unbelief haunted the atheist Eliot, most of all in her public role as a writer. The novel is clear that no such ethics-free zone is possible; indeed, its secular understanding of the retribution which lies in the 'irrevocable consequences' of 'our deeds' is quite as inexorable as that provided for by any system of divine sanction (pp. 96, 165, chs 9, 16). All the same, the troubling figure of Tito leaves us with the thought that the novel is divided against itself. For Tito's part in the web has allowed for an artistic design which cuts across canons of judgment. Both as the dark shadow of Romola, threatening false or failed transmission, and as the transplanted scion of Greece, bearing his own gifts by way of 'commodities', Tito has appeared as the equivocal exemplar of modern cultural exchange. *Romola* is to that extent a self-undoing text. Its transmissions – and translations – are incorrigibly plural and more various than its progressively dialectical structure supposes. In that respect, there is reason to be glad that, as Eliot told Hutton, 'great, great facts have struggled to find a voice through me, and have only been able to speak brokenly'.[54]

sensually aware but childless woman' in *George Eliot* (London, Virago Press, 1987), p. 174; Julian Corner's, of *Romola* as a novel '*about* . . . reconciliation' of 'authorities' in ' "Telling the Whole": Trauma, Drifting and Reconciliation in *Romola*', in Levine and Turner (eds), *From Author to Text*, p. 69; and Thompson's, of Romola 'as an "Italia" figure, a Risorgimento icon symbolising maturity, achieved independence, and fully realised identity' (Thompson, *George Eliot and Italy*, p. 4).

54 Haight (ed.), *Letters*, 4: 97.

8

'The old Tuscan rapture': the response to Italy and its art in the work of Marie Spartali Stillman

Jan Marsh

IN 1895, towards the end of her third decade as a professional artist, Marie Spartali Stillman sent a large watercolour entitled *A Florentine Lily* (see cover) for exhibition at the New Gallery in London. In a relatively narrow upright space, a single half-length female figure stands holding a stem of the eponymous Florentine lily or iris that, as the fleur-de-lys, is the city's emblem, in a room whose lancet window frames a distant view of the Palazzo Vecchio. Reminiscent of Renaissance female portraiture, the picture's manner and motifs pay homage to the city where Spartali lived and worked from 1878 to 1884, and to her enduring love of early Italian art. Unusually for the artist, the work is signed but undated, suggesting that it was probably created, if not finally completed, some time before its exhibition, and perhaps kept by Spartali until then as a token of aesthetic affection.

It is a commonplace that the works themselves are more reliable than artists' verbal pronouncements as guides to their ideas and influences. Since Spartali was an excessively modest individual who disliked personal publicity, despite needing to sell her work, and shrank from self-revelatory correspondence and conversation, her views on things Italian remain largely to be inferred. This essay aims to explore aspects of her pictorial output that form a record of visual response to the pictures, places and people of Italy. Spartali was an artist-expatriate in Italy in the last quarter of the century, when the idea of 'Italy' in the British imagination was ceasing to hold its earlier Romantic and political associations. Hitherto, her residence in Italy has been regarded as somewhat incidental to her career – to the extent that her career has been seriously considered at all – rather than as a sustained and formative influence on her work.[1] Altogether, around seventy out of Spartali's

1 A full account of Spartali's professional career remains to be written. Some information is available in two books by the present author in collaboration with

documented oeuvre of over one hundred and seventy works have Italianate themes or subjects.

Now seen as a Rossettian Pre-Raphaelite with a talent for 'greetings card' images, Marie Spartali Stillman (1843–1927) was a British-born artist whose parents were part of the Greek diaspora from Ottoman oppression in the 1820s and 1830s, migrating to join the cultured Anglo-Greek community in London. By the 1860s this included several notable patrons of the visual arts such as Constantine Ionides, who bequeathed his picture collection to the Victoria and Albert Museum and bought from many in the Pre-Raphaelite circle. As pupil to Ford Madox Brown and friend to Dante Gabriel Rossetti and Edward Burne-Jones, Marie Spartali allied herself to 'second-wave' Pre-Raphaelitism, becoming one of the few female artists invited to exhibit at the prestigious new Grosvenor Gallery in 1877.

In the early years of her career, the artist's political allegiances to national liberation, women's independence and personal idealism, were signalled in her choice of pictorial subjects celebrating Greek history and heroines; they included Korinna, scholar and poet; Athena, goddess of war and wisdom; and Antigone, who defied the state for the sake of her principles.[2] After Spartali's marriage in 1871 to American journalist

Pamela Gerrish Nunn, *Women Artists and the Pre-Raphaelite Movement* (London, Virago, 1989), pp. 98–106 and *Pre-Raphaelite Women Artists* (Manchester, City Art Galleries, 1997; London, Thames & Hudson, 1999), pp. 131–5. See also Rowland Elzea, *The Pre-Raphaelite Collections of the Delaware Art Museum* (Wilmington, Delaware Art Museum, 1984), pp. 171–9, and Julia Ionides, 'The Greek Connection – the Ionides Family and their connection with Pre-Raphaelite and Victorian Art Circles', in Susan P. Casteras and Alicia C. Faxon (eds), *Pre-Raphaelite Art in its European Context* (London, Associated University Presses, 1995). David B. Elliott, grandson and biographer of Charles Fairfax Murray, is currently writing a biography of Spartali and I would like to acknowledge his generous sharing of information and opinions. Throughout this essay I am also indebted to the chronological checklist of Spartali's works compiled by Kristen A. Shepherd for her MA thesis *Marie Spartali Stillman: A Study of the Life and Career of a Pre-Raphaelite Artist*, George Washington University, 1998.

2 In *Beyond the Frame: Feminism and Visual Culture 1850–1900* (London, Routledge, 2000), Deborah Cherry has also drawn attention to Spartali's participation in reciprocal artistic explorations of such themes in her costume sittings for photographer Julia Margaret Cameron, as well as providing an introduction to the feminist aspects of Spartali's own productions (pp. 167–73). David Elliott disputes the ascription of the latter to Spartali, seeing her as holding 'quite uncomplicated' and generally traditional views of women's position in society (personal communication, March 2001). It is however true that these early works select for depiction from mythology strong, emancipated female figures, which at least suggests intellectual homage, if not radical commitment to women's rights.

William J. Stillman, these relatively 'strong-minded' themes were set aside, and many works in the subsequent period were flower pieces and studies of children. Without more knowledge of her biography than is yet available, the reasons for this remain speculative, but are likely to include pregnancy and child care. Her daughter Euphrosyne (always known as Effie) was born in January 1872. Marie also cared for her step-daughters Bella and Lisa, as well as her terminally-ill step-son, who died in 1875. Moreover, her husband, himself a lapsed artist, held a rather traditional view that she should pursue art as a pastime rather than a profession.[3]

However, within a few years it became clear that Stillman's earnings could not consistently support a family in comfort, and at this stage Spartali (as she will here be referred to, to avoid confusion) renewed her artistic commitment, both for her own satisfaction and in order to contribute to the household income.[4] In 1875, 1877 and 1878, she sent flower pieces to the New York watercolour exhibition, in evident hope of sales.[5] Her subject pictures in this period already exhibit Italian themes, as for example *The Last Sight of Fiammetta*,[6] which was shown at both the Royal Academy (1876) and the Exposition Universelle in Paris (1878), and *Fiammetta Singing*,[7] which went to the Grosvenor Gallery in 1879. Both take their subjects from Boccaccio's sonnets under the titles given in Dante Gabriel Rossetti's volume of translations *Early Italian Poets* (1861, reprinted 1874).

3 Although during their courtship, William J. Stillman made much of their shared commitment to the arts, after marriage his conjugal support was decidedly lukewarm; surviving correspondence contains many injunctions such as the following (c. 1880): 'I am very glad you don't find inspiration to do any work – much better for you to amuse yourself with Mico [Michael, then aged around 2–3 years]', letter 532, William J. Stillman collection, Union College, Schenectady. However, for large proportions of the time, Stillman was away home on journalistic assignments, and Spartali's sustained output shows that there was no substantial hindrance to her work, however unhelpful his attitude. On this point, David Elliott believes that William J. Stillman's desire for his wife to remain an amateur artist arose not merely from his adherence to traditional gender roles, but from artistic jealousy (personal communication, March 2001).

4 Spartali's family were well to do, but disapproved of her marriage and were as reluctant to support her husband as he was to receive subsidy; later her father suffered business reverses.

5 At some stage she acquired an unidentified American dealer, whom she later described as having 'for many years ... made things easy for me abt. money' prior to his death in 1910: see letter from Spartali to Vernon Lee, 12 January 1912, Somerville College Library, Oxford University.

6 Currently unlocated.

7 Sotheby's Belgravia, 1 July 1975.

Boccaccio was and is known as a bawdy author, and might there-
fore have been regarded as an inappropriate choice for an artist like
Spartali, who certainly did not wish to be identified with lewd themes.
We cannot tell how well she knew Boccaccio at this date beyond the few
pieces in Rossetti's volume, but it may be worth noting that a decade
earlier she and her sister had afforded amusement to more worldly
artists by enthusing over Swinburne's poetry, without apparently under-
standing its indecencies.[8] Moreover, the two sonnets from which the
Fiammetta subjects are drawn are decorous, having been selected for
translation 'for their beauty alone' by Rossetti, who was certainly aware
of Boccaccio's prose bawdy in the *Decameron*. They were accompanied
by a third poem, of which he remarked: 'its beauty of colour (to our
modern minds, privileged to review the whole pageant of Italian Art)
might recall the painted pastorals of Giorgione'.[9] This was at least a hint
to the artist, whose *Fiammetta Singing* is a pastoral group with a dis-
tinctly Giorgionesque aspect.

Spartali came from a cosmopolitan background, but her family
contacts were with Greece and France (the home of her sister and
brother-in-law) rather than Italy, whose art and literature she knew
through individuals like Rossetti, whose work she admired and whom
she had once wished to marry,[10] as well as through study. By the 1860s,
London's National Gallery was already notable for its collection of work
by what were then known as the Italian 'Primitives', whose example had
prompted the naming of the Pre-Raphaelite Brotherhood in 1848.[11]

8 See Robin Spencer, 'Whistler, Swinburne and Art for Art's Sake', in Elizabeth
Prettejohn (ed.), *After the Pre-Raphaelites: Art and Aestheticism in Victorian
England* (Manchester, Manchester University Press, 1999), pp. 83 n. 43, quot-
ing the 1867 letter from Edwin Edwards to Fantin Latour, on how '*ces demoiselles
Spartali ont mis leurs pieds dans tous ces ordures*' ('the Misses Spartali have
trodden in all this filth').

9 Dante Gabriel Rossetti, *Poems and Translations* (London, Everyman, 1912),
p. 380. The third poem is 'Of Three Girls and their Talk', with its opening line
'By a clear well, within a little field.'

10 According to Dante Gabriel Rossetti's brother William, Spartali was 'very
graciously disposed towards him' in the mid-1860s and would have accepted
had he proposed; see Jan Marsh, *Dante Gabriel Rossetti: Painter and Poet*
(London, Weidenfeld and Nicolson, 1999), which cites William Rossetti's diary
for 1 March 1880 (p. 230).

11 This was due in large measure to Charles Eastlake, as chronicled in David
Robertson, *Sir Charles Eastlake and the Victorian Art World* (Princeton,
Princeton University Press, 1978). The rising interest in early Italian work is
also usefully outlined in Luciano Cheles, 'Piero della Francesca in nineteenth-
century Britain', *The Italianist*, 14 (1994) 218–60.

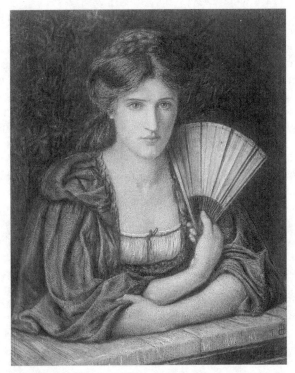

13 Marie Spartali Stillman, *Self-Portrait*, 1871

In 1878, Spartali's husband found permanent employment as a for-
eign correspondent, and when towards the end of the year the family
settled in Florence, she gained first-hand knowledge that informed her
production henceforth, as she relocated her professional practice on
Italian soil. Here she was in daily contact with painting, sculpture, fresco
and architecture from what many believed to be the finest period of
Renaissance art. This henceforth brought Italian influences and inspira-
tion to bear visibly on her own work, which steadily shed some of its
English Pre-Raphaelitism in favour of Florentine clarity and serenity.

It can be suggested, however, that Spartali had pictorially anti-
cipated the Italianate influence in the finished drawing of 1871 that is now
described as a self-portrait [13] but may well have been conceived more
in terms of an untitled study. As an undoubted self-image, it may be
said to portray the artist as a Renaissance woman, in historical pose and
costume. We have no information on her views of the contemporary
scene, but it may be noted that it was nearly twenty years since the

political struggles that engaged Elizabeth Barrett Browning, Jane Benham Hay and others at mid-century.[12]

Spartali gave birth to her son Michael in Florence, in October 1878.[13] As friends in Britain remarked, however, this was unlikely to stop her working for long. In January 1879 she asked for all her work and painting equipment to be sent out from Britain, explaining that they intended to stay in Florence for 'several years' and that although the baby was very demanding she wished to resume work.[14] A few months later Rossetti surmised that painting was going on 'over the baby's head',[15] and so it proved.

Setting to work, her first Italian productions took their cue from the location: *Gathering Orange Blossoms*,[16] and *Among the Willows of Tuscany*.[17] The former is a fanciful rendering of a woman in a sumptuous Renaissance gown reaching up to an orange tree, described as 'one of Spartali's most achieved female half-lengths'.[18] Figure and branches push forward boldly, while both costume and foliage are strikingly 'Italian' in conception. Following Tennyson's invocation of the Mediterranean lands 'of orange-blossom, / Of olive, aloe, and maize and vine',[19] for British audiences the orange tree with simultaneous flowers and fruit was almost

12 In William J. Stillman, *Autobiography of a Journalist*, 2 vols (London, Grant Richards, 1901), Spartali's husband states that his wife never read the newspapers in Italy (and was therefore unaware of premature reports of his death in the Balkans). He himself viewed Italian politics in the 1880s and 1890s as 'only the wrangle of personal ambition and faction intrigues' (2: 253).

13 The family had left Britain the year before, spending the winter with Spartali's relatives in Corfu and arriving in Florence the next summer. According to an undated letter soon after settling in Florence, Spartali told Ford Madox Brown that her time had been much taken up with caring for her sister Christina, and that she keenly felt 'the privation of not being able to paint especially where nature is so lovely' (Madox Brown Archive, National Art Library, London, copyright Victoria and Albert Museum).

14 Letter from Spartali to Ford Madox Brown, 19 January 1879, National Art Library, London, copyright Victoria and Albert Museum.

15 Letter from Dante Gabriel Rossetti to Charles Fairfax Murray, 4 January 1880, Harry Ransom Humanities Research Centre, The University of Texas at Austin.

16 Grosvenor Gallery, summer 1879; believed to be the same work as *The Orange Grove*, now in the collection of St Lawrence University, Canton, New York.

17 Royal Manchester Institution, 1880; Grosvenor Gallery, summer 1881; probably the work belonging to a descendant showing a young girl with a garland of anemones beneath willow boughs.

18 Personal communication from Pamela Gerrish Nunn.

19 See Alfred Lord Tennyson, 'The Daisy', ll. 3–4, in Christopher Ricks (ed.), *Tennyson: A Selected Edition* (Harlow, Longman, 1989).

emblematic of Italy, while the rich costume pays obvious homage to Renaissance female portraiture, with square-cut necklines and elaborate damask or embroidered sleeves.

Other works followed in quick succession: two female portraits and one of the artist's daughter, all shown at the Grosvenor winter show in 1880; two scenes from Dante's *Vita Nuova*, at the Grosvenor in summer 1880 and 1881; and three flower pieces,[20] indicating a sustained output despite the birth of a third child in August 1881, in London. As Rossetti told Charles Fairfax Murray, 'the cares of the charming Mrs Stillman have been increased by another baby.'[21] Sadly, the little boy died in Florence the following June; on a personal level part of his mother's heart was buried with him in the city, where she paid for upkeep and flowers for his grave.[22]

A photograph of what is presumably Spartali's studio,[23] taken in the early 1880s, shows several framed works ready for exhibition [14]. They include *The Chaldean Priest* (1872);[24] a smaller half-length of a girl reading which could be *The Missal*,[25] and the newly-completed *Childhood of Saint Cecily*.[26] The last is a large work in watercolour with two attractive female figures – the eponymous saint and her young mother – framed against vine leaves, honeysuckle and an Italian landscape of city walls and distant mountains.

20 Seen respectively at Grosvenor Gallery winter 1881, Grosvenor Gallery summer 1882, Liverpool autumn exhibition 1882.

21 Letter from Dante Gabriel Rossetti to Charles Fairfax Murray, 7 September 1881, Harry Ransom Humanities Research Centre, The University of Texas at Austin. This was James William Stillman, often called Giacomo in correspondence.

22 See frequent references to this task, which was undertaken by Vernon Lee after the Stillmans' departure from Florence, in Spartali's letters to Vernon Lee, Somerville College.

23 The uncaptioned photo, in a collection of materials deriving from Charles Fairfax Murray at John Rylands Library, Manchester, shows a room containing Spartali's works, with costumes and props she is known to have used, so *prima facie* this is her studio, referred to in correspondence early in 1879; however, she also sometimes borrowed or shared studios. At this date, William J. Stillman also intended to resume painting, and in his autobiography wrote 'we took a house' and 'I took a studio' (2: 209). This attempt was short-lived, however, and during the winter months following Michael's birth, Stillman was in fact away from Florence, sailing in the Aegean, 'on the track of Ulysses', reporting on excavations.

24 Private collection, USA.

25 Dudley Gallery, 1878; currently unlocated.

26 Grosvenor Gallery, 1883; now private collection, Australia.

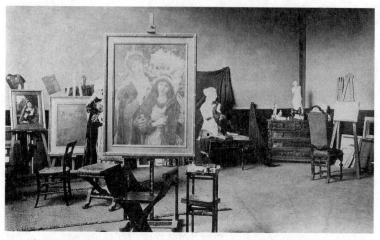

14 Photograph of Marie Spartali Stillman's studio, c. 1883

Her next works were two more figure subjects: *The Legend of Fair Women*, from Tennyson[27], and *By a clear well, within a little field.*[28] This last completed the pictorial trio inspired by texts from Boccaccio translated by Rossetti, being based on the poem specifically compared by the latter to 'the painted pastorals of Giorgione'.

While a full inventory of Spartali's oeuvre remains to be compiled,[29] *By a clear well, within a little field* brings together Italian literature and an observed local landscape for the first time. Three young women, in roughly historical costume (pink, blue and russet respectively), are seated by a stone-built wellspring, amid trees and shrubs, with a green hillside in the background stretching towards distant mountains. The landscape is tentatively achieved and over-full, but the whole offers a *mise-en-scène* appropriate to the poem, in which the girls are said to shade their faces from the sun as the artist shows them doing with chestnut leaves. It is possible that one or more of the figures are studied from 'a

27 Grosvenor Gallery, summer 1882; currently unlocated.

28 Grosvenor Gallery, 1884; John Christian, *The Last Romantics* (London, Barbican Art Gallery, 1989), no. 29; Christie's, 25 October 1991.

29 Many works, previously known only from contemporary exhibition records, are now reappearing. See, however, the list compiled by Kristen Shepherd in n. 1 above, and the forthcoming biography of Spartali by David Elliott.

charming peasant girl' Spartali hoped to use as a model in the early 1880s while completing a picture of irises.[30]

By a clear well is described as a good example of Spartali's 'gentle lyric vision',[31] which typically blends literary-romantic subject matter with soft brushwork, finely modulated colour, and hesitant drawing. Exchanging the dramatic qualities of her teacher Ford Madox Brown for the tranquil suspension of movement more commonly seen in the work of Edward Burne-Jones, her style is also indebted to the example of Rossetti's Dantesque scenes such as *Dante drawing an Angel* (1852), *Rachel and Leah* (1855) and *Dante's Dream on the Death of Beatrice* (1856). However, in composition, colour and mood, *By a clear well* is also a tribute to Italian art, its elements evoking a timeless place and contemplative atmosphere that indirectly echo works such as Giorgione's *The Tempest* in the Venice Accademia and Titian's *Concert Champêtre* in the Louvre, which was then also attributed to Giorgione. It offers convincing evidence of how far Spartali had brought her response to, and vision of, Italian art, landscape and literature to the centre of her practice, to create a distinctive pictorial aesthetic.

A decade earlier, Henry James praised Spartali's touch for its 'patience, its refinement, its deep pictorial sentiment', drawing attention to the 'grave and soft' tone of her work, which made some other, more evidently skilful pictures seem vulgar.[32] In her Florentine work, these qualities were maintained and strengthened, as Spartali responded to both the art and poetry of her domicile in a manner consonant with her aesthetic preferences for lyricism and timeless fancy individually rendered within a late Romantic mode. In her pictures, 'Italy' is a place of gentle, chaste Renaissance dreams – more Raphael than Renoir, albeit with the latter's soft focus and even an 'impressionistic' touch. Some have hints of an Italianate Arcadian landscape derived from Poussin and Claude Lorrain.

Later, in one of her few surviving comments on Italian art, Spartali would write of 'the intense deep greens and scarlet afterglows of [the] Lombard masters, so exactly what one sees from the train passing in the

30 See letter provisionally dated 1882 in Somerville College beginning 'I was so glad to get your letter your kind words sink deep into my heart'. The Group of Flags/Irises was exhibited at the Liverpool Autumn Exhibition in 1882.

31 Christian, *The Last Romantics*, cat. no. 29.

32 Henry James, 'Art', unsigned review, *Atlantic Monthly* (January 1875) 119, reprinted in Henry James, *Essays on Art and Drama*, ed. Peter Rawlings (Brookfield, Vt., Scolar, 1996), pp. 54–5.

sunset some 20 miles from Milan', and go on to contrast the keynotes of this colour scale as 'so different from the Tuscans'.[33]

During her years in Tuscany, Spartali grew familiar with most of the northern Italian schools, it being the family's habit to leave Florence for Venice in early summer, followed by some weeks in the cooler Tyrol or Dolomite districts, before returning to Florence in autumn.[34] In his autobiography (devoted to professional matters, including his contentious role as war correspondent in the Ottoman-occupied Balkans) the artist's husband noted that Florence was an ideal residence, because Spartali's 'enjoyment of Italian art was intense',[35] and her work confirms this in drawing on various elements she found most sympathetic in Renaissance painting, while ignoring other, more demonstrative and flamboyant aspects.

In its title at least, her now unlocated *Luisa Strozzi*[36] invokes Raphael's half-length portrait of Maddalena Strozzi Domi in the Uffizi. By contrast, *Madonna Pietra degli Scrovigni* [15][37] pays evident homage to Leonardo. Deploying a format similar to *Gathering Orange Blossoms*, a half-length female figure is set against a landscape background – in this case an imaginary scene of rocky mountains emblematic of the woman's name, Madonna Pietra/My Lady of Stone. The title was Dante's, or at least appended to a poem by Dante about the eponymous figure, who is thus described in Rossetti's translation:

> Utterly frozen is this youthful lady
> Even as the snow that lies within the shade;
> For she is no more moved than is a stone
> By the sweet season which makes warm the hills.[38]

On selling the picture, Spartali identified the source text, adding that her image was 'just a lady clad in green in a green stony landscape which repeats her name'.[39] Neither this characteristically modest account nor

33 Letter from Spartali to Vernon Lee 5 May 1899 or 1900. Quoted by permission of the Principal and Fellows of Somerville College Oxford.

34 Stillman, *Autobiography*, 2: 239. The family correspondence of Vernon Lee adds to this itinerary Spartali's regular summer visits to London, to see her parents, friends, and exhibitions; see for example Irene Cooper Willis (ed.), *Vernon Lee's Letters* (London, privately printed, 1937) under June/July 1881, 1882, 1884.

35 Stillman, *Autobiography*, 2: 210.

36 Royal Institute of Painters in Watercolour, 1884, currently unlocated.

37 Grosvenor Gallery and Liverpool, 1884, now Walker Art Gallery, Liverpool.

38 'Sestina: Of the Lady Pietra degli Scrovigni', in Rossetti, *Poems and Translations*, pp. 318–19.

39 See Marsh and Nunn, *Pre-Raphaelite Women Artists*, cat. no. 50.

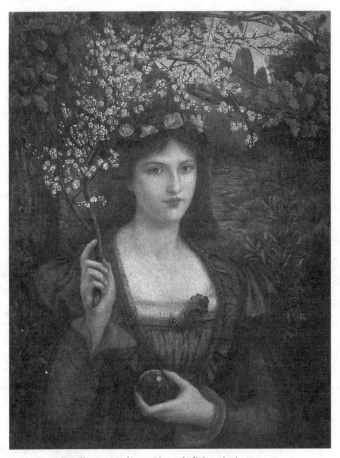

15 Marie Spartali Stillman, *Madonna Pietra degli Scrovigni*, 1884

the source text, however, allude to the elements the artist has brought to the subject: a branch of blackthorn, a garland of hellebore and ever-green oak leaves – all winter flora – offset by the warm red/orange sprig of wallflower. Once more, the figure is dressed in Renaissance costume (an actual garment that did duty in many pictures) and this time the Italianate landscape is reminiscent of that in the *Mona Lisa* (then at the start of its phenomenal fame and not yet a universal icon). To the composition Spartali also added a crystal sphere containing a vision of the Annunciation, presumably allusive to the Feast of the Virgin on 25 March, the end-of-winter season of the picture, as well as to the ubiquitous presence of this motif in Florentine galleries and churches.

At this stage of her career, she sought to secure a name and widen her repertoire, but not to strive for new effects. Having created the mode that suited her talents and tastes, she hoped always to improve the realisation of her concepts – in large part her self-deprecation was due to the artist's sense of inevitable inadequacy as works failed to achieve unattainable 'perfection' – but no more aimed at realism, political comment or plein air 'impressions' than she aligned herself with high allegory or nascent Symbolism (to name some of the art genres on offer at this time). Certainly her works show no wish to follow fashion, and to this extent Spartali stood outside the main art worlds of the day. She was nevertheless a regular visitor to the main exhibitions in London (and presumably Paris en route) while her circle of acquaintance included several fellow artists who were also Florentines-by-adoption such as Charles Fairfax Murray, who settled in the city with his Pisan wife in 1878, and J. R. Spencer Stanhope, friend and associate of Rossetti and Burne-Jones, who lived at the Villa Nuti from 1880. Other friends in Florence included scholars Henry R. Newman and Willard Fiske, professor of linguistics, writers Robert Browning, Henry James (who was there in spring 1880, beginning *The Portrait of a Lady*), Vernon Lee and J. A. Symonds, author of *Renaissance in Italy* (1875–86).[40] It is likely that she also knew the American-born artist Francesca Alexander, who collected and illustrated Tuscan *rispetti* and whose apartment boasted several reputed works by Giotto and Ghirlandaio.

Over her five years based in Florence, Spartali thus developed and refined her own intrinsic artistic mode through an aesthetic rapport, so to speak, with the art of the city and the country. Quietly, without rhetorical flourish, the works testify to an abiding admiration for the qualities of simplicity and sincerity that, notwithstanding the clear difference in scale, were seen as the hallmarks of early Tuscan art in tempera and oil. In surviving correspondence, Spartali frequently invokes her need for time and tranquillity in order to complete pictures, and these qualities too correspond to the perceived repose ascribed to Florentine works.

For the sake of the children's health, in 1884 the artist's family decided to return to Britain,[41] where she re-established her household while her husband spent some months in the United States. Unable to find work in Britain, however, he then returned to journalism, becoming foreign correspondent for *The Times*, covering Italy, Greece and

40 Other friends included the family of Linda White Villari, formerly Mazzini, whose daughter Mrs Zina Hulton sat for Spartali for her portrait in Venice in 1880.
41 Their son Michael caught typhoid, and this year also saw outbreaks of cholera in Italy, restricting travel.

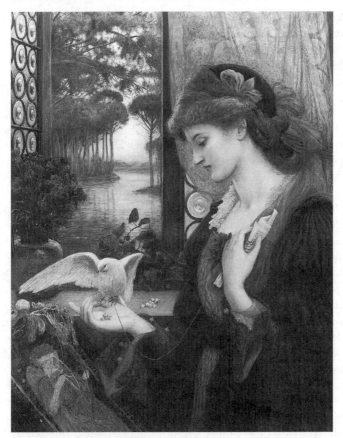

16 Marie Spartali Stillman, *Love's Messenger*, c. 1885

places in between. The family followed him to Rome, which Spartali found larger, noisier and less immediately congenial than Florence, though it too possessed a substantial expatriate and artistic community and she would later write nostalgically from Surrey of 'the solitude of a city like Rome'.[42]

In the meantime, she had successfully executed and exhibited *Love's Messenger* [16].[43] This more ambitious essay in the single-figure format sets the woman in profile before a window that looks out on a wide, light-

42 Spartali to Vernon Lee, 7 January 1900. Quoted by permission of the Principal and Fellows of Somerville College Oxford.
43 Grosvenor Gallery, 1885; now Delaware Art Museum, Wilmington. It bears the alternative title *Persefone Umbra*, though the signification of this title is unclear.

reflecting river or lake, edged by pine trees, leading the eye to a distant horizon – an idealised Italianate landscape. In a typically self-deprecating manner, Spartali described the picture to a later correspondent as 'merely a study from a model' done simply 'for the pleasure of painting'[44] and inspired by the sight of a 'fair head' against a bulls-eye window such as is shown. Testifying to her artist's sense of intrinsic pleasure in the act, these remarks are also partly disingenuous. For one thing, she had used the same motif before.[45] For another, the self-deprecation may be viewed as a rhetorical device, deployed by many female artists and writers to appeal to public and patrons by means of modest avowals confuting all imputation of arrogance, even if the modesty were genuine, as in Spartali's case.

Most significantly, however, the work also marked a departure in that no textual or narrative inspiration is adduced, yet the picture has a clear story, presumably of the artist's own devising. The woman depicted at the window by her embroidery frame, with a half-worked figure of a blindfold Eros, is feeding a dove with a cord tied to its foot attached to a letter, which will in due course fly off as 'love's messenger' to deliver the missive to her beloved. Or, as some commentators read the image, the woman is rewarding the bird that has brought the letter from her lover. It does not much matter which, except that the woman is clearly figured not just as a beloved but as a lover, through her embroidery and the red rose in her bosom, and the more active, yet also more poignant, narrative – will her letter reach its destination? – is thereby presented.[46] The colour balance in the work is accomplished, the red/green dialogue is symbolic of love/hope, and if the subject has a sweetly pretty aspect, the pictorial rendering also has gravity and repose, partly created by the woman's absorption, outwardly directed to the (well-realised) bird, inwardly to the love letter.

While the figure is Pre-Raphaelite rather than Italianate, the landscape view opens up the vista in a more classic manner than the artist had previously achieved, offering distinctly Italianate echoes. This, however, was inserted later, when the picture was re-worked.[47] 'I painted a

44 10 June 1906, quoted Elzea, *The Pre-Raphaelite Collections*, p. 174.

45 For example in *Mariana* (c. 1868, private collection, UK) and *Forgetfulness* (1869, Dudley 1870, Sotheby's 20 November 1969).

46 'Love's messenger' is a familiar Western trope, alluding variously to Eros or Cupid, a dove, a red rose, a swallow. If an actual textual source for Spartali's picture can be identified, the author of this essay will be pleased to hear of it.

47 Other changes to the picture may relate to technique and materials; according to Delaware Art Museum, the work employs watercolour, tempera and gold paint, and some of the firmness of handling may result from the use of a thicker medium.

landscape from the Villa Borghese as background when I made several changes in the picture while at Rome', Spartali wrote in 1906, referring to the 1886–98 period. Despite the avowal, however, the scene is not an observed topographical depiction, but an imaginary view, as the broad swathe of water and sky bestows a touch of mysteriousness, prompting the spectator to wonder: is this lover immured behind a moat, or on an inland island, only able to communicate by pigeon? If so, who is imprisoning her? She is evidently not a forlorn, forgotten Mariana but, taking a cue from the emblematic embroidery, is she a sister to the Lady of Shalott who has found an indirect means to communicate with the world? Her costume, we note, is neither fully historical nor contemporary, and the headwear would indeed pass muster in the street.

In 1887, her first full year in Rome, Spartali sent four works for exhibition in London, three to the Grosvenor Gallery and one to the Royal Institution of Painters in Watercolour. In subject, the three Grosvenor items were a reversion to Rossetti's Dante, two drawn from his translations and the third a rendering of Rachel and Leah from *Purgatorio*.[48] It may well be that all three were in some sense a tribute to Rossetti, who made Dante his main artistic motif and had died in 1882; certainly they trespass, as it were, on his territory. At the same time, and partly of course by virtue of their literary allusions, they are also tributes to the idea of historic 'Italy' that had been created during the nineteenth century. *A May Feast of the House of Folco Portinari, 1274*[49] shows the first encounter of Dante and Beatrice, as children. A charmingly grouped street scene, it contains over fifteen figures, mainly young. Although the drawing is perhaps over-delicate, both the grouping and the perspective are successfully handled, the movement and mood are lively, and the colours attractive, dusky blues and rusty reds being set off against grey walls and paving. Non-derivative in detail, the scene also evokes the freshness and simplicity of the Florentine quattrocento, and the chalky tones of fresco.

Its companion piece, *Upon a Day came Sorrow unto me*[50] is drawn from Dante's sonnet 'On 9 June 1290' (the date of Beatrice's death) using as its title the first line of Rossetti's translation and showing Dante interrupted by three female visitors, who bring the sad news. According to the sonnet, the visitors are Sorrow, Bile and Pain, whom Dante rebuffs, until Love enters, wearing black raiment and hat (as does the pictorial

48 The subject also of a watercolour by Dante Gabriel Rossetti, which Spartali could have seen at his retrospective Burlington Fine Arts Club exhibition in 1883 if she visited London at this date. It belonged to a collector in Leeds.
49 Grosvenor Gallery, 1887; Sotheby's, 1 March 1984.
50 Grosvenor Gallery, 1887; currently unlocated.

Eros) and weeping. Outside in the street the funeral procession is begin-
ning. The *Athenaeum* critic, who praised the colour and design,[51] also
commented on the Rossettian mood of this picture, with reason given its
comparability to *Dante drawing an Angel on the Anniversary of Beatrice's
Death*, despite Spartali's care in selecting a different text and episode.[52]

Together, these two Grosvenor works form a pair, featuring the
beginning and end of Dante and Beatrice's mortal acquaintance within
the city where Spartali herself had lived on the Via Alfieri. Folco Portinari,
traditionally identified as Beatrice's father, founded the Santa Maria
Nuova hospital near the Duomo and lived on the Via del Corso, close to
where Dante's own house is said to have stood. So the pictures can also
be seen as the artist's tribute to Florence and its inspirations.

Dante at Verona followed,[53] taking its theme from Rossetti's original
poem of the same title and selecting a scene in that text where young
women at leisure by one of the city's fountains urge the exiled poet to
recite from his own *Vita Nuova*. In this quasi-pastoral urban group, set
in a public garden with a high view of city roofs and towers, Spartali
returned to the grouping of her earlier *Fiammetta Singing*, moving the
male onlooker to the centre of the composition. The warmer colours,
visual rhythms and graceful figures, differentiated but not strongly
individuated, pay homage to much Italian art – by Ghirlandaio, Fra
Angelico, Botticelli – as well as to contemporary work by Burne-Jones
(perhaps owing to his domination of the Grosvenor Gallery). Spartali's
women, for example, recall the drapery and postures of those in Burne-
Jones's *Mirror of Venus* (1877), while the *mise-en-scène* is also reminis-
cent of *The Mill* (1882), one of Burne-Jones' most Italianate pieces.
Spartali could have seen both at the Grosvenor Gallery, and the latter in
the London home of Constantine Ionides during her 1884–86 residence
in Britain. (Indeed, the Ionides family suggested that the 'three graces'
or dancing female figures in *The Mill* were images of Aglaia Ionides
Coronio, Maria Zambaco and Spartali herself, whom Burne-Jones had
first met as young women in the 1860s.)[54] Equally significantly, the
picture marked Burne-Jones's 'return to a romantic and coloristic style',[55]

51 *Athenaeum*, 7 May 1887.
52 As with *Rachel and Leah*, if in London, Spartali could have seen *Dante drawing
an Angel* at the Rossetti retrospective in 1883; otherwise it remained with its
purchaser in Oxford.
53 Grosvenor Gallery, 1888; private collection USA.
54 See Stephen Wildman and John Christian, *Edward Burne-Jones: Victorian Artist
and Dreamer* (New York, Metropolitan Museum of Art, 1998), cat. no. 111.
55 *Ibid.*

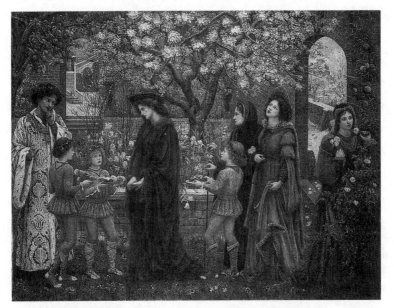

17 Marie Spartali Stillman, *The Enchanted Garden of Messer Ansaldo*, 1889

which chimed with Spartali's own preferences and talents. As Henry James wrote in the *Atlantic Monthly*, there was no indication 'what period of history, what time and place' were evoked in *The Mill*, which was rather 'an echo of early Italianism . . . impregnated with the love of Italy'.[56] It may truly be said that Spartali's *Dante at Verona* gives a local habitation and a name to this same quality.

Next, she turned to include Petrarch in her repertoire of source materials, possibly prompted by friendship with Professor Willard Fiske, a Petrarchan collector. She sent *Petrarch and Laura at Vaucluse* to Liverpool in 1889, followed by *Petrarch and Laura at Avignon* in 1890.[57] At the same time she returned to Boccaccio for her most elaborate work to date, which also most plainly expresses Spartali's response to Italian art. *The Enchanted Garden of Messer Ansaldo* (1889) [**17**][58] is a small, highly decorative and decorated piece depicting an incident from the *Decameron* in which Ansaldo attempts to seduce the (married) Dianora

56 Henry James in *Atlantic Monthly*, quoted in Wildman and Christian, *Edward Burne-Jones*, cat. no. 111.

57 The Vaucluse picture is currently unlocated; the Avignon one was seen at Christie's, 12 June 1992.

58 New Gallery, 1889; now Pre-Raphaelite Trust.

by magically turning winter into summer. Set as it were in medieval Tuscany, the work draws on quattrocento Florentine painting, its graceful figures and scattered flowers recalling Botticelli's *Primavera* and the pageboys those of Ghirlandaio and Gozzoli (whose three red-stockinged and curly-haired lads in the Medici Chapel seem to have dismounted for the purpose). The medium (watercolour with bodycolour) provides some of the softness of faded fresco, though the whole is as densely patterned as a tapestry. If the intricate detail of flowers, fruits and fabrics – the source of Dianora's amazement and dismay – tends to compete with the figures' drama, the blossoming details, with their soft creamy, red and orange hues, create an aptly magical contrast to the snowy terraces glimpsed beyond the garden; this is indeed the visualisation of an enchanted place.

It is also Tuscany in springtime, based on the delighted appreciation of the glory of irises and roses that the artist recorded seeing again the following year when re-visiting Florence.[59] In her essay 'Old Italian Gardens', Vernon Lee refers to this work with the following comparison, which renders verbally the aesthetic qualities of Spartali's picture:

> We must imagine [Boccaccio's] magic flower garden rather as a corner – they still exist on every hillside – of orchard connected with the fields of wheat and olives below by the long tunnels of vine trellis and dying away into them with the great tufts of lavender and rosemary and fennel on the grassy bank under the cherry trees. This piece of terraced ground along which the water – spurted from the dolphin's mouth or the siren's breasts – runs through walled channels, refreshing impartially violets and salads, lilies and tall flowering onions, under the branches of the peach tree and the pomegranate to where in the shade of the great pink oleander tufts, it pours out below into the big tank for the maids to rinse their linen in the evening.[60]

Spartali's deep affection for the city resulted in the allegorical work *A Florentine Lily*, mentioned at the start of this essay, which depicts a young woman in fancy costume holding a fleur-de-lys and standing

59 Letter from Spartali to William Bell Scott, 5 June 1890, Fitzwilliam Museum Cambridge. Henry James also recorded 'the perfume and promise of a Florentine Maytime'. See Leon Edel (ed.), *The Letters of Henry James*, 2 vols (London, Macmillan, 1974 and 1978), 2: 289.

60 Vernon Lee, *Limbo and Other Essays* (London, Grant Richards, 1897), p. 114. Responding to the publication of this essay, Spartali told Vernon Lee she was 'much flattered to find your description of my little picture of Dianora'. See letter from Spartali to Vernon Lee, May 1897. Quoted by permission of the Principal and Fellows of Somerville College Oxford.

before a distant view of the Palazzo Vecchio. Although also presenting an attractive model such as might appeal to late-Victorian purchasers, and perhaps alluding invisibly to the brief life of little Giacomo, the work is also a civic personification, or invocation of the Florentine spirit, in terms that foreground its illustrious artistic heritage. It speaks of a response to a real and imagined past, signified by Renaissance art and architecture, which remained apparent and indeed dominant to those like Spartali who, pictorially speaking, ignored all post-1500 developments. As she would remark when again settled in Britain, 'I must content myself with the National Gallery for my enjoyment of Italy now'.[61]

By the early 1890s, chiefly through her artistic relation to the art and literature of her (half-) adopted country, Spartali had thus created a distinct oeuvre of her own, with a delicate aesthetic offering quiet harmonies in soft pinks and greens. Her pictorial aims were beauty of form, line and colour, coupled with restfulness of atmosphere, her ideal apparently being the depiction of quiet scenes where 'things have been at a standstill for 300 years probably'.[62]

The understated attractions of her painting were, however, not sufficient to create a commercial or critical reputation. She lamented that her works seldom sold in Britain (though exact records are lacking and by her own account sales were better in France and Italy) and had always been 'particularly disagreeable to the Press'.[63] Both her geographical and social position (as a married woman any public advertisement of financial need would impugn her husband's honour) made self-promotion virtually impossible as well as personally distasteful. Moreover, Spartali was temperamentally given to extremes of artistic abjection which did not serve her well in the competitive art world; as Fairfax Murray complained more than once, Mrs Stillman 'ruined her reputation in Rome by running down her own work'.[64] Our understanding both of gender constraints in relation to public presentation and of artistic dissatisfaction in general – like Spartali, both Rossetti and Burne-Jones were apt to keep

61 Letter from Spartali to Vernon Lee, 5 May 1899 or 1900. Quoted by permission of the Principal and Fellows of Somerville College Oxford.

62 Spartali's description of the house and garden at Kelmscott Manor Oxfordshire, where she stayed with Jane Morris. See letter from Spartali to Vernon Lee, 19 September 1902. Quoted by permission of the Principal and Fellows of Somerville College Oxford.

63 Letter from Spartali to Ford Madox Brown, 8 December ?1879 (National Art Library, London, copyright Victoria and Albert Museum).

64 As quoted for example in W. S. Spanton, *An Art Student and his Teachers in the '60s* (London, Robert Scott, 1927), p. 83.

works long in hand in hopes of realising the original vision, although neither allowed patrons to know this – should warn us against accepting her self-belittling at face value, although in relation to her aspirations it was certainly heartfelt. Nevertheless, the absence of conventional 'success', coupled with the gentle hesitancy of her hand – in many respects a most appealing feature – has led to Spartali being judged a quasi-amateur or insignificant artist, unimportant in the context of the main streams of late nineteenth-century European art.

Yet in this period, when she reached her fifties, her work extended from scenes of poetic imagination and fancy Renaissance-style portraits to actual landscape and incident. Several works attest to travels in Umbria, while others depict scenes in and around Rome. Thus, for example: *Monte Luce from Perugia at Sunset* and *Via della pergola, Perugia* both at the New Gallery in 1893;[65] *Monte Amiata and the Paglia river;*[66] *Afternoon in Colonna Garden, Rome* and *St Peter's*, both at the New in 1894;[67] *Ponte Nomentana* (New Gallery, 1895); *Tomb in Roman Campagna* and *San Clemente* (New Gallery, 1897). At some date a visit to Capri yielded at least one view, shown at the New Gallery in 1893, while one landscape from Ciocaro near Allessandria in Piedmont was at the same venue in 1896 and three scenes of Venice were seen at the Oehme Galleries in New York in 1908.

Such landscape works were probably encouraged by proximity to the 'Etruscan school' of artists in Rome, prominent among them being Giovanni Costa, in whose studio Spartali worked for a time. Family papers also attest to her liking for al fresco painting, as for instance in May 1892 when she told Effie (then in Britain) that she was painting every afternoon on the Palatine Hill, where she found 'several charming subjects' which she hoped would sell in due course. A few days later Bella added that Marie was 'well in the swim' with her work, and therefore 'refuses to be sent' to visit the Fiskes in Florence in accordance with her husband's wish.[68]

Two charmingly idiosyncratic works whose titles are currently unknown also appear to derive at least in part from landscape observation.[69] One shows a group of herons or cranes wheeling and preening in a blossom-filled orchard, the other a young woman in a wintry woodland feeding a squirrel. The latter could conjecturally relate to her engagement

65 Respectively private collection UK, and unlocated.
66 Oehme Galleries, New York, 1908; currently unlocated.
67 Both currently unlocated.
68 Quotations from family correspondence by kind permission.
69 Both in family possession, they may have been painted after Spartali left Italy.

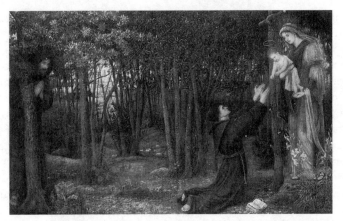

18 Marie Spartali Stillman, *Vision of the Virgin Mary appearing to Brother Conrad of Offida*, 1892

with a new group of Italian subjects inspired by Catholic history and legend. These include the *Vision of the Virgin Mary appearing to Brother Conrad of Offida* [18], sent to Liverpool in 1892;[70] and a comparable scene, *The Vision of the Good Monk of Soffiano* (New Gallery 1893) depicting the deathbed of St Francis of Assisi visited by the Virgin Mary, taken from *The Flow'rets of St Francis*. As the artist told Vernon Lee ten years later, she had 'loved St Francis long before [Paul] Sabatier's life made him the fashion'.[71]

Both works evince a sensibility that can be seen as sentimental but also recalls the sacred art of earlier eras. *The Ordination of St Lawrence* by Fra Angelico in the Vatican, for example, shows a kneeling figure not unlike Spartali's Brother Conrad although an even closer source may be Giovanni Bellini's *Assassination of St Peter Martyr* in the National Gallery, London.[72] At least one reviewer noted this, remarking that Spartali's

70 Now National Trust Wightwick Manor. The subject is from the story of Fra Conrado d'Offida, sanctified 1817.

71 Letter from Spartali to Vernon Lee, 5 August 1905. Quoted by permission of the Principal and Fellows of Somerville College Oxford. I believe that *The Good Monk of Soffiano* and the work currently known as the *Deathbed of St Francis* (dated 1893) are the same work, since the quotation in the New Gallery catalogue about three Holy Virgins, cherubim and seraphim neatly dovetails with the figures in the 'Deathbed' picture. *St Catherine in her Garden* (Manchester 1903, unlocated) may also belong to this group.

72 New Gallery, no. 812, from 1870. Egg tempera and oil on wood. This St Peter was a Dominican friar and inquisitor, who in 1252 was ambushed and killed on the road to Milan. The background wood is very similar to that in Spartali's picture.

Vision of . . . Brother Conrad displayed a sincerity and piety of feeling that conveyed 'a little of the old Tuscan rapture'.[73] With *St Francis blessing the Pigeons he has freed*, seen at the New Gallery in 1902,[74] the artist returned to her Franciscan theme, and the three works would appear to form a group of carefully designed and delicately executed pictures invoking the blend of naturalism and pious symbolism characteristic of early Italian painting. Spartali's own religious beliefs, incidentally, were personal rather than doctrinal; she believed in the immortality of the soul but had strong objections to being 'fettered to the tenets of any church',[75] particularly that of Rome.

Another group of works extended Spartali's range into the sphere of architectural interiors such as were frequently depicted in Renaissance painting. Showing neo-classical buildings in receding perspective, these include the already mentioned *First Meeting of Petrarch and Laura in the Church of Santa Chiara at Avignon* (1889),[76] which foregrounds the two main figures against receding planes with a variety of other scenes and figures in a manner that opens a tense space between poet and beloved. The architectural setting is rendered in minute detail, with a diaper-tiled floor emphasising the articulation of vanishing-point perspective characteristically deployed by early Italian Renaissance artists; as has been remarked, it is a complex and successful composition,[77] which nevertheless refuses any claim to virtuosity. A second work in this vein, *After Vespers in San Clemente* (1897)[78] offers a contemporary scene – relatively rare in Spartali's oeuvre – showing dark-garbed women standing and kneeling as white-gowned clergy and acolytes move forward from the sanctuary. In this instance, however, the subject is the building rather than the human figures, which rather serve as foils to the receding arches, marble floors and distant mosaics.

A Lady of Thoulouse, whom Love doth call Mandetta (1903)[79] forms the third work in this group. Although produced after the artist had moved back to Britain, and despite depicting a French setting – the

73 *Saturday Review*, (13 May 1893), p. 511.

74 Currently unlocated.

75 See letter from Spartali to Vernon Lee, 27 November 1912 or 1913. Quoted by permission of the Principal and Fellows of Somerville College Oxford. She had of course been reared within the Greek Orthodox Church.

76 Liverpool, 1889; New Gallery, 1890; Christie's, 12 June 1992.

77 See Kristen Shepherd, *Marie Spartali Stillman*, pp. 59–60, for detailed exposition of this work, together with an illustration.

78 New Gallery, 1897; now private collection USA.

79 New Gallery, 1903; now National Trust Wightwick Manor.

famous mosaic-filled church of Notre Dame de la Daurade in Toulouse – the picture is still fully Italianate, with architectural perspective similar to that in the other two works. It moreover marked a return to Spartali's original sources, in Rossetti's translations from Italian poets of Dante's era. Here the theme is Cavalcanti's *ballata* where he, writing in Florence, apostrophises the poem, which in the picture is hand-delivered by Love to the lady Mandetta:[80]

> Go, Ballad, to the city, even Thoulouse,
>> And softly entering the Daurade, look round
>> And softly call, that so there may be found
> Some lady who for compleasaunce may choose
> To show thee her who can my life confuse.

As painter, Spartali has visually rendered the verbal suavity and quaintness of the poetic lines.

In 1898 Stillman retired and the family left Italy for Britain, where Spartali spent the remaining years of her life. She continued to visit Italy, however, having many friends there, as well as to produce and exhibit pictures with Italian subjects and locations. In February 1901 she reported to a prospective patron that she was 'painting Effie watering lilies in the Cypress garden of the Villa Landor at Florence', adding that she had studied it with the intention of a picture during her last visit to Professor Fiske, whose residence it was. 'In this cold land it is good to think of sunshine and cypress trees fragrant in the hot summer air.'[81] In 1903 she stayed with her friend Vernon Lee, the following year proposing to return in hopes of painting in the famous garden of the Villa Gamberai in Settignano, partly for the sake of re-visiting Italy in spring, and partly to produce the kind of garden pictures then popular with 'the sort of public who can pay for them'.[82] Among other works, the New Gallery saw the *Lake of Nemi* and *Via Praenostina, Rome* in 1899, *St Peter's at Dawn* in 1903 and *Flower Girls at the Fountain of Bacchus, Florence* in 1907. A sequence of undated but strongly coloured flower pieces from the last, post-exhibition, years of her career continue to

80 Rossetti, *Poems and Translations*, p. 325.
81 Letter from Spartali to Samuel Bancroft, 1 February 1901, Delaware Art Museum.
82 Letter from Spartali to Vernon Lee, 15 May 1904. Quoted by permission of the Principal and Fellows of Somerville College Oxford. It is not known whether this plan was carried out, although a new Florentine scene was shown at the New Gallery in 1907. In this period several artists, including Beatrice Parsons and Lilian Stannard, specialised in supplying the market with watercolour garden scenes.

evoke the warm south, using as accessories hand-painted Italian pottery and Italian-grown pomegranates.

Her last major work, *The Pilgrim Folk* (1914),[83] was in some sense a tribute and a farewell to the land that had so consistently provided inspiration and influence. Its source is the penultimate sonnet of the *Vita Nuova*, where Dante addresses a group of travellers, inviting them to lament with him the loss of Beatrice. Spartali inscribed Rossetti's translation of this sonnet to hang below her picture, which shows an imagined medieval street scene with figures clustered round a public well listening as the poet speaks from a high loggia, but it is perhaps Dante's preceding words that – insofar as Beatrice is a symbolic figure of Italy in her early, pre-modern aspect – suggest the pictorial mood and message. 'These pilgrims seem to come from very far', says Dante to himself, 'and I think they cannot have heard speak of this lady, or know anything concerning her. Their thoughts are not of her, but of other things; it may be, of their friends who are far distant, and whom we, in our turn, know not.'[84]

The quotation evidently voices the artist's own thoughts, recalling places and people once known, now distant or dead. In her 'grave and soft' images of Italian literature, legend and landscape, Spartali presented a 'far distant' Italy, informed by present locations but inviting the viewer to step into an imaginative vision of the past.

By 1914, the eve of World War I, this was as outdated as it could be. Two years earlier, the first Italian Futurist exhibition had been shown in London. Though small, it was extremely newsworthy, thanks to noisy avant garde publicity by the poet Marinetti, a catalogue with three manifestos and a riotous private view. Nothing could have been further from Spartali's gentle visions than the exhibitors' aggressive declaration that their aim was to replace 'the tumbling and leperous [sic] palaces of Venice' with 'the rigid geometry of large metallic bridges, and manufactories with a waving hair of smoke'.[85] Such were the industrial manifestations of Italy she had never permitted to enter her visual rendering of its identity.

83 Now Delaware Art Museum.
84 'The New Life' in Rossetti, *Poems and Translations*, p. 308.
85 Quoted in Anna Gruetzner Robins, *Modern Art in Britain 1910–1914* (London, Barbican Art Gallery, 1997), p. 57.

9

'Amiable but determined autocracy': Margaret Oliphant, Venice, and the inheritance of Ruskin

Francis O'Gorman

JOHN RUSKIN's *The Stones of Venice* (1851–53) was a major achieve-ment of his early career, and consequential in the wider culture. It significantly influenced the mid-nineteenth-century Gothic revival, though Ruskin regretted the form this took. The specifically textual consequences of the book, which had appeared in four full editions by 1884 and a *Traveller's Edition* (1879–81), also echoed and re-echoed in volumes on the history and art of Venice through the second half of the nineteenth and into the twentieth century. Ruskin dominated the Eng-lish imagination of the sea city from the 1850s; it was inseparable from his name. But his presence was diversely perceived as both inspiring and confining, as a source of possibilities and, from a different perspective, as a shadow from which it was necessary to escape. This chapter considers the nature and achievement of the complex literary exchanges between Margaret Oliphant in her work on Venice in the 1880s and Ruskin's Venetian writing throughout his career as she endeavoured to negotiate a space for herself in relation to his capacious literary presence. I pro-pose that Oliphant's multiple strategies of resistance against the author of *The Stones of Venice*, together with her influential mythologising of Ruskin, were important aspects of her textual self-definition within a model of reading that was dominated by a paradoxical concept of opposi-tion. This chapter sees in Venice in the late nineteenth century a city of opportunity for a distinctive form of literary self-inscription.

At the crossover of the nineteenth and twentieth centuries, Henry James was the most obvious fiction writer to acknowledge the tenacious nature of Ruskin's cultural diagnosis. Engaging with Ruskin, as Hilary Fraser says, 'at every turn',[1] in *Italian Hours* (1909), he also mediated a

1 Hilary Fraser, 'Ruskin, Italy, and the Past', in Martin McLaughlin (ed.), *Britain and Italy from Romanticism to Modernism: A Festschrift for Peter Brand* (Oxford, EHRC, 2000), pp. 87–106 (p. 87).

Ruskinian version of Venice in fiction in *The Aspern Papers* (1888) and *The Wings of the Dove* (1902). In the latter, Venice eloquently served, in the paradigm established by *The Stones of Venice*, as a textual and geographical space in which to critique the state of England, a nation whose moral health had deteriorated sufficiently to produce the attitudes of Lancaster Gate and the ambitions of Kate Croy.[2] Milly Theale's identity is bound up with Ruskinian tropes of Venice too – innocent, beautiful, aestheticised, female, dying. Her final destiny is also, like Venice in *The Stones*, to be remembered, but in a way that is a powerfully shocking transformation of Ruskin's hopes for the potentially redemptive remembrance of Venice. Prior to James, novelists had already exploited the nexus of associations suggested by Ruskin, indicating the extent to which his Venetian narrative of moral fall had permeated. Wilkie Collins' *The Haunted Hotel: A Mystery of Modern Venice* (1879) was set in 1860, only a few years after the completion of *The Stones*. It sensationally employed the notion of the city as one of ghosts and decay, in which good acts were no longer possible and wretched moral standards prevailed. Like *The Wings of the Dove*, it welcomed for its own purposes the connection between the Ruskinian 'degradation'[3] of Venice and the failure of human moral substance.

But the afterlife of *The Stones of Venice*, its 'quite extraordinary power and utterly incalculable influence',[4] as Tony Tanner puts it, was not discernible in fiction alone. Venetian historiography was transformed by the end of nineteenth century, partly in the light of archival research, partly as a result of the positivist professionalisation of history as a discipline in general. Yet Venice did not become, as she never has, the exclusive preserve of the professional scholar. Informal biographies of the ruined city, or literary histories closer to the method of *The Stones of Venice*, continued to negotiate with the spectral presence of Ruskin, who had thought of Venice herself as the 'ghost upon the sands of the sea' (9: 17), in the final decades of the nineteenth century. Ruskin's own work in the 1880s was disrupted by periods of mental illness, and he withdrew from public life into carefully guarded silence in 1889. But the

2 On James's Ruskinian conceptions of Venice in *The Wings*, see Jonathan Freedman, *Professions of Taste: Henry James, British Aestheticism, and Commodity Culture* (Stanford, Stanford University Press, 1990), pp. 93–101. Freedman does not consider the transformation of Ruskin's idea of memory.

3 E. T. Cook and Alexander Wedderburn (eds), *The Library Edition of the Works of John Ruskin*, 39 vols (London, Allen, 1903–12), 10: 428. Subsequent references are given in the text.

4 Tony Tanner, *Venice Desired* (Oxford, Blackwell, 1992), p. 68.

circulation of his Venetian words continued even as he became no longer capable of attempting to police their reception.[5] Writing about Venice in the wake of Ruskin became a distinctive literary occasion, for it necessitated textual transaction with the traces of *The Stones*, and an engagement with the politics of Ruskinian influence.

Collins and James found Ruskin's construction of Venice suggestive. But for no one writing non-fictional prose at the end of the century was the 'Ruskinised'[6] city, to borrow Tony Tanner's word, both more problematic and more potentially rewarding than for the prolific novelist and reviewer Margaret Oliphant. Ruskin's Venetian legacy was peculiarly alive to her, though no critic has ever considered it. As she contemplated her own book, *The Makers of Venice: Doges, Conquerors, Painters, and Men of Letters* (1887) for Macmillan's in the mid-1880s, it seemed also a peculiar challenge. For, in a manner distinctive in Oliphant's career, Ruskin occupied a complex and symbolic space. When pressed, towards the end of her life, she admitted to admiring aspects of his prolific writing, and she thought him a master of English prose – in a way Ruskin himself would have deplored. But her response was profoundly double. Ruskin, for a start, had persisted in her mind for decades as an embodiment of male authority in non-fictional prose, of a voice and presence in the realm of nineteenth-century letters that was unwelcome. He was an 'autocrat',[7] she said, who spoke a discourse of oppressive conviction. She often judged those convictions prejudices, remarking in 1892 that he had, 'like other men, a world of prejudices, dislikes, and aversions, which he [did] not, like most other men, attempt to subdue in public'.[8] Oliphant's annoyance with these unsubdued and, as her work paradoxically admitted, unsubduable words, the authoritative voice of a writer she made out to be a Carlylean man of letters, expressed itself alongside irritation with Ruskin's material working conditions that were always preferable to hers. She laboured to support a circle of dependents, earning the condemnation of Virginia Woolf in *Three Guineas* (1938): Ruskin had no such crudely practical imperatives.

5 There is some discussion of the consequences of Ruskin's silence on the reception of his works in Brian Maidment, 'Interpreting Ruskin, 1870–1914', in John Dixon Hunt and Faith M. Holland (eds), *The Ruskin Polygon: Essays on the Imagination of John Ruskin* (Manchester, Manchester University Press, 1982), pp. 158–71.

6 Tanner, *Venice Desired*, p. 169.

7 Mrs Oliphant, *The Makers of Venice: Doges, Conquerors, Painters, and Men of Letters* (London, Macmillan, 1887), p. 53. All future references in main text.

8 Mrs Oliphant and F. R. Oliphant, *The Victorian Age of English Literature*, 2 vols (London, Perceval, 1892), 2: 214.

She felt similarly about George Eliot,[9] but her irritation with Ruskin was more composite, and it was, at least in part, gendered. In 1868, Oliphant had remarked to John Blackwood that Ruskin's assumptions about a good working environment – she was thinking of a letter she had seen from him that she thought, mistakenly, was an unreasonable request to his friends not to disturb his writing – would 'throw you into fits of laughter'.[10] This reaction was more than mean-spiritedness. It gained momentum partly from her general grievance with the cultural prestige of Ruskin as a man of letters, advantaged symbolically, as she saw it, by his own inherited wealth, and literally by the marketplace of late Victorian non-fictional prose.[11]

Ruskin continued to vex Oliphant long after her letter to Blackwood. Shortly before beginning *The Makers of Venice*, she agreed with George Craik, from Macmillan's, to excise a rant about him (Ruskin) from the

9 See Judith van Oosterom, 'Unlikely bedfellows: Thomas Carlyle and Margaret Oliphant as vulnerable autobiographers', in C. C. Barfoot (ed.), *Victorian Keats and Romantic Carlyle: The Fusions and Confusions of Literature Periods* (Amsterdam, Rodolpi, 1999), pp. 247–66 (p. 261).

10 Mrs Harry Coghill (ed.), *Autobiography and Letters of Mrs Margaret Oliphant*, with an introduction by Q. D. Leavis (Leicester, Leicester University Press, 1974), p. 266. Oliphant was not being quite fair; see Cook and Wedderburn (eds), *Works of John Ruskin*, 34: 651.

11 There is some assessment of Oliphant's admiration in her reviewing for those who wrote for a living in Joanne Shattock, 'Work for women: Margaret Oliphant's journalism', in Laurel Brake, Bill Bell, and David Finkelstein (eds), *Nineteenth-Century Media and the Construction of Identities* (Basingstoke, Palgrave, 2000), pp. 165–77 (p. 175). On Oliphant's *Autobiography* and the male world of non-fictional prose, see Elisabeth Jay, 'Mrs Oliphant: The Hero as Woman of Letters, or Autobiography, a Gendered Genre', *Caliban*, 31 (1994) 85–95. For a different view of the gender/genre question, see Linda H. Peterson, 'Margaret Oliphant's *Autobiography* as professional artist's life', in Elisabeth Jay and Francis O'Gorman (eds), *Women's Writing, Special Edition: Margaret Oliphant*, 6: 2 (1999), pp. 261–78. There is some consideration of Anna Jameson's response to what is described as Ruskin's perception of and 'colonisation' of Italy in *Modern Painters* 1 (1843) in Judith Johnston's *Anna Jameson: Victorian, Feminist, Woman of Letters* (Aldershot, Scolar, 1997), pp. 170–4. Unfortunately, this presents something of a caricature of Ruskin as simply speaking the language of the male coloniser 'overwhelmed by the "otherness" of the place that he would colonise if he only could' (p. 173). Johnston's approach fails to acknowledge the complexity of Ruskin's purposes in *Modern Painters* 1. I offer a general critique of claims about Ruskin as coloniser in chapter four of my *Late Ruskin: New Contexts* (Aldershot, Ashgate, 2001), and there is a more positive reading of Anna Jameson's connections with Ruskin in Linda H. Peterson's 'The Feminist Origins of "Of Queens' Gardens"', in Dinah Birch and Francis O'Gorman (eds), *Ruskin and Gender* (Basingstoke, Palgrave, 2002), pp. 86–106.

manuscript of *The Literary History of England in the End of the Eighteenth and Beginning of the Nineteenth Century* (1882). It would not have done to have left such intemperance in print, but she was glad to have given voice to her irritation. 'I should have [cut] it myself', she said, 'though to say it was a relief to my mind for the moment'.[12] What that excised text said is not known. But it must have been another product of her frustration with Ruskin's iconic significance in her professional life. She was prepared in 1892 to admit that he was 'the greatest writer on art in the Victorian age'.[13] But she was also conscious that he stood for – or, more to the point, could be made to represent – an inhospitable aspect of the sexual politics of non-fictional prose, a quality of voice and a power over readers, a form of Victorian literary fame, and a classed identity with a provokingly forceful influence on the perception of European arts, especially those of Italy, with which she was peculiarly pleased to contest.

Writing on Venice offered the unique occasion for a form of literary 'relief' and self-projection. Her book was part of a series. It was a companion volume to *The Makers of Florence: Dante Giotto Savonarola and Their City* (1876) – by 1887, this was in its third edition – and later *The Makers of Modern Rome* (1895). A volume on Siena was also planned, but Oliphant died before it could be written. Elisabeth Jay succinctly remarks that Oliphant's biographical approach, her preference for human anecdotes and informal but researched analysis, in this Italian cities series, neatly demonstrated her 'power to recognize the demands of the market and transform these into a vehicle for her own talents'.[14] But the opportunity to produce a book on Venice offered more than this. It provided a tempting chance to write a palimpsest of Ruskin's Venetian work. For Oliphant, *The Makers of Venice* was an occasion to negotiate a space for her own literary identity, distinct from her persona as novelist and reviewer for *Blackwood's Magazine*, directly in relation to Ruskin's, and to counter both subtly and explicitly what she described in *The Victorian Age of English Literature* (1892), with a politeness that was almost sarcasm, as his 'gentle strain of self-satisfaction and self-belief'.[15]

A well received illustrated volume of 390 pages, *The Makers of Venice* transacted with the problematic figure of Ruskin directly and indirectly. And Oliphant's literary resistance revealed something of the

12 Coghill (ed.), *Autobiography and Letters of Mrs Margaret Oliphant*, p. 304.
13 Oliphant and Oliphant, *The Victorian Age of English Literature*, 2: 214.
14 Elisabeth Jay, *Mrs Oliphant: A 'Fiction to Herself': A Literary Life* (Oxford, Clarendon, 1995), p. 255.
15 Oliphant and Oliphant, *The Victorian Age of English Literature*, 2: 216.

role of misprision in arguing with a literary predecessor. Harold Bloom's theory of poetic appropriations in *The Anxiety of Influence* (1973) established useful terms for reading the marks of influence in poetry and a number of Oliphant's strategies in her non-fictional prose, often concerned with her handling of tone, relate to Bloom's revisionary ratios just as her overall reaction relates, though not without significant qualification, to his conception of writing as a practice against a predecessor. In turn, Oliphant's response to Ruskin contests Sandra Gilbert's and Susan Gubar's key feminist revision of Bloom, just as Ruskin himself does not fit into the model of Victorian gender politics they assume. Challenging the so-called 'patrilineal literary inheritance'[16] discussed by Bloom, Gilbert and Gubar argue in *The Madwoman in the Attic* (1979) that nineteenth-century female writers suffered not an anxiety of influence but an anxiety of authorship that urged them to seek out '*female* precursor[s] who, far from representing a threatening force to be denied or killed, [proved] by example that a revolt against patriarchal literary authority [was] possible'.[17] Gilbert's and Gubar's diagnosis of the sexual and textual politics of Victorian England is problematic. But, confining oneself to this theory of nineteenth-century women's response to precursors, the textual dialogue I discuss here is certainly outside their terms. Ruskin was no straightforward example of 'patriarchal . . . authority';[18] Oliphant's negotiation with his presence as Venetian historian was not only a matter of gender politics; and the confidence revealed in *The Makers'* handling of a male literary influence placed Oliphant beyond the paradigm described in *The Madwoman* of how a Victorian woman read a man's work.

In her mixed, double-edged chapter on Ruskin in *The Victorian Age of English Literature*, Oliphant's restlessness with Ruskin was most visible, revealingly, regarding the city on which she too had written. *The Stones of Venice*, she said,

> mark[s] the beginning of that life-long adoration of the Sea City which Mr. Ruskin has communicated to so many, and which no doubt has had some share in the now rising prosperity and activity of that wonderful home of art and beauty, though no one could more heartily detest and abhor all participation in that revival than the author. His

16 Sandra M. Gilbert and Susan Gubar, *The Madwoman in the Attic: The Woman Writer and the Nineteenth-Century Literary Imagination* (New Haven, Yale University Press, 1979), p. 51.

17 *Ibid.* p. 49, italic original.

18 For more debate on Ruskin's gender position, see Birch and O'Gorman (eds), *Ruskin and Gender.*

delightful expositions of the history, and loving survey of the glorious wrecks of Venice which in the first half of the century excited the enthusiasm of many chiefly because they were wrecks – are mingled with fierce denunciations of the rising of the new life in a place which in its most palmy days was nothing if not a seaport and centre of industry – which are sometimes almost absurd in their shrill anathema notwithstanding the sympathy of the reader in them.[19]

The admiration of Ruskin here – such that it was – sat side by side with Oliphant's pointed criticisms in a way that was typical of her handling of him in *The Makers*. Highly qualifying her praise, she was suggesting the illogicality of Ruskin's construction of the medieval city as a locus of the ideal, the eccentric nature of his admonishing tones – the 'shrillness' of which she was contrasting with her own oblique mode – and, with the added 'no doubt', she was quietly querying the influence of *The Stones* itself on the history of the sea city.

The Makers of Venice probed Ruskin's diagnosis of Venetian history and art with a similarly layered voice. Surface charm and deference haboured plainer critique, amounting at times to archness, as Oliphant laid claim to the distinctiveness of her own Venetian discourse. Her long discussion of the early Doges was typical. She saluted the 'beautiful description' (p. 51) of the baptistery of San Marco in *The Stones of Venice*,[20] but only as a prelude to an elegant rebuttal. She commented on the presence of candlelight in Venice, adding: 'Mr. Ruskin would have us believe that he for one would like Venice better if this were the only illumination of the city; but we may be allowed to imagine that this is only a fond exaggeration on the part of that master' (p. 51). The apparent generosity of this 'allowance' masked Oliphant's hint to the reader that Ruskin's proposal – or what was imagined to be Ruskin's proposal – was absurd and could certainly not be dignified by being taken seriously. In fact, Oliphant was not being entirely fair. Ruskin was no friend of the gas pipes in Venice as he was not of the Ponte della Libertà, but explicit public recommendations that Venice would be better with illumination from candlelight alone were hardly central to his purposes. His were more significant objections.

Standing, nonetheless, as a useful synecdochic representation of his more general dissatisfaction with the presence of the modern in Venice, Oliphant's lamplight idea expressed scepticism effectively. In *The Victorian Age* she mulled over this with less reservation. 'That Venice has a

19 Oliphant and Oliphant, *The Victorian Age of English Literature*, 2: 223.
20 See Cook and Wedderburn (eds), *Works of John Ruskin*, 10: 86–8.

right to seek her own advantage and comfort even by ways that are naturally hideous as well as utterly offensive to Mr. Ruskin is a fact which he could never allow,' she said, 'notwithstanding the moral certainty that the old Dandolos and Foscari would have certainly done the same had such things been in their power.'[21] Her point was partly – and here again she misread him[22] – that Ruskin could not understand the benefits such changes brought. There were, to be sure, 'horrible iron bridges' thrown over the Canal Grande that Ruskin hated. But he should have remembered that 'they are a great convenience to the poorer inhabitants and save many a tedious mile of way'.[23] Oliphant was characteristically focusing on what she saw as the consequences on his attitudes of his independent income, with all its symbolic significance.

The Makers of Venice asked Ruskin a direct question about the idealisation of the medieval city. Remembering the industry of the ancient Murano glassworks in her section on Venetian painters, Oliphant tagged on an irresistible afterthought: 'but I wonder whether Mr. Ruskin thinks there was no smoke over Murano even in the ages of primal simplicity and youth' (p. 298). Her notion was that Ruskin's apparent effacement of the signs of industrialisation in the medieval city was the triumph of idealism over the ordinary truths of practical reality. Referring to the Gothic period of Venice's greatness as 'primal simplicity and youth', moreover, she refashioned Ruskin's characteristic language for the location of his Venetian ideal in alien terms, reducing the stature of his conceptualisation of the period of Venice's apogee. Oliphant was contesting a general tendency in The Stones, and Ruskin's Venetian writing altogether, to regret the encroachment of the present in the wrecked remains of the city. But her Murano example indicated more of the misprision, the forms of creative misreading, that she employed to clear a literary space for her own voice in relation to Ruskin's. The modern smoke cloud over Murano *was* something that Ruskin had written about. But he had told his readers in The Stones of Venice not to regret it precisely because it *did* recall the past. It was, in a manner at odds with Oliphant's implication, a last sign of the older, happier world amid ruined villages.[24]

Deferentially referring to Ruskin as the 'master' (p. 51), Oliphant added irony to her view that his supposed idea about Venetian illumination was unreasonable. She was bolder in her challenge to his account

21 Oliphant and Oliphant, The Victorian Age of English Literature, 2: 223–4.
22 See note 34.
23 Oliphant and Oliphant, The Victorian Age of English Literature, 2: 224. See also n. 34.
24 See Cook and Wedderburn (eds), Works of John Ruskin, 10: 39.

of the tomb of Doge Domenico Michaeli. This literary tussle saw Oliphant inventively using a Ruskinian position to distinguish herself from the continuing power of his aesthetic judgments. Her complaint was not addressed to *The Stones* but to *St. Mark's Rest* (1877–84), Ruskin's brief anecdotal account of Venetian history, aimed at a new generation of English tourists (Thomas Cook organised his first tour of Italy in 1864). In the first chapter, Ruskin regretted that the original tomb of the fearless Doge Domenico in what was once the monastery beyond Palladio's San Giorgio Maggiore had been replaced by Longhena's 'frightful modern upholsterer's work' (24: 217). The first, with its bold declaration '*Terror Graecorum iacet hic*', was 'too modest and time-worn for the vulgar Venetian of the seventeenth century' (24: 217). Oliphant's sympathies were not with Baldassare Longhena, but her seemingly gracious reply to Ruskin involved more friction between tone and substance. He was right, she said, about the 'hideousness of the tomb' (p. 53). Yet:

> though nothing may excuse the vulgar Venetian of the seventeenth century for his bad taste in architecture, it is still morally in his favour that he desired in his offensive way to do honour to the great dead – a good intention which perhaps our great autocrat in art does not sufficiently appreciate. (p. 53)

Ruskin's 'autocracy' was gently resisted. He had often defined praise as the central duty of the critic, but here, Oliphant – whose view was more faithful to the recorded history of the tomb than Ruskin's[25] – teased him with his own characteristic posture. She praised more than he, and her revisionary practice was a new version of Bloom's *tessara* enacted in prose. Here, the writer reads the parent text as if to retain its terms but to mean them in another sense, 'as though', as Oliphant's response suggested, 'the precursor had failed to go far enough'.[26]

Oliphant developed her self-positioning further in terms of art criticism through a critique of Ruskin's 'extreme devotion' (p. 268) to Vittore Carpaccio, and in so doing revealed a further gender issue in her self-defining transaction with Ruskin's legacy. Thinking chiefly of his account of the Ursula cycle in the *Guide to the Principal Pictures in the Academy of Fine Arts at Venice* (1877), Oliphant complained that he misled many readers from the 'crowd' who 'follow the great writer without comprehending him' (p. 269). She was still anxious about the nature of Ruskin's influence in 1892 when she opined, with cautious duality, that

25 See Cook and Wedderburn (eds), *Works of John Ruskin*, 24: 217n–218n.
26 Harold Bloom, *The Anxiety of Influence: A Theory of Poetry* (Oxford, Oxford University Press, 1973), p. 14.

his words 'pervaded the world' and 'led rightly or wrongly . . . the generations of his time'.[27] Irritated by this persuasive textual power in 1887, Oliphant steered the reader symbolically away from his opinions in her view of Carpaccio as a painter who deserved 'enthusiasm' rather than ridiculous Ruskin-inspired 'worship' (p. 269). The fervency of discipleship Ruskin encouraged seemed to her unnatural, foreign to the model of detached, independent reading she preferred in her own critical writing. Her response indicated another gender issue at stake in her adjudication of Ruskin's influential words. She was sceptical of his devoted modern readers, under the spell of what she called in 1892 his 'beautiful writing, expressed in the noblest language and full of the purest sentiment',[28] partly because there was a connection between 'worshipping' art and the excesses of Aestheticism. Half visible in Oliphant's reaction in *The Makers* was the concern that Ruskin's ardent followers were, where male, transgressing a barrier of acceptable manliness, making themselves, as she delicately put it, 'a little ridiculous' (p. 269). Restive with the literary authority of this male figure, Oliphant was also doubtful of forms of transgressive manliness that authority facilitated. To her, such transgression was another sign of the unwatchful reader's captivation by Ruskin, a man who was not, as she said sharply in 1892, 'always . . . a safe or even just guide'.[29]

Oliphant's scepticism about the lure of Ruskin's words over the art lover anticipated a better known and differently motivated negotiation with the afterlife of his views on Italian art and antiquities at the beginning of the twentieth century, and this connection helps reveal her text's influential (and problematic) construction of Ruskin in terms of class. E. M. Forster's *A Room with a View* (1908) exploited the comic potential of a Ruskinian 'worship [of] Giotto'[30] in chapter 2, but there was a serious dimension. Mr Eager's Ruskinian argument that Santa Croce – a church Ruskin had written about at length in *Mornings in Florence*[31] – was built by faith alone is violently punctuated by Mr Emerson's pragmatism – ' "No!" ', he says, ' "Built by faith indeed! That simply means the workmen weren't paid properly" '.[32] Forster, like

27 Oliphant and Oliphant, *The Victorian Age of English Literature*, 2: 214.
28 *Ibid.*
29 *Ibid.*
30 E. M. Forster, *A Room with a View* (Harmondsworth, Penguin, 1978), p. 43. There is some treatment of Ruskin and Forster in Penelope Gay, 'E. M. Forster and John Ruskin: The Ambivalent Connection', *Southern Review*, 11 (1978) 283–95.
31 See Cook and Wedderburn (eds), *Works of John Ruskin*, 33: 295–311.
32 Forster, *A Room with a View*, p. 44.

Oliphant, envisaged Ruskin aloof from the practicalities of the world and its daily needs. But his response drew its motivation from a source separate from the complex nexus of issues urging Oliphant's parrying of Ruskin's cultural presence. Forster would, of course, poke more fun at Ruskin in *Howards End* (1910), presenting *The Stones of Venice* as unconnected with the impoverished life of Leonard Bast. Oliphant, regretting that Ruskin had no time for the 'new occupations which give bread to the poor Venetians',[33] and frustrated with his apparent failure to understand the advantages to ordinary people of the new bridges over the Canal Grande or the usefulness of modern lighting, was well ahead of Forster in fashioning a myth of Ruskin as speaking neither for nor to the representatives of humble, working life.[34]

Forster was unfair to the sincere Ruskin readers of his day. Lawrence Goldman implied this in 1999 in his discussion of Ruskin's influence on the workers' education movement at the end of nineteenth century;[35] Jonathan Rose made it explicit in *The Intellectual Life of the British Working Classes* (2001).[36] But there is no doubt that Oliphant would have ignored such claims insofar as they included her. The version of the author of *The Stones of Venice* that she fashioned in *The Makers* served significant personal and political purposes. And these were too important to blur with qualification, or risk with compromise. Thinking of Ruskin's separation from the quotidian needs of work and wages, his status as a 'rich man . . . speaking to us from his gondola',[37] as Forster would elegantly and brutally put it later in *Howards End*, was to make a classed reading of his cultural position that was invested with Oliphant's annoyance at what she saw as his symbolic position in the map of late nineteenth-century literary production and influence.

Oliphant's response to Ruskin in *The Makers of Venice* was not only a matter of explicit commentary. Part of the force of her confrontation with the Ruskinisation of Venice was located in the substance of her history. Readers who knew the outlines of Ruskin's version of Venice's

33 Oliphant and Oliphant, *The Victorian Age of English Literature*, 2: 224.

34 For Ruskin's view of the iron bridge over the Canal Grande, see Cook and Wedderburn (eds), *Works of John Ruskin*, 24: 172. For his repudiation of the idea that it was a convenience and his regret about its devastating effects on boatmen – overlooked by Mrs Oliphant – see *ibid.*, 172n.

35 See Lawrence Goldman, 'Ruskin, Oxford, and the British Labour Movement 1880–1914', in Dinah Birch (ed.), *Ruskin and the Dawn of the Modern* (Oxford, Oxford University Press, 1999), pp. 57–86.

36 See Jonathan Rose, *The Intellectual Life of the British Working Classes* (New Haven, Yale University Press, 2001), p. 405.

37 E. M. Forster, *Howards End* (Harmondsworth, Penguin, 1992), p. 61.

biography, and who had absorbed the principles of his judgments about the rise and fall of the city, would have been confronted with substantial points of contest in Oliphant's reworking of Venetian history, art, and cultural identity. Her text, multiply engaged in a debate with the lingering power of the author of *The Stones of Venice*, defined its own terms for the history of the city of the sea in evident opposition to his. The chief divisions of her broader dealings with the presence of Ruskin in Venice involved her approach to the spirit of the medieval city in general. This included her scepticism about the age of faith; her erasure of the significance of the Gothic/Renaissance divide; her revocation of Venetian governance in terms that Ruskin had outlawed; and her melancholy fascination, at the biographical level, with moments of betrayal and personal calamity in the lives of noble Venetians, contrary to the memorial intentions of *The Stones of Venice*. Writing her 'Preface' to the *Memoir of Count de Montalembert* (1872), Mrs Oliphant instructed her readers on the principle of her biographical practice in the case of a man she admired. 'I have reserved my own opinion on all points', she said, '– the only possible means by which an artist, of whatever description, can hope to produce a genuine and recognizable portrait.'[38] The necessities of detachment, independent judgment, and the preservation of an individual identity were all the more important for *The Makers* and its textual settlement with Ruskin.

In *St. Mark's Rest*, Ruskin expressed his annoyance with Edward Sedley's *Sketches from Venetian History* (published anonymously by Murray in 1831 and associated with Murray's *Handbooks* in Ruskin's mind) for suggesting that medieval Venetians 'had as little piety as we have ourselves, and were as fond of money' (24: 209). Ruskin stressed, as he had done throughout his life, that the temper of medieval Venice was free from such petty materialism. Indeed, in relation to Sedley's specific opinion, Venice's 'covetousness' was a noble part of her earnest piety. In reality, Ruskin said,

> Venice was sincerely pious, and intensively covetous. But not covetous merely of money. She was covetous, first, of fame; secondly, of kingdom; thirdly, of pillars of marble and granite, such as these that you see [on the Molo]; lastly, and quite principally, of the relics of good people. Such an 'appetite,' glib-tongued Cockney friend, is not wholly 'commercial.' (24: 209–10)

Oliphant, 'reserv[ing] my own opinion on all points', wrote over such ideas.

38 Mrs Oliphant, *Memoir of Count de Montalembert: A Chapter of Recent French History* (Edinburgh, Blackwood, 1872), p. viii.

She concurred with the 'Cockneyism' of Sedley's book that commercial appetite drove the city throughout the heydays of its fame. The medieval Venetians were, she said, 'men of strictly practical vision', who, thinking of the possibility of raiding Constantinople, were characteristically 'dazzle[d]' by 'the extraordinary advantages' (p. 77) lying before them. The Fourth Crusade was one of 'splendid conquests' (p. 85), albeit disgusting in its barbarity. The *quadriga* horses of San Marco, 'curious, inappropriate bizarre ornaments', were a permanent reminder of the appetitive spirit of ancient Venice, the 'lasting piece of spoil' (p. 85) of the thirteenth-century invasions. Oliphant, exploiting a connection between Venice and spoils that Henry James would use to devastating effect a year later in *The Aspern Papers*, dwelt on the colonial activities of the sea city and its acquisitive practices, maintaining her account – an appropriate pun – of the state as anticipating England's own position in the eighteenth century as a 'nation of shopkeepers' (p. 217). Commercial appetite determined her view of Venice's great painters also. Titian, she thought, was interested chiefly in prosperity. He was a 'practical, money-making, pleasure-loving painter' (p. 297), whose business was with the wealthy and eminent. Anything 'is to be got from Titian for money', she admitted (p. 301). Tintoretto was similarly focused on personal advantage, if not on literal enrichment. Quoting an historical source, she assented to the view that he '"[proposed] to himself no other end than self-satisfaction and glory"' (p. 314).

On other aspects of the character of the state, Oliphant swerved – to adapt another of Bloom's words[39] – from Ruskin, building her text in pronounced conflict with the substance of *The Stones of Venice*. She had little time for the notion of the medieval city as an age distinguished by what Ruskin called in *The Crown of Wild Olive* (1866) her 'pure national faith' (18: 443). The beginning of great art in Venice – which Oliphant saw as the arrival of Jacopo Bellini and his two sons from Padua – was disconnected from Christian piety. 'No theory has ever explained to the human intelligence how such a thing can be', she said (p. 250), silently erasing Ruskin's life's work on the theorisation of such a question. In politics, commerce and a desire for Venice's glory were the controlling terms of Oliphant's description, and, when she alluded to it, she was unconvinced by medieval Christianity, cutting across Ruskin's reverence. Considering the odd celebration of the third Doge Michieli's intervention in an attempt to secure the independence of the metropolitan church of Grado, she was characteristically sceptical of the integrity of pre-Reformation

39 See Bloom's definition of *clinamen*, *Anxiety of Influence*, p. 14.

Italian Catholicism. The celebration involved hunting a bull in the Piazza, and the decapitation of twelve pigs, in memory of the bishop and his twelve priests seized during the independence struggle. Oliphant did not leave her account neutral, remarking that, 'notwithstanding all the reverential sentiments of these ages of faith', it revealed 'a certain contempt for the priest as an adversary' (p. 55). Ruskin, in *St. Mark's Rest*, regretted the earlier pre-'unconversion' Protestant tone of *The Stones of Venice* and self-referentially suggested to his readers the danger of 'leaning on our own understanding; [and] the thought that we can measure the hearts of our brethren, and judge of the ways of God' (24: 260). Oliphant, seeking, for the purposes of her own authority, to break the logic of her Venice from Ruskin's, found it more useful to remain suspicious of the nature of Venetian faith, where she cared to mention it at all.

One clear division in Ruskin's work she erased completely. Ruskin's writing on Venice was fundamental in the construction of the Renaissance as a cultural concept. In *The Stones of Venice*, as J. B. Bullen rightly says, 'Ruskin unwittingly armed the myth and gave it a secure position in European history.'[40] But it was not secure as far as Oliphant was concerned. Her interest was in human beings not in movements, in individuals and their biography, not in generalised changes in the moral character of the state. This was part of the human-centred mode of all her books on Italian cities. (It was a historiography that was fully aware, moreover, of the female lives that were usually excluded from official histories and ancient sources, the 'poor women' whose stories were 'unconsidered trifles [dropped] through the loopholes of history' [p. 236].) But choosing the biographical mode in *The Makers of Venice* – exemplified, as I discuss below, in her fascination with fallen heroes – had a distinctive purpose for it facilitated her closing-down of the Ruskinian division of Gothic and Renaissance, satisfactorily eclipsing a central feature of Venice's enduring Ruskinisation. Ending her ample discussion of painters with Paolo Veronese's frescoes, Oliphant described the changes in the fortunes of *tromp l'œil* paintings on the exterior of Venice's domestic dwellings. Her words were about a specific art practice. But, as the last statement in her account of Venetian art altogether, it is difficult not to read them as covert sparring with Ruskin's conceptualisation of the moral forces that left still legible marks in the 'book of [Venice's] art' (24: 203). '[T]hus', Oliphant said, 'the fashion wore itself into poverty and decadence, as fashions have a way of doing,

40 J. B. Bullen, *The Myth of the Renaissance in Nineteenth-Century Writing* (Oxford, Clarendon, 1994), p. 124.

going out in ridicule as well as in decay' (p. 323). Veronese was, in the first volume of *The Stones of Venice*, the painter from whom Ruskin said it was possible to find evidence 'a thousandfold' that the 'fifteenth century had taken away the religious heart of Venice' (9: 32). Oliphant's careful appropriation of Ruskin's Renaissance diction – 'decadence', 'decay' – to articulate her alternative version of a downward turn at the close of Veronese's career, offered here as a natural process of fashion not of spiritual fall, was nicely coherent with her oblique purposes to dispute *The Stones* and overcome its remaining potency.

Byron offered a view of Venice in *Marino Faliero* (1821) and *The Two Foscari* (1821) that emphasised its internal brutality, making the torture chambers of the Palazzo Ducale expressive of the sinister nature of the state's governance. Ruskin's work – though he acknowledged how much he owed to Byron as a young man[41] – was the key agent in changing this conception of the city in the mid-nineteenth century, in erasing Byron's association of Venice with the politics of hidden violence. Oliphant's strategy in *The Makers of Venice* against the work of her immediate precursor (Ruskin) was to re-invoke the outline of *his* precursor (Byron): a way of bringing back the past to disempower the past. Of Venice's internal politics, Oliphant stressed its non-democratic nature, the secretive operation of the Council of Ten, dwelling with affective force on the betrayals and failures of heroes and men of stature to obtain due reward from a shameful state. Ruskin, in volume 1 of *The Stones of Venice*, admitted that, after the dogeship of Francesco Foscari, the government of Venice entered its terminal decline. It took 'the mysterious and perfidious form under which it is usually conceived' (9: 22). Oliphant, unconcerned with mapping changes around pivotal dates, allowed her readers to believe that Venetian government had been variously suspect, perfidious, and increasingly mysterious from the start.

The biographer in Oliphant was attracted to particular moments in the lives of Venetian heroes. But congruent with her belief in the intrinsic failings of the governance of the city, she was drawn especially to instances that crystallised the emotions of human calamity. The affective force of her text was tragic and through this she found a final way of struggling against the persistence of *The Stones*. Ruskin took the

41 See Cook and Wedderburn (eds), *Works of John Ruskin*, 35: 150. For more on Ruskin's Venice, Byron and memory see Francis O'Gorman, 'Ruskin's Memorial Landscapes', *Worldviews: Environment, Religion, Culture: Special Edition: Writing, Landscape, and Community*, 5: 1 (2001) 20–34; on Ruskin and Byron's political reading of Venice, see Kenneth Churchill, *Italy and English Literature 1764–1930* (Basingstoke, Macmillan, 1980), pp. 78–9.

death of Carlo Zeno in 1418, the victor of Chioggia, to mark the commencement of the fall of Venice, yet he did not dwell on his story. Oliphant, characteristically regarding that death as nothing to do with a pivotal point, narrated at length the painful occasion of his downfall and the 'secret pleasure' taken by the state in 'branding the hero of Chioggia, the deliverer of Venice, her constant defender and guard, as a traitor and miserable stipendiary in foreign pay' (p. 192). She made of Zeno's death a plot of heroic loyalty betrayed. More extensive narration was allowed for the fate of the most famous of the doomed Venetian *condottiere*, Francesco Bussone da Carmagnola, the adversary of Filippo Maria Visconti, Duke of Milan, in wars between 1425–32. Oliphant, in distinction from other historians of the Republic, regarded Carmagnola as a heroic man, the victim of a 'remorseless Council' (p. 235) who cruelly punished him because he was 'too great, and for once he had failed' (p. 235). Horatio Brown, in his *Venice: An Historical Sketch of the Republic* (1893), thought, as other late Victorian Venetian scholars did, there was 'little doubt of Carmagnola's guilt towards Venice. His conduct had been that of a true *condottiere* – absolutely regardless of his employers' interests'.[42] But Oliphant's sympathies were elsewhere, and she told the story of the *condottiere*'s bitter end in a way that was shaped by her general thinking about the fate of Venice's heroes throughout the period. Her narration of Carmagnola's first sight of the ducal prisons as he became the victim of a callous state exemplified the affective work of her text, and it can stand for many occasions in *The Makers of Venice* when Oliphant accented moments of pain in the lives of those who had been, as she saw it, faithful to a heartless city:

> No sentimental Bridge of Sighs existed in these days. But when the door of the strong-room which was to be his home for the rest of his mortal life was opened, and the lively voices of his conductors sank in the shock of surprise and horror, and all that was about to be rushed on Carmagnola's mind, the situation is one which requires no aid of dramatic art. Here, in a moment, betrayed out of the air and light, and the freedom which he had used so proudly, this man, who had never feared the face of men, must have realised his fate. At the head of a great army one day, a friendless prison the next, well aware that the light of day would never clear up the proceedings against him, or common justice, such as awaits a poor picker and stealer, stand between him and the judges whose sentence was a foregone conclusion. Let us hope that those intimates who had accompanied him thus far slunk

42 Horatio F. Brown, *Venice: An Historical Sketch of the Republic*, 2nd edn (London, Rivington, Perceval, 1895), p. 294.

away in confusion and shame from the look of the captive. So much evil as Carmagnola had done in his life – and there is no reason to suppose, and not a word to make us believe, that he was a sanguinary conqueror, or abused the position he held – must have been well atoned by that first moment of enlightenment and despair. (p. 234)

Such narrative episodes levered the affective into the historiography of *The Makers of Venice*. In moments when the sympathetic imagination bridged history and connected, through humanist assumptions of universal subjectivity, with the feelings of fated men in the distant past, Oliphant impressed the reader's memory of Venice with human episodes of hopelessness. The illustrations in the book revealed the fragments of ancient Venice faintly visible amid the modern, insisting on Venice as a place recollectable by remains and signed by loss. Likewise, the memorial work of the written text was imaginatively to preserve fragments of distant human lives, chiefly those inscribed with pain and betrayal, from the fragile remnants of history.

The work of memory in Oliphant's text contested the memorial function of *The Stones of Venice*. It commemorated the tragic or the disastrous, not the potentially redemptory, as Ruskin thought Venetian history should be. The affective thrust of *The Makers*, and the aspect of Venice's history that Oliphant ensured would live longest in the reader's mind, went against the commemorative spirit of Ruskin's life's work with the city. Ruskin, once again, in the oppositional paradigm of reading evident in *The Makers*, provided the terms against which Oliphant wrote as she articulated her own voice as Venetian historian over the lingering presence of a man whose public statements were increasingly silenced by sickness. Opposition, through a rich array of self-inscribing strategies, determined Oliphant's reading of Ruskin, and, within this framework, contestational misprision was her ally. Even as she challenged Ruskin for failing (or so she thought) to note the conditions of lives in the modern world, she effaced the political dimension of his Venetian work – *The Stones'* nationally significant interventions in a mid-century debate about labour conditions – with which she might have been more sympathetic. Ruskin's vexation with his own influence on readers, as expressed in *St. Mark's Rest* and the prefaces to the reissued *Stones*, and his increasing interest in the 1870s and 1880s in a historiography that privileged the lives of the poor and of those who fell through the 'loopholes of history'[43] brought him closer to Oliphant's

43 See Francis O'Gorman, 'Ruskin, and Writing History from Home', in Werner Oechslin (ed.), *John Ruskin: Werk und Wirkung* (Zürich, ETH, forthcoming).

interests than she could allow. Selective in her representation, she was helping to create a myth of Ruskin as much as she was using him to answer her own needs. Indeed, her work played its role in assembling a model of Ruskin as a kind of literary despot, a man whose denunciations were ridiculous in their 'shrill anathema', whose principles were grounded in ideals detached from the quotidian world, and whose life in art had separated him from the pressing concerns of his day. Challenging Ruskin with such convictions, Oliphant assisted in creating the conditions that would help ensure the collapse of his public reputation at the beginning of the next century.

Such an outcome was not the ambition of *The Makers*. But the operative paradigm of reading Ruskin, and the source of the text's personal energy, was certainly one of bold resistance. For Oliphant this was a compelling obligation. Gillian Beer, in her study of writers arguing with the past, queries the patterns of opposition in literary influence assumed by Harold Bloom in *The Anxiety of Influence*. She argues for an alternative acknowledgement of reading as a practice that privileges complexity and recognises how texts challenge by 'offering questions we had not thought of, and suggestions not on our terms'.[44] Oliphant's conflictual model of reading Ruskin was not Beer's, as it was not Gilbert's and Gubar's. But if Oliphant did not allow Ruskin's work to offer 'questions . . . not thought of', she did, at another level, find that he provided the terms of a textual solution to a personal and cultural predicament. She recognised the enduring strength of Ruskin's Venetian legacy at the same time that she found in Venice the possibilities of using his discourse to her own profit. By competing with her construction of Ruskin, she signed her own name as a Venetian historian (as well as, paradoxically, re-signing his) and, by implication, proposed herself as authentic author of non-fiction critical prose. Joseph Brodsky wrote in *Watermark* (1992) that he knew on his first night in Venice that he would 'never possess this city'.[45] Oliphant's many-sided engagement with Ruskin 105 years earlier suggests how an effort to possess a textual version of Venice, or at least to leave one's own traces despite another's, could lead to enabling self-possession and self-inscription. Determined to ensure a place of her own as a non-Carlylean woman of letters at the end of the nineteenth century, Mrs Oliphant descried in Venice, and the textual spoil the Queen of the Adriatic represented, a remarkably advantageous prospect.

44 Gillian Beer, *Arguing with the Past: Essays in Narrative from Woolf to Sidney* (London, Routledge, 1989), p. 6.
45 Joseph Brodsky, *Watermark* (Harmondsworth, Penguin, 1997), p. 16.

Vernon Lee and the ghosts of Italy

Catherine Maxwell

So why should the past be charming? Perhaps merely because of its being the one free place for our imagination. For, as to the future, it is either empty or filled only with the cast shadows of ourselves and our various machineries. The past is the unreal and the yet visible; it has the fascination of the distant hills, the valleys seen from above; the unreal, but the unreal whose unreality, unlike that of the unreal things with which we cram the present, can never be forced on us. *There is more behind; there may be anything.* This sense which makes us in love with all intricacies of things and feelings, roads which turn, views behind views, trees behind trees, makes the past so rich in possibilities.[1]

THIS ESSAY explores the imaginative importance of the past for the writer Vernon Lee (1856–1935), celebrated in the late nineteenth and early twentieth centuries for her diverse works on aesthetics, ethics, history, and for her short stories, and essays of travel. Sharing Percy Shelley's Romantic aim to 'always seek in what I see something beyond the present & tangible object', Lee was fascinated by the 'beyondness', the vistas of the past.[2] The perspectives opened up by such vistas allowed her space to project her own ideas and images, and her writing on history, memory and association is pervaded by a form of imaginative perception and interpretation which she identifies with ghosts and ghostliness. The essay therefore introduces the reader to some of these manifestations of ghostliness, but at the same time it also introduces the reader to Lee's past, to her formative upbringing, her interests and her aesthetic and cultural milieu. Lee spent most of her life in Italy, and Italian art, culture and scenery are integral to her writings. That Italian past

1 Vernon Lee, 'In Praise of Old Houses', in *Limbo and Other Essays* (London, John Lane, 1897), p. 40 (italics in original).
2 *The Letters of Percy Bysshe Shelley*, ed. F. L. Jones, 2 vols (Oxford, Clarendon Press, 1964), 2: 47.

now seems to us far distant, so this essay attempts to revive something of its presence as a context for Lee's intellectual development and as a source of inspiration for her writing.

'Vernon Lee' was a pseudonym adopted when the young Violet Paget was about to publish her articles on Italy in the eighteenth century in *Fraser's Magazine* in 1878 – 'as I am sure no one reads a woman's writing on art, history or aesthetics with anything but unmitigated contempt' – but it was also the name she preferred to be known by and to her friends and intimates she was always 'Vernon'.[3] Born at Château Saint Léonard, twelve miles from Boulogne, into a distinctly unconventional middle-class family, she was brought up on the continent – 'we shifted our quarters every six months, and by dint of shifting, crossed Europe's length and breadth in several directions'[4] – although much of her earliest childhood seems to have been spent in Germany. The household was dominated by Lee's forceful free-thinking mother Matilda, a woman determined to develop the intellectual talents of her two children. Eugene Lee-Hamilton (1845–1907), later to achieve some fame as a poet, was her son by her first marriage to Captain Lee-Hamilton and her primary concern. Violet, her daughter by her second husband Henry Ferguson Paget, Eugene's one-time tutor, was initially looked after by a succession of Swiss and German governesses. However, as Violet grew older and Eugene was away, first at Oxford and then starting his short-lived career in the diplomatic service, her mother played a greater part in her education, instructing her in a somewhat idiosyncratic fashion in grammar, Euclid, rhetoric and rationalist philosophy.[5] Eugene was proud of his sister's abilities, monitored her progress, and advised on her course of study in the letters he sent home from Paris, where he was attached to the British Embassy. Violet's father, financially dependent on his wife, played no part in these intellectual experiments, being more interested in mechanical gadgets and outdoor pursuits such as shooting or fishing.

It was at Nice where the family were wintering in 1866–67 that the ten-year-old Violet met John Singer Sargent, only ten months older,

3 Letter to Mrs Jenkin (18 December 1878) in *Vernon Lee's Letters with a Preface by her Literary Executor*, ed. Irene Cooper Willis (London, Privately printed, 1937), p. 59, and cited in Peter Gunn, *Vernon Lee: Violet Paget, 1856–1935* (London, Oxford University Press, 1964), p. 66.

4 Vernon Lee, 'The Sentimental Traveller', in *The Sentimental Traveller* (London, John Lane, The Bodley Head, 1908), p. 6.

5 Vernon Lee, *The Handling of Words and Other Studies in Literary Psychology* (London, John Lane, 1923), pp. 297–301.

who was to remain a lifelong friend. The families became close and Mrs Sargent persuaded the Pagets to spend the winter of 1868–69 in Rome. This was to be a turning point for Violet, for it was Rome which would awaken in her what Tennyson had called the 'passion of the past'.[6] Although at first unimpressed by the bad weather and the squalor she saw in the city, Violet was won over when she was taken to a magnificent mass at St Peter's during the Christmas festival. It was the imaginative and aesthetic, rather than the spiritual, impact of this spectacle which wrought upon her consciousness: 'And indeed from that moment, I poor tiny creature, constituted the most microscopic among the conquests of the world-conquering and heart-subduing city.'[7] In spite of their peripatetic existence, the Pagets were not curious travellers, and it was Mrs Sargent who was responsible for introducing Violet to the sights of Rome and, more importantly, feeding her imagination with stories about the city: 'For what I saw was less potent than what I overheard at meals in the hospitable little house . . . which looked across to St. Peter's'.[8] John, his sister Emily and Violet went for walks together in the Forum, the Baths of Caracalla, the Borghese and Medici Gardens, looking for coins or bits of antique marble. One of those sought-after antique coins would become the inspiration for Violet's first publication, a historically-informed tale about the peregrinations of a Roman denarius, written in French as *Les Aventures d'une pièce de monnaie* and published in the Lausanne paper *La Famille* for May, June and July 1870. Recalling her former enthusiasm for these old coins in an essay about the past, Lee writes 'had they not concentrated in their interesting verdigrised, brass-smelling smallness something, to me, of the glory and wonder of Rome?'[9]

Fascinated by Roman history, John and Violet immersed themselves in antiquarian studies and pored over Murray's *Guide* and Smith's *Smaller Dictionary of Antiquities*, but were also children enough to enjoy ' "bombarding" the pigs, then kept outside Porta del Popolo, with

6 Tennyson to James Knowles: 'it is what I have always felt even from a boy, and what as a boy I called the "passion of the past." And it is so always with me now; it is the distance that charms me in the landscape, the picture and the past, and not the immediate to-day in which I move.' Cited in the note on 'Tears, idle tears', from *The Princess*, Book 4, in *Tennyson: A Selected Edition*, ed. Christopher Ricks (Harlow, Longman, 1989), p. 266.

7 Vernon Lee, 'Christkindchen', in *Juvenilia: Being a Second Series of Essays on Sundry Aesthetical Questions*, 2 vols (London, T. Fisher Unwin, 1887), 2: 198.

8 Lee, 'The Sentimental Traveller', p. 13.

9 Lee, 'In Praise of Old Houses', p. 26.

acorns and pebbles from the Pincian Terrace; and . . . burning holes in bay-leaves with a burning glass, until we were expelled as *"enfants mal élevés"* by the ferocious porter of Medici Gardens'.[10] Lee also gives us a tantalising glimpse of the expatriate artistic community in Rome who occasionally came to dine with the Sargents:

> [T]hose legendary artists: Harriet Hosmer, Randolph Rogers, W. W. Story, and so forth, whose statues, each in every stage of wet-sheeted clay, pock-marked plaster, half-hewn or thoroughly sand-papered marble, were displayed on a weekly *day* by their explanatory creators, and which you can read about – and, of course, we children in 1868–69 were perpetually reading about – in Hawthorne's 'Marble Faun.' The 'Marble Faun!' the illustrious prototypes of its Kenyon, Hilda and the other lady – ah! her name was Miriam – somehow coupled (but children needn't ask why) with Beatrice Cenci – all these sculptors and sculptresses as monumental as their own *Zenobias* and Libyan Sibyls, were having coffee upstairs, with a due proportion of painters.[11]

This brief snapshot of an aesthetic circle, already characteristically seen through an associative veil of reading and reverie, is also prescient of Lee's own adult life, in which she too would be at the centre of an aesthetic group in her own Florentine community.

The Pagets returned to Rome in subsequent years. During this time, from about the age of thirteen to twenty, Lee explains that her regular childhood passions gave way to

> an unaccountable passion for the people and things of the eighteenth century, and more particularly of the eighteenth century in Italy . . . I really did find my way into that period, and really did live in it; for I began to see only the things belonging thereunto; and I had little or no connection with anything else.[12]

This period had to date evoked little scholarly interest, leaving it open ground for Lee:

> [T]he Italy of the eighteenth century, accidentally opened to me, became, so to speak . . . the remote lumber-room full of discarded mysteries and of lurking ghosts, where a half-grown young prig might satisfy, in unsuspicious gravity, mere childlike instincts of

10 Lee, 'J. S. S.: In Memoriam', in Hon. Evan Charteris KC, *John Singer Sargent* (London, William Heinemann, 1927), pp. 241–2.

11 *Ibid.*, pp. 243–4.

12 Lee, 'Rococo', in *Juvenilia*, 1: 136–7.

make-believe and romance. Save for a few funny pedants . . . no one ever seemed to enter my lumber-room of an Italian eighteenth century; and I was left to transpose it into a place of wonders.[13]

Out of this passion would eventually come her *Studies of the Eighteenth Century in Italy* (1880), an extraordinarily assured, elegant and erudite survey of the cultural and, in particular, musical life of the period, which Lee would publish at the age of twenty-four. Her scholarly researches, however recondite, always seem to have been prompted by findings which fired her imagination such as her discovery in June 1871, aged fourteen, of the neglected garden and villa known as the Bosco Parrasio, which had been the home of the most famous of the Italian academies during the eighteenth century, the Accademia degli Arcadi, subsequently the subject of the first chapter of her book: 'The house was full of old portraits; the neglected garden was bright in May and June with flowers sprung, so to speak, from the bulbs and slips planted in former days – an elegy which you touched with your hand and trod under foot.'[14] Another stimulant was music, specifically the unheard melodies of the past: 'Have you ever thought over the fate of forgotten melodies?' she asks wistfully in a later essay on Galuppi (that same composer who inspired Browning's poem on evocation).[15] Haunted by the notion of songs and voices trapped in the past, Violet became a transcriber, collector and devourer of old musical manuscripts. Picking out the tunes for herself on the piano, 'conning those few pieces for weeks, months, years, phrase by phrase', she came into a deep affinity with the music: 'Indeed, I suspect that some of the extraordinary poignancy which eighteenth-century music still possesses for me may be due to the imaginative fervour with which I spelt out those songs and sonatas, to the inner dramas by which their hearing were accompanied.'[16] She writes also of her trepidation of hearing her mother play for the first time a collection of transcribed airs and, feeling 'shy of those unknown, longed-for songs', is obliged to go out and listen in the garden, filled with anxiety lest a particular celebrated piece – *Pallido il sole* – '*should turn out hideous* . . . on that piece hung the fate of a world – the only one which mattered – the world of my fancies and longings'.[17] Moved

13 Vernon Lee, Introduction to the second edition of *Studies of the Eighteenth Century in Italy* ([1880] London, T. Fisher Unwin, 1907), p. xvi.

14 Lee, 'Rococo', in *Juvenilia*, 1: 142.

15 Lee, 'The Immortality of Maestro Galuppi', in *Juvenilia*, 2: 12.

16 Introduction to Lee, *Studies of the Eighteenth Century in Italy*, pp. xxiii, xlvii.

17 *Ibid.*, p. xlviii.

by the ephemerality of music in this age before mechanical recording, Lee pictures the musicians of former ages as suppliant ghosts:

> music requires the attention not only of the hearer, but also of that costly middleman, the performer ... Hence while museums and appreciation may enlarge and house more and more old-fashioned, archaic, nay, pre-historic art ... the musicians of former ages may be compared to the ghosts flocking hopelessly round the sacrificial trench of Odysseus, waiting in vain for the drink which restores their bulk and their voice; spectres, some of them, heroic or loveable, but who, for lack of that life-blood of attention, can never speak to posterity nor lay their hands on its soul.[18]

Of course as an antiquarian researcher and writer, Lee, too, would become something of a 'middleman' or 'performer', bodying out for her readership these shades of the musical past by giving them the 'life-blood of attention'.

In the autumn of 1872 the Pagets and the Sargents spent ten days together at Bologna, where they rambled round the city sightseeing, and in the mornings spent 'hours over the portfolios of prints and unreadable ... scores of the music school'.[19] In this music school, the Philharmonic Academy, hung, as it still does, a painting of the eighteenth-century castrato Carlo Broschi, better known as Farinelli, one of Italy's finest singers, who kept at bay the madness of Philip of Spain by singing to him the same three songs every night for ten years. Both John and Violet were entranced by this painting, which inspired Lee's story 'Winthrop's Adventure' in 1874, and which was also the germ for her later more famous story 'A Wicked Voice', about a composer haunted by the voice of an eighteenth-century castrato.[20] The earlier story was published in *Fraser's Magazine* for January 1881 as 'A Culture-Ghost: or, Winthrop's Adventure'. In her preface to the reprint of the story in the collection *For Maurice* (1927), Lee explains the title by which her ghost 'was introduced to the reading public': 'he was a "Culture-Ghost ...

18 *Ibid.*, p. xlv.

19 Lee, 'J. S. S.: In Memoriam', p. 248.

20 'A Wicked Voice' has been one of the most discussed of Lee's ghost stories. See Catherine Maxwell, 'From Dionysus to "Dionea": Vernon Lee's Portraits', *Word & Image*, 13 (1997) 253–69. See also the following excellent articles: Carlo Caballero, 'On Vernon Lee, Wagner and the Effects of Music', *Victorian Studies*, 35 (1992) 386–408; Angela Leighton, 'Ghosts, Aestheticism and "Vernon Lee"', *Victorian Literature and Culture*, 28: 1 (2000) 1–14; Patricia Pulham, 'The Castrato and the Cry in Vernon Lee's Wicked Voices', *Victorian Literature and Culture*, 30: 2 (2002) 421–37.

the word *culture* signifying in the earliest" eighties anything vaguely connected with Italy, art and, let us put it, the works of the late J. A. Symonds.'[21] Although Lee pretends to a certain embarrassment about this rather cumbrous title, it provides an interesting gloss on her idea of a ghost which is not restricted to conventional notions of the supernatural. Here 'ghost' is associated with an aesthetic milieu or atmosphere, specifically Italian in kind. She quotes a letter from John Singer Sargent, written in 1881 after receiving a copy of the story, in which he singles out Lee's evocative treatment of the setting for praise: 'I like its Italian colour very much and the delicate observation throughout, so much so, indeed, that the local atmosphere, so to speak, strikes me as the real raison d'être of the thing, and the ghost story a pretext.'[22] But the point is rather that in this tale Lee transforms the ghost story into a general exercise in evocation, widening our sense of what a 'ghost' or the 'ghostly' might be. Comparing 'Winthrop's Adventure' with 'A Wicked Voice', she declares her preference for the earlier story:

> *A Wicked Voice* is a thoroughly carried out impressionist study of Italian things properly lit up and perspectived . . . the Italy of the old *Culture-Ghost* (I am getting to love that title as one loves certain Victorian chairs and tables) is of another sort. It is Italy entirely believed in because entirely interesting, entirely lovely, terrible, picturesque, entirely Italian. The Italy of Ouida and J. A. Symonds (let alone of Childe Harold), made solely for the heart's desire of the imaginative tourist; and therefore awakening the genuine feelings of which it was born.[23]

She then continues in a more personal vein to conjure up her own remembrance of her experience as an 'imaginative tourist' in Bologna:

> Those genuine feelings of those youthful days of mine I can sometimes almost recapture, catch the swish of them vanishing in the distance of years. I mean the ineffable sense of the picturesqueness and wonderfulness of everything one came across: the market-place with the stage coach of the dentist, the puppet show against the Gothic palace, the white owl whom my friend John and I wanted to buy and to take home to the hotel, the ices we eat [sic] in the medieval piazza, the skewered caramelles and the gardenias and musky, canary gaggias hawked about for buttonholes; the vines festooned over corn and hemp,

21 Vernon Lee, Introduction to *For Maurice: Five Unlikely Stories* (London, John Lane, 1927), p. xxxvi.
22 Lee, *For Maurice*, p. xxxvii.
23 *Ibid.*, p. xlii.

the crumbling villas among them, the peasants talking like W. W. Story's *Roba di Roma* . . . 'Kennst du das Land?' . . . a land where the Past hunted on with its wizards, sphinxes, strange, weird, *curious*. A land where on full-mooned terraces, and in company with countesses – in those *Roderick Hudson* days a countess was herself an exotic – you might listen to not the intermezzo of *Cavalleria* but mysterious eighteenth century songs, might almost hear the voice (*not* wicked, oh no, ever so virtuous) of Farinelli himself.[24]

Here the evanescent ghosts of memory of Lee's 'youthful days' get mixed up with the spirit of place, where Bologna stands in for the essence of Italy, and Italy is synonymous with the past, the whole seasoned by evocative literary references. Lee is adept at making her nostalgia our own, making familiar to us things of her past which she extracts from a distance which is simultaneously near and far. Playing always on her – and our – curiosity for what is beyond, she awakens desire by perpetually alluring us with another vista, or better still a series of receding vistas, tinged with her peculiarly elegiac sense of colour, making one think of what she calls elsewhere 'the colour . . . of forgotten songs'.[25]

In 1873, Violet Paget's half-brother, Eugene Lee-Hamilton, was invalided out of the diplomatic service with health problems, probably psychosomatic in origin and later diagnosed by Charcot as 'cerebral-spinal neurasthenia'. This condition was to keep him bed-bound for more than twenty years until he recovered his strength in the 1890s. The Pagets, unable to keep up their transcontinental travels, settled in or near Florence, at hotels or lodgings, then at two addresses in the city before they finally moved in 1889 to the Villa Il Palmerino at Maiano (just outside Florence), where Vernon Lee lived until her death in 1935. While the life of the household tended to centre around Eugene, the Pagets certainly did not lead a cloistered existence. When well enough Eugene was taken out by his mother and sister on his plank bed for a daily drive in the hills round Florence, and in the evenings he received visitors selected by Violet out of the many eminent men and women who came to pay calls at the house.

While Violet proved a supportive sister to Eugene, helping him find publishers for his poems, she was by no means content to subordinate her life's work to his. She continued her own intellectual interests and writing. During 1875–79, she kept up a correspondence with the novelist and republican Giovanni Ruffini (1807–81), whom she had met through

24 *Ibid.*, pp. xlii–xliii.
25 Lee, 'The Immortality of Maestro Galuppi', 2: 17.

Eugene in Paris in 1870.[26] Ruffini gave her advice and encouragement and, in the 1880s, she began to travel more widely, paying almost annual trips to London to meet the major intellectual and artistic figures of the day. As she wrote in her preface to *Juvenilia* (1887), a collection of essays on aesthetics she dedicated to her friend, the critic Carlo Placci, 'while Italy makes one think of the past, England inevitably leads one think to speculate upon the future'.[27] England for Lee was associated with technological innovations and advances but also, one assumes, was identified in a more practical way as the centre of the world of letters, with publication, and thus her own literary reputation and future.[28] During this period she was actively publishing, showing her talents in a number of different literary genres: novels *Ottilie* (1883) and *Miss Brown* (1884); a children's story, *The Prince of a Hundred Soups* (1883); a biography, *The Countess of Albany* (1884); the philosophical dialogues, *Baldwin* (1886) and *Althea* (1894); a collection of supernatural tales, *Hauntings* (1890); and a collection of modern morality tales, *Vanitas* (1892). Trips to England were important in gaining her significant friends and contacts such as Walter Pater and Robert Browning and helping establish her on the literary scene. However, Lee was not easily impressed by literary London, and her amusingly caustic observations are preserved in the letters she wrote home to her mother, edited and privately printed in 1937 by her literary executor Irene Cooper Willis.

Lee would always remain something of an outsider in England, although, as Hilary Fraser has demonstrated, being of a cross-cultural and cosmopolitan identity, she hardly appeared like a 'wholly native inhabitant' of Italy.[29] Nonetheless her social relations with Italian and other continental writers were far easier, and at home in Florence it was she, rather than Eugene, who came to be the key figure in Florentine literary culture. It had been unusual during the nineteenth century for English and American visitors or residents in Italy to mix very much

26 For details of Lee's relationship with Giovanni Ruffini (1807–81), see Peter Gunn's biography of Lee, Beatrice Corrigan, 'Giovanni Ruffini's Letters to Vernon Lee 1875–9', *English Miscellany*, 13 (1962) 179–240, and pp. 20–2 of the useful introduction 'Vernon Lee and Italy' in Rita Severi's English and Italian edition of Lee's *Ariadne in Mantua* (Verona, Edizione Postumia-Cierre, 1996).

27 Lee, Introduction to *Juvenilia*, 1: 13.

28 For Lee's scepticism about these innovations and advances, see her description of the polluted Tyne in her Preface to Lee, *Juvenilia*, 1: 13–16.

29 Hilary Fraser, 'Vernon Lee: England, Italy and Identity Politics', in *Britannia Italia Germania: Taste and Travel in the Nineteenth Century*, eds. Carol Richardson and Graham Smith (Edinburgh, VARIE, at the University of Edinburgh, 2001), pp. 175–91 (p. 182).

with Italians. The Brownings, for example, in the 1850s moved within a firmly defined Anglo-American circle while later, in 1874, Henry James writing to Grace Norton remarks: 'I have been nearly a year in Italy and have hardly spoken a word to an Italian creature save washerwomen and waiters.'[30] Sybille Pantazzi, author of two invaluable essays on Lee's Florentine acquaintances, comments:

> Indeed Vernon Lee's circle was in some ways the successor of the famous group which gathered around the Brownings and the Trollopes in the 1850's and 1860's. Her group was, however, both more Italian and more international than the earlier one had been. It included for instance Enrico Nencioni, Mario Pratesi, Telemaco Signorini, Angelo de Gubernatis, Pasquale Villari, Giuseppe Buonamici, Gaetano Salvemini, Gabriele d'Annunzio and Carlo Placci, the Germans, Karl Hillebrand and Adolf von Hildebrand, and the French writers Anatole France, Paul Bourget, Daniel Halévy, Charles du Bos and Romain Rolland.[31]

Lee's relations with the poet and critic Enrico Nencioni (1837–96), and the anglophile man-of-letters Carlo Placci (1861–1941) were of particular importance. Nencioni, to whom she dedicated the second edition of *Studies of the Eighteenth Century in Italy* (1907) and who was her model for the figure of the professor in *Althea*, was 'the recognised authority in Italy on English contemporary literature' and wrote articles on the Brownings, Carlyle, Dickens, Swinburne, Whitman and Kipling among others.[32] He reviewed a number of Lee's earlier works and it was through his contacts that Lee came to write for many leading Italian journals. Placci, the dedicatee of her *Juvenilia*, a cosmopolitan host, sparkling conversationalist and good pianist who knew many of the best contemporary musicians, also reviewed some of Lee's works, and kept up a correspondence with her from 1883 to 1926. Another later influential relationship was with the young Mario Praz (1896–1982) whom Lee befriended and encouraged as he was starting his career as an Italian academic working on English literature. An account of their relationship,

30 Henry James, letter to Grace Norton, 14 January 1874, in *The Letters of Henry James*, ed. Percy Lubbock, 2 vols (London, Macmillan, 1920), 1: 36.

31 Sybille Pantazzi, 'Carlo Placci and Vernon Lee: Their Letters and their Friends', *English Miscellany*, 12 (1961) 97–122 and 'Enrico Nencioni, William Wetmore Story and Vernon Lee: An Italian Critic's Anglo-American Friendships', *English Miscellany*, 10 (1959) 249–60. Citation from 'Carlo Placci and Vernon Lee', pp. 97–8. Placci's correspondence including his letters from Lee was donated to the Florentine Biblioteca Marucelliana where it can still be consulted. For other accounts of Lee's Florentine relationships, see also Peter Gunn's biography and Severi, 'Vernon Lee and Italy', pp. 22–6.

32 Pantazzi, 'Enrico Nencioni, William Wetmore Story and Vernon Lee', p. 250.

including excerpts from her letters to him, is included in his memoir *La casa della vita* (1958), available in an abridged English version as *The House of Life*; his letters to her are preserved in the Vernon Lee collection at Somerville, Oxford.[33] Praz's reminiscences of Lee are grateful and affectionate although other of his academic writings which mention her can assume a somewhat condescending tone.[34] Interestingly his most famous work, known in English as *The Romantic Agony*, has as one of its major themes the femme fatale, a theme central to Lee's ghost stories which pass unmentioned in Praz's text.[35]

Lee's unconventional upbringing and independence of mind meant that she led an emancipated life, unshackled by the constraints of Victorian polite society. Her 'New Woman' habits of bicycling round Rome, travelling unchaperoned, and speaking her mind, coupled with her 'mannish' appearance and severely-tailored attire, made her seem formidable to many of those who met her. The celebrated illustrator Joseph Pennell, who made drawings for a number of her articles, wrote to his fiancée Elizabeth Robins: 'I share your fright of "Vernon Lee". She – (or he as she is frequently called) is quite overpowering'.[36] In his memoir *The Adventures of an Illustrator* (1925), Pennell records accompanying Lee with her friend, the poet Mary Robinson, to Urbino and Rimini to illustrate an article she was writing on Raphael. Although his tone is rather muted, Pennell gives the impression that the ladies were very much in command and the chapter is headed by a facsimile of the just-mentioned letter to his wife which contains a unflattering caricature of Lee's 'masculine' appearance.[37] However, Lee's authoritative manner

33 Mario Praz, *The House of Life*, transl. Angus Davidson (London, Methuen, 1964), pp. 226–46.

34 See, for example, his review of Peter Gunn's biography of Lee in *English Studies*, 47 (1966) 310–14, and his essay 'Vernon Lee' in *Studi e svaghi inglesi* (Florence, G. C. Sansoni, 1937), reprinted in *Il patto col serpente* (Milan: Arnoldo Mondadori, 1973), pp. 270–85.

35 Mario Praz, *La carne, la morte e il diavolo nella letteratura romantica* (1930); *The Romantic Agony*, transl. Angus Davidson (1933; 2nd edn 1951), reissued with a new foreword by Frank Kermode (Oxford, Oxford University Press, 1970). Praz does, however, include references to Lee's *Miss Brown* and *Studies of the Eighteenth Century in Italy* in his footnotes.

36 Pennell illustrated Lee's 'The Youth of Raphael', *Art Journal*, 35 (1883), 337–40, 373ff; 'San Gimignano of the Many Towers', *Portfolio*, 14 (Dec. 1883), pp. 200–4, and 'North Tuscan Notes', *The Magazine of Art*, 7 (Jan 1884), pp. 1–8. See Elizabeth Robins Pennell, *The Life and Letters of Joseph Pennell*, 2 vols (Boston, Little, Brown and Co., 1929), 1: 92.

37 Joseph Pennell, *Adventures of an Illustrator* (Boston, Little, Brown & Co., 1925), pp. 125–9.

stood her in good stead in other situations. Her love of Italy and things Italian made her a champion for conservation. She was a member of the 'Associazione per la difesa di Firenze antica' (Society for the Protection of Old Florence) and, as one of its few foreign members, was requested to write a letter to *The Times* explaining the work of the Society with regard to a particular controversy about planning and modernisation then raging in Florence. In her letter of 5 December 1898, Lee explains how the cholera epidemic of 1885 had prompted the destruction of the historic 'Centre' of Old Florence. Instead of improving the sanitation and ventilation of this area, the authorities had simply demolished it. Now schemes for modernisation were planned in other parts of the town and the newly-formed Society was anxious to gather support throughout the world to prevent similar destruction. While Lee stresses that she is not against measures being carried out to improve the living conditions of the poor and the working people, she is keen to emphasise that such improvements could be made without sacrificing more of Florence's ancient heritage. Her pragmatism surfaces when she writes that

> Every means should be taken to educate the taste and historic spirit of the small *bourgeoisie* and working people by lectures, newspaper articles, tracts, pamphlets, and such public events as the proposed congress of art history. Moreover, it ought, by every similar method, to be made clear to the hotel and shop keepers, to the owners of lodgings, to jobmasters and cabowners, and to every class directly or indirectly interested in the presence of foreigners that one of the chief attractions of this city is its well preserved medieval character, an attraction in which it already has very dangerous rivals in Siena and Perugia.[38]

From the 1880s onwards Lee began to write the kind of travel essay for which she became famous – short impressionistic articles which, through clever use of detail and evocative local colour, summed up the essence of a particular spot. As her friend the critic Desmond MacCarthy wrote: 'In the art of weaving a delicate net of words in which to catch the spirit of place, not even Henry James is more skilled.'[39] Over a period stretching from the very end of the nineteenth century until the end of the first

38 The letter dated 5 December was printed in *The Times* (15 December 1898), and takes up the first three columns on page 8. My thanks to Carlotta Farese for this information.

39 Desmond MacCarthy, 'Out of the Limelight' (1941), *Humanities* (London, MacGibbon and Kee, 1953), p. 190.

quarter of the twentieth century, these essays were published in the collections *Limbo and Other Essays* (1897), *Genius Loci: Notes on Places* (1899), *The Enchanted Woods and Other Essays on the Genius of Places* (1905), *The Spirit of Rome* (1906), *The Sentimental Traveller: Notes on Places* (1908), *The Tower of Mirrors and Other Essays on the Spirit of Places* (1914) and *The Golden Keys and Other Essays on the Genius Loci* (1925). While the essays describe all manner of European places, it is the pictures of Italy for which she is most remembered, perhaps because they seem most steeped in her imaginative sense of the past. What is also interesting and perhaps rather surprising about these travel essays is the way in which Lee insists that the moment of present perception in which one is exposed to the new sight or scene is meaningless unless it is already permeated by the past of preparatory anticipation. In 'On Modern Travelling', she declares, 'before visiting countries in the body, we ought to have visited them in the spirit; otherwise I fear we might as well sit still at home', and in the title chapter of *The Sentimental Traveller*, she writes:

> For the passion for localities, the curious emotions connected with the lie of the land, shape of buildings, history, and even quality of air and soil, are born, like all intense and permeating feeling, less of outside things than of our own soul. They are of the stuff of dreams, and must be brooded over in quiet and void. The places for which we feel such love are fashioned, before we see them, by our wishes and fancy; we recognise rather than discover them in the world of reality; and this power of shaping, or at least seeing, things to suit our heart's desire comes not of facility and surfeit, but of repression and short commons.[40]

Another essay in *The Sentimental Traveller* informs us of Lee's childhood fondness for the old-fashioned Victorian annual *The Keepsake*, whose illustrations of foreign places had made such a deep impression that, encountering some new place as an adult, she could say: 'I had loved it all, like Rudel the Lady of Tripoli, before seeing it; and the faint thrill of that imaginative love still made the place, of a kind so familiar and almost hackneyed to me nowadays, delightful and in a way wonderful.'[41] Thus in an essay on Portofino, also in *The Sentimental Traveller*, Lee writes of how the experience of visiting the place is bound up with the desire and expectation of having wanted to see it many

40　Lee, 'On Modern Travelling', in *Limbo and Other Essays*, p. 92; Lee, *The Sentimental Traveller*, p. 4.

41　Lee, 'The Keepsake', in *The Sentimental Traveller*, p. 227.

times while staying nearby as a child: 'Nay if all this beauty around me, this real Mountain of Portofino, had, besides a visible body, also a soul, why, it almost seemed that this immortal essence of the thing was my thwarted wish of all those years ago.'[42] All places then are connected into a psychic geography. In musing on roads, Lee sees that they make possible the communications essential to the growth and maintenance of human society, but that they also inspire and channel our own internal impulses: 'it is not merely civilisation, art, language, which flow along roads, along those dusty rivers made by human hands. Our thoughts and our sympathies travel also along them, far quicker than across the ploughed field and the mountain sides over which, as we say, the crow flies.' Moreover, for Lee, the physical landscape can suddenly merge into a mental one yet the abruptness of this transition, as she describes it, seems itself to be felt as physical, even visceral: 'The white riband before me, twisting along the dull green and brown valley of the Apennine stream which I hear but cannot see, twists into my past.'[43] A more gentle modulation of this experience is narrated in 'In the Euganean Hills', where Lee remembers how, walking in conversation with a companion in the countryside,

> at a turning of the path my interest in politics and economy suddenly went out; we were in romance, in the fairyland of Italian poetry. Imagine (and I seemed imagining rather than walking in reality) a mediaeval castle of the Scaligers, perfect with battlemented walls, circular like its rock, but a castle turning magically into a villa such as d'Annunzio has made immortal.

Having detailed the constituent parts of this scene, she notes:

> all these things at such angles as to make perfect pictures; towers, battlements, cypresses, statues all perspective not merely for the eye but for the imagination, compelling each back into that charmed circle, so that the impression of Ezzelino's Castle (for it was Ezzelino's also) and Armida's garden interchange, interlace, like theme with theme in a subtle piece of music, enclosing the soul and subduing it in a maze of romance and beauty.[44]

As we saw earlier, memory is for Lee a series of vistas as one layer of perception gives way or transmutes into another. Lamenting the changes

42 Lee, 'The Mountain of Portofino', in *The Sentimental Traveller*, p. 120.
43 Lee, 'Of Roads', in *The Sentimental Traveller*, pp. 92–3.
44 Lee, 'In the Euganean Hills', in *The Enchanted Woods*, 2nd edn (London, John Lane, The Bodley Head, 1910), pp. 190–1.

that have overtaken the environs of Siena, she fuses past and present, physical and metaphysical in one of her elegiac colour studies:

> But one thing has *not* faded (although the hills seen from Lizza are very dim blue from heat-mist or the mist of years), and that is the odd longing with which those low hills south-west of Siena have always filled me.
>
> Indeed I remember as if it were yesterday, I can almost feel, the little stab-in-the-heart, of the ultramarine of those hills beyond the Lizza, as I first saw them some thirty-eight years ago: that special blueness against the evening sky, identified itself with, became, so to speak, the colour of, longing for the unattainable, the colour of parting from the too briefly enjoyed.[45]

Elsewhere other objects of vision move and mutate under her gaze. Thus, for example, in her prefatory account of how she came to write 'Winthrop's Adventure', Lee fixes on the painting of Farinelli which fascinated her so much:

> And as to Farinelli himself, magnificent and benign, quite incredibly Metastasio's *Gemello Adorabile*, he is teaching Signora Teresa her song with its innocence *obbligato*. But at the same time, in the oddest way, is sliding, sliding into dreamland or Lethe, fading (despite his solid buckled shoes) into an amiable, exquisitely turned-out ghost.[46]

As Lee explains in a fine essay on the power of association, imaginative association (which draws on memory) is itself phantomising, and overlays the present moment or object of perception with traces of ghosts. For Lee, whose mnemonic and impressionistic sensibility naturally expresses itself synaesthetically, these ghostly effects lend themselves to comparison with musical accompaniment:

> [I]t seems to me that in our perceptions of nature and of art there usually exists a kind of phantom of the past, omitting which, we enjoy in a less poignant way (a sort of thrumming accompaniment or set of chords) – the resemblances and diversities between which and the present occasion a sort of half-conscious pleasure, nay, the past may exist only in the condition of a harmonic, a sound which we do not disentangle at all in our impressions, but which still forms part of them, marking, by a recognition of some distant and past thing, the qualities of the present.[47]

45 Lee, 'The Woods around Siena', in *The Golden Keys and Other Essays on the Genius Loci* (London, John Lane, The Bodley Head, 1925), p. 220.

46 Lee, Preface to *For Maurice*, p. xxviii.

47 Lee, 'The Lake of Charlemagne', in *Juvenilia*, 1: 68.

Lee would literalise this analogy in her ghost story 'A Wicked Voice', in which her protagonist, Magnus, who has refused to honour the music and the memory of the castrato singer Zaffirino, is punished by finding himself perpetually haunted by phantom eighteenth-century-style melodies.

Sometimes Lee varies her metaphor so that rather than experiencing the present as overlaid by an intervening veil of (past) association or as melting away to reveal anterior views, she sees the present as permeated by a past whose marks and traces then rise to the surface. Former influences prove so indelible that certain places appear to be archives of the traces of past inhabitants which can be accessed by the sensitive observer. Writing on old Italian gardens in *Limbo and Other Essays*, Lee records:

> A friend of mine . . . assures me that it is not the whole ghosts of the ladies and cavaliers of long ago who haunt the gardens; not the ghost of their everyday, humdrum likeness to ourselves, but the ghost of certain moments of their existence, certain rustlings, and shimmerings of their personality, their waywardness, momentary, transcendent graces and graciousnesses, unaccountable wistfulness and sorrow, certain looks of the face and certain tones of the voice (perhaps none of the steadiest), things that seemed to die away into nothing on earth, but which have permeated their old haunts, clung to the statues with the ivy, risen and fallen with the plash of fountains, and which now exhale in the breath of honeysuckle and murmur in the voice of birds, in the rustle of the leaves and the high invading grasses.[48]

Ravenna, for example, seems such a place: 'Other places become solemn, sad, or merely beautiful at sunset. But Ravenna, it seems to me, actually grows ghostly; the Past takes it back at that moment, and the ghosts return to the surface.'[49]

In an early essay on the supernatural in art, Lee, as she will so often throughout her career, turns to the question of what constitutes a ghost, and in the course of a marvellous extended description makes it apparent that for her ghosts, memory and association are intimately bound up with Italy and the Italian past:

> By *ghost* we do not mean the vulgar apparition which is seen or heard in told or written tales; we mean the ghost which slowly rises up in our mind, the haunter not of corridors and staircases but of our fancies. Just as the gods of primitive religions were the undulating

48 Lee, 'Old Italian Gardens', in *Limbo and Other Essays*, p. 130.
49 Lee, 'Ravenna and Her Ghosts', in *Limbo* and *Other Essays*, p. 176.

bright heat which made the mid-day solitary and solemn as midnight; the warm damp, the sap-riser and expander of life; the sad dying away of the summer, and the leaden, suicidal sterility of winter; so the ghost, their only modern equivalent, is the damp, the darkness, the silence, the solitude; a ghost is the sound of our steps through a ruined cloister, where the ivy-berries and convolvulus growing in the fissures sway up and down among the sculptured foliage of the windows, it is the scent of mouldering plaster and mouldering bones from beneath the broken pavement; a ghost is the bright moonlight against which the cypresses stand out like black hearse-plumes, in which the blasted grey olives and the gnarled fig-trees stretch their branches over the broken walls like fantastic, knotted, beckoning fingers, and the abandoned villas on the outskirts of Italian towns, with the birds flying in and out of the unglazed windows, loom forth white and ghastly; a ghost is the long-closed room of one long dead, the faint smell of withered flowers, the rustle of long-unmoved curtains, the yellow paper and faded ribbons of long-unread letters . . . each and all of these things, and a hundred others besides, according to our nature, is a ghost, a vague feeling we can scarcely describe, a something pleasing and terrible which invades our whole consciousness, and which, confusedly embodied, we half dread to see behind us, we know not in what shape, if we look around.[50]

This essay first appeared in 1881 – the year that Lee published 'A Culture-Ghost' – heralding the composition of the ghost stories which make up *Hauntings* (1890). The narrators of three of these four stories, some of her most impressive supernatural tales, encounter their ghosts through their complex relations to Italy and her history. They are men who see what they see because of their own powerful associations. In 'Dionea' Dr Alessandro De Rosis, an elderly bachelor living in the Italian coastal town of Montemirto Ligure, is working on a mythographical study of the gods in exile. In a series of letters addressed to his patron, Lady Evelyn Savelli, he makes a series of powerful connections between a mysterious and beautiful young local woman washed up on the shore when she was a little girl and the goddess Venus. In 'Amour Dure' Spiridion Trepka, a highly-strung young Polish historian, arrives in Italy full of expectations. At first he is disgusted by what he finds: 'I had longed, these years and years, to be in Italy, to come face to face with the Past; and was this Italy, was this the Past? I could have cried, yes

50 Lee, 'Faustus and Helena: Notes on the Supernatural in Art', in *Belcaro: Being Essays on Sundry Aesthetical Questions* (London, W. Satchell & Co., 1883), pp. 93–4.

cried, for disappointment when I first wandered about Rome.'[51] How-ever, as he journeys towards Urbania, where he will work in the town archives,

> each single village name as the driver pointed it out, brought to my
> mind the recollection of some battle or some great act of treachery
> ... And then, not two hours ago, entering the town at dusk, passing
> along the deserted streets, with only a smoky light here and there
> under a shrine in front of a fruit stall, or a fire reddening the blackness
> of a smithy; passing beneath the battlements and turrets of the palace
> ... Ah, that was Italy, it was the Past![52]

Trepka comes to Urbania already intrigued by the history of one Medea da Carpi, Duchess of Stimigliano Orsini and then wife of Duke Guidalfonso II, who was put to death nearly three hundred years before at the age of twenty-seven 'having in the course of her short life, brought to a violent end five of her lovers'.[53] Trepka is keen to seek out portraits of Medea and to speculate obsessively about her character. Eventually he discovers a wonderful painting of her in the palace which houses the archives and thereafter is haunted by her in a series of strange events which end only with his own death, narrated in a note at the end of the story. Although Lee cleverly preserves the ambiguity as to whether Trepka's spectre is authentic or the product of monomania, the story makes it apparent that he is susceptible to this haunting because his powers of suggestion and association are so finely tuned. And here, as in other of her stories, it is a painting, seen through the lenses of a height-ened sensibility, which acts as a trigger to the supernatural. Similarly, in 'A Wicked Voice', it is only after the young Norwegian composer Magnus has openly derided the portrait of Zaffirino, a portrait which he none-theless finds unpleasantly compelling, that he begins to be haunted by the castrato's voice.

Magnus, a follower of Wagner, is staying in Venice to write a new opera *Ogier the Dane*. He declares himself contemptuous of the music of the past (by which he seems to mean eighteenth-century Italian music) yet appears to have studied it in great detail, in order, as he claims, 'to display its vileness'.[54] He mocks Zaffirino's portrait but admits he finds him 'almost beautiful . . . I have seen faces like this in my boyish

51 Lee, 'Amour Dure', in *Hauntings: Fantastic Stories*, 2nd edn ([1890] London, John Lane, The Bodley Head, 1906), p. 3.
52 Lee, 'Amour Dure', in *Hauntings*, pp. 4–5.
53 Lee, 'Amour Dure', in *Hauntings*, p. 16.
54 Lee, 'A Wicked Voice', in *Hauntings*, p. 197.

romantic dreams, when I read Swinburne and Baudelaire, the faces of wicked vindictive women.' And finally, although having come 'to find some inspiration in this strange Venice', he seems irritated by its romanticism and languor: 'How fearfully this cursed heat, these moon-struck nights, must have unstrung me! This Venice would certainly kill me in the long-run!'[55] Magnus's subsequent haunting by Zaffirino suggests a return of the repressed with the repressed being not merely eighteenth-century music, but sexuality and Venice herself.

Interestingly Lee, in a much later essay, admitted her own unease with Venice: 'Venice is always too much and too much so . . . I cannot cope with it, it submerges me.'[56] Lee, a lover of eighteenth-century music who was made uncomfortable by Wagner, here reverses the musical opposition we find in 'A Wicked Voice'; Venice 'make[s] . . . me understand what Wagner's music is to some other folk'. The excess of Venice is like the excess of Wagnerian music. It is a place which has too many associations:

Instead of the bracing effects of the other arts . . . Venice, taken all in all, has the effect rather of music when music is least like them and most viciously itself. It brings up, with each dip of the oar, the past, or rather the might-have-been; it dissolves my energies like its own moist and shifting skies; it brings a knot into my throat and almost tears into my eyes, like a languorous waltz or a distant accordion, and into my mind the ignominious sadness of lovers' quarrels, like Musset's and George Sand's, of the going to bits of Byron, and of its own long, shameful, crumble, ending in a sale of shrines and heirlooms, and dead women's fans and dead babies' shoes at the curiosity dealers.[57]

That word 'viciously' is interesting: although it has reference to vice and degeneration, it can also signify savagery or violence. The haunting of the past which takes place in 'Amour Dure' and 'A Wicked Voice' is explicitly violent. Trepka is found stabbed in the street at the end of 'Amour Dure' while Magnus is terrorised by the insidiously penetrating music of Zaffirino, which at the climax of the tale is envisaged as an assailing knife: 'I heard the voice swelling, swelling, rending asunder that downy veil which wrapped it, leaping forth clear, resplendent, like

55 Lee, 'A Wicked Voice', in *Hauntings*, pp. 206, 208.
56 Lee, 'Out of Venice at Last', in *The Golden Keys*, pp. 75–6. Carlo Caballero's 'On Vernon Lee, Wagner and the Effects of Music' is interesting about the relation of 'A Wicked Voice' to Lee's writing on music, although it does not mention 'Out of Venice at Last'.
57 Lee, 'Out of Venice at Last', p. 76.

the sharp and glittering blade of a knife that seemed to enter deep into my breast.'[58] The other Italian story in *Hauntings*, 'Dionea', also implies the fatal use of a knife: Gertrude, the wife of the sculptor Waldemar, is found dead lying across the altar which her husband has set up in front of his statue of Venus, 'her blood . . . trickling among the carved garlands'.[59] As we have seen elsewhere, Lee uses hints of the imagery of transfixion when she speaks of the poignancy of memory: the road which 'twists into my past' or the 'little stab-in-the-heart, of the ultramarine'. This imagery is also at the heart of the last piece I want to discuss, 'Ravenna and her Ghosts'.

The essay 'Ravenna and her Ghosts' contains a ghost story also related by Boccaccio, Dryden and Byron, but which Lee claims she is giving in another version 'arisen in Ravenna itself'.[60] Purporting to translate from the 'barbarous Romagnol dialect of the early fifteenth century', she tells how the young Nastasio de Honestis leaves Ravenna for Rome to earn his fortune having all but beggared himself in trying to win the hand of the beautiful but shrewish daughter of Messer Hostasio de Traversariis. Lingering gloomily in the wood of Classis outside Ravenna, Nastasio becomes the witness of a ghostly hunt scene. A cold wind blows in from the sea bringing with it the sound of a hunt, and Nastasio hides behind a tree and watches a dark-garbed huntsman track down a young naked woman, transfix her with a spear, cut out her heart and throw it to his hounds. Nastasio recognises in the huntsman and his quarry Messer Guido Degli Anastagi and Monna Filomena, daughter of the Lord of Gambellara: 'Messer Guido had loved the damsel greatly, and been flouted by her, and leaving home in despair, had been killed on the way by robbers, and Madonna Filomena had died shortly afterwards.'[61] Remaining in the forest a month longer he discovers the same scene recurs every week at the same time and this inspires him to conceive a plan. He returns to Ravenna pretending that he has made his fortune in Rome and sets about making arrangements for a marvellous pageant to be held in the wood. Mortgaging himself to money lenders he commissions a sumptuous pavilion from which invited spectators

58 Lee, 'A Wicked Voice', p. 235.
59 Lee, 'Dionea', in *Hauntings*, p. 102.
60 Boccaccio tells the story in the *Decameron* (fifth day, eighth story), Dryden resets it in his poem 'Theodore and Honoria', and Byron mentions Boccaccio's tale and Dryden's poem in *Don Juan*, Canto 3, stanzas 105–6. Lee's version of the story differs substantially from those of Boccaccio and Dryden in its tone, style and detail.
61 Lee, 'Ravenna and Her Ghosts', in *Limbo and Other Essays*, p. 186.

can view the pageant and includes Messer Hostasio de Traversariis and his daughter among his guests. All is arranged for the day on which the ghostly hunt scene recurs, which is also the eve of the Feast of the Dead. In due course the guests assemble and after a lavish feast Nastasio announces a pageant called the Mystery of Love and Death. True to form the ghostly scene is re-enacted and Filomena hunted down, transfixed and her heart thrown to the hounds. At this point Nastasio blows on the herald's trumpet and cries out 'The Pageant of Death and Love! Such is the fate of cruel damsels!' and his unyielding mistress falls into a swoon. Here, Lee tells us, the manuscript breaks off, but she reminds us that Boccaccio continues the story by having Nastasio's mistress relent, marry him and live happily every after.

In this story, as in 'Amour Dure', 'A Wicked Voice' and 'Dionea', the ghosts of the past inflict violence on the present, although here there is a difference in that Nastasio learns to manipulate that past – sadistically we might think – so that Filomena's fatal wounding pierces the heart and consciousness of his lady. But perhaps this laconic tale offers us an analogy for the writer of ghosts, of memories and associations. If, as she says in her essay on the supernatural in art quoted earlier, a ghost is 'something pleasing and terrible which invades our whole consciousness', Lee wants her ghosts to invade the consciousness of her readers. By replaying the past, whether hers or that of others long dead, she calls on her readers' sympathetic identifications to make them experience these past scenes as their own; she passes down the line the things which delight, move and disturb her for the reader to experience as referred pleasure and referred pain. The 'great novelist', she remarks in an essay on the French analytical novel, 'can people our fancy with living phantoms whom we love, he can enrich our life by the strange power called *charm*', but the novelist, the short story writer and the essayist can also create for us phantoms which are not unequivocally charming but trouble us, arouse in us strong, complex ambivalent sensations of the kind Lee herself had about Venice.[62] In introducing readers most probably unfamiliar with Lee's writing to her treatment of memory, association and the supernatural as stimulated by her contact with Italy and the Italian past I hope that this essay has gone some way to evoke the phantoms that power her strangely haunting prose.

62 Lee, 'Rosny and the French Analytical Novel', in *Gospels of Anarchy and Other Contemporary Studies* (London, T. Fisher Unwin, 1908), p. 239. (Italics in original.)

II

Resurrections of the body: women writers and the idea of the Renaissance

Angela Leighton

IN 1877 Henry James found himself back in Italy and feeling an inexplicable sense of 'shameless optimism': 'The only reason, I am afraid, is the old superstition of Italy – that property in the very look of the written word, the evocation of a myriad images, that makes any lover of the arts take Italian satisfactions on easier terms than any others. The written word stands for something that eternally tricks us'.[1] Whatever the 'satisfactions' of its art, 'Italy' remains an elusive concept. A 'superstition' or 'evocation', it has the unfounded character of a 'word' which tricks us out of objective reality. Ostensibly poking fun at Italy as a fashionable tourist destination, James is also suggesting that its real 'satisfactions' may in fact only be those of a 'word', a 'superstition' of meaning.

The nineteenth-century rediscovery of Italy begins, as has often been pointed out, with women.[2] Madame de Staël's *Corinne, or Italy* (1807) first offered a compelling tour guide to the woman artist's feelings, ambitions and sufferings. The doubling of heroine and country – Corinne *is* Italy – ensures that the other country, at least in the early decades of the century, is an idea performed on the woman's body, improvised to the moment, in a Sappho story brought a little up to date. By the mid-century, however, this sentimental reading of Italy as a *tableau vivant* of suffering womanhood gives way to something else. On the one hand it becomes a political place, its Risorgimento politics finding an eager audience in Victorian England; on the other, it becomes an aestheticised place, removed from contemporary reality – a place in which, as James puts it: 'the past seems to have left a sensible deposit, an aroma, an atmosphere. This ghostly presence tells you no secrets, but

1 Henry James, 'Italy Revisited', in *Italian Hours* (London, Heinemann, 1909), pp. 107–35 (p. 109).
2 Ellen Moers was the first to point this out in her seminal book, *Literary Women*, ([1963] London, The Women's Press, 1978), pp. 173–210.

it prompts you to try and guess a few'.[3] Paradoxically, just as Italy becomes a nation, a contemporary, industrialising power in the modern world, it also becomes a ghost, a mysterious, enigmatic riddle of the past. Moreover, it is increasingly figured at this time, against Ruskin's championing of moral-medieval Gothic, as the home of the Renaissance. The picture of Italy as a framed moment of the past, ghostly with absence yet hauntingly recuperable, provides the energy of much later Victorian writing. As Hilary Fraser notes: 'Victorian painters, writers and historians fabricated the Renaissance in their own image'.[4] In particular, the idea of the Renaissance gives to Victorian aestheticism one of its key, recurrent images: that of the resurrected body. While early Victorian women writers claimed Italy as a body of their own, an instrument of song and suffering, later aesthetes find in it a body figured almost for its own sake, impersonal, inhuman, and the sign, therefore, of a materialist aesthetic which subversively challenges many of the values of high Victorianism. The Sappho-Corinne story gives way to the story of the Italian Renaissance as the new obscure object of Victorian desire. The ways in which later women writers, particularly Edith Wharton and Vernon Lee, embody the 'ghostly presence' of that past are, I would argue, at least as daring as those of their male contemporaries.

Two books made the idea of the Renaissance fashionable and risqué. Jacob Burckhardt's *Civilization of the Renaissance in Italy* (1860) makes the grand claim that the 'Italians are the first among modern peoples by whom the outward world was seen and felt as something beautiful'.[5] The word 'modern', and the awkward change of tense, pivot present and past, so that modernity belongs as much to the Renaissance as to nineteenth-century Italy. Far from being of mere historiographical interest, the Renaissance is the foundation of the modern world. The challenge of modernity is then taken up in J. A. Symonds' *Renaissance in Italy* (1877): 'It was the highly perfected individuality of the Italians that made them first emerge from mediaeval bondage and become the apostles of humanism for the modern world'.[6] Symonds propounds a

3 James, 'Florentine Notes', in *Italian Hours*, pp. 279–310 (p. 298).

4 Hilary Fraser, *The Victorians and Renaissance Italy* (Oxford, Blackwell, 1992), p. 2.

5 Jacob Burckhardt, *The Civilization of the Renaissance in Italy*, transl. S. G. C. Middlemore (London, Penguin, 1990), p. 192. This was first translated into English in 1878. However, the German contains the same slip from present to past tense: 'Die Italiener sind die frühesten unter den Modernen, welche . . . wahrgenommen und genossen haben.'

6 J. A. Symonds, *Renaissance in Italy: The Revival of Learning* ([1877] London, Smith, Elder, 1897), pp. 6–7.

Renaissance Italy dedicated to the values of individualism, intellectual freedom, cosmopolitanism, paganism and the appreciation of beauty for its own sake.[7] This is as much a manifesto for Victorian aestheticism as a historical account of fifteenth-century Italy. Against medieval attitudes, of patriotism, theological rule and repressive morality 'the modern world' rebels, both then and now.

While both Burckhardt and Symonds write ostensibly as historians, though their criteria are aesthetic rather than utilitarian, the author whose influence is most pervasive is the one who writes as an art historian, Walter Pater. It is he who fabricates a Renaissance which is iconographic, artistic, mysterious and female, and epitomised by the Mona Lisa:

> She is older than the rocks among which she sits; like the vampire, she has been dead many times, and learned the secrets of the grave; and has been a diver in deep seas, and keeps their fallen day about her; and trafficked for strange webs with Eastern merchants; and, as Leda, was the mother of Helen of Troy, and, as Saint Anne, the mother of Mary; and all this has been to her but as the sound of lyres and flutes, and lives only in the delicacy with which it has moulded the changing lineaments, and tinged the eyelids and the hands.[8]

Although introduced as a type of the Renaissance moment in all its moral ambiguity, 'the return of the Pagan world, the sins of the Borgias',[9] the Mona Lisa soon slides, on the seductive rhythms of Pater's sentence, out of history and into myth and imagination. For the next forty years or more this piece of ornamental word-painting will sum up the Renaissance as, indeed, a mystique, a 'superstition', a formula of words almost for words' sake, or at least for 'something that eternally tricks us'.

The trick of Pater's own writing is to turn history into a body. To decode the Mona Lisa as a femme fatale – for Paglia, she is 'the weight and burden of biology',[10] or for Psomiades a 'purely formal'[11] figure of femininity – is perhaps to personalise her more than Pater does. She is barely even female. Like the Renaissance of Burckhardt, she is as modern as she is ancient: 'the embodiment of the old fancy, the symbol

7 Symonds, *Renaissance*, p. 10.
8 Walter Pater, *The Renaissance: Studies in Art and Poetry*, 6th edn (London, Macmillan, 1906), p. 125.
9 Pater, *Renaissance*, p. 125.
10 Camille Paglia, *Sexual Personae: Art and Decadence from Nefertiti to Emily Dickinson* (London, Penguin, 1991), p. 486.
11 Kathy Alexis Psomiades, *Beauty's Body: Femininity and Representation in British Aestheticism* (Stanford, Stanford University Press, 1997), p. 200.

of the modern idea'.[12] If, meanwhile, 'she has been dead many times', Pater lets us know that she has been resurrected many times, and the long, wave-like sentence which charts her transmutations from vampire, Leda, to Helen, St Anne and Mary, then ends by fixing on two parts: 'the eyelids and the hands'. What comes through the weird time-travel of this sentence is almost a neutral object: the body. As if rhetorically acting out Michelet's theory of history as *'resurrection'*,[13] the sentence suggests that what is resurrected in words is not a ghost or spirit of the past, but its 'embodiment' in 'eyelids' and 'hands'. The '"archaeological, necromantic metaphor of *disinterment*"'[14] which runs through Renaissance writing is adopted by Victorian aesthetes to smuggle a materialist, agnostic, un-English revival of classical values into their writing. Certainly, this is a resurrection of the body without spiritual promise or moral reassurance. St Anne and Mary only take their place in a levelling story line where nothing is sacred or permanent except, perhaps, those oddly transmutable eyelids and hands.

Pater's hologram effects and fetishistic close-ups lay down the principles of an aesthetic Gothicism which will accompany ideas of the Renaissance for the rest of the century. Art offers a (faked) resurrection of the flesh in the cause, not of reviving the past, but of suggesting the modernity and scepticism of the present. It resurrects the body, not for eternal but for material life. It is not a person, la Gioconda, but matter itself which ghosts the picture of the Mona Lisa. Who she is or was, her eccentrically drawn-out history of incarnations, resolves into eyelids and hands.

This rhapsody on the past is recalled in a curious passage in Michael Field's unpublished journal for 1895. It is written by Edith Cooper, and reports a dream she has had about her lover, 'Michael', or Katherine Bradley:

> Michael & I were in an Italian Duomo, visiting a Tomb on which was the Effigy of a beautiful Youth, painted to look like life. The board-floor was shaky round the tomb, but treading lightly we came close: then the Effigy turned over from supine to prone, & we saw the rich-long lashes of oaten-gold lift & pale mocking eyes opened on us, while a fine, smiling tremour [sic] quickened the mouth, & I cried out *I have seen the Renaissance!* The effigy then came down & Michael would kiss its hands & cheeks while I shivered least [sic] she should catch the

12 Pater, *Renaissance*, p. 125.
13 Jules Michelet, *The People*, transl. John P. Mackay (Urbana, University of Illinois Press, 1973), p. 19.
14 Thomas Greene, quoted in Fraser, *The Victorians and Renaissance Italy*, p. 40.

plague. Then the figure returned to its tomb, & sitting with drawn-up legs watched us go toward the door – I heard a strange noise like a pebble being rolled about 'It's his tongue moving' I thought with indescribable fright – & sure enough these slow, stony words came from the beautiful mouth 'I – can – lend – you – a pair of – scissors.' We fled out at the highest pitch of terror.[15]

Here the idea of '*the Renaissance*', baroquely realised 'in an Italian Duomo', is encountered as an unnervingly lively tomb-sculpture. The 'beautiful Youth', who is 'painted to look like life', suddenly comes alive and turns over. Such an implied exposure of the flesh leads to another fetishistic displacement as, among all the things the dreamer might see, she chooses 'the rich-long lashes of oaten-gold'. Like Pater, instead of meeting the eyes, she fixates on eyelids, something unseeing, impersonal. Such a resurrection from the tomb recalls the biblical one in the garden, but instead of Mary's 'I have seen the Lord', this dreamer has '*seen the Renaissance*'. What that is is summed up, in defiance of the Christian story, as tangibly physical. Michael kisses the youth's 'hands & cheeks'. The Renaissance is thus dreamed as an artwork come to life, a beautiful body restored, as well as just a word, '*the Renaissance*', made flesh.

The modestly 'drawn-up legs' then lead, comically, to the nightmarish 'noise like a pebble', as the tongue, presumably, both loosens into speech and turns back to stone. The image brilliantly conveys a quality of lifelikeness which is also stone dead. This tongue speaks in distinctly hollow tones. The hilarious illogicality of what the 'beautiful Youth' then proposes slyly intimates another dream logic at work: there is something here, whether lashes, tongue or other part, which is in need of cutting. What terrifies the dreamer is not the statue moving, or even its being desirably beautiful, but that homely offer of 'scissors' spoken by the stony tongue rolling about the mouth. By 1895 the idea of the Renaissance has clearly accrued enough imaginative potency to release in the woman poet this nightmare comedy of desire and castration. By this time it is a familiar by-word for immorality, paganism, all things Italian, art for art and a cult of beauty only understood by men.

He 'understood the spirit of the Renaissance', Henry James declares of his hero in 'The Author of Beltraffio' (1884), a story loosely based on the troubled homosexuality of J. A. Symonds.[16] ' "Of course it's difficult

15 British Library Add. MS. 46783, fol. 13a–b, quoted with permission. I am grateful to Katharine McGowran for bringing this passage to my attention.

16 James, 'The Author of Beltraffio', in *The Novels and Tales of Henry James*, 26 vols (New York, Charles Scribner's Sons, 1909), 16: 3–73 (p. 4).

for a woman to judge how far to go"', Miss Ambient, the aestheticist-minded spinster declares.[17] That hesitation may be part of the problem for Edith Cooper, as she disinters her own beautiful figure from the tomb, but finds it terrifying. If Italy is the productive tomb of Victorian aestheticism, the place from which the body beautiful is roused, it also suggests an emotional destination, for both women and men, of '"how far to go"'. That destination is the theme of a novel that may also have inspired Michael Field's moving statue. In Hawthorne's *The Marble Faun* (1860), an antique statue becomes a living Italian, at least in the 'aesthetic'[18] imaginations of the artists who encounter him. Although the resurrected statue appears in Mérimée's *La Vénus d'Ille* (1837),[19] Hawthorne's novel imagines the past, not as an avenging Gothicism, tied to a moral perspective, but as an indifferent force which uncannily evades both censure and approval. The beauty of the faun lies outside both moral and emotional frames of reference, as his distant pagan provenance makes all such frames relative and questionable.

George Eliot might be countering Hawthorne in her own historical novel set in Renaissance Italy. *Romola* (1863) starts by imagining the past as a human form: 'Our resuscitated Spirit was not a pagan philosopher, nor a philosophising pagan poet, but a man of the fifteenth century, inheriting its strange web of belief and unbelief; of Epicurean levity and fetichistic dread; of pedantic impossible ethics uttered by rote, and crude passions acted out with childish impulsiveness'.[20] The pull of pagan against Christian, 'unbelief' against 'belief', makes fifteenth-century Italy a suggestive playground for Victorian anxieties. The beautiful, irresponsible hero, Tito Melema, whose Greek name hints at an older pagan past, at one point substitutes a picture of Bacchus and Ariadne for Romola's crucifix – a substitution which, almost prefiguring the Mona Lisa's reincarnations, lies at the heart of Victorian aestheticism. Eliot, however, points the moral against Tito. 'It seems to me beauty is part of the finished language by which goodness speaks',[21] Romola protests. But the novel proves her wrong. Tito's free, pleasure-loving, criminal

17 James, 'Beltraffio', p. 50.

18 Nathaniel Hawthorne, *The Marble Faun*, intro. Malcolm Bradbury (London, Everyman, 1995), p. 105.

19 Mérimée's tale set the fashion for a host of resurrected statue stories, including James's 'The Last of the Valerii' and Vernon Lee's 'Saint Eudaemon and His Orange-Tree'.

20 George Eliot, *Romola*, ed. Andrew Sanders (Harmondsworth, Penguin, 1980), p. 48.

21 Eliot, *Romola*, p. 251.

impulse is forcefully corrected by woman's (heroine's and author's) moral conscience. That conscience is caught in the very object which, for the rest of the century, will represent art's aesthetic neutrality. Piero di Cosimo's portrait of Tito, with its 'expression of such intense fear in the dilated eyes and pallid lips, that he felt a cold stream through his veins, as if he were being thrown into sympathy with his imaged self',[22] is an unambiguous moral mirror. It catches not the body's beauty but the soul's guilt. Meanwhile Romola, lacking the lively admixture of the pagan in her blood, freezes into a picture of the Virgin Mary. Without the ghost of Helen or Leda to leaven her, she seems, paradoxically, never quite to come to life.

Italy, then, by the 1860s is already associated with an aestheticism that claims its own modernity from the contradictions of the past. The plethora of texts which invoke statues or paintings, buried, broken or come to life, is a sign of how much the artwork signals both a peculiarly self-aware commodification and a covert recovery of the material body. Italy is the historical and metaphorical frame in which such resurrections of the flesh take place. The question of '"how far to go"' is a destination in time rather than place, as pagan epicureanism, delight, pleasure and beauty become associated with the 'trick' of that 'written word', Italy. If to write about the body requires historical circumlocution, the aestheticist text, with its formally resurrected bodies of art, at least permits the impermissible to be said. Between soul and body, past and present, art and life, there is only a thin line. That line, like the frame of the picture, will be explored by women writers after George Eliot, and generally with less moral anxiety.

When, as late as 1905, the heroine of Edith Wharton's *The House of Mirth* creates a *tableau vivant* not, we are told, of a Titian or Veronese, but apparently of herself, her own 'flesh and blood loveliness',[23] she is drawing on an idea which runs through aestheticist writing, but also goes back to Emma Hamilton's famous 'Attitudes' in Naples in the late 1700s.[24] Lily Bart's manipulation of the *tableau vivant* not only reinstates her own body in the market of class and marriage, but also suggests, as so many portrait texts do, that the soul is the body, subjectivity an object, the self a likeness in a frame. The materialist undercurrent of Wharton's thinking finds its pretext and example in a

22 Eliot, *Romola*, p. 247.

23 Edith Wharton, *The House of Mirth*, ed. Michael Millgate (Harmondsworth, Penguin, 1979), p. 153.

24 Margaret Reynolds, *The Sappho History* (Basingstoke, Palgrave, 2003), chapter two, forthcoming.

Renaissance painting brought, literally, to life, though at the expense of its real-life impersonator.

In one of her lesser-known short stories, 'The House of the Dead Hand' (1904), this materialising motif becomes central. Set in Siena, it concerns a certain Dr Lombard, an elderly scholar and 'devout student of the Italian Renaissance',[25] who owns an unknown Leonardo which he will only show to a few chosen visitors. Wharton is audibly reproducing what is by now a stock cliché. The picture, we are told, symbolises 'the central truth of existence: that all that is raised in incorruption is sown in corruption'. It marks, indeed, a resurrection of life into perfect artistic form. Such a resurrection, however, reverses the terms of the biblical quotation, as 'incorruption' returns to 'corruption', and soul to body, specifically, body parts. Dr Lombard's scholarship is a sort of tomb-robbery: 'I who have given my life to the study of the Renaissance, who have violated its tomb, laid open its dead body, and traced the course of every muscle, bone and artery'.[26] The '"necromantic metaphor of *disinterment*"' has, by now, developed a certain gruesome familiarity. Less resurrection than body snatching, less Christ than Frankenstein, such anatomical investigation recovers the body of the past for some not entirely wholesome purpose. What comes out of the tomb, however beautiful and precious, keeps a whiff of the plague about it.

The Leonardo itself, however, is simply beautiful. It shows a small crucifixion scene in the background, but in the foreground a luxurious, classical figure of a woman, seated on a throne, attended by 'a young Dionysus', and surrounded by 'the symbols of art and luxury'. This is Tito Melema's act of substitution imagined in a single picture. A legend in the foreground drives the point home. It is called, as if parodying Holman Hunt's *Light of the World*, simply *Lux Mundi*. In this 'Musée des Beaux Arts', the Christian scene has been sidelined by a *carpe diem* motif which seems more enlightened and enlightening than that of the suffering Christ. What is preciously hidden in the connoisseur's dark house, closed to all except the initiated, is the pagan past, with its unabashed assertion of pleasure for pleasure's sake, the light not of the dying but the living body, and that, of course, a woman's. The hand of the beautiful Lady, in case we miss the connection, '"recalls the hand of the Mona Lisa"'.[27]

25 Edith Wharton, 'The House of the Dead Hand', in *The Collected Short Stories of Edith Wharton*, 2 vols (New York, Charles Scribner's Sons, 1968), 1: 507–29 (p. 507).

26 Wharton, 'House', p. 514.

27 *Ibid.*, p. 513.

Clearly the ghost of Pater hangs over this story, as Dr Lombard thrills to his second-hand aestheticist rhetoric. While the hand of the Mona Lisa can be traced in the picture, and the hand of Pater detected in the writing, Wharton's story contains yet another hand: the 'dead hand' of the title. The name of the house recalls, quite explicitly, the central section of *Middlemarch*, in which the dead Casaubon keeps a legal, tenacious hold over Dorothea's future life. Dr Lombard is a similar wizened scholar with an enthusiasm for dead things, but it is not his hand which names the house and hangs over its main doorway, as we might expect. 'The hand was a woman's – a dead drooping hand'.[28] Inside the house there is a daughter: Sybilla. It is she who details the beauties of the picture to her father's visitors. It is she who is also the object of one particular visitor's interests. The Count Ottaviano desires to marry her and tries to use the narrator's visits as a pretext to send her letters. He has also prepared an elaborate getaway, and a wealthy purchaser for the Leonardo. This is not quite, however, a Bluebeard story. When Wyant, the narrator, refuses to be a go-between, claiming obligations to the father who '"has allowed me to see his picture"', the Count expostulates: '"*His* picture? Hers!"'[29] It is Sybilla's money which has procured the Leonardo, just as it is Sybilla's consequent lack of money which has set the Count's family against the marriage. Wharton has taken Pater's Mona Lisa and, removing her archaic mystique, exposed her as a commodity of the market of marriage as well as art.

While it is the 'dead hand' of the father which seems to be in control, however, this story is full of other hands. An 'unknown hand' plants a letter in Wyant's hat, the Count lays 'a hand on his heart', Wyant holds out 'his hand with a smile' to the Count, Dr Lombard's 'hands' hang down 'like the claws of a dead bird', the marble hand above the door looks like 'the cry of an imprisoned anguish', Sybilla's hand is 'cold and nerveless', Wyant fancies 'a hand on his shoulder'.[30] In recalling '"the hand of the Mona Lisa"', Wharton seems to enter a play of hands which are not only fetishised, material objects, somehow detached from their human possessors as if by some grim punishment, but which are also forces of will and power, of authorship and artistic pleasure.

On one level the story seems to be a moral tale, a condensation of *Middlemarch*, in which a woman is trapped by the hand of a father and by the hand of the painter who has, indirectly, made a beautiful object

28 *Ibid.*, p. 509.
29 *Ibid.*, p. 521.
30 *Ibid.*, pp. 518, 519, 521, 524, 525, 527.

of her. We are told that the painted, classical figure's 'hand drooped on the arm of her chair',[31] thus creating a kind of chainlock between the picture, the Mona Lisa, Sybilla, and the 'drooping hand' above the door. However, unlike *Middlemarch*, the social and legal context of this rhetorical handcuffing is non-existent. As the Count points out, 'the means of escape lay in her own hands . . . she was of age, and had a right to sell the picture'.[32] Why does Sybilla not get out? It may be that Wharton is dealing with a hand larger than her father's or husband's: the hand of ideology. Or it may be the hand of the painter which keeps Sybilla, like the painted figure, in an objectivised frame. The picture is hers because she is the picture, tied by a subtle chain of signifiers to Leonardo's woman, figured as the epicurean sign of male pleasure and ownership. However, the hand is also Sybilla's own. It is she, after all, who chooses not to sell the picture after her father's death, for the sake of a marriage which will buy her out only to keep her in. Instead, she remains in the house with the Leonardo. The figure of classical luxury, beauty and pleasure is hers for life; it remains in her 'own hands', instead of being the thing she sells for (and to) a husband. Hands of art and hands of ownership are hard to tell apart, in this story, from the hand of fate. By assigning Eliot's title to her heroine, Wharton has at some level handed power to the woman. However ambiguous the transaction, it is she who finally owns her own picture. If that means being imprisoned in the dead house of history and beauty, at least, Wharton suggests, it is Sybilla rather than Dr Lombard (Casaubon or Pater) who has the key in her hand.

Evidently, this story wrestles with the shadows both of Eliot and of Pater. But it also acknowledges a woman writer on aesthetics and the Renaissance whose name, in the late nineteenth century, was as well known as her male contemporaries'. Wharton once recalled her own generation's debt of gratitude to the three figures of 'Pater, Symonds and Vernon Lee'[33] for their writings about Italy. 'The House of the Dead Hand' might, at some level, be about passing the Renaissance from a dead father, Pater, to a living, sybilline daughter, Lee. Certainly, as a commentator on Italy and the Renaissance, Lee is as crusadingly secular as her male contemporaries. The Renaissance, she writes, is an 'enigmatic picture drawn by the puzzled historian'.[34] When she describes

31 *Ibid.*, p. 513.
32 *Ibid.*, p. 520.
33 Edith Wharton, *A Backward Glance* (New York, Charles Scribner's Sons, 1933), p. 141.
34 Vernon Lee, *Euphorion: being Studies of the Antique and the Medieval in the Renaissance*, 2 vols (London, Satchell, 1884), 1: 29.

Lorenzo de Medici she might be writing about a Victorian aesthete. He 'is new, Renaissance, modern . . . completely the man of impressions . . . of art for art's sake, or rather effect for effect and form's sake'.[35] Elsewhere, she relishes the pagan energies of that age, imagining, for instance, one Domenico Neroni, 'a most fervent anatomist', for whom 'indeed, bones, muscles, and tendons were mistress and god all in one to this fanatical lover of human form'.[36] Here form is fleshed out, literally, with parts of the body in a well-worn exhumation scene. What the Renaissance recovers from the ground of Italy is not only art or artefacts, but the body itself, long forgotten, but ripe for resurrecting. In a fine account of Botticelli's painting, Lee outdoes her mentor Pater in finding form to be, not the human form divine, but something almost inhuman in its material beauty: 'hands combed out into wonderful fingers'.[37] This is indeed flesh as dead matter, not idealised or even resuscitated, but somehow managed as matter: 'combed out' like any other thing. Resurrections of the body, for Lee, as for many of her predecessors, are not necessarily resurrections into life, eternal or otherwise.

Lee's main contribution to the cluster of ideas surrounding the Renaissance is to be found in her stories. Here, she goes further than any of her contemporaries in realising the implications of aestheticism's obsession with Italy and the past. The 'enigmatic picture' of the 'puzzled historian' becomes, in her hands, a figure for a psychological puzzle as curious as any facts of history. In an essay called 'The Child in the Vatican' (1880), for instance, she sets out to recall her own childhood: 'how did it feel?' she asks. 'Alas, we should, in order to know, first have to find that little, obscure, puzzled soul again; and where is it gone? this thing which may once have been ourselves, whither has it disappeared, when has it been extinguished?'[38] This is a prose version of Hadrian's last song to the little wandering soul, but here the '*animula vagula blandula*' is the soul of the past, not the future. As Lee tries to be the historian of herself, she admits there is no recalling what she was or felt. Instead, she is confronted with a lost 'thing', an 'it' that seems to have got clean away. The neutral pronoun is not an accident of grammar, but a haunting from some elusive but oddly matter-of-fact ghost.

35 Lee, *Euphorion*, 1: 153–4.
36 Vernon Lee, *Renaissance Fancies and Studies: Being a Sequel to Euphorion* (London, Smith Elder, 1895), pp. 176–7.
37 Lee, *Renaissance Fancies*, p. 101.
38 Vernon Lee, *Belcaro: being Essays on Sundry Aesthetical Questions* (London, Satchell, 1880), pp. 19–20.

The personal past, for Lee, thus becomes as much a subject of strange renaissances as the historical past. In an essay called 'Puzzles of the Past' (1903), she asks: 'What are the relations of the Past and Present? Where does the Past begin? And, to go further still, what *is* the Past?'[39] The answers she gives are two. Firstly, the past is an unknown continent, always faced but never known; secondly, because unknown, the past is always imaginable. In the Preface to her collection of stories, *Hauntings* (1889), she returns to the same problem. 'That is the thing – the Past, the more or less remote Past, of which the prose is clean obliterated by distance – that is the place to get our ghosts from. Indeed we live ourselves, we educated folk of modern times, on the borderland of the Past'.[40] Like Burckhardt, Pater and Symonds, Lee's sense of the 'modern' is unearthed from the past. That past is both too far and too near, both 'obliterated by distance' and yet so close that 'we' live perpetually on its 'borderland'. The very nature of 'modern times' is thus, not to have dismissed the past, but to be so haunted and reinhabited by it that the difference becomes unclear. The country of ghosts extends to the very edge of where we are. It also, therefore, in a disturbing way, extends to who we are, living as 'we' do on the 'borderland' of ourselves. As the historical past becomes a psychological past, Italy, the foreign country, comes to lie within, and the ghosts that are summoned from it turn out to be our dead, but perhaps revivable, selves.

Lee thus takes the aestheticist possibilities of Italy a step further (and nearer to home) than any of her contemporaries. Perhaps as a result of her own upbringing in Italy, her truly 'cosmopolitan intellectualism',[41] as Shaw once described it, she is able to imagine the past as always almost here, the Renaissance as almost now. At the same time a crucial 'borderland' separates us from ourselves, making us haunted creatures of what lies 'more or less remote', just on the other side. Like Italy, the terrain of the self is a very local tomb. In a letter to Ethel Smyth, Lee seems to sum up a lifelong anxiety when she writes: 'I cannot take people as – how express it? *wholes in time* . . . I don't feel they are the same. I don't identify myself sufficiently with my own past to be able to identify others in this way . . . Perhaps for this reason, the past of my friends, at any given moment, remains as intact and as stable as

39 Vernon Lee, *Hortus Vitae: Essays on the Gardening of Life* (London, John Lane, 1903), p. 181.
40 Vernon Lee, *Hauntings: Fantastic Stories* ([1889] London, John Lane, 1906), p. x.
41 Quoted in Peter Gunn, *Vernon Lee: Violet Paget 1856–1935* (London, Oxford University Press, 1964), p. 2.

does their portrait.'[42] In this extraordinary challenge to the notion of individual identity, Lee points out that the self, by being subject to time, loses itself. She struggles to find the right expression, and then brilliantly lights on that *'wholes in time'*. The reason why self fails to cohere is that the past has always snatched it away from itself. The borderland between them is a crossing with no return, except, of course, for 'it', the imaginary ghost or soul. And yet, paradoxically, what is whole, 'intact' and 'stable', is the past moment caught as a 'portrait'. The dead thing is more true than the living; the framed representation more ourselves than we are.

Thus Lee brings the past, figured as Italy, the Renaissance, the ghost, the portrait, to the very doorstep of who we are. 'I don't feel they are the same', she writes of her friends. It is this streak of psychological incoherence which makes her stories, in some ways, failures, yet also peculiarly memorable and odd. If nothing else, they show the extent to which we, as readers, still depend on the conventions of characters being *'wholes in time'*. Well before modernism, the aestheticist idea of 'the modern' shows up the cracks in Victorian conceptions of the self. Lee, more than any, makes those cracks widely visible.

Most of her stories figure a ghost from the past who interferes, usually mortally, with the present. This, of course, is the stock-in-trade of the ghost story. But in Lee's work there are two differences. First, these ghosts tend to be distinctly fleshly, even to the point, as in 'A Wicked Voice', of being a figure for the flesh.[43] Second, they seem to have lost their moral connection to the protagonists, though sometimes carrying out inordinate revenges against them. As a result, the story, like most aestheticist texts, abandons its moral meaning. It also, and this is the far-fetched point to which Lee reaches, loses its psychological coherence. By going back in time, in search, for instance, of an eighteenth-century castrato ('A Wicked Voice'), a pagan Venus ('Dionea'), a cavalier poet ('Oke of Okehurst'), a scheming Renaissance woman ('Amour Dure'), they invite the past to return to derange the logic of the present. Objects of passionate desire, these ghosts act out a killing drama with all the irrational satisfaction of a love story. Some critics have read a gendered revenge into these stories. Julia Briggs, for instance, suggests

42 Quoted in Ethel Smyth, *Maurice Baring* (London, Heinemann, 1938), p. 327.
43 For two discussions of the flesh in 'A Wicked Voice', see Carlo Caballero, '"A Wicked Voice": On Vernon Lee, Wagner, and the Effects of Music', *Victorian Studies*, 35 (1992) 386–408, and Angela Leighton, 'Ghosts, Aestheticism and Vernon Lee', *Victorian Literature and Culture*, 28 (2000) 1–14.

that 'Amour Dure' is ' "My Last Duchess" in reverse'.[44] Christa Zorn suggests that Lee rethinks 'Paterian aesthetic historicism'[45] by making the 'ghost (myth) of the past , personified in a *femme fatale*' be 'a production of male hysteria',[46] though she does not examine stories in which the 'ghost' is male or the hysteric female. Catherine Maxwell connects the portrait with the death-dealing Gothic tradition: 'Representation preserves the dead who defy the ravages of the grave, but it also prematurely mortifies the living'.[47] There is something even odder about Lee's stories, something which makes any moral or ideological interpretation hard to sustain at all.

To read them as the natural development of an aestheticist cult of the revived past, what the ghost then represents is not the horror of death but the powerful temptation of physical life – of the beautiful body raised from the dead through the desire of the living. These are, in a sense, Renaissance texts because they involve an exhumation of the past which brings it back to a sort of life. The ghost is less a dead person come to haunt the present, than a still-living past haunted and reawakened by the historian. Lee also seems to be attempting an experiment in psychology which is the logical conclusion of Pater's aestheticist manifesto. What counts in her stories is not individualism, the sense of self as a creature of cause and effect, but the complete breakdown of identity by time. As her protagonists encounter the flesh-and-blood ghosts of the past, they are brought to the very edge of who they are. Some of them, then, go over.

In 'Amour Dure', for instance, a Polish historian, Spiridion Trepka, goes in search of that familiar destination, 'Italy . . . the Past',[48] and finds, in various old manuscripts, the story of a scheming Renaissance woman, Medea da Carpi, who has killed off several unwanted lovers. In true aestheticist fashion, the past then comes alive in a picture. This is a Bronzino rather than a Leonardo, but the scene in which the portrait first appears reads, of course, like another variation on the Mona Lisa:[49]

44 Julia Briggs, *Night Visitors: The Rise and Fall of the English Ghost Story* (London, Faber, 1977), p. 119.
45 Christa Zorn, 'Aesthetic Intertextuality as Cultural Critique: Vernon Lee Rewrites History through Walter Pater's "La Gioconda" ', *Victorian Newsletter*, 91 (1997) 4–11 (p. 10).
46 Zorn, 'Aesthetic Intertextuality', p. 9.
47 Catherine Maxwell, 'From Dionysus to "Dionea": Vernon Lee's Portraits', *Word & Image*, 13 (1997) 253–69 (p. 253).
48 Lee, 'Amour Dure: Passages from the Diary of Spiridion Trepka,' in *Hauntings*, pp. 3–58 (p. 3).
49 For a discussion of this connection, see Maxwell, 'From Dionysus to "Dionea" ', pp. 257–61.

As I was passing, my eye was caught by a very beautiful old mirror-frame let into the brown and yellow inlaid wall. I approached, and looking at the frame, looked also, mechanically, into the glass. I gave a great start . . . Behind my own image stood another, a figure close to my shoulder, a face close to mine; and that figure, that face, hers! Medea da Carpi's! I turned sharp round, as white, I think, as the ghost I expected to see. On the wall opposite the mirror, just a pace or two behind where I had been standing, hung a portrait. And such a portrait! . . . (for it is Medea, the real Medea, a thousand times more real, individual, and powerful than in the other portraits) . . . The dress is, with its mixture of silver and pearl, of a strange dull red, a wicked poppy-juice colour, against which the flesh of the long, narrow hands with fringe-like fingers; of the long slender neck, and the face with bared forehead, looks white and hard, like alabaster.[50]

If this is 'the scene of a transfusion', as Elisabeth Bronfen suggests all portrait texts are,[51] it is not the bood-letting activity of the male artist, who kills, literally or metaphorically, for art. Instead, the transfusion is across another divide: past and present. Brilliantly set in a hall of mirrors, frame within frame – the 'very beautiful old mirror-frame' being the thing that Trepka first notices, as if framing were itself the issue – this scene of recognition is about the past coming to life again. This is the Renaissance for 'real', and all the more real for opening up, in the name Medea, a vista to the classical past which lies behind it. The thing in the frame is 'more real, individual, and powerful' than, it is hinted, anything out of the frame. And it is, characteristically, very much a thing: the 'narrow hands with fringe-like fingers' are described like furnishings, while the final epithet, 'alabaster', which ought to be a traditional, sexual compliment, suggests instead a cool petrification. As the writing fidgets between life and death, the figure of Medea appears to move. Like Pater's, this is a reanimation, not literally, for the portrait does not move, but in the writing, as it lovingly details the matter of Medea's flesh and dress. Resurrection is also a rhetorical act. Meanwhile, it is Trepka who turns white 'as the ghost I expected to see', as if his blood had drained into the 'poppy-juice' dress. What has been transfused is his individuality into hers, so that for the rest of the story he merely ciphers her powerful presence, and eventually, like the other lovers, dies for it.

50 Lee, 'Amour Dure', pp. 31–2.
51 Elisabeth Bronfen, *Over Her Dead Body: Death, Femininity and the Aesthetic*, (Manchester, Manchester University Press, 1992), p. 112.

To read the story as just the deranged ravings of an unwholesomely obsessed historian might just miss the point that this is also about not being *wholes in time*. As the Renaissance returns, in a typical nineteenth-century second coming, it confounds not only morality and belief, but also that most cherished of mid-Victorian ideals: the integrity of the individual. What appears in the portrait is more 'intact' and 'stable' than the distinctly unstable, living protagonist. The gendered nature of the reversal is enjoyable – the Mona Lisa kills off Pater at last – but it is not essential. The point is that the past steals us from ourselves, fixes us into portraits, and only a convention of sanity stops us from being so much historians, like Trepka, that we simply go over. The frame of the picture is the crucial 'borderland', not only of present and past, homeground and Italy, but also, psychologically, of self and 'it'. If the rest is a trick of words, that too is part of Lee's playful, ghostly point.

In 'The Legend of Madame Krasinska' (1892) she explores the same problem. The aristocratic heroine of the title sees the sketch of an old beggar woman, the Sora Lena, who is a familiar sight in the streets of Florence. Legend has it that she has lost her sons in the battle of Solferino and, having lost her wits as a result, goes each day to the railway station to meet them. The story recalls two of Elizabeth Barrett Browning's poems, 'The Forced Recruit', and 'Mother and Poet', in which a mother laments the deaths of her two sons in a battle for Italian Unification. The scene in which Madame Krasinska arrives at a fancy dress party dressed, not as a marionette or champagne bottle, but as the Sora Lena herself, is dramatic:

> there walked into the middle of the white and gold drawing-room, a lumbering, hideous figure, with reddish, vacant face, sunk in an immense, tarnished satin bonnet; and draggled, faded, lilac silk skirts spread over a vast dislocated crinoline. The feet dabbed along in the broken prunella boots; the mangy rabbit-skin muff bobbed loosely with the shambling gait; and then, under the big chandelier, there came a sudden pause, and the thing looked slowly round, a gaping, mooning, blear-eyed stare.[52]

Here, Lee puts all the tricks of aestheticist writing to the service of a moment of anti-aesthetic horror. The dehumanised language, the fixation on clothes and body, bring to life a creature whose degraded presence for a moment shocks the gathered company. This is almost not a person,

52 Lee, 'The Legend of Madame Krasinska', in *Vanitas: Polite Stories* (London, Heinemann, 1892), pp. 225–76 (pp. 240–1).

but a 'pause', a 'thing', a 'stare', the dabbing feet horribly inhuman in their duck-like movements.

But the point is not only a socio-political challenge to fin-de-siècle frivolity, a haunting, perhaps, from the serious political world of Barrett Browning's mid-century Florence; it is also a psychological challenge. After the party, Madame Krasinska begins to understand what 'people might mean when they said that So-and-so was *not himself*'.[53] She starts to feel bored, to wander the streets, her feet drawn to the railway station and the old slums. 'For gradually, slowly, she had come to understand that she was herself no longer'.[54] The metaphorical language of break-down becomes literal, as Madame Krasinska becomes the person she had impersonated: the Sora Lena. The story takes us across the border-line of the present, which is also the borderline of sanity, sense and self, in order to suggest that the place in which we are not ourselves lies very close, all round. Knowing 'how far to go' is not a problem for Lee. She goes almost further than anyone else in the aestheticist game of curious, far-fetched self-resurrections.

These eerie, yet literal-minded, ghost stories neither chill the blood nor point a moral; instead, they test the limits of belief, in order, it seems, to show how thin all limits are. In Lee's work the picture frame, which should keep those territories separate, in fact allows them to leak into each other, so that the body of the past comes back to claim its flesh-and-blood reality. Like much Victorian aestheticist writing, these stories are 'modern' in the ways in which they challenge, by returning to the past, the assumed moral, industrial, even psychological superiority of the present. The idea of the Renaissance is thus disinterred, many times, from the productive ground of an imaginary Italy, to suggest resurrec-tions of the body which playfully question the integrity of the self. If this is no more than a trick, as James hints: a trick of words at the expense of facts, a trick of mythmaking at the expense of reality, a trick of Italy at the expense of Victorian England, it is nonetheless a trick with a sharp and subversive point. History is a levelling and relativising power. It is also a form of resurrection without religious purpose. Certainly Lee, far from being frightened into moral or emotional conclusions, takes the playful inhumanity of such imaginary resurrections to almost surreal ends. After her, the twentieth century will assert its own modernity, and modernism, at the expense of the past, and the old, aestheticist 'super-stition' of Italy, that trick of a mere 'word', finally dies.

53 Lee, 'The Legend', p. 254. (Italics in original.)
54 Lee, *Ibid.*, p. 260.

Index

Note: 'n.' after a page reference indicates the number of a note on that page; works are listed under authors.